MORE THAN TWO TO TANGO

18 de sept.'13

Para Vero:
Con todo el
cariño que tuve
guardado en estos
años y que este
reencuentro maravilloso
lo ha vuelto a hacer
realidad
¡Por muchos
encuentros más!
Ana

More Than Two to Tango

Argentine Tango Immigrants in New York City

ANAHÍ VILADRICH

THE UNIVERSITY OF
ARIZONA PRESS

TUCSON

The University of Arizona Press
© 2013 The Arizona Board of Regents

www.uapress.arizona.edu

Library of Congress Cataloging-in-Publication Data
Viladrich, Anahí.
 More than two to tango : Argentine tango immigrants in New York City / Anahí
Viladrich.
 pages cm
 Includes bibliographical references and index.
 ISBN 978-0-8165-2946-9 (pbk. : alk. paper)
 1. Tango (Dance)—Social aspects—New York (State)—New York. 2. Immigrants—
New York (State)—New York—Social conditions. 3. Argentine Americans—Social
conditions. 4. Argentine Americans—Social life and customs. I. Title.
 GV1796.T3V465 2013
 793.3'3—dc23
 2013009926

Publication of this book is made possible in part by a subvention from Queens College of
The City University of New York.

Manufactured in the United States of America on acid-free, archival-quality paper
containing a minimum of 30% post-consumer waste and processed chlorine free.

18 17 16 15 14 13 6 5 4 3 2 1

To the memory of Damián M. Viladrich,
the enchanting tango singer who has never left my side

The tango is what brings us together and, by the same token, is what pulls us apart.

—Chardoma, a female tango participant

Contents

List of Illustrations ix

Acknowledgments xi

Introduction 1

1. The Tango's Social History in a White-Imagined Argentina 25

2. Welcome to the Argentine Tango World: From the Study Design to My Field Experience 46

3. Argentine Tango Artists: The Craft of Marketing Authenticity 73

4. Elderly Newcomers and the Tango's Vulnerable Image 105

5. Legal Trajectories and the Elusive American Dream 123

6. The Social Geography of New York's Tango 148

7. Paradoxical Solidarities in the Tango Field 170

8. Finding the Cure Through the Grapevine: Tango Brokers and Alternative Sources of Help 193

9. Conclusions: From Bonding to Bridging Ties 216

Notes 225

Glossary 229

References 231

Index 245

Illustrations

Figures

1. Allegoric representation of the book's title, I 4
2. Allegoric representation of the book's title, II 5
3. United States Postal Service stamps: Latin music legends 10
4. Outdoor mural of Carlos Gardel, advertising an Argentine sparkling wine 11
5. Tango mural decorating an old government office 12
6. *La esquina argentina* (the Argentine corner) can be read on this restaurant's awning 50
7. Anahí Viladrich by the "Argentine tribute wall" 51
8. Outdoor tango dancing by the Verrazano-Narrows Bridge 53
9. Free outdoor tango dancing that takes place every Saturday during the summer months, by the Shakespeare statue in Central Park in New York City 53
10. Tango embrace I 56
11. Dancer performing as a "wallflower"; an iconic representation of a female tango aficionado who is waiting to be asked to dance 68
12. Argentine dancing parlor (*milonga*) in New York City 74
13. Tango couple I 79
14. Tango couple II 80
15. Tango demonstration of the "Dinzel School" 86
16. The tango's avant-garde 87
17. Tango shoe shop in El Abasto neighborhood 95
18. Tango souvenirs in El Abasto neighborhood in Buenos Aires 96

19. Souvenir book representing a *bandoneón* displayed at the Librería del Colegio (the School Library) in Buenos Aires 117
20. Fantasy tango I 194
21. Fantasy tango II 195
22. Conceptual model of immigrants' health-seeking behaviors 197
23. Tango embrace II 217

Table
1. Nonimmigrant admissions by country of citizenship (Argentina) and by selected class of admission, 1996–2010 130

Acknowledgments

Out of encounters of sorrow,
circular paintings of embodied bliss.
Tango is never what it promises to be
and makes you long for . . .
Arms that arm you against grief,
hugs that hug you against defeat,
eyes that left you in the past
not quite ready to return.

Syncopated melodies
suddenly find me in a foreign land,
whispering memories of another era,
woven embraces that reinvent the joy.
Tango is grief, pain, and abyss,
and everything in between that has been lost.

ANAHÍ VILADRICH, "THE TANGO'S FULL CIRCLE"

The title of the poem above speaks to both my personal and professional journeys, which, for more than a decade now, have steered the research project that ultimately led to this book. My initial interest in tango was spearheaded by my own migratory path from Argentina to the United States in the mid-1990s, which was followed by my research on migration trends that eventually led to my coming of age as a social scientist in New York City. This process would not have been possible without the mentorship, support, and assistance of countless friends and colleagues along the way.

I want to thank my editors Kristen Buckles and Amanda Piell, and the wonderful editorial team at the University of Arizona Press, for leading me, patiently and kindly, through the different stages of the manuscript's preparation and its peer-review and editing processes. I am indebted to Malka

Percal for providing outstanding proof-editing expertise during the (almost) final steps of the book's preparation; and to Barbara Kilborn (and her expert team) for skillfully leading this book throughout its final copyediting and typesetting process. I am deeply thankful to Rita Baron-Faust, who carefully proofed the initial version of the manuscript, and to Nancy Bruning, Domenic Casenelli, and Sarah Stetson for copyediting shorter related pieces. Foremost, I want to express my sincere gratitude to two of my beloved colleagues and friends, Eva M. Fernández and Alyshia Gálvez, who offered invaluable comments on this book after painstakingly reading a complete draft. This volume also owes a special thank-you to the anonymous reviewers who provided challenging, albeit constructive, criticism of the initial book proposal and the complete manuscript later on.

The study that led to this book was part of my dissertation on Argentines in New York for my doctoral degree in sociomedical sciences (medical anthropology) at Columbia University in 2003. I could not have asked for a better dissertation committee, graciously led by Richard G. Parker and joined by Ana F. Abraído-Lanza, Robert E. Fullilove, Petter A. Messeri, and Sherry B. Ortner.

Diverse sources supported my long-term project on Argentine immigrants and their tango networks. A grant by the National Institute on Aging, administered by the Columbia Center for the Active Life of Minority Elders, financed my early ethnographic study on the elderly Argentine minority in New York City. The Rousseau Gift for Alternative Healing and funds from the Provost's Office at Hunter College, along with a couple of PSC-CUNY awards, supported my work on alternative healing practices that involved Argentine immigrants in New York City. I am also grateful to my mentors and colleagues at Hunter College, particularly Nicholas Freudenberg, Jennifer Raab, Vita C. Rabinowitz, and Laurie N. Sherwen, for their encouragement of my work; and to Jerome Richardson, Robert Buckley, Carolynn Julien, and Diane Brows for their guidance dealing with the college's administrative maze, including running grants and complying with ethics protocols.

A 2010–11 sabbatical leave granted by Queens College, my current home institution, allowed me to complete the final chapters of this book. I spent most of that year as a resident scholar at the Gino Germani Institute of the University of Buenos Aires. This stay provided me with the precious time for research and writing that ultimately allowed me to finish this book. I am enormously thankful to Susana Novick, my superb colleague and friend, and to Julián Rebón for inviting me to join their team at the Institute. Alejandro Frigerio offered great advice and generous ideas

that led to my better understanding of the racial and ethnic categories that pervade the Argentine social imaginary.

At Queens College, I am particularly indebted to Andrew A. Beveridge, the chair of the Department of Sociology, whose leadership and invaluable advice kept me on track while I finished this book. I am also thankful to Elizabeth Hendrey, Sue Henderson, James Muyskens, Kate Pechenkina, Jeffrey Rosenstock, James R. Stellar, and Dana Weinberg for their enthusiastic support of my work on immigration. My colleagues in the Departments of Sociology and Anthropology at Queens College, and at the Doctor of Public Health program at the Graduate Center of the City University of New York have been remarkably inspirational to my research in many distinctive ways; I apologize for not having the space here to thank them all individually.

Terry Williams, Rayna Rapp, and Deborah Poole—my mentors at The New School—were pivotal in shaping my interests in urban ethnography, gender, immigration, and public health. I am also grateful to Sana Loue and Kathleen D. McCarthy for being amazing role models throughout the years. Many colleagues offered advice and helped me shape the main arguments of this book. I particularly recognize Lila Abu-Lughod, David Fitzgerald, Donna Gabaccia, Scott A. Hunt, Gaku Tsuda, and Pablo Vila for their insightful comments on my early work on tango. I warmly thank Cynthia Pizarro, Gabriela Karasik, and our colleagues from the Network of Argentine Researchers in International Migration for welcoming my research on tango with open arms, and for the exciting work we are doing together.

Many members in the tango community were key to the completion of this book. Central to the project was Virginia Kelly, whose in-depth involvement with the Argentine tango world in New York City made a difference in turning this book into a reality. Coco Arregui, Daniel Carpi, Lucille Krasne, and Juan Pablo Vicente generously opened their tango parlors to me, and their insights helped me understand the intricacies of the New York City tango field. María C. Gómez's assistance was pivotal in gathering statistical data and streamlining the book's references. In Buenos Aires, María Celeste Castiglione offered timely research aid that led me to better comprehend both the open and subtle nuances of the Buenos Aires' tango community, along with its transnational liaisons.

A long-term intellectual project would not have been possible without the support of friends and family. My late father, Alberto Viladrich, continues to guide me with his love, commitment to social justice, and personal integrity, and his legacy remains as an inspiring beacon in my life. Carol

Pfeffer and Jorge Garaventa, my two "guardian angels," provided me with unparalleled advice and emotional support throughout the years. I want to acknowledge *las comadres académicas* (the "academic godmothers"), an informal network of female scholars in the New York metropolitan area, whose friendship has brought tremendous joy and delight to my life. I particularly thank the group's leader, Suzanne Oboler, for being a steady source of inspiration, and my *comadres* Alyshia Gálvez, Ramona Hernández, Lina Newton, and Elena Sabogal.

I am grateful to Marta E. Savigliano, whose groundbreaking work on tango inspired my own. I also owe special thanks to Mayte Vicens, Virginia Kelly, Maike Paul, and Celeste Castiglione for many of the beautiful pictures in this volume, and to Juan Carlos Cáceres for sharing his poem "Tango Negro."

I must mention Victor Penchaszadeh, an extraordinary mentor and ally during my years as a doctoral student at Columbia University and beyond. Many dear friends and colleagues have been present during this research journey, in one way or another. They are, in alphabetical order, Rev. Fabián Arias, Beatriz Arpayoglou, Ashley Barnett, Kristy Bright, Angeles Cabria, Jesús Casquete, Arachu Castro, Gabriela Chistik, Arlene Dávila, Carmen Ferradas, Nora Glickman, Carmen González, Sabina Gritta, Carolina Mera, Lucas Monzón, Sara Poggio, Marcela Rodríguez, Diana Romero, Ron Scapp, Meryl Siegman, Silvana Suárez, Leonor Vila, Iris Yankelevitch, and Ming-Chin Yeh. Special thanks to the Sancho family—Diana, Miguel, Tamara, and Iván—who always offer me "a home away from home" when I visit Barcelona to present my work; and to Olga Gil García and her lovely family in Madrid.

This book would have not been possible without my adorable husband, Stephen Pekar, who has always been by my side embracing me with his loving encouragement and caring support. His brilliant advice and inquisitive mind have opened my eyes in countless ways, and have taught me to look at social phenomena through innovative lenses.

Lastly, I acknowledge the participation of all the tango performers and producers who generously volunteered their time to be part of this research study. This book has finally come to fruition because of their enduring commitment to and passion for their artistic trade.

MORE THAN TWO TO TANGO

Introduction

"You cannot live this way forever," Manuela grumbled in a low-pitched voice, almost whispering to herself. Manuela, a gorgeous Argentine tango instructor in her late twenties, had been in job-hopping mode for the past couple of years, eager to pay the symbolic dues that global cities like New York charge newcomers in the artistic field.[1] She was fighting a cold on that nippy Friday morning of December 2001, when we got together for coffee in a fast-food venue in Midtown, before she had to rush to teach her first class at a dancing studio nearby. With the financial downturn that followed the terrorist strikes of September 11, 2001, it had become more difficult for tango instructors to woo potential students into taking dancing lessons. The *milongas* (tango parlors) that Manuela and her friends frequented were less populated than ever before. Two of Manuela's students had decided not to take private classes with her anymore, and with that decision, her chances of paying the rent on her studio that month had vanished.

Again, Manuela vented: "I don't see the way for anybody to give me a real visa that will pay for the rent and groceries." By a real visa, she was actually referring to having a job *en blanco* (declared employment) that would eventually make her eligible for a renewable work permit. This would give her the needed financial stability that she had been recurrently denied by the flurry of short-term and unstable paychecks, which came and went depending on the capricious mood of occasional students or the weather forecast. The last piece of gloomy news she shared with me on that day was that several of her outdoor performances had been canceled

1

due to a series of disastrous weekends in which rain had been a steady, albeit uninvited, guest.

When I bumped into Manuela less than a year later, her situation had taken a turn for the better. Tango dancing was blossoming in the city once again, and she had finally been able to secure a temporary visa as a journalist, thanks to her occasional written collaborations to tango magazines in Argentina, for which she rarely got paid. This also meant that she taught tango mostly off the books for an income that was way below market values. However, with the help of her tango friends, she was in the process of applying for an artist visa and was hopeful about gaining a more permanent legal presence in the city.

Manuela's account is just one of the many stories that I have heard for more than a decade now, and it clearly portrays the struggles that a tango artist usually endures in order to make a living in the field. By the late 1990s, the Manhattan tango world was already turning into a booming market on its own, supported by the rising popularity of tango dancing and music playing. In recent years, large numbers of Argentine tango performers have come to New York City, either as occasional visitors or prospective settlers, hoping to satisfy the increasing demand stemming from the offerings of tango products, including the opening of tango salons and novel tango shows.

How are they able to maneuver their often volatile working and housing conditions while trying to launch and support their artistic careers? How do they provide for basic necessities, including medical care when needed? And, more important, how are tango artists able to resourcefully utilize their seemingly fragile and transient social webs in order to make ends meet? These questions haunted me in those days, as well as today, as I marveled at the resourceful abilities and social assets marshaled by tango artists in their attempts to earn a decent living in one of the most competitive and expensive cities in the world.

In *El Cantor de Tango* (*The Tango Singer*), one of the last novels by the late Argentine writer Tomás Eloy Martínez (2004), the author chronicles the adventures of a young American university student who travels to Buenos Aires in search of a mythical male tango interpreter. The student's voice weaves a path in which his endless pursuit for the *cantor* becomes a striking reflection of his own migratory journey. In this book, I mirror that search — only the other way around — for the purpose of exploring the lives of tango dancers, singers, and musicians in New York City. As in Martínez's case, I am also an Argentine scholar who hopes to disentangle the rich life stories and convoluted paths of Argentine tango practitioners from

varied backgrounds. Rather than concocting an imaginary tale, however, my work retraces these artists' transnational journeys along with the cosmopolitan social liaisons they end up crafting in New York City.

This book unscrambles the informal, yet powerful, social webs in the tango field that reflect artists' struggles to make a living amid the cosmopolitan glamour of upscale amusement trends. More broadly, I am interested in exploring how a worldwide entertainment industry supports the career opportunities of tango performers while, at the same, time reproduces global inequalities in one of the world's most exciting cities. The narrative that is about to unfold provides a cross-sectional analysis of Argentines' trajectories in New York, which the worldwide success of Argentine tango helped to flourish. This is my chance to narrate the personal stories that have not been accounted for in travel guides or dance books, and that expand beyond artists' enthralling auras as the natural interpreters of tango passion.

This book's title, *More Than Two to Tango*, conveys more than just a figurative and linguistic twist on a popular speech idiom. It highlights the ubiquitous, and often invisible, forces of co-ethnic ties that both support and undermine Argentines' careers abroad. For tango artists, well-trained opera singers, and impromptu street performers alike, much of what drives them overseas arises from networks of opportunity (and people) through which promises of a better future are waiting to unfold. Despite the fact that most artists tend to advertise their tango careers as "solo adventures," their trajectories (including their upward tales of success) greatly depend on their peers. From this perspective, the tango field represents a loose web of performers who, in cities such as New York, Buenos Aires, or London, are supported by local and global ties that advertise the tango genre as an Argentine trademark. It is precisely because of the driving power of their bold dreams of success, combined with their vulnerability, that Argentine performers seek their co-nationals' company.

This book offers a window of opportunity to learn about contemporary trends of artistic migration spearheaded by the globalization of music and dancing as mass consumption. In many ways, tango performers have always been transnational migrants. Dance and migration have much in common, as both are rooted in people's movements that do not exist in pure forms but are actually conceived, and transformed, by their everlasting journeys around the planet (Scolieri 2008). In recent decades, globalization and transnationalism—along with the explosion of worldwide tourism—have accelerated the wide-reaching journeys of artistic forms, giving birth to unique musical expressions (Fernandes 2011; Levitt and

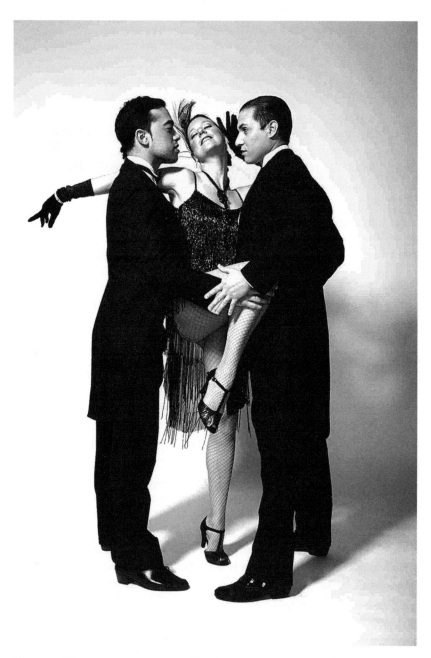

Figure 1. Allegoric representation of the book's title, I. Dancers from left to right: Leonardo Sardella, Virginia Kelly, and Walter Perez. (Photographer: Maike Paul)

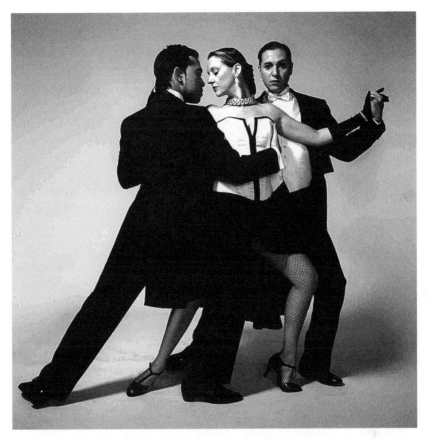

Figure 2. Allegoric representation of the book's title, II. Dancers from left to right: Leonardo Sardella, Virginia Kelly, and Walter Perez. (Photographer: Maike Paul)

Jaworsky 2007; Viladrich and Baron-Faust 2012). Contemporary tango artists—as a new breed of transnational migrants—have found in their *argentinidad*, defined by the shared experience of being an Argentine citizen, a dazzling passport to foreign lands with the help of their informal webs. The tango newcomers in this book represent a special group of artists who, even if not alone in their entrepreneurial efforts, have grown to be a conspicuous expression of the worldwide entertainment industry.

Along with the tango's awakening has come a wealth of original research, ranging from its analysis as another commodity in the international capital of emotions (Savigliano 1995, 2003) to its hybridization as a transnational artistic genre (Merritt 2012; Pelinski 1995; Steingress 2002) to its role in making Argentina's capital, Buenos Aires, the ultimate "Disney

World" tango heaven to foreign expatriates (Dávila 2012). Nevertheless, the blossoming literature on contemporary artistic trends has somehow overlooked the convoluted migratory paths of the tango's creators and performers. Concomitantly, the scholarship on social networks has not yet fully regarded the importance of entertainment forms as social spaces for immigrants' resolution of their everyday needs. As a result, the roles of Argentine artists' informal webs, and such webs' contribution to the creation of a worldwide tango community, have remained hidden both in the academic literature and in mass media accounts of the subject.

We know little about tango interpreters' hazardous lives vis-à-vis their reliance on informal social ties. Prevailing glamorous representations of tango artists have veiled their struggles to make ends meet, a fact that has become one of the better-kept secrets of the dancing and music realms. This coincides with the scarce literature on Argentine immigrants in the United States, which somehow contrasts with past and recent studies on their migratory streams to Europe (Actis and Esteban 2007; Garzón 2007; Novick and Murias 2005). In countries such as Spain, where Argentines' presence has become more noticeable in recent decades, they tend to inspire contradictory representations as accepted returnees (blood-related immigrants) on the one hand, or as impoverished foreigners from the South (pejoratively called *sudacas*) on the other—images that contest their possibilities for social integration (Cook-Martin and Viladrich 2009a, 2009b).

The situation in the United States is quite different. Neither an ideal minority nor a clearly acknowledged Latino group, Argentines have a fuzzy "neither/nor" (neither white nor Latino) status that endorses an imprecise rhetoric regarding their ethnic and racial heritage. Argentines' invisibility in the United States is not only due to their scant numbers and ethnic camouflage within the larger white majority but also to the cultural diffusion of the myth of the resourceful Argentine immigrant. Most of the books and articles about Argentines in the United States have been written in Spanish, and they consist of descriptive and journalistic accounts with limited conceptual reflection on their contemporary migratory exodus.[2] Political persecution, economic instability, and Argentines' better opportunities for success abroad are the major themes in this literature.[3] Although this body of work offers a remarkable contribution to our understanding of Argentina's contemporary migration flows, it overemphasizes the case of the white, well-educated Argentine émigré who is destined to thrive overseas by joining prestigious corporations and research institutions. These portraits have effaced the presence of those who neither are

middle-class nor conform to the image of the white European inheritor. Consequently, darker-skinned Argentines from working-class and rural backgrounds have remained invisible, both in ethnic and class terms.

A close look at the lives of tango artists in New York City can help address these gaps, while examining the unsettled marriage between the entertainment field and the service economy, a union that is ubiquitous among artists globally. New York City is one of the most important worldwide tango hubs, which attracts a plethora of aspiring and accomplished performers from almost every country on earth. Conversely, the city also inflicts grueling financial and employment conditions that limit performers' upward trajectories. "If you can make it in New York City, you'll make it anywhere" is the omnipresent motto that underscores Argentines' keen awareness of the backbreaking market circumstances they face, along with their hopeful dreams of dancing and performing on stage.

By building on the concepts of social capital, broadly defined as the access to material and symbolic goods on the basis of informal ties, this ethnographic study explores how Argentine tango artists and entrepreneurs obtain valuable resources on the basis of their social relationships. Although much has been written on social capital, my work offers a fresh perspective by conceiving the tango world as an ideal place for understanding immigrants' informal ties, on the basis of belonging to the same tango-oriented webs. From tips on how to get a dancing gig to referrals for seeing a dentist at a lower fee, Argentine artists rely on their loose tango networks to resolve a myriad of everyday issues. In this vein, the term "paradoxical solidarities" is coined to draw attention to the dual role of immigrants' social networks as both supportive and obstructive in fostering social and economic opportunities. Contrary to the tendency of underscoring their positive effect, my analysis reveals the shortcomings of artists' interpersonal relationships that are tainted by unmet expectations, broken loyalties, and fractured reciprocity exchanges. I now turn to reviewing the historical scaffold of Argentine artists abroad, toward better understanding the tango's homecoming "with a vengeance" in recent years.

Tango Artists in the United States: Public Personas amid Invisible Lives

It is now broadly accepted that Argentines, once they move overseas, find in their sudden affinity for, and practice of, tango a remarkable source of nostalgic inspiration that helps them forge their own versions of national

and cultural belonging (Savigliano 1995; Viladrich 2005). As an Argentine immigrant in the United States, my initial interest in tango stemmed from its public stance as the "visible face" of the Argentine minority in New York City (Viladrich 2007b). Yet despite the marked publicity of tango in recent years, little is known about the Argentine performers who first brought it overseas. With the exception of historical studies on tango artists and idealized accounts of the lives of contemporary dancers, as in the case of the late tango performer Carlos Gavito (Di Marco and Fumagalli 2007), there have been no scholarly studies on this breed of Argentine performer in foreign lands. While researching the trajectories of Argentine tango pioneers, who somehow foresaw the struggles of tango émigrés almost a hundred years earlier, I was startled to learn how little information has remained about their early visits to the United States.

By the winter of 1913–14, New York City had welcomed the tango with open arms, letting the rage catch fire in dance salons, orchestras, and classes as it had a little earlier in Paris, Rome, and London. While Argentines became trendsetters in making the tango a fashionable dance in France, the tango craze in the United States was instead pioneered by a handful of Americans—led by Vernon and Irene Castle—and by exotic Italians like Rudolph Valentino, whose sexy Latin image drew thousands of followers onto the ballroom floor (Goertzen and Azzi 1999; Groppa 2004).

The rise of tango fever, known as *tangomanía* (tangomania), experienced its final boost with Valentino's ascent to the silent movie screen. He debuted in the film *Four Horsemen of the Apocalypse* (1921), with his Americanized Spanish character as a classic "Latin lover." The movie became an instant worldwide hit. Set in a Hollywood recreation of Buenos Aires' La Boca neighborhood, Valentino was dressed in a bolero and frilled shirt that made him look more like a rural Argentine gaucho (a herdsman from the pampas) than a *porteño* (a Buenos Aires native) tango interpreter (Taylor 1998). Beatriz Dominguez, his female partner fully clad as a Spanish Sevillian, seemed closer to an Andalucian flamenco dancer than a tango performer from the Argentine seaport.

Americans' obsession with exoticism and primitivism at the time led Argentine interpreters, including renowned singer Carlos Gardel, to wear gaucho outfits and other folkloric garb as a strategy for getting hired while conforming to Argentina's idealized image sold abroad. In a similar manner, while the Argentine nationalistic discourse of the late nineteenth century favored destroying the "barbaric" gaucho subjects via immigration and hybridization, the reinvention of Argentine tradition—to paraphrase

Hobsbawm (1994)—needed the gaucho (and the *gauchesca* literature) to reframe the national epic of the nation. Thereafter, gaucho dress and folk tradition became key components of the nationalist revival that accompanied Argentina's entry to modernity (Archetti 2003; Taylor 1997). The gaucho was then publicly cast as the quintessential *criollo* (creole), represented as something between a free cowboy and a nomad ranger, who hunted and worked only when needed.[4] An extreme example of this trend is recorded in an anecdote told by Juan Carlos Gobián, an accomplished tango musician of the time. Living in New York City in the mid-1930s and in desperate need of money, he agreed to play tango music while dressed as a "savage" from the pampas. For these performances, he remained chained to the piano during his entire concert and wore his own version of aboriginal garb, which included a feathered head ornament (Groppa 2004). Such literary and anecdotal tales have colored much of what we know about the handful of Argentine tango singers and dancers who tried their fortunes in the United States during the first decades of the twentieth century (Del Priore and Amuchástegui 2010).

When it comes to the tango literature, the fable of the self-made man has been often reified through the mythical figure of Carlos Gardel, portrayed as the most famous tango singer and the irrefutable symbol of Argentines' accomplishments overseas. Born in the late 1880s as the illegitimate child of a French washerwoman (of European origin after all), Gardel embodied the Argentine dream of social mobility in a sort of rags-to-riches course, which allowed him to escape poverty while gaining world-class fame and recognition. Having become the most famous tango singer ever, Gardel visited New York City in the early 1930s and propelled the rising reputation of the Argentine film and media technology that already had expanded beyond the nation. Between 1931 and 1935, he appeared in seven Paramount musical films that made him an international star (Navitski 2011; Remeseira 2010) Along the way, he became the quintessential globetrotter, pioneering the use of modern air travel to promote his art in foreign lands (Collier 1986).

Gardel's tragic death in an airplane crash in Medellín, Colombia, in 1935, at the height of his career, made him an instant myth. Rather than diminishing over time, Gardel's revered image has continued to evolve through the decades becoming a "Latin music legend" even in the United States. Gardel's rising stature has paralleled a growing tango imagery that, particularly in Buenos Aires, burgeons in both public and private spaces. This is summarized in the saying "Gardel sings better and better each day," which has endlessly reinstated his postmortem presence in Argenti-

na's cultural repertoire. Yet Gardel's success in the United States was the exception rather than the rule among tango artists of the time. His career overseas had little in common with the perils endured by most struggling artists, and it resembled instead the victorious path of a seasoned celebrity determined to conquer an English-speaking world.

Regardless of early tango performers' public charisma, their artistic paths in the United States were less flamboyant than they may have appeared at first glance. Argentine musicians, who visited New York City to dance, play and sing, and hopefully record their songs, frequently faced unexpected hardships after their contracts ended. Excepting Gardel and a few other famous artists, including the avant-garde musician and composer Astor P. Piazzolla (1921–92), uncertain and often contradictory stories circulate about the successes and scuffles experienced by tango artists abroad. As Groppa (2004) notes, the furor unleashed by the tango at the turn of the twentieth century welcomed the journeys of Argentine tango musicians and dancers, about whom very scarce information remains.[5]

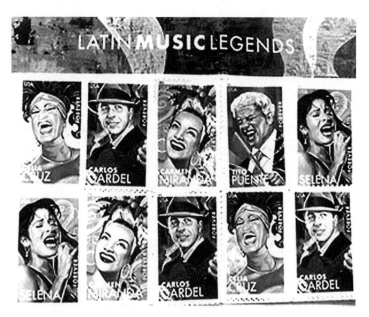

Figure 3. United States Postal Service stamps: Latin music legends. From left to right: Gardel's figure appears second on the first row of stamps, and third and fifth on the second row, along with the images of Celia Cruz, Carmen Miranda, Selena Quintanilla-Perez, and Tito Puente. (Photographer: Anahí Viladrich)

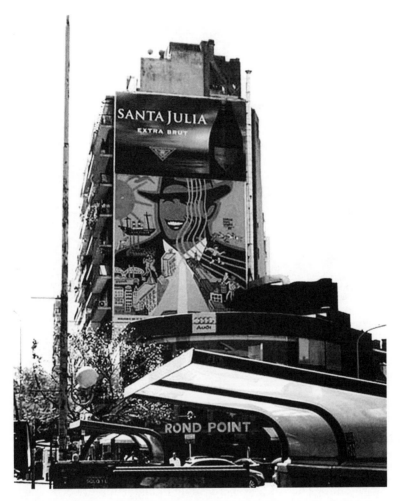

Figure 4. Outdoor mural of Carlos Gardel, advertising an Argentine sparkling wine. Painted by plastic artist Pérez Célis in Barrio Parque in Buenos Aires. (Photographer: Celeste Castiglione)

We know little about what happened to most of those early voyagers after they quit their tango endeavors to pursue more mundane lives. "So what did the Argentine dancers and musicians do in that world? Why is there little trace of them? What factors made it impossible for them to remain longer?" (Groppa 2004: 27).

For most early struggling tango artists, their dreams of success in America often became a sweet temptation that earned them an aura of achieve-

Figure 5. Tango mural decorating an old government office in the San Telmo neighborhood, a traditional area in Buenos Aires. (Photographer: Celeste Castiglione)

ment back home, even if they had gained little fame and fortune overseas. Dancers and singers eager to make a living from their artistic métiers were often persuaded to interpret much more than tango in order to make ends meet; this included working in low-paid occupations and using their talents to indulge upscale audiences with their mastery of other rhythms and musical genres. Then as now, performing in nightclubs or becoming music and dance instructors guaranteed artists unstable and meager incomes that often did not equal a living wage in expensive urban centers. The tango's vanishing from America's mainstream cultural repertoires in the 1940s helped to further obliterate the legacies of those early tango migrants. More than half a century later, a new wave of tango artists would become visible as a response to a renewed tangomania that has continued to unfold its boundless social and artistic wings.

A Worldwide Tango Renaissance

Just when the practice of tango seemed to remain solely as romantic memorabilia or in encrypted forms of experimentation, an uplifting dancing

trend recycled the old tango traditions to make them new all over again. The global tango resurgence took off in the mid-1980s, as the result of specific processes, including the transition to democracy in Argentina, the worldwide success of Argentine tango shows, and the relatively booming economy of some cosmopolitan hubs in the midst of globalization. This phenomenon was accompanied by the reinvigorated popularity of old tango tunes that helped foster a worldwide tangomania.[6]

As in the case of Brazil and other Latin American countries (Parker 1999), the 1980s became a period of redemocratization in the region characterized by an initial optimism that was followed by economic restructuring, which mostly meant the privatization of public services and the growth of the external dependency (and debt) on international agencies, mostly the International Monetary Fund and the World Bank. The return to democracy in Argentina in 1983 was undoubtedly a point of inflection in the genre's renaissance along with the revival of other music forms. A feverish period of popular and political participation was boosted with the creation of the CONADEP (National Council for the Disappeared People), which signaled the democratic government's commitment to human rights. This set the conditions for trials for those responsible for human rights violations, including the ex-commandants. In a country that had suffered decades of authoritarian governments, the new "state of rights" led to the revamping of past artistic genres amid renewed musical traditions. After many years of embracing foreign (mostly American) music, the return to Argentina's national artistic roots represented an *apertura* (openness) to the country's inner legacy, which now welcomed international tourism along with the spur of popular genres including Argentine folk music and national rock-n-roll.

The musical revue *Tango Argentino* in the early 1980s has been widely acknowledged as the "eye opener" that introduced to the world a treasured Argentine trademark, which would mature in years to come (Savigliano 1995; Windhausen 2001). Created by Claudio Segovia and Héctor Orezzoli, this show launched a wave of new interest in the tango's sensual movements, and it succeeded in such far-flung places as Tokyo and London. With a cast of Argentine artists, *Tango Argentino* inspired a complete refurbishment of the image of Argentines abroad, resulting in an international tango craze. A show that was supposed to last just one week in Paris continued for a completely sold-out season and then triumphed in other European and American hubs, including New York, in 1986.

What the public realized at the time was that even seasoned and out-of-shape dancers were able to glide on the stage like young zealots. The Ar-

gentine tango suddenly became acknowledged as a sensual and creative genre that could be danced by anybody regardless of technical expertise, previous training, or physical ability (Maronese 2008). Although *Tango Argentino* was not performed in Buenos Aires until 1992, the tango had by then begun gathering momentum in Argentina, with younger generations waking up from the long years of a military dictatorship that had previously erased most of its practice, including the controversial aspects of much of its lyrics (Viladrich 2006).

Right after the explosive success of *Tango Argentino* abroad, tango dancing grew into a high-class trend practiced by an international community of fans around the globe.[7] A spate of Argentine tango sequels followed, including *Forever Tango, Tango X2,* and *Tango Pasión.* Together, these confections helped reclaim the Argentine character of the tango, restoring to it moves more passionate than those featured in the American version of the dance. For one thing, the tango's renaissance in the United States took place at a time when ballroom dancing (e.g., salsa, swing, rumba) was becoming popular on both the East and West coasts, following a renewed global interest in eclectic ethnic trends and world music. The latter resulted in a growing number of dancing aficionados taking lessons in Latin American and Caribbean rhythms. Amateur dancers soon became mesmerized by the tango's exoticism, expressed in its physicality and close partnering as well as in the creative and sensual composition of its steps.

For the past two decades, tango dancing has morphed into the epitome of a lofty leisure trend supported by an avid global community of fans while reaching into new geographical, commercial, artistic, and symbolic fields. Tango melodies are now heard and danced to by an international clientele in cities such as Buenos Aires, New York City, Istanbul, Barcelona, and Tokyo by amateurs with enough money and free time to pursue an endless search for new products of sublimated passion (Savigliano 1995).

Along the way, the rising reputation of Buenos Aires as the "Tango Mecca" has been dexterously maneuvered by Argentine national and municipal governments that have made tango into a booming tourist trend. This process has gone along with an ambitious urban renewal plan that restored old Buenos Aires neighborhoods, such as San Telmo and El Abasto, and created new ones (Puerto Madero) in order to suit the tastes of a rising domestic and global elite (Dávila 2012). The Argentine economic debacle of 2001, which drastically devalued the exchange rate of the peso to the US dollar, opened the gates to global tourism in unprecedented ways. Thereafter, Argentina successfully capitalized on the "tango dollars"

brought to its shores by a renewed wave of tourists and expatriates—all mesmerized by Buenos Aires' endless supply of tango parlors, upscale shopping, and cultural shows. As a corollary of this trend, in October 2009, the tango was officially declared part of the world's intangible cultural heritage by the United Nations (Gómez Schettini, Almirón, and Bracco 2011).

Concomitantly with the tango's worldwide popularity, larger numbers of Argentine artists and aspiring professionals have been visiting the United States, Europe, and Asia in order to perform, practice, and teach tango to a rising wave of apprentices and professional dancers. Over time, many young performers and seasoned Argentine artists—the latter who had continued practicing and performing tango during the "dark ages" in Argentina—decided to settle abroad, encouraged by an unprecedented demand for Argentine artists who swiftly became both visible and popular overseas. I now turn to the conceptual scaffolding that led me to explore these performers' networks of hope, work, and struggle by focusing on the role of social capital in paving their personal trajectories in the United States.

Social Ties in Tango Immigrants' Lives

A main conceptual issue in this study revolves around tango immigrants' access to social resources, from information about visas to health referrals, with assistance from their social webs. To what extent are Argentine tango artists able to succeed in New York City's tango world by relying on their tango peers? How do Argentine performers rate the help received and provided by their compatriots in the tango field? Under what circumstances do Argentines highlight either their mutual aid or competition as the main basis for their reciprocal ties? To answer these questions, I rely on the notion of social capital, which conveys the social resources that individuals have access to as members of social and artistic webs.

Following Bourdieu's classic definition, social capital is generally defined as the nontangible assets that are circulated (donated, received, and shared) via social ties on the basis of reciprocal relationships that involve mutual trust and loyalty (Bourdieu 1986).[8] The flow of information channeled via social networks is pivotal in getting jobs, affordable housing, and even free health care; however, it requires investing in interpersonal relations in exchange for expected returns (Lin 2001). By drawing on their social ties, immigrants are able to gain valuable information, moral support, and material assistance that may diminish the perils (i.e., costs and

risks) of their international journeys (Massey and Aysa-Lastra 2011; Massey and Riosmena 2010).

Recent conceptualizations of social capital have underscored its bridging and bonding properties (Brettell 2005; Leigh and Putnam 2002). While bridging social capital involves individuals' heterogeneous liaisons, bonding capital encompasses interactions among homogeneous ties (Derose and Varda 2009; Putnam 1995). Although bonding capital may be more effective in ensuring social cohesion, it is not necessarily more practical for gaining access to resources. Granovetter's (1974) celebrated assertion of "the strength of weak ties" further illuminates the point, as uniform and strong networks are not necessarily more convenient for the circulation of social capital than diffuse and heterogeneous ones. At first glance, Granovetter's notion would seem counterintuitive, as we tend to consider close networks of family and friends as more helpful in seeking, and gaining, valuable assets (Portes 1998). Yet loose webs may allow access to a wider and richer array of resources via a greater, and more diverse, number of people. For example, immigrants with strong social ties living in impoverished areas tend to count on less social capital than those embedded in diluted webs who reside in richer ones (Cattell 2001; Domínguez, 2011; Fernández Kelly 1994, 1995).

While bridging webs are positively associated with getting jobs and stable incomes, bonding networks may not have an impact on improving economic assets (Lancee 2010). Furthermore, weak ties may turn into strong ones through marriage or surrogate kin (e.g., *compadrazgo*), as noted by Wilson (1998) in her study on Mexican nationals moving to diverse US destinations. Social capital may be drawn from different types of ties, as in the case of employment networks and religious webs (Garcia 2005).

Probably one of the most relevant bridging properties of social capital is found in the term "multiplexity," defined as the degree to which members with differing social statuses join a social web linked in a variety of ways, with actors belonging to several fields of activity. In fact, the more bridging power a network has, the more multiplexial (and rich) it will become for its members (Fernández Kelly 1995). The explanatory power of social capital is contingent on the available local resources vis-à-vis accessibility to other types of capital (Li 2004). Certainly, social capital cannot replace other forms, such as human and economic capital, and actually depends on them for its own reproduction and expansion (Wang and Li 2007). I now turn to unraveling the role of social capital in promoting solidarity and ethnic cohesion among immigrants.

Ethnic Solidarity at Stake

When conducting research for this book, one of the main conundrums I faced revolved around the extent to which Argentine tango performers either help or undermine each other while pursuing their artistic careers. The vast literature on ethnic solidarity among immigrants and ethnic minorities came to my rescue in untangling this issue. Nevertheless, I soon found that researchers do not always agree on what ethnic solidarity is, or on how it should be measured, as it encompasses a multidimensional concept (Alberts 2005). In studying Argentine artists' ties of mutual help and reciprocity, my overarching objective was to overcome epistemological dichotomies that conceptualize immigrants as either harmonious parishioners or as "Hobbesian" competitors.

Much of the earlier literature on ethnic entrepreneurship took for granted the idea of a ubiquitous solidarity among co-ethnics (for a discussion, see Pessar 1995). A critical body of work has addressed the deeper social roots that impinge upon community bonding and social cohesion (Coleman 1988; Fernández Kelly 1995; Pessar 1995; Portes 1998; Putnam 1995).[9] Social capital enables collective action, solidarity, and cooperation among actors on the basis of strengthening their social liaisons, identities, and trust. Immigrants' bridging capital promotes ethnic solidarity in the form of reciprocal aid among colleagues, fellow citizens, and distal acquaintances (Crow 2002; Ramos-Pinto 2006).

Further, social scientists have pointed out the roles of competition, rivalry, and even economic exploitation among those sharing the same ethnic or national origins (Berkman et al. 2000; Braga Martes 2000; Chin 2005; Mahler 1995; Margolis 1994, 2009). These studies reveal the fragmented character of immigrants' alliances vis-à-vis the pervasive competition existing among members of the same ethnic or national groups, which may lead to divergent patterns of either inclusion or exclusion from the ethnic economy. For instance, in their studies on Salvadorians and other Latino groups in the United States, Mahler (1995) and Menjívar (2000) found the source of co-ethnics' conflicts in their financial constraints and competition for jobs. In this vein, the term "networks of exploitation" has been used to refer to the abusive interpersonal patterns existing among family and compatriots (Cranford 2005).

Inspired by Bourdieu's theory of social fields, I conceive the tango world as an artistic niche that operates both at local and transnational levels. The struggles of a field, reckoned like a game, arise from the position-taking of agents who legitimatize themselves as capital holders of different value

(Bourdieu 1986). As Small (2009) notes, rather than depending on personal will, much of the power of social capital lies in the institutional conditions that provide differential access to resources. Yet, group members have at their disposal assorted resources and dispositions (e.g., *habitus*, knowledge, and skills) that allow them mobility within and outside any particular realm. Hence, the rules and boundaries of the tango field are subject to struggles and redefinitions on the basis of different individuals trying to legitimate their locations, and domination, inside and across diverse social worlds.

The concept of social capital, as defined in this volume, mostly accounts for the contradictory ways in which mutual help and competition for resources are ubiquitous in immigrants' social networks. Social capital also reinforces mechanisms of exclusion and social differences among actors (Falcón 2007). A main characteristic of social capital refers to its disparate distribution, both within and across social webs, which strengthens the impact of enduring inequalities in the allocation of economic and social power. Furthermore, the power of social capital in remedying groups' tensions, and in creating ethnic solidarity, is highly contested by individuals' power differentials based on dissimilar ascriptions in terms of class, ethnicity/race, education and cultural assets, and personal trajectory.

Against the romantic image of ethnic groups as homogeneous and supportive of their members, this study assumes the paradoxical nature of social ties, particularly regarding the extent to which members of the same artistic niche both help and contend with each other when seeking valuable assets. Immigrants' interpersonal liaisons are characterized by evolving relationships of cooperation, assistance, and competition through time as part of their symbolic contests (e.g., involving class and racial/ethnic hierarchies) to access diverse forms of capital.

At the interpersonal level, the roots for disagreements and conflicts involving social capital exchanges are multiple and often comprise negative outcomes. The literature mentions the excessive claims that group members are subjected to, which include restrictions to individual freedom and group pressure to follow mainstream norms (for a review, see Derose and Varda 2009). Contrary to other forms of monetary or contractual exchanges, what characterizes the provision and reception of social capital is that reciprocity terms are neither univocal nor scheduled in advance (Portes 1998). Although in some cases it may seem that no payment is involved, exchanges may be delayed in time, and specification of mutual benefits may not be explicit (Coleman 1988; Viladrich 2005, 2007a).

Moreover, social capital is not as transparent and specific as economic capital, because it is characterized by unspecified and uncertain time horizons that can also be violated. The absence of explicit contractual terms in interpersonal trades (e.g., lending money to friends or helping them with household chores or babysitting) can create ambivalence, conflicts, and misunderstandings that may lead to unpaid dues, unmet expectations, and feelings of betrayal (Portes 1998). For instance, an immigrant leaving for the United States will seek to borrow money for the venture from his family and friends with the expectation of paying them back at some point, although the terms of repayment may remain diffuse in time and amount—as in the case of those promising to pay interest on the borrowed sum without specifying the percentage and the total amount or the length of the loan.

Immigrants' inclusion, and exclusion, from social webs also defies idealized expectations of co-ethnics' mutual assistance, particularly due to the groups' gatekeeping power in the selection of their members. Denying information on jobs to some co-ethnics while providing referrals to others is one example of those who are left out or in (Falcón 2007). In addition, as with any form of capital, there are costs involved in its production and circulation (Bourdieu 1986; Hawe and Shiell 2000), as investment in social capital costs money, energy, and time. For example, in order to reach out to diverse social fields, immigrants will most likely invest more resources than if they remain isolated indoors in the company of stronger but narrower social webs. Members of ethnic or national groups may also feel obliged to fulfill moral obligations with their networks' members through bounded solidarity and enforceable trust (Portes and Manning 1986). These are two main mechanisms that ensure obedience to the group norms and values and that sanction disapproved behavior (Portes and Zhou 1992). Finally, binding ties may lead to exaggerated demands on network members as well as conformation to rules imposed by those in power (Hawe and Shiell 2000; Portes 1998).

How This Book Is Organized

Many changes have occurred since the day I envisioned this project more than a decade ago. While at the time a case study on Argentine immigrants seemed like an unusual enterprise, this project soon began to make sense as tango dancing became, and has remained, a worldwide hit. Through the lens of immigrants' informal social ties, this book accounts for the ex-

periences of tango performers in New York City: from the creative ways they make a living to their utilization of health services for free in exchange for tango lessons or practice. This study intertwines a critical narrative of the historical and societal processes that have shaped the tango's trajectory in Argentina, with an in-depth ethnographic account of Argentine tango artists in New York City.

Chapter 1 frames the sociopolitical context that nurtured the tango's birth at the time of the formation of the Argentine state under ideals of racial purity, which conformed to European ideals of modernity and positivistic progress more than one hundred years ago. This historical analysis builds the scaffolding for our understanding of both the continuities and disjunctures found in the social trajectories of tango artists through time. To that end, the origin of the tango is interpreted amid a convulsed national history in which the elites of a young country were committed to crafting a national tradition at the expense of deleting their colored legacies.

Created as the bastard child of a confusing blend of African and European rhythms, in Argentina and Uruguay the tango slowly but steadily slipped away from its original African and creole roots. The triumph of the tango in Argentina by the early twentieth century, following its success abroad, marked the upper- and middle-class hegemonic construction of a tamed genre that suffered from a modernizing (and "whitening") project through which creole, black, and aboriginal populations would succumb to the European hegemony of the nation. The final acceptance of the tango by the elites coincided with the nation's embrace of modernity, which quickly transformed Buenos Aires into one of Latin America's cosmopolitan centers—widely known as "the Paris of the South." What had been rejected by the aristocracy in the late 1900s as barbaric, and even criminal, became a national icon by the early twentieth century.

Following its Golden Age (the years 1917–35), the tango experienced uneven periods of stardom that followed a progressive decline, particularly during Argentina's series of military dictatorships in the twentieth century, which ended with the nation's democratic renaissance and the rising pinnacle of the tango in recent decades. Through time, the chromatic blindness that would progressively obliterate the presence of African descendants in Argentina resulted in a subtle system of racial stratification, in which being black no longer was associated with skin color but rather with markers of social class (i.e., status and prestige). Rather than disappearing, much of the social hierarchy that combines phenotypes with social-status

features in Argentina has remained alive, even in immigrants' contexts abroad.

The nature of the research process, from both a personal and a methodological perspective, is the subject of chapter 2, in which I address the underpinnings of the study design and the data collection process, along with a description of the sample drawn from a rich, albeit dispersed, artistic tango community. The chapter ends with a self-reflexivity exercise that accounts for my subjective journey as both an ethnographer and an Argentine immigrant in the United States.

Contrary to the unified representation of tango artists as glamorous performers, chapters 3 and 4 reflect on the disparities existing among tango immigrants in New York City, from those who have become dancing stars and versatile self-made entrepreneurs to those vulnerable elderly individuals who are interpreters of the tango *canción* (song). Combined patterns of open ethnic solidarity and subtle interpersonal competition are at stake in these practitioners' eagerness to keep their common interests afloat. While some of these artists have become transnational pilgrims by traveling and living wherever they can dance and perform, others have decided to make their homes in New York, thus becoming the visible face of the Argentine minority in the city.

Chapter 3 underscores Argentine artists' shared crusade for being at the center of the tango's cosmopolitan production. To that end, they advertise themselves as a new breed of transnational migrant by relying on their marks of *argentinidad* that provide them with a unique artistic passport to foreign lands. They do so by involving their compatriots in their tango endeavors while branding themselves as the genuine interpreters of the tango passion. These combined strategies engender performers' alliances that foster Argentine leadership in the tango field over non-Argentine competitors.

A closer look at tango artists' work and lives in New York in chapter 4 reveals a less idealized version of their alleged flamboyant personas. Here, I explore the contradictory role of bonding social networks, which, although pivotal in assisting newcomers upon arrival, are often limited in connecting them with the mainstream entertainment field. In tandem with the service industry jobs prevalent in global cities, elderly tango immigrants tend to endure the informality of an artistic market that exposes them to unstable and unprotected working conditions, where no legal tenure exists to support their artistic trade. Despite their invisibility in the literature, older newcomers have also chosen to migrate to the United States

as a strategy to remain active in the arts industry and as a way to make a living in the third-sector economy. As a result, many endure a "dual life" in order to make ends meet, by combining their tango activities with temporary employment in the service industry on the side.

The term "legal trajectories" is introduced in chapter 5 to explore the changes in artists' documented status, ranging from remaining unlawfully in the United States to obtaining full citizenship rights. This concept is inspired by Erving Goffman's social interactionism approach that names both the conscious and unconscious rituals of passage involving the roles and beliefs concerning the self and others. Tango artists who succeed in advancing their legal trajectories are able to improve their educational and employment credentials, while embedding themselves in rich social networks (e.g., contacts for jobs and visa sponsorships). The combined power of artists' social connections (social capital) and individual skills (human capital) are crucial in ensuring their successful legal paths in the United States.

How do Argentines see themselves vis-à-vis other minority groups, including other Latinos, in the city? Answers to this question in chapter 6 provide the symbolic threads that weave the continuity (and hiatus) of public discourses on race and ethnicity in Argentina, along with immigrants' perceived ethnic and racial differences. Argentine tango artists' involvement with their fellow citizens are mostly defined in terms of informal networks that are subjected to norms of inclusion and exclusion of those who can, and cannot, benefit from their material and social assets. Thus far, disadvantaged groups can maximize their social capital, and access to varied resources, by positioning themselves in strategic locations. Those who are closer to the artistic and entertainment cores gain more assets (and social capital) than those located on its margins, as will be shown by comparing the Manhattan tango field versus outer borough dancing events. By the same token, the more excluded and marginalized immigrants are from the tango's mainstream field, the fewer social assets (e.g., connections for jobs) they will count on.

In consonance with the tango's social history, presented in chapter 1, Argentines' embodied metaphors of class and race are somehow reflected in what I call the "tango's social geography," which distinguishes Manhattan milongas from outer borough events. While the first represents the epitome of global tangos enjoyed by an upper- and middle-class cosmopolitan (mostly white) clientele, outer borough gatherings welcome local tangos held by Argentines from the lower middle class and working class, wherein tango dancing and singing embrace a broader Latino repertoire.

Contrary to the widespread image of Argentines as "European whites," this chapter further reveals a myriad of Argentine émigrés: from middle-class Italian and Spanish descendants, who tend to see themselves as white, to dark-skinned *criollos* (creoles) from working-class backgrounds, who more often identify themselves as Latinos. Even though the Manhattan world welcomes a multiethnic crowd, darker-skinned artists from working-class backgrounds are a minority. These artists must go the extra mile in order to appear exotic and proficient enough to gain entry into the tango's cherished New York core. In essence, the Argentine migratory stream offers a unique kaleidoscope of artists' trajectories along the adaptive frontiers of race, ethnicity, and social mobility.

Juxtaposed with the multiple and successful liaisons that bring Argentine tango artists together, chapter 7 examines the contradictory discourses that make them suspicious of each other as members of a broader artistic community. At the bottom of artists' paradoxical discourses—which blend tropes of solidarity and lack of reciprocity—I found unmet needs in their struggles for valuable resources. As pointed out by Mahler (1995) in her study on Salvadorians in New York City and on Long Island, part of the anthropologist's work is to reveal the contradictory discourses immigrants convey about each other, as behavioral intents may actually contradict their verbal remarks. More than operationalizing the different levels of ethnic solidarity, we learn how Argentine artists conceptualize this term and even contradict themselves while emphatically pointing to the absence of mutual help among their peers.

Chapter 8 reckons the importance of Argentines' networks of care by introducing a cultural model of health-seeking behaviors embedded with artists' interpersonal ties. Here, the tango field becomes a health reservoir in which Argentine performers seek free or affordable health care, in exchange for tango lessons and other in-kind contributions, thus symbolizing social capital exchanges based on trust and reciprocity. This chapter further examines the disadvantages of obtaining health care via informal webs, such as unspecified obligations among parties, which may lead to fractures in reciprocity terms and the potential violation of exchange norms.

The conclusions abridge the most relevant lessons drawn from this book regarding the importance of interpersonal networks in providing valuable resources to their members, notwithstanding their paradoxical nature. Based on a highly noticeable group of tango artists, within the almost invisible population of Argentine immigrants in the United States, I illuminate broader questions pertaining to the understudied role of infor-

mal webs in the entertainment field, which endorse coexisting patterns of mutual help and competition among group members. Warnings against the role of social capital as the "cure for all maladies" are discussed in terms of dependence on informal webs and of the absence of enduring societal and state responses able to guarantee to artists rightful labor conditions and equitable access to health care.

The Tango's Social History in a White-Imagined Argentina

From black parents
this child was born
black like them
solid black.

This little child
is so black
that when he cries
his tears are brown.

I would not change
my little black child
neither for a black
nor for a white one.

GERMÁN BERDIALES, "PARA DORMIR A UN NEGRITO"

I was probably four or five years old when I had the opportunity to recite, in front of the audience at my primary school in Buenos Aires, the above poem by Germán Berdiales. The occasion was the first of the many patriotic celebrations in which I would take part, as an impromptu actress, in the years to come. On that cold Friday morning, the event was set to honor the Revolution of May 25, 1810, one of the most important annual festivities in Argentina, marking the popular revolt that took place against the Spanish monarchy in the city of Buenos Aires. It is a national parable that on that day, Spaniard descendants, along with gauchos and black slaves,

25

gathered at the Plaza de Mayo (May Square) to embrace the cause of liberating the region.

The poet Berdiales, a white librarian born in 1896, had spent most of his childhood in the neighborhood of La Concepción in Buenos Aires, a mixed-race area where Afro-Argentine children could be found playing on the street; several of his poems pay tribute to them. Back in my school years, it was customary to wear clothes that symbolized the main actors of the fabled patriotic epic marked by the revolution. Not surprisingly, I was dressed as a *negrita de la casa* (little black household servant), ready to interpret a lullaby poem dedicated to my black baby, who was embodied by a white doll that had been colored accordingly. To play the role, my white face had been painted with the ashes of a burnt wine-bottle cork, and my hair had been wrapped into a colorful scarf that matched a cooking apron to complete the costume.

I still remember the feelings of incredulity and confusion that I experienced on that cold morning, when I found myself standing alone on the huge main stage of my schoolyard in front of hundreds of people. All of the attendees (teachers, parents, and their offspring) appeared to my eyes to be white and seemed both delighted and amused by my characterization, despite the fact that I could not make sense of my having been turned into the "other." As a parody of what upper-class white Argentines would do during Carnival throughout the nineteenth century, when they customarily mocked African *comparsas* (dancing troupes), I had also been transformed into a member of a racially marginalized group. Nonetheless, my self-characterization was not accidental; instead, it signified much of the dominant imagery surrounding the black population in my country.

This chapter explores the tango's transformation in Argentina from a multiracial hybrid art form to a white genre on the one hand, and from its lower-class and overtly sensual origins to a tamed dancing and musical expression on the other. The tango's social trajectory reveals, as perhaps no other artistic form does, the racial and social tensions that characterized the formation of the Argentine state by the end of the nineteenth century. On the basis of a complex process of historical displacement, the Afro-Argentine population was finally condemned to disappear from Argentina, although its phenotypical and sociocultural traits were displaced to other subaltern groups. Corresponding to the tango's evolution, one of the most unimpeded racial fallacies in Argentina is the belief that all African descendants of the slave trade disappeared long ago. According to this color-blind trope, most Argentine nationals are white individuals.

Even today, the belief that "there are no blacks in the country, unless

they are foreigners" is widespread among many Argentine urbanites, both at home and abroad. According to this notion, the whole population of Afro-Argentines was already gone by the beginning of the twentieth century, presumably as a result of the wars of independence and the devastating yellow fever epidemic of 1871, which took a toll on this population (Cottrol 2007). This and other myths begin with the assumption that black slaves did not experience in Argentina the grueling conditions of the plantation system that were typical in many other places, including the Caribbean, during colonial times (see the critiques of Bergad 2007; Cirio 2006; Frigerio 2006; Oboler 1995; Oboler and Dzidzienyo 2005; Perri 2007; Schávelzon 2003).

Argentina's "humanitarian" slave system is often portrayed as having been more benevolent than those existing in the plantations of neighboring countries such as Brazil. This compassionate view of slavery had the strategic function of lessening the significance of this mode of production in the capital accumulation process, by assuming that only a selected breed of the best Africans had been shipped to Argentina. As a result, Argentine slaves were presumably easily assimilated into the domestic sphere and treated with condescending affection by their owners.

In any case, the bare record of slavery in Argentina lies far from the romanticized fable ingrained in public discourse, as slaves were trained in a pedagogy of fear that remained long after slavery was abolished (Cottrol 2007; Solomianski 2003). Surely, the image of the docile African maid also helped camouflage the central role that slaves played in the development of rural agriculture. Such was the case of the black gauchos, known for their roles as singers of the early tangos, particularly given their profitability as free labor along with the scarcity of rural workers—especially during high harvest seasons. Concomitantly with these misconceptions, my interpretation of the docile and sweet *mamá negra* (black mother) in my school play matched ingrained folkloric ideas that iconized Afro-Argentines as faithful nannies, cooks, and valets who readily and happily served their white masters.

The "Disappearance" of Blacks in Argentina: A Mystery Solved?

Fast-forward three decades from the day of my school play to the year 2000. During one of my visits to Buenos Aires, I came across an issue of the prestigious magazine *Todo es Historia* (*All Is History*), which had the

following sentence spelled on its cover: "The Black Slaves: Why Did They Get Wiped Out?", a question that epitomizes, once again, the widespread belief of African Argentines' disappearance.[1] This view was also featured in the 2002 documentary film *Afroargentinos* (*Afro-Argentines*), directed by Diego H. Ceballos. In the film, former President Carlos Menem, whose ten-year neoliberal government (1989–99) resulted in one of the worst socioeconomic collapses in Argentina's history, was asked during a visit to the United States whether there were blacks in his country. He responded that only Brazil has that problem, as there are no blacks in Argentina (Theis 2004). In tune with this official discourse, just a couple of years ago, an Argentine citizen and well-known black activist was detained by immigration authorities as she was waiting to board a plane at the international airport in Buenos Aires, charged with counterfeiting her Argentine passport. The reason? Migration officers could not believe she was from Argentina, since it is widely accepted that there are no blacks in that country (Perri 2007).

George R. Andrews (1980) was one of the first to systematically challenge the fallacy that condemns African descendants to nominal extinction in Argentina. As he notes, the numbers of Afro-Argentines did shrink in the country beginning in the second half of the nineteenth century, mostly due to poverty-related causes (e.g., high mortality rates due to infectious diseases), lower life expectancies, and mixed marriages that followed the massive influx of Europeans to the region. Nevertheless, Andrews also shows that African descendants were semantically whitened through the introduction of social categories that underrepresented their numbers in the official records. Following what Oboler (2005) conspicuously observes in the case of Peru, and contrary to the United States, one drop of white blood could make you white in Argentina. Thereafter, race mixing ended up turning into the Argentine state policy to be obtained via *blanqueamiento* (whitening), a project aimed to *mejorar la raza* (improve the race).

The politics of whitening were not unique to Argentina and actually mirrored the consensual efforts of Latin American nations aimed at erasing black and native traces in the region. Throughout Latin America, the Spanish elite mixed their blood with indigenous and African populations through *mestizaje* (racial mixture or miscegenation). As a result, a social pyramid based on different shades of skin color gave birth to a "pigmentocracy" (Oboler 1995, 2008; Oboler and Dzidzienyo 2005). Still, the whitening project in Argentina took a more extreme course than in other Latin American countries, where miscegenation allowed for a more complex

system of racial classification. Certainly, blacks and aboriginal populations did not disappear from the discursive constructions of the modern state in countries such as Brazil, Bolivia, Colombia, Paraguay, and even across the Andean region (Appelbaum, Macpherson, and Rosemblatt 2003; Wade 1995). In Brazil, for instance, the hegemonic construction of the nation rested on a tripod that acknowledged blacks, aboriginal populations, and the white Portuguese, while Mexico endorsed racial heterogeneity on the basis of *Mexicanidad* (Mexicanness) by proudly embracing its indigenous legacy (Briones 2002).

Contrary to dominant Latin American paradigms that celebrated hybridity in terms of indigenous and black mixtures, the Argentine elite rejected this notion altogether (Karush 2012). The ideal of the modern Argentine nation was founded on the *crisol de razas* (melting pot), built on a white self-representation that accredited only the contributions of "just off the boat" European immigrants (Briones 2002: 68). Thereafter, the construction of *argentinidad* rested on the denial of nonwhite populations achieved through symbolic and genetic miscegenation. To that end, the racial binary system ultimately led to overrepresenting the white population by making blacks virtually invisible in Argentina (Frigerio 2008). Through time, mixed-race individuals utilized the lightness of their skin color in order to move up the social ladder. For example, the category *trigueño*, which became popular in the nineteenth century, was initially used to refer to people of dark skin color and was not directly associated with being black, contrary to the conception of mulatto or *pardo* (the latter referring to a very dark-skinned person of mixed heritage).

While the Argentine census's classificatory markers had formerly included three options (black, white, and trigueño), after 1886 these were switched to a dual category: white versus pardo/*moreno* and white versus colored (Andrews 1980). Concomitantly, during the second half of the nineteenth century, African descendents were progressively allowed to shift racial categories in order to receive full access to citizenship rights. Thus, the mulattos who in the past had more often been identified as trigueños became white in the census (Andrews 1980). When addressing Andrews's argument, the question of how easy it became for blacks to pass for whites (see Healy 2006) could be answered by examining both the open and subtle ways through which social hierarchies in Argentina have been shaped in terms of race and ethnicity, in tandem with class divisions and markers of upward mobility.

Cirio (2006) analyzed blacks' iconography in the nineteenth century only to uncover the disguised stratagems through which Afro-Argentines

would whiten their looks, either by dressing according to European fashion or by applying rice powder to their faces. Through time, these subterfuges became ingenious devices to ultimately weaken the presence of African traces from the Argentine racial imagery. This chromatic blindness led to a pervasive system of racial discrimination in the twentieth century, when being black no longer was associated with skin color but with belonging to a low-status social category. Slowly but steadily, the Argentine racial discourse gave birth to a mixed standard in which brownness, rather than blackness, turned into the preferred label to represent the "other" featured as a member of an inferior racial and class stratum.

In any event, it is not that African descendants became totally invisible in Argentina but, rather, they were deemed observable in specific ways—from archaic representations of street vendors to heroic icons in the wars of independence and against Paraguay. These were all acts of appropriation that underscored their phantasmagoric presence in the colonial period (Peñaloza 2007). In fact, black heroism in Argentina is still praised in movies, history books, and novels, so it has never vanished from the national imaginary (Maffia and Lechini 2009). Even today, the Afro-Argentine legacy is routinely celebrated in school events, which, as in my school-play story above, has led to their being iconized as caricatured tokens of a distant past.

Dominant narratives in Argentina portray black soldiers as self-sacrificing heroes, somehow emulating the eponymous character in the famous novel *Uncle Tom's Cabin* (Beecher Stowe 1852) who dutifully served his white masters. Rather than revealing the ways in which blacks were forced to enlist in the military, the image of Falucho—something between a historical figure and a mythical hero—stands for the heroic black soldiers who died for Argentina while fighting the Spanish Crown in 1824. Falucho's statue is currently located on a prominent square in the city of Buenos Aires as a physical reminder of the long-gone blacks' one-time existence and the endurance of a country without them. Whether real or fictitious, Falucho's epic representation is there to remind all Argentines of the blacks' commitment to their nation.

Although largely unknown to many Argentines, the Afro-Argentine culture was kept alive by the descendants of slaves, particularly in the cities of Buenos Aires, Salta, Santa Fé, and other well-established urban milieus (Cottrol 2007; Frigerio 2008). Beginning in the 1990s, a sense of redefinition of the African identity began to gather momentum in Argentina with the birth of grassroots organizations such as Africa Vive (Africa Alive),

which publicly denounced and resisted the endemic patterns of marginality and invisibility suffered by Afro-Argentines for more than one hundred years (Maffia and Lechini 2009). This process has been invigorated by a relatively recent and fruitful scholarship, mostly in the social sciences, aimed at tracing blacks' social and cultural legacy vis-à-vis their current social struggles (Frigerio 2000; Perri 2007; Schávelzon 2003; Solomianski 2003). Through revisions of mainstream narratives, this body of work has documented the different social and cultural strategies deployed by the Afro-Argentine community to remain both active and visible in Argentina through time. Much of this groundbreaking research has been influenced by Afro-Americanist academic trends in the United States, Brazil, and other American nations (Cottrol 2007). The next section reflects on the contributions to the tango's genesis by blacks and creoles, who have mostly been absent from Argentine hegemonic narratives unless they are allegorically portrayed as folkloric storytellers or protagonists of minor artistic forms.

The Tango's Whitening Journey Amid Modernization in the Southern Cone

> Tango today is a sea of white faces, but Brazil's samba, Colombia's *cumbia*, Peru's *lando*, and Suriname's *kasiko* are not the only black beats on the continent. Tango started black, and *milonga*, the dance preceding it, even more so. (Farris Thompson 2005: 12)

> After all, *porteños* today are dancing a black dance in a city that used to be full of black people—yet almost no one has any idea. That's Argentina for you. (Winter 2007: 123)

One of the most popular controversies, both in academic circles and in popular culture, has revolved around the genesis of the tango (Castro 1991, 2001; Savigliano 1995). Despite the efforts to erase the influence of Afro-Argentines from tango music and dancing, recent research reveals their presence in related multifold cultural traditions. Historians and anthropologists point to the contributions of African descendants in the arts, including the existence of black gauchos becoming tango singers and musicians, as in the case of Gavino Ezeiza (Pooson 2004). Some proponents argue that the word "tango" comes from *tambor* (drum in Spanish), which was pronounced like *tambó*, and even from the Yoruba (Nigerian) word

shango, which represents the god of thunder (Cáceres 2010; Farris Thompson 2005; Pooson 2004).

Frigerio (1993, 2000) notes that the fact that many tango dancers and musicians do not acknowledge being of Afro-Argentine descent reveals an attempt to protect themselves from the stigmatizing effect of being a *negro* (black) in Argentina. By reviewing a positivistic corpus that considers blacks' legacy as a fragmented hiatus, this scholarship underscores the continuities, rather than the disjunctures, of the contributions of black artists to the tango's evolving path (Cáceres 2010; Castro 1991; Farris Thompson 2005).

What is known today as the Argentine tango, in its many variations, seems to have resulted from a blend of different musical traditions. These include African influences (*candombe* and the Cuban *habanera*) and Spanish and Italian rhythms that merged with the creole tango of the De La Plata River region by the last decades of the nineteenth century (Carretero 1999; Castro 2001). The mixed urban ferment in the slums of Montevideo and Buenos Aires brought together Italians, Spaniards, and Poles, along with an ethnically diverse blend of people, including African descendents of native slaves, creoles, and gauchos from the pampas—all attracted to the city by the meat industry and the export trade (Goertzen and Azzi 1999).

The first period in the tango's development owes much to the legacy of Afro-Argentines, mostly in its rhythm and changing steps, which evolved from an open to a close embrace, as well as in the first tango lyrics improvised in the *naciones* (nations), the neighborhoods where most blacks lived in Buenos Aires. The term "nations" identifies communal societies organized according to Africans' ethnic origin (e.g., the Congo and Mozambique), which subscribed to a kingdom structure where officials were democratically elected. Dancing and singing were two of the nations' major activities that gave birth to the Argentine *candombe* and *milonga*, as spirited predecessors of the tango (Farris Thompson 2005).[2] By the 1880s, the tango's early musical forms could be found in the *tango negro* (black tango), *candombe criollo*, and *candombe milonga*. A version of the black tango was interpreted by the Afro-Argentine *candomberas* (performers), who combined classical *candombe* with *tango milongas* (Farris Thompson 2005).[3]

As noted earlier, the Argentine conversion from a colonial Spanish center to an independent republic in South America was inspired by the idea of Argentine exceptionality, where European traits were to be assimilated, leaving no trace of regional shades. This was in tandem with Latin

America's modernist project—a bold, visionary, and, ultimately, quixotic effort to transform itself from a racially mixed, predominantly nonwhite region into a white enclave (Andrews 2004; Oboler 2005). The conditions that fed the slave system were then replaced by a new mode of production, marked by the second industrial revolution that took place in Europe by the 1880s. The demand for raw materials, particularly meat and cereals from Argentina and Uruguay, launched the boom for development. The new modern state, supported by an agro-export economic model, committed itself to guaranteeing capital accumulation based on the country's agricultural power, which soon made Argentina famous as the "breadbasket of the world" (Grimson and Kessler 2005). Throughout this process, new liberal principles of equality were rapidly merged with scientific racism, which, rooted in social Darwinism, achieved fast popularity in Europe and North America at the time (Hobsbawm 1994).

The narratives of the modern state were publicized through such slogans as "settle the desert" and "to govern is to settle," as clearly spelled out in the Constitution passed in 1853, which assured basic rights to all men (regardless of nationality) who wished to live in the Argentine nation. The complex and contradictory process that gave birth to the Argentine "racial bleaching" was both subtle and brutal overall. The national campaign popularly known as *La Conquista del Desierto* (Conquest of the Desert) was orchestrated as a state-sponsored military initiative launched by General Rocca in the 1890s. This campaign imposed clear territorial borders aimed to protect the Argentine country from both indigenous groups and neighboring nations, while allowing the entrance of railroads, telegraph wires, and capital (Martínez Sarasola 2005).

Under the assumption that Argentina was an empty young nation, the "settle the dessert" crusade reckoned the image of conquering presumably unpopulated territories. This became a subterfuge to make invisible the fact that the desert was in fact inhabited by well-established aboriginal groups. Under a twofold objective, the campaign forcibly removed the natives and opened their lands to agriculture and livestock. While some groups kept their freedom, the majority were persecuted, exterminated, and confined to marginal reservations. Through time, the legacy of most of the mixed descendants of those aboriginal populations, or *mestizos*, would breed a new Argentine racial type: the creole, who would play an essential role during the second urbanization process in the 1940s.

Parallel to the Conquest of the Desert, an elaborate policy of capital importation and massive immigration was launched in a country that turned its eyes toward Europe. The "Argentinization" of the country's di-

verse inhabitants was aimed at leveling inner differences, by granting universal access to public education and promises of upward social mobility. Throughout the last quarter of the nineteenth century and first decades of the twentieth century, the dominant elites succeeded in advancing a hegemonic message based on the idea that "to be truly Argentine" meant to be educated and of white European descent. The white melting pot became the Argentine dominant belief among public representations of nationhood during this period. This process achieved its climax with Domingo F. Sarmiento, who was president from 1868 to 1874, and who spearheaded the country's process of race unification and modernization (Andrew 2004; Chamosa 2010).

On the basis of a laissez-faire foreign policy, the official discourse promoted the notion that a modern country would result from white immigrants imported from different parts of the globe. In a young Argentina, where cultural unity seemed to be blurred, the rising agricultural elite built its power on ideals supported by European liberalism, industrial urbanism, and positivist rationalism. At the time, the Argentine economy was experiencing one of the most impressive growth rates in the world, with per capita incomes more than 30 percent higher than those in Spain or Italy (Solimano 2003). The combination of thriving domestic conditions with a welcoming migration policy led to a fast-paced immigration stream of millions of Europeans who settled in rural areas and rising urban enclaves. As a result, between 1890 and 1914, the country experienced one of the greatest immigration waves in its history, with one third of the population being foreign-born in 1914 (eight million in total). During this period, more than three million European citizens, mostly Italians and Spaniards, arrived in Argentina to settle in blossoming urban areas and the pampas' fertile rural belt (Chamosa 2010).

The First Tangomania: From the Tango's Success Abroad to Its Acceptance at Home

Coinciding with the reshaping of Buenos Aires as a modern urban center, the first official tango period, 1890–1917, underscored the role of prostitution in a port city where European and internal immigrants were eager for a piece of the Argentine dream (Guy 1991; Vila 1991; Viladrich 2006). The first publicly known tango songs were born *sobre la parrilla* ("on the grill," or spontaneously), often charged with sexual connotations conveyed by *lunfardo* words (Spanish argot) and disseminated orally in the brothels

and bars located in the outskirts of Buenos Aires. Despite being rejected by the upper classes, the tango rapidly became an essential genre in the popular dancing repertoire, which included waltzes, mazurkas, and *paso dobles* (a Spanish dance). These were performed on tenement patios, at dance halls and academies, and even at the circus—anywhere that dance and drinks provided the backdrop for sexual encounters (Carretero 1999; Dos Santos 1994).

While brothels located in the inner city catered to the native and foreign working classes, debonair establishments would rent their whole *casitas* (little houses) to groups of well-off individuals. Garramuño (2007) points outs that some of the casitas were apartments or houses owned by upper-class men, where women of the "easy life" would join them for dinner and sexual encounters. The relationship between brothels, casitas, and theaters signaled the tango's geographical and symbolic displacement from the peripheral neighborhoods to the center of cosmopolitan urban life (Azzi 1996; Corradi 1997; Groppa 2004). As noted by Vila (1991) and Castro (1991), the tango's transition from a sinful to an accepted genre was pioneered by a diverse male population that spread it beyond the slums and port area to the tenement houses of Palermo and La Boca, with their *cafetines cantantes* (singing cafés), around 1910 and, finally, to its ultimate success in Paris in 1912 and in the rest of Europe and the United States soon afterward.

The Europeanization of the tango in the French ballrooms prior to World War I was fed by the Europeans' uncanny appetite for sensual and exotic forms of art during this period. Dancers, musicians, and young Argentine libertine aristocrats first introduced the tango to the high Parisian elite, who soon fired the tango fever known as the first tangomania. The next challenge was how to make of tango a widespread entertaining brand to be embraced by the Argentine upper and middle class (Castro 1991; Luker 2007; Savigliano 1995). As Donna Guy (1991) notes, the tango would not win Argentines' broad acceptance just because they could emulate the French. Still, its racial and working-class origins (along with its "impudent" lyrics and dancing styles) needed to be shed off. Thus, the tango had to endure a process of sanitization or domestication before receiving a laudatory social reception and its ultimate patronage by the Argentine agro-industrial elite.

The young Argentine "beef barons"—the source in Paris of the expression "as rich as an Argentine"—did more than secure foreign approval for the tango (Savigliano 1995). Less a matter of imitation than of appropriation, they legitimized the neocolonial version of the tango through social

and racial cleansing, which was key to the blessing that the Argentine dominant class finally bestowed on its practice. This led to reducing the sensuality of the tango steps and dancing figures by replacing fast beats for slow tempos and by taming its lyrics (Viladrich 2006). This also meant disciplining the practitioners' body movements by focusing on walking and on keeping a fine posture (vertical torso) while deemphasizing the body's cuts and breaks.

These modifications ensured the tango's transition from the old guard to its Época de Oro (Golden Age), or La Nueva Guardia (New Guard), which gave birth to the most well-known tango lyrics, created in a period of twenty years, from 1917 to the mid-1930s. Ultimately, the tango achieved upward mobility in two ways: from its darker working-class origins to its acceptance by the white middle and upper strata; and from the active sensuality of the dance form to an emphasis on the tango song—or a shift from the feet to the mouth (Castro 1991; Viladrich 2006). By the mid-1910s, the tango had become a main player in assuring the agro-industrial elite's hegemony, which was in jeopardy during the first decades of the twentieth century. Tango dancing, along with other symbols such as Catholic images, began to be strategically utilized by the state in order to advance its national brand of *argentinidad*, aimed at counteracting the country's blurred national boundaries. The latter had resulted from the conflated impact of two simultaneous processes: the massive European immigration on the one hand, and the sketchy borderlines drawn by displaced aboriginal populations and creoles on the other (Vila 1991).

The closure of houses of prostitution in 1919 brought the tango into the more accepted environment of the cabaret and *teatro de revistas*, similar to vaudeville in the United States (Castro 1991). The path leading to the tango's upward mobility required, by the beginning of the 1920s, that musicians no longer be recruited from the working class; instead, they had to come from the middle and upper social strata that mingled at the cabaret as a refined substitute for the old brothel. Working girls moved to the streets and to these new amusement places, which opened their doors to a new generation of female artists who combined their skills as entertainers, musicians, actresses, and singers (Dos Santos 1994; Viladrich 2006). Most of the tango lyrics of this period describe romantic male heroes longing for love and companionship, along with women being tempted by the easy lives of nightclubs and cabarets. The tensions brought by these new themes vividly reflected the emerging and conflicting morals which, in the midst of changing class and gender relationships, were taking place in an emergent modern Argentina (Archetti 1999; Viladrich 2005).

Contested "Brownness" and the Tango's Decay

Beginning in the 1930s, new attempts at nation building led to a demographic shift that signaled the influx of internal migrants from rural areas to the cities. This coincided with the end of massive European immigration, as European economies began to recover and even surpass Argentine standards of living. As a result of the worldwide crisis of the 1930s, the international prices of Argentine agricultural exports plummeted and the country's main staples (meat and wheat) no longer meant profitable business. Import substitution became the solution which, rooted in the consolidation of a strong national industry, encouraged mass consumption and full employment. Following an independent capitalist model, Juan Domingo Perón inaugurated the modern welfare state in the 1940s, providing social benefits to the new working class and ethnic minorities. Often described as the leader of a conservative-corporatist welfare state, Perón granted favors to strong corporate unions that, in turn, offered political backup and weakened the strength of left-wing labor groups and any other political opposition (Romero 1994).

The new mode of industrial production needed a strong labor force, eager to engage in low-skilled manual labor in exchange for decent wages, which marked a novel acquisition of social benefits and political rights. To this end, a new urban proletariat was recruited from the internal borderlines, particularly from rural areas in the North where the highest concentration of creoles lived. These internal migrants, previously marginalized rural actors in the national drama, now had access to regular salaries and state-supported social services tied to unions. This freshly minted working class clashed against the self-defined urban (European-like) middle sectors, and a racial terminology based on color differentials was born to stigmatize the newcomers. For the first time in fifty years, the official discourse of racial neutrality was confronted with social inequality. Creoles began to be called *negros sucios* (dirty blacks) and *cabecitas negras* (little black heads) in reference to their dark skin and rural origins, in an attempt to impugn the dreams of upward mobility of Argentina's most disenfranchised populations (Grimson and Kessler 2005).

Perón's arrival to power elevated these actors to a new role and stature: the *descamisado* (shirtless), a term meant to disparage rural working-class individuals who work without shirts. Rather than deploying this term deceptively, the Perón regime shifted its meaning to make it the ultimate representation of the working-class hero. Eva Perón's crusade in favor of the descamisados gave birth to an innovative form of social beneficence

which, embedded in political activism, culminated with the creation of the Eva Perón Foundation in 1948. As I have explored previously (Viladrich and Thompson 1996), the descamisado was a far cry from the vicious poor represented by the conservative model, or the revolutionary actor proclaimed by the socialist and communist systems. Instead, the new urban poor became the symbol of new class alliances created by the state and the labor unions.

The increasing identification between a darker skin tone and labor-based movements did not take place in Argentina alone—although it was probably there that these social changes became mostly ingrained in terms of color. The exaltation of brownness turned into the expression of a racial democracy fed by Latin Americans' search for their own ethnic heritage, which swept throughout the region hand-in-hand with the rise of labor-based populist governments (Andrew 2004). The military coup that sent Perón into exile did not lead to his disappearance but just the opposite. A strong clandestine movement in the 1960s culminated with his return to Argentina, where he became president again in 1973. The turbulent times that followed Perón's last mandate deepened an industrial process that lasted until the final coup d'état in 1976 (Romero 1994).

The tango's progressive decline in Argentina, from the 1950s to the early 1980s, has been the object of different explanations (Castro 1991; Vila 1991). The most important ones emphasize the conservative and moralistic policies of a succession of military regimes that banned tango lyrics; the massive internal migration and consequent promotion of folk genres; and the increasing impact of foreign music. Tango music and dancing in Argentina suffered from competition with North American rhythms including swing, jazz, and rock-n-roll, as well as Latin American genres such as mambo, cha-cha-cha, rumba, and bolero.

The waning of the tango that had timidly begun during Perón's reign has also been explained by the anachronism between the genre's melancholy and the fresh optimism of his populist government. Most of the popular tango lyrics created prior to Perón's era conveyed individualistic complaints about male abandonment along with tales of female perdition and urban poverty, topics that seemed dated amid the populist view of Perón's growing Argentina. As a result, the tango lyrics of the 1940s and 1950s mostly resulted in nostalgic vignettes of the past rather than critical chronicles of the present. This was also reflected in the scarce production of new tango lyrics during this period, revealing, as Vila (1991) observes, the impossibility of creating a Peronist tango. In fact, some of the main tango poets at the time, such as Homero Manzy and Enrique Santos

Discépolo, abandoned their work as tango writers so that they could devote themselves to politics.

In his remarkable analysis of this period, Vila (1987, 1991) argues that the emergence of new folkloric genres in Argentina rose from the internal migration process beginning in the 1930s, which uncovered antagonistic cultural identities in the urban milieu. Slowly but progressively, the tango became a faded symbol of an urban middle class and proved inadequate to represent the new poor. For the middle and upper classes, the turning of rural workers into major urban actors somehow threatened their cultural and social identity. Therefore, they mostly dismissed folkloric music by derogatorily considering it *música de negros* (dark-skinned people's music). Through time, the struggles for hegemony between the urban middle class and the rural migrants led to the prevalence of folk genres, and to the decline of the tango as the national icon of the Argentine patriotic repertoire. Argentine folklore never traveled the world as tango did, and it is still downplayed as the cultural expression of the *gente del interior* (inhabitants of the inner provinces) who find their roots in the country's internal borderlands.

The Peronist government also endorsed the first wave of "brain drain" in Argentina, which, beginning in the early 1950s, recurrently witnessed the departure of professionals, artists, and intellectuals. Famous tango interpreters, as in the case of Libertad Lamarque, chose self-exile to other countries due to their differences with Perón's regime. Lamarque's arrival in Mexico in the mid-1940s was allegedly due to her personal squabbles with Eva Perón, with whom she had shared the stage years before (Dos Santos 2001). Several renowned artists remained abroad or returned to Argentina during more favorable political times, often to leave again either for political reasons or due to economic need. The departure of intellectuals and artists (including Perón's supporters) only deepened with following military regimes, which systematically persecuted the Argentine intelligentsia and symbolically destroyed its academic, professional, and artistic contributions.

The tango's fragmented trajectory also suffered a great deal from a succession of military regimes that censored lyrics as part of sanitization campaigns that favored foreign musical genres. The most infamous of these measures was *La Ley del Buen Hablar* (Law of Good Speech), a decree passed by General Pedro P. Ramírez in 1943. Under the sponsorship of the Catholic Church and the right-wing conservative elite, the government ordered radio stations to alter tango titles and lyrics in order to conform to both good morals and correct grammar, as dictated by the official Hispanic-

Castilian dictionary (Fraschini 2008). Strong censorship of tango lyrics was enforced, and the lunfardo terms typically used in tango were banned. Lyrics seen as immoral were changed to the point that their original content was unrecognizable, and those who broke the law by singing the original versions were heavily fined.

Despite its disjointed history, the tango's soul did not disappear from the Argentine social and emotional repertoire. It survived in sheltered spaces as a vivid memory of the past, and it continued to evolve through innovative musical fusions. This period was characterized by an emphasis on tango music rather than on lyrics and dancing (Luker 2007). Beginning in the 1950s, new forms of tango experimentation were born, particularly with Astor P. Piazzolla, who inspired the neo-tango vanguard that merged the genre with classical music, jazz, and rock-n-roll. This multitalented composer, who resided alternately in Argentina, the United States, France, and Italy, suffered bitter criticism from traditionalist tango interpreters and followers. In the end, however, he was widely accepted as the pioneering figure who spurred an unprecedented worldwide tango revival.

Meanwhile, traditional tango music remained alive in secluded spaces where older *milongueros* (devoted tango dancers) cherished it as a nostalgic remembrance of an ebullient time gone by. Intimate salons, where quartets and quintets filled the rooms, replaced the big tango ballrooms and large orchestras. Tango dancing also survived in shows that catered to foreigners and Argentines from the provinces, a practice that greatly contributed to the production of the "fantasy" or "for export" tango. This trend marked the beginning of the tango spectacle, whose audiences came to watch and listen but not to dance (Cáceres 2010). This modality has been highly criticized by the *cultores del género* (expert keepers of the genre) for allegedly representing a commoditized form of tango that mostly relies on complicated figures and pirouettes. Despite its detractors, the enduring popularity of the "for export" tango style allowed the genre to remain alive even during harsh times.

Convulsive Times and the Final Military Dictatorship

Perón's fall due to a military coup in 1955 was followed by turbulent times that witnessed the rise of short democratic periods alternating with fierce military dictatorships, all signaled by the crisis of the industrial process and the reign of an agro-business alliance supported by neoliberal models. Meanwhile, the proscription of *Peronismo* (Peronism) between 1955 and

1972 led to the social polarization of right- and left-wing sectors. The Onganía military coup (1966–70) accelerated the process of revolutionary activism that derived from the *Cordobazo* movement in 1969, which began with a student revolt in the province of Córdoba that was inspired by the French protests of May 1968. Along with the radical spirit of vast sectors of the middle and working classes and a class-based union movement, the country experienced a burst of revolutionary force representing different tendencies and factions, including leftist guerrilla Peronist armies (Franco 2008). Meanwhile, beginning in the mid-1960s, Argentina faced the growth of right-wing movements that, supported by the army, followed the principles of the National Security Doctrine to embrace an anticommunist ideological form of state-supported terrorism.

The power coalition that democratically brought Perón back from exile to govern for a third term in 1973 was joined by a vast political spectrum, from the extreme left to right, which confronted each other while seeking preeminence within the movement. Perón's third wife and his vice president, Isabel Martínez de Perón, took over the country after the leader's death in 1974, during a period marked by economic turmoil and political unrest. At the time, a state-supported paramilitary and repressive force was launched by the Argentine Anticommunist Alliance (AAA) to conduct secretive strikes against activists from a wide range of political groups and union leaders (González Jansen 1983). The AAA became the first arm of state terrorism, which marked the triumph of the conservative branches over progressive forces and took the lives of the first victims of the period, sending into exile large streams of intellectuals and activists (Yankelevich 2010).

The increasing activities of paramilitary groups amid the guerrillas' strikes created the conditions for the final military dictatorship beginning in 1976. It was with the *golpe* (strike) of March 24, 1976, that the ultimate systematic repression of vast sectors of society was launched. Operation Condor, a program driven by intelligence forces in Argentina and its neighboring countries, captured and often murdered individuals suspected of terrorist activities. The resulting so-called "dirty war" was responsible for more than thirty thousand people who "disappeared" at the hands of paramilitary groups.[4] The strategy of considering subversive any ideology or activity that could be interpreted as leftist had an impact on the whole society and led a large number of artists, activists, and professionals to leave Argentina in order to protect their lives as well as their families (see CONADEP 1984; Maletta, Szwarcberg, and Schneider 1986).

The military government that led the coup d'état in 1976 dismantled

the welfare state by disciplining the labor unions and the petite-bourgeoisie industrialist class. The outcome was a deep change in the economic structure, with an emphasis on the liberalization of commerce rather than on the productive apparatus. A new mode of state intervention was instituted on the basis of the "sweet money" state of affairs, characterized by the transference of wealth to the financial sector as the main mechanism of capital accumulation. The result was a geometric increase in foreign debt along with the dismantling of the production system, rising unemployment, and impoverishment of the population.

Meanwhile, exiled artists, some of them interpreters of a vast musical repertoire from tango to rock-n-roll, continued to show their art to the rest of the world, while denouncing the violation of human rights taking place in Argentina at the time (Yankelevich 2010). Books such as Julie Taylor's *Paper Tangos* (1998) delved into the feelings of internal and external exile of artists who practiced tango dancing in Argentina's secluded places, where they remained isolated in order to protect themselves from political terror. Movies such as *The Exile of Gardel*, directed by the exiled filmmaker Fernando (Pino) Solanas, drew attention to the sociopolitical conditions that sent thousands of Argentine intellectuals and artists overseas in the 1970s (Taylor 1998).

The Argentine defeat in the Falklands war in 1982, during which the military government fought against the United Kingdom, became the armed forces' last attempt to maintain political leverage on the basis of a public call for national pride. The lost war, along with the growing popular consensus in support of a constitutional transition, soon led to a democratic election that brought Dr. Raúl Alfonsín to office in 1983. This constitutional regime encouraged the homecoming of many who had left the country in the previous decade (Maletta et al. 1986). This process motivated an "ideology of return," in tune with the government's support of the repatriation for those living abroad, which infused a generalized optimism about the country's democratic future.

The stream of Argentine returnees peaked in the first half of 1984, under the sponsorship of the newly created National Committee for the Return of Argentines Living Abroad, which counted on the financial support of the International Migration Committee, or IMC (Zuccottti 1987). Unfortunately, this initial process was not sustained by a clear return policy, and Argentina's promising economic outlook soon soured. As a result, the IMC was dismantled before the end of 1985. By the end of 1984 only two thousand exiles (and their families) had gone back to Argentina with the help of the IMC (Maletta et al. 1986). Still, at the time, many well-known

tango singers and artists, including Susana Rinaldi and Nacha Guevara, decided to return to Argentina to resume their artistic careers and support the tango's renaissance.

Throughout the years, many veteran and upcoming Argentine artists have reconfigured their crafts by turning to tango singing and playing, as in the case of Sandra Mihanovitch or Adriana Varela, the latter becoming the tango's singing revelation in the 1990s (Dos Santos 2001). Meanwhile, slowly but steadily, tango themes have continued to epitomize key elements in Argentina's urban culture. This trend is palpable in the rising familiarity of the word *milonga*, signifying both the fast tango rhythm (that resulted from the Afro-Argentines' legacy) and the ultimate tango parlor.

Argentina's Unresolved Racial Legacy

> Black tango, black tango
> you left us without notice
> the foreigners kept changing
> your dancing style.
>
> Black tango, black tango,
> the master left by sea
> and there are no more candombes
> being played
> in the neighborhood of Monserrat. (Cáceres 2010)

When visiting Buenos Aires in early 2011, I was thrilled when I finally got tickets to see the show *Puro Tango* (*Pure Tango*), the latest creation of the producer and renowned tango dancer Miguel Angel Zotto. The show had received rave reviews for both its musical mastery and faithful account of Argentina's tango history. What impressed me the most about the play was its wide-ranging recreation of historical periods that showcased main tango styles—canyengue, milonga, ballroom, and scenery (or fantasy) tango—as a testimony to the genre's evolution over the past century and a half. The multimedia effects of the show masterfully combined photo displays and video productions amid the dancing and singing, all spiced by original choreographies that made the artists shine in unique ways, with the dancers' beautiful dresses and shoes matching their virtuosity.

Nevertheless, halfway through the play I began to feel that something was missing. I soon realized that the early contributions of the *payadores*

(duet singers) along with the Afro-Argentine legacy and creole tango versions were absent from the script's historical parade. Near the end of the spectacle, I was still hopeful that the Afro-Argentines' early tangos would be acknowledged one way or another. I was wrong. Despite the overall merit of the production, I was disappointed by the limited exposure of the earliest tango legacy, and I came away from the performance with mixed feelings. Following the pattern of most folklore surrounding the tango mystique, the show depicted its origins in the brothels, around 1890, when men would dance with each other while awaiting their turn to experience sexual pleasures with the women. The tango's technique and sensibility were displayed mostly as a white cultural tradition tinged by a sprinkling of creole customs, including a dancer in gaucho garb who accompanied his steps with the rhythmical sound of the *boleadoras* hitting the stage floor.[5] And that was it.

The show complied with a long legacy of invisibility for African and creole progenitors in the construction of Argentina's social and cultural repertoire. As argued in this chapter, Argentina's self-affirmation as a white nation in the twentieth century was built amid a dominant discourse that obliterated both the presence and cultural contributions of people of color. The country's entrance to modernity accelerated the invisibility of *negritud* (blackness) under the assumption that the African population had disappeared long ago due to illness, war, and assimilation. Throughout this process, tango was domesticated and turned into an icon of the elites' commitment to erecting a modern country in the Southern Cone. As a result, the Afro-Argentines who had contributed to the musical creation of the creole tango were ultimately removed from the genre they had helped craft.

By the time the Afro-Argentine population seemed to have finally disappeared, the cabecitas negras came to take their place, becoming the "true blacks" of modern Argentina during Perón's reign (Frigerio 2006; Guber 2002; Solomianski 2003). Even after Perón's fall, the urban creole continued to carry the negative labels formerly deployed against Afro-Argentines (Cottrol 2007). In fact, many of the social, cultural, and psychological features attributed to the new negros replicated those associated with their African ancestors some forty years earlier. On the basis of pervasive semantics, the word *negro* in contemporary Argentina has been imprinted with markers of social class (i.e., status and prestige) that do not exactly correlate with skin color. This association meshes with a hegemonic color-blind ideology in Argentina, which assumes that social differences are not traced according to color but to status differentials. Throughout this process, the

linguistic loss of the term "blackness" was replaced by the word "brown-ness."

As in Oboler's study on Peruvians (1992, 2005), most middle-class Argentines currently believe that structural and institutional racism do not exist and are not a source of social inequality in their homeland. In fact, while the term "social class" has remained a taboo topic in US contemporary politics as well as cultural analysis (see Ortner 2003, for a critique), this concept in Argentina, and its proxies via socioeconomic status, is embedded into mainstream discourses of social inequality. This is in tune with liberal notions of meritocracy that rest on principles of equal opportunity according to individual talent and effort. Nowadays, the term *negro* in Argentina is still widely used as an ethno-class cultural category that represents a poor person who has no education. In fact, the terms *negro*, *villero* (shantytown dweller), and *cabecita negra* all refer to both the dark-skinned and white poor.[6] Yet it is not enough to have dark features to be seen as a negro by Argentines, as this label may have either a negative or positive meaning depending on the context, the uttered intention, and even the tone utilized by the speaker.[7]

Even if race has been erased from the historical account, it has remained as the uninvited guest in the Argentine colorized prism that still reflects the country's power differences. Immigrants from neighboring countries (e.g., Paraguay and Bolivia) also represent today's negros in Argentina who, along with the native underclass, are geographically and socially displaced to the margins of society as they mostly reside in slum areas circling the city limits (Dávila 2012; Frigerio 2006). Despite the fact that some of these individuals bear physical signs of African and aboriginal heritage, they are not considered descendants of those original groups. Still, the notion of brownness, as an identifier of individuals belonging to a socially marginalized group, has remained alive and well in the Argentine discursive repertoire. In the end, the terms *negro* and *negra* (in their masculine and feminine versions) hold all the conflicting archetypes that eventually forged the marriage between racial and class categories in Argentina.

Welcome to the Argentine Tango World

From the Study Design to My Field Experience

> My beloved Buenos Aires
> the next time I see you again
> there will be no more grief nor forgetfulness.
> Today let luck wish that I come back to see you,
> port city of my only love
> I hear the lament of a bandoneón
> asking for his heart to be set free.
>
> My Buenos Aires
> flowered land
> where I will end my life.
> Under your shelter
> there are no disappointments,
> years fly by, pain is forgotten.
>
> In caravan memories go by
> like a trail sweet of emotion,
> I want you to know that when I call you
> sorrow leaves my heart.

CARLOS GARDEL, "MI BUENOS AIRES QUERIDO"

Many of the tangos that my compatriots and I hardly knew back in Argentina, such as "Mi Buenos Aires querido," became part of our migratory emotional repertoire after living abroad for a while. This tango, written by Carlos Gardel and Alfredo Le Pera during their long stay in New York

City, was broadcast directly from NBC Studios to Argentina on the day of its debut in 1934, becoming an instant hit. Since then, this song has appeared in countless pieces of fiction and has been played anytime Argentine expatriates are eager to evoke their nostalgic yearning for a distant land.

My incursions into the tango field began more than fifteen years ago when, as both an Argentine immigrant living in New York City and a newcomer to the United States, I was compelled to find traces of my own Argentine identity. Early on during my migratory career, I fell prey, as have many others among my peers born in the Buenos Aires metropolitan area, to connecting my own feelings of longing and homesickness with the tango. As Savigliano (1995) observes, tango and exile (in the sense of being away from home) are tightly related. My increasing interest in tango throughout the years also paralleled the acquisition of my migratory *habitus* (Bourdieu 1984), which translated into my craving for Argentine sounds, smells, voices, and places that felt closer when I listened to a tango song. I occasionally visited tango venues for the purpose of meeting up with compatriots, while listening to the tango tunes my relatives used to hum when I was growing up in Buenos Aires.

I then joined the nomadic milongas that were mushrooming in the mid-1990s, along with the underground social world that attracted Argentine and international regulars alike. In those years, tango dancing in Manhattan was rapidly turning into a unique social field that brought together a diverse crowd of cosmopolitan regulars and tango artists of different nationalities. Given the scarcity of Argentine niches in New York City, tango parlors soon became inviting social milieus for my fellow nationals who longed for familiar vocabulary, flavors, and music.

Contrary to tango dancing, which does not require an understanding of the lyrics, listening to tango songs is a unique *porteño* pastime. The feelings that the tango lyrics convey are complex and contradictory, from heartfelt to melancholic. Even when passionate, tango songs never portray a superficial happiness or joyful cheer in which everybody dares to celebrate recklessly. By listening to tango music and even dancing to it, many of my Argentine friends and I engage with memories that shelter us from the nebulous sense of loneliness that we often experience when living abroad. If tango evokes shared human feelings of passion, exoticism, and melancholy (Goertzen and Azzi 1999), much of Argentines' sudden interest in it represents both a product and a reaction against cultural globalization, as a sort of resistance identity and surrogate for other respected selves (Castells 1997).

For many immigrants, being anonymous in the big city encourages their search for whatever ethnic token is able to transport them back to their lost environment. For the same reason that other national minorities tend to gather in familiar restaurants and clubs, even if sporadically, the tango's public representation leads Argentines to engage with each other in seemingly familiar territories. If Brazilians have samba and bossa nova and Caribbeans have salsa, cumbia, and merengue, what do Argentines use to symbolize themselves as a singular ethnic group? Tango. In other words, while for non-Argentines the tango may be a glamorous dance form and an expressive way to dive into their individual (passionate) subjectivity, for most Argentine émigrés it provides an opportunity to craft their membership as a singular collective within the metropolitan melting pot.[1] Porteños' involvement with the social production of the tango reckons a shared sense of belonging to a common national identity, along with a striking means to connecting with individuals from the same country.

Being acknowledged as a tango aficionado also bestows upon Argentines a status that protects them from the "alien" stigma some feel labeled with in the United States. And because tango is the only Argentine rhythm with international recognition, it somehow fulfills my co-nationals' internalized yearning for revered public visibility. In sum, by learning to appreciate the tango in the United States many Argentines, including me, have echoed the tango's fate: they have discovered and appreciated it abroad although they may have ignored, or despised, this genre at home (Savigliano 1995). Finally, becoming familiar with the tango, and even dancing and playing it, represents Argentines' unique path to joining informal social networks. Next, I reconfigure the dispersed New York City map of Argentines who hold onto the tango legacy in endearing, albeit disparate, ways.

The Scattered Argentine Minority: An Insider's Challenge

Although Argentines can be found almost anywhere in the city, their numbers are meager when compared with other Latino groups. According to the Census Bureau, 9,578 Argentines were living in New York City in 2000; by 2011, that figure had increased by almost 60 percent to 15,169 (New York City Department of City Planning 2000, 2010). Parallel to the domestic crisis that led to the Argentine "exodus" beginning in 2001, the Argentine population in the United States rose from 100,864 in 2000 to

224,952 in 2010, representing a 123 percent population change within the total Hispanic population.

Argentines neither belong to a community that is spatially delimited nor constitute a clearly identified ethnic enclave, as is the case for other Latin American groups in New York City, despite the fact that they were one of the first Latin American groups to settle in the region beginning in the 1960s. This coincided with changes to US migratory law that opened the quotas to immigrants from Latin America and the Caribbean (Foner 2000, 2001). Argentines' geographic dispersal, which led them to move into different boroughs and neighborhoods, has contributed to highlight their invisibility; nonetheless, this physical scattering was not always the case. In the 1940s and 1950s, Jackson Heights in Queens was mainly an Italian neighborhood; by the mid-1960s, Colombians, Peruvians, and Ecuadorians had joined a noticeable community of blue-collar Argentines in the social construction of a Latin American enclave in this neighborhood (Leeds 1996). Throughout the years, Cuban exiles and a more diverse influx of South American and Mexican immigrants moved to the crossroads of Roosevelt Avenue and Junction Boulevard, which has been described as New York City's "real" Avenue of the Americas.[2]

In subsequent decades, a small enclave of Argentines remained in Elmhurst, Queens, although upward trajectories led many families of the first Argentine pioneers to move to other districts (Wilman-Navarro and Davidziuk 2006), including more upscale neighborhoods in Queens (Forest Hills and Rego Park), Long Island (Port Washington), New Jersey (Jersey City, Livingston, Paterson, Union City), and Manhattan. Still, the Argentine flavor in Elmhurst was kept alive, thanks to the presence of ethnic purveyors that include Argentine restaurants, bakeries, and butcher shops where Argentines can buy their beloved cuts of meat.

Twenty years ago, Junction Boulevard and Corona Avenue was mainly a small Argentine area, a phenomenon that can still be witnessed at the celebrated "Argentine corner." Evidence of the Argentine presence at this fork is reflected by an ethnic supermarket that caters to Argentines and other South American communities, the Argentine bakery, the *Rioplatense* club, and a couple of Argentine eateries—including the restaurant-butcher shop, El Gauchito, which allegedly makes some of the best *empanadas* (filled turnovers) in the city. This is also the place where many newly arrived Argentines *atterrizan* (land) and search for jobs, housing, and familiar faces. Although the Argentine minority gathering in this area is much smaller than in other communities, such as the Cubans in Miami (Portes and Stepick 1993) or the Chinese in New York City (Chen 1992), it none-

theless promotes the circulation of resources among immigrants. Argentines from all boroughs, including those who used to live in Queens, tend to socialize and entertain in this neighborhood whether to buy Argentine foods, celebrate Carlos Gardel's anniversary, or see their peers, as also happens with Brazilians who congregate in Little Brazil in Manhattan (Margolis 1994, 2009).

The Reinvention of Argentine Tango in New York City

By the time the tango had reclaimed its place in the US entertainment field, its unique Argentine brand had already reigned over other forms. In New York City, tango dancing became most visible in the mid-1990s, when it left its hidden place in the inventory of ballroom dances and achieved a social identity of its own, partly as a result of talented local entrepreneurs who foresaw the potential of the tango market lured by an international clientele. Following the success of *Tango Argentino* on Broad-

Figure 6. La esquina argentina (the Argentine corner) can be read on this restaurant's awning in Queens, New York City. (Photographer: Anahí Viladrich)

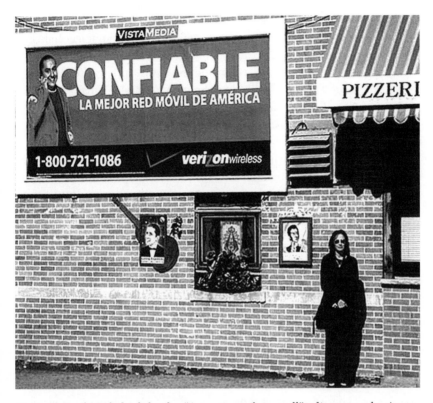

Figure 7. Anahí Viladrich by the "Argentine tribute wall" adjacent to the Argentine corner in Queens. From left to right: an image of Carlos Gardel; the Virgin of Luján, the Catholic patron of Argentines in New York City; and San Martín, Argentina's chief national hero who led the revolution against the Spanish Crown in the early nineteenth century. (Photographer: Stephen F. Pekar)

way, a combination of factors allowed the genre to regain a prime position in the Manhattan dancing field, with Argentines being the first to capitalize on it. At the time, a group of mostly urban, middle-class Argentines, inspired by an eagerness to recover a piece of their national heritage, mingled in different venues to dance and listen to tango. The lack of formal places where it could be routinely performed led to a series of engagements in bars and dance studios. These nomadic encounters soon turned into more regular milongas that were held at cafés and restaurants in different Manhattan locations. An Internet press release authored by Daniel Carpi (2002), a tango pioneer and successful Argentine tango producer, summarizes this rising trend:

At that point, mid-1996, some of New York's best tango bands, like the New York Tango Trio, the Enrique Quagliano Tango Trio, singer Isabel de Sebastián and pianist Bob Telson, had generated a large following of Latin American, European, Asian, and even African fans. Renowned New York–area dancers like Valeria Solomonoff and Tioma, Rodrigo and Gabriela, Carlos Duarte, and others also became regulars of the tango scene and were soon in demand to give tango lessons.

Dancing academies (where tango had formerly had a timid presence) rapidly expanded their tango repertoire, a phenomenon soon supported by a mushrooming of tango venues where teaching and dancing tango, and tango only, became a cornerstone of the city's entertainment economy. In spite of the participation of amateurs of all nationalities in the genre's social reproduction, the predominance of Argentine tango as the leading style on the ballroom floor (with all its variances) placed Argentine artists in the spotlight. In response, they rapidly learned to take advantage of the foreign decoy for passion by making tango their own product, while stealing potential clientele from other competitive genres such as salsa, swing, or cumbia. Thereafter, middle-class Argentine immigrants and international entrepreneurs made tango a centerpiece of dance salons, cafés, and restaurants.

Outside of Buenos Aires, which is considered the tango kingdom par excellence, where one can visit over a hundred tango venues on any given night, New York City represents a prime tango hub that is in motion seven days a week. There, tango is practiced and danced in a variety of physical and social settings: from regular studios to private clubs, restaurants, piers, and other public venues. Tango options range from a Buenos Aires–style environment (known as *La Nacional*) to "hit-and-run" events that are held without permission in public spaces. One of the most celebrated public venues is a free outdoor tango practice, located next to the Shakespeare statue in Central Park, which has become internationally renowned. It happens every Saturday from June 1 to the last Saturday in September, with free beginners' lessons occurring around 7:30 p.m.

In only a few years, Manhattan tango parlors have become glamorous events that are readily available to an international clientele with the economic capital, spare time, and loneliness to share. Most indoor milongas consist of a main dance floor surrounded by chairs and tables, with an informal food or snack station offering chips and soft drinks, a full bar, and even a restaurant. Throughout the evening, dancing is arranged according to *tandas* (sets of three to five songs played in a row), followed by quick musical breaks, or *cortinas*, during which other types of music are played.

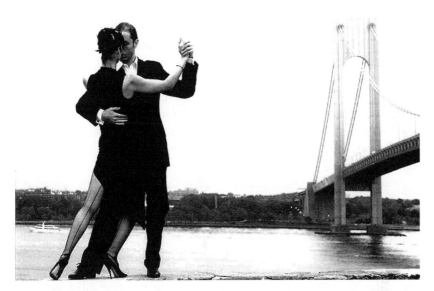

Figure 8. Outdoor tango dancing by the Verrazano-Narrows Bridge, which connects the boroughs of Brooklyn and Staten Island in New York City. (Photographer: Igor Maloraski; dancers: Mayte Vicens and Tioma Maloraski)

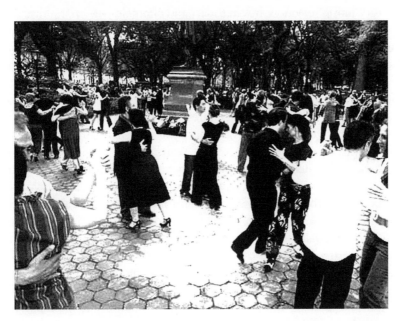

Figure 9. Free outdoor tango dancing that takes place every Saturday during the summer months by the Shakespeare statue in Central Park in New York City. (Photographer: Anahí Viladrich)

Tango halls are primarily settings meant for dancing, yet their welcoming social flair invites regulars and visitors to meet and greet each other while having a bite to eat or a glass of wine. Some of these dance halls epitomize unique social resorts, held in restaurants and clubs, where dancing goes along with dining and drinking.[3] Tango parlors also provide plenty of leisure time for small talk and personal interactions, with lasting friendships (and loving relationships) regularly occurring. Watching and being watched on the tango floor is intrinsic to the role that milongas play in the enacted hierarchy of dancers, who all must prove their skills on the *pista* (floor).

As will be further developed here, tango places are not only glamorous events readily available to an international clientele but also supportive social sites for struggling Argentine artists and different generations of regulars who get together to dance as well as socialize while exchanging intangible social resources in the form of social capital. Subtle codes of belonging are embedded in the dancers' techniques that are measured according to a complex hierarchical system that distinguishes between *buenos* and *malos* (good and bad) dancers, which also include both professionals and amateurs.

Although each milonga tends to create its own signature brand—in terms of music selection, hosting style, and clientele—it is not unusual to have tango aficionados routinely attending several milongas, workshops, and *prácticas*. The latter are best defined as informal tango gatherings for the purpose of rehearsing tango steps, often under the supervision of an instructor. Milongas are typically held on a regular weekly basis and begin with either a class, which may be included in the fee, or a demonstration by experienced regulars or invited guests. Only a few milongas in the city are run by Argentines; however, the participation of Argentine artists, hosts, and DJs provides tango venues with a touch of legitimacy. Most milongas are located in commercial districts and in studios and restaurants that are centrally located, so dancers can get in and out easily by using public transportation even late at night. Even after the tragic terrorist strikes on September 11, 2001, and the economic downturn that hit bottom in 2008, greater numbers of Manhattanites have gone tango dancing in recent years. According to Tiara, a tango instructor, tango dancing actually became a source of healing after the events of September 11, 2001.

At the beginning, it was a *pálida* [deserted and depressed environment], but two weeks later, everybody went back to the milongas; it was like a way to resolve what had happened. Everybody needed to be hugged and to cut off all the negativity and the horror you would see on television,

you know, with the Twin Towers falling on the ground. And, yes, there are more milongas today; part of it is because there are more people dancing tango. Although the [economic] situation here is not easy, many [tango entrepreneurs] tend to believe that a milonga will help them economically.

Tiara's quote coincides with the opinions of most tango practitioners who argued that after September 11, 2001, New Yorkers' need to reconnect with each other led them to seek novel social and artistic expressions. More than ten years after those dramatic events, the number of Manhattan milongas has reached unprecedented numbers. The sense of comfort provided by the tango embrace (along with the temporary feeling of safety it provides) is purportedly seen as the main force behind the boost that the tango has continued to experience even during economic downturns.

As this book goes to press, every single day of the week in Manhattan there are between four and nine tango events to choose from, including milongas, prácticas, and workshops, with Fridays and weekends hosting the largest number of tango functions. A much smaller, but growing, tango market has begun to emerge in Brooklyn and Queens (Astoria), mostly due to the expanding interest in tango in these boroughs that has given residents an opportunity to enjoy its practice locally, rather than commuting to Manhattan. As will be further explored in chapter 6, these venues differ from the social events held by the Argentine tango old guard (mostly in Queens) that attract an all-Spanish-speaking Argentine and Latino clientele.

Regardless of the tango's popularity, the growing number of milongas and workshops has made for a stiffer rivalry among those hoping to make a living from it. While earning an income from tango teaching and dancing may be fun, it is always a challenging endeavor. Some tango practitioners compare the current situation to the tango's "dark ages," its difficult period mostly stretching from the 1950s to the 1980s, when it was hard to fill a milonga with customers due to a general lack of interest in the tango. Although today's circumstances are exactly the opposite, they have similar consequences. The tango's current popularity has led to a burgeoning of tango parlors, making it harder for tango entrepreneurs to attract a sizable number of seasoned practitioners to the field.

The Research Project

A few years after my first incursions into the Manhattan tango world, my interest in this subject awoke once again when, as a doctoral candidate at

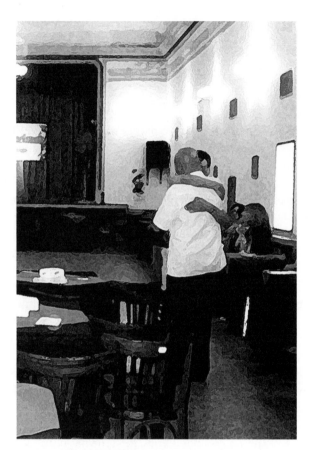

Figure 10. Tango embrace I. (Photographer: Celeste Castiglione)

Columbia University, I decided to conduct research on Argentine immigrants and their access barriers to health care in the United States. The first stage of my research took place between 1999 and 2003 and featured the larger Argentine minority in New York City with a focus on their informal access to health networks. At that time, I was particularly interested in exploring Argentines' class and legal trajectories vis-à-vis their reliance on diverse health systems with the assistance of their informal social webs (Viladrich 2007a). By reentering the tango world, I meant to study the visible façade of the Argentine community, which, until then, had remained a hidden immigrant group in New York City.

Little by little, my interest in the tango achieved a life of its own, as I began reckoning the analytical blend between the globalized artistic man-

ufacture of its Argentine form on the one hand and the reproduction of social capital on the other. Through time, my interest in this genre evolved from being just a case study in a larger project to becoming a fieldwork endeavor in its own right. Consequently, the tango niche eventually turned into a "natural laboratory" that allowed me to explore some of the most important aspects regarding immigrants' social webs. I then conceptually defined the Manhattan tango world as a specific social field where Argentines congregate to dance and share valuable resources—from information about visas to free prescriptions of drugs in exchange for tango lessons.

Because there are no official data on Argentine tango artists, either in Argentina or in the United States, word of mouth was key to my meeting up with most of the practitioners who participated in this study. I soon became a habitué of two milongas in Manhattan, run by Argentine entrepreneurs who welcome not only Argentine regulars but also a plethora of international regulars and artists. At these milongas, I met tango connoisseurs and practitioners of varied sorts, some of whom turned into my key informants and introduced me to other Argentine settings. In the years that followed my graduation, which led to my current path as a college professor, I continued visiting tango parlors and getting acquainted with tango artists and compatriots on a fairly regular basis.

My regular trips to Buenos Aires in recent years provided me with a special opportunity to witness the ever-growing international tango community. The sponsorship of the Institute Gino Germani in Buenos Aires, where I was a visiting scholar during the 2010–11 academic year, offered the ideal environment for completing this research project. This last stage allowed me to formally bring up to date the data I had previously collected, as well as record the changes that have been taking place in the Argentine tango transnational community in the past decade.

Following classical ethnographic procedures, the methods I relied on mostly included participant observation and semistructured interviews. Informal conversations were held with more than one hundred Argentine tango artists, tango entrepreneurs, and tango amateurs in New York City and Buenos Aires. Participant observation is typically defined as researchers' ongoing presence in the field, where observations take place "on the informant's turf" (Agar 1980: 195). Therefore, it entails a progressive involvement with the population under study, usually ranging from less obtrusive to more active participation (Spradley 1980; White 1984). While in-depth interviews provided the most systematic data in my study, participant observation turned out to be at the core of my research that allowed

me to grasp the relevance of the tango field as a community of shared interests that attracts worldwide tango artists and patrons. Using participant observation as the basis for convergent methodologies, I was able to collect data in different settings, and from different sources, and then crosscheck the findings to validate the results, a process that is typically termed "triangulation." In qualitative research, it is neither the number of encounters nor their length that matters, but rather the consistency of the information gathered (across different venues and respondents) that makes the data reliable and valid.

The first step in the research process consisted in laying out ethnographic maps on the basis of identifying the spatial locations, social activities, and relationships involving Argentine tango artists amid the large Argentine minority. Tango mapping included an inventory of the city's milongas, as part of my ethnographic pathway to finding the venues where Argentines (artists and regulars) regularly met, as well as the ethnic stores and religious activities involving the Argentine community. In order to cover the far-flung realm of Argentines in the city, my work also involved paying periodic visits to ethnic organizations and shops located in "Little Argentina" in Queens, including the Argentine school, social club, barbershop, and bakery where many Argentines (newcomers and senior immigrants) congregate on a regular basis.

I also participated in activities organized by community organizations, including talks, picnics, fund-raising festivals, trips to Atlantic City (New Jersey), and national festivities and religious ceremonies. In so doing, I was able to gather information from various sources by contrasting immigrants' several discursive levels (e.g., contradictory statements regarding the social assistance received and provided) with the actual situations in which social exchanges took place. In this way, I better comprehended both the nuances and the contradictions in my respondents' perceptions of the help supplied by their peers along with their statements to the contrary.

Ethnographic mapping also led to minimizing my presence in the field by facilitating a progressive rapport with my respondents who, in most cases, felt comfortable enough to share information on sensitive topics (e.g., legal status) that would otherwise have been difficult to obtain. Besides, not all tango artists belong to the same social fields. I encountered Argentine artists who, although they danced and taught tango, were not involved with mainstream tango networks. Likewise, I became acquainted with a couple of my study participants at subway stations, where they performed regularly, as well as in ethnic restaurants and at outdoor tango events.

My project also required my taking field notes and jotting down quotes and accounts of conversations with Argentine immigrants, whose remarks greatly illuminated some of the main aspects of this tango study. These notes also included accounts of conversations held with immigrants in the field ("field cases") who did not participate in the purposive sample but whose comments shed light on some of the main aspects and processes described in this book. Jotting notes also allowed me to compare observations in the field with data collected through individual interviews (Berg 1995; Bernard 1994). For example, the information gathered at the milongas and ethnic events (e.g., fund-raising festivals and community celebrations) helped me corroborate, and even complete, data I had previously gathered during individual interviews and vice versa. By comparing my respondents' remarks with the ethnographic evidence, in the end, I was able to assess the extent to which Argentines relied on their social networks despite their frequent statements to the contrary. As will be further shown in chapter 7, immigrants' verbal statements about the influence of ethnic solidarity in their lives were often biased by either their most recent experiences, or by an excessive emphasis on their social networks' negative traits.

Tango Interviews

The next step in the research process was to identify participants for in-depth interviews, a task that was mostly accomplished via snowball sampling, also known as chain referral or peer-driven sampling. This is a method commonly utilized in network studies within hard-to-reach populations when there is no sampling frame available, as in the case of unauthorized immigrants (Chávez 1992; Cornelius 1982). Because I wanted a wide spectrum of artists' profiles—including those devoted to tango on a part-time basis—I relied on an extended network of tango regulars, including Americans and non-Argentines, who introduced me to Argentine tango artists, some of whom eventually became my interviewees.

My work with community organizations in Queens (many of which support charitable causes) allowed me to meet Argentine newcomers and community leaders who shared a broader perspective regarding the unwritten story of the tango revival in the city. It was through all these diverse social worlds that I was able to get familiar with different tango fields. For instance, I identified a network of unauthorized immigrants who regularly gathered in Little Argentina (in Elmhurst, Queens), a few of whom played and sang tangos while working menial day jobs such as landscaping and

housekeeping. Although members of this group hardly interacted with the fancier Manhattan tango world, they were often present at the diasporic activities organized by the long-established Argentine community of Queens.

I conducted seventy-six interviews with Argentines who were differently involved with tango in New York City. Thirty-eight of these interviews were held with either full-time or part-time tango dancers and instructors, with women outnumbering men (twenty-four female dancers versus fourteen male dancers). This trend reflects a general pattern in tango dancing that accounts for larger numbers of females as both customers and professional dancers. The situation is, however, the opposite among musicians and vocal performers, who in some cases interpret other genres in order to make ends meet. Seventeen musicians and singers were included in the interviewee sample, of whom fourteen were male and only three female. Seven elderly male immigrants, sixty-five years old and up, were represented in this group.

The sample also included nine tango producers (seven males and two females), who in some cases also performed as tango instructors (e.g., for beginners' classes), DJs at milongas, and managers of tango artists. Finally, and in order to provide a fully rounded picture of an alternative tango world, I interviewed a dozen members of the old tango guard who arrived in the United States decades ago. For the most part, these were senior citizens (and not tango professionals) who continued dancing tango as a social pastime.

Tango dancing tends to favor younger and more agile bodies, whereas playing a musical instrument pairs well with maturity and lifelong experience. The age distribution of the sample confirmed this general trend. While the majority of dancers surveyed were younger than forty (thirty out of thirty-eight participants, or 79 percent of the dancers' sample), only four of the musicians were within this age range. Generally, the older population (sixty-five years old and above) held low levels of formal education, which nonetheless did not correlate with their proven tango expertise and high recognition in the tango field. Meanwhile, all of the younger participants had finished high school, and some had attended college and even completed university degrees in Argentina. Furthermore, many belonged to struggling middle-class sectors. As will be further noted in chapter 3, choosing a tango career represents an alternative path to prospective downward class trajectories, signaled by the devaluation of traditional degrees in Argentina.

The interview schedule, which consisted of semi-open- and open-ended questions, was conducted in Spanish and lasted from one hour to more than two hours over one or two sessions. Approximately 75 percent of the interviewees participated in more than one session. However, as in typical ethnographic studies, the research process did not end once the formal interview was over, and it often continued informally upon meeting at the milongas and other Argentine events. In fact, relevant information regarding tango artists' legal and social trajectories in the United States often came up after the formal interview was over.

The interviews were organized around participants' migratory biographies, including their decisions to migrate and reasons to remain in the United States, the steps involved in their migratory paths, as well as their health status and main illness episodes and their strategies to overcome them. Collected data also included immigrants' backgrounds and questions about their social contacts (e.g., friends, colleagues, acquaintances). All interviewees were asked to assess their reliance on social networks for the resolution of their most pressing needs, including finding jobs and housing and solving their health problems.

This study mostly addressed the experiences of the first generation of tango immigrants, who arrived on their own or with their dancing partners, motivated by the sudden success of tango in New York City since the late 1990s. Although a handful of the artists who participated in the interviews were partners in dance as in life, I purposely interviewed them separately. Therefore, the analysis was based on "egocentric networks," also called first-order star networks (Hannerz 1980), which are anchored in individuals and not in their lateral contacts. By considering the direct links from the ego outward, this project estimated the networks' influence on each unit of analysis, contrary to other designs based on lateral relationships (such as first-order zone and second-order star networks).

Over time, I learned that some of the artistic couples I met during my early fieldwork had dissolved their unions, while others got romantically involved but parted ways later on. Because of the great deal of time that artists tend to spend together, it is not uncommon for them to pick both their professional and romantic partners from their tango webs. This research project presents the limitation of not including additional (and even multiple) social ties that artists might have been connected to. For instance, I did not follow the pathways of alternative social webs (e.g., restaurant settings or construction businesses) that some tango immigrants were involved with, or the social networks involving relatives and close friends

back home. In any case, throughout the text I provide several examples of the intersection of tango networks, based on the fact that immigrants' exchanges took place in venues where different groups of people convened.

All the quotes that appear in this book are from participants who actively agreed to be part of the study, and they therefore explicitly allowed the interviews to be taped or manually recorded. Additional notes from field cases, including those who casually participated in social interactions, were included in the larger analysis. I am a native Spanish speaker from Argentina, and am familiar with the Argentine nuances of Spanish terms; therefore, I did all the translations from Spanish to English myself. Throughout the text, I also acknowledge the fact that some Argentine expressions do not have a direct translation; hence, I made notes of terms that are not easily understood in Spanish by providing their respective English explanations.

The Backstage of Ethnographic Research

Concerns about ethical issues involving subjects' participation in research have a long history in the social sciences, with remarkable case studies teaching us about both the common and subtle risks that study participants and scholars may be exposed to during the research process (Bourgois 2003; Gálvez 2011; Loue 2011). The precautions taken to protect the identity, privacy, and safety of study participants seem never to be enough, so research protocols aimed at protecting human subjects are now customary in the United States. This project was no exception. My concerns about guarding participants' identities, amid the confidentiality of their volunteered information, were deepened by the fact that some immigrants held unauthorized legal statuses and were involved in off-the-book activities to make ends meet.

From the very beginning of the research process, I followed the regular informed consent routine required by most sponsored social research: I handled information sheets, utilized pseudonyms by choosing uncommon names in the tango world (hoping to avoid erroneously identifying someone by chance), kept information confidential, gave participants the right to refuse to answer any general or specific questions, and respected their decisions to terminate interviews at any time.[4] Interview sessions were arranged in places convenient for study participants, including public spaces (such as parks and coffee shops) and dance studios, where interviews were conducted away from proximity to others.

Given that the research design contemplated the possibility of inter-

viewing undocumented immigrants, my home institution granted me a waiver from the requirement to obtain written consent from study participants. Instead, interviewees gave their oral consent upon being informed of the nature of the research process and prior to the beginning of the interview. I also protected the privacy of my respondents by not asking questions that might have been considered invasive, which did not preclude them from volunteering any kind of information (e.g., HIV or documented status).

Throughout the entire process, my interviewees were aware of my participant observation activities, which occurred at different venues. On all occasions, I introduced myself as doing research on Argentines' tango networks and asked permission to participate in their conversations. Most details concerning artists' social trajectories were gathered after having developed reliable relationships with the study participants, typically after the first interview. Some performers, who had initially stated being financially stable or holding US resident status, later acknowledged being undocumented or having experienced financial hardships in New York City.

The world of tango, regardless of its broad and global nature, is a small one—a sort of tightly knit village where everyone knows each other or eventually will, sooner or later. Therefore, it was critical to protect participants' identity not only from outsiders but also from those sharing their tango webs. As mentioned earlier, the fact that some participants were undocumented or had engaged in dubious job arrangements brought additional ethical concerns. In order to safeguard their identities, I purposely modified some details of their personal stories, which could have made them identifiable to others, including their towns of origin or previous migratory paths. In addition, I did not reveal anyone's association with any specific tango venue, and I omitted the names of the shows in which interviewees performed. Many of my core findings were accessed when "not doing interviews," meaning while interacting at tango parlors, meeting for coffee either before or after a tango practice, or doing errands. For example, the discussions of racial/class categories and the importance of health brokers emerged almost naturally when exploring participants' self-images, along with the informal ways in which they resolved their most immediate health problems.

Contrary to my initial expectations, some artists hoped that I would acknowledge their real names, perhaps expecting that my study would help them publicize their practice or at least become known outside their tango circle. A couple of dancers who were among my study participants were originally interested in being interviewed with the expectation that

their names would appear in print. On more than one occasion, I found it hard for my tango respondents to understand that the whole point of the project was to protect their identities and the confidentiality of the data they provided.

I turn now to some of the key experiential aspects that characterized my involvement with my own ethnic community, as a participant observer and not as a tango dancer. By reflecting on my dual role as a social scientist and Argentine immigrant, I hope to make known the frequently unstated aspects of fieldwork that may have an uncanny impact on ethnographers' ability to comprehensively analyze and interpret their study findings.

Becoming a Professional Voyeur

Tango as a second language,
English and tango married into one,
crisping, devouring, smelling
the intangible fragrance of your shyness
on the floor.

Tanglish teaches you to live abroad
and unwraps your bilingual inked soul;
it corners you in an alleyway
and holds your yearning for new sounds.

Once again, you surrender to it and soon become
painfully perceptible,
hermeneutically fragile,
trivially resilient,
beautifully volatile.

Tanglish shapes your broken figures
peeling off your ephemeral skin.
It implodes from its lure to hold you here,
even if you are not yet found at its crossroads.
Will this be my hindmost temptation to its call?
(Viladrich 2012c)

Anthropologists are usually fond of engaging in epistemological discussions (among themselves as well as with others) about the dilemmas they frequently encounter when doing fieldwork, particularly when this means

working in places far removed from their own ethnic communities. But what happens when "the field" is found just around the corner, in your own backyard, and involves dealing with your peers? Much has been written about self-reflexive ethnography and experiential fieldwork, both vehicles that help participant observers examine their own (often biased) positions, including dealing with the emic-ethnic tensions drawn from the temptations of "becoming native" (Behar 1996).

Soon after beginning my ethnotango incursions, fieldwork taking place at the milongas, I found my own way of dealing with this dilemma and decided to do what some of my colleagues in the tango world would probably consider a mockery: I decided not to dance tango. So here I was, a nondancing Argentine ethnographer conducting research on Argentine tango. Far from being the result of a well-thought-out research strategy, this turned out to be a serendipitous choice drawn from the social dynamics I had observed in the tango field, where gender and interpersonal hierarchies often lead to unstable (and often conflicting) relationships.

All in all, the main raison d'être to attend milongas is to dance tango. Therefore, my nondancing stance in an entertainment field where dancing is the main leitmotif has often been criticized by my Argentine colleagues and, of course, by my tango friends. I must say that these reactions are found not only in the tango world. At conferences and seminars of all types, after presenting my work on Argentines and tango, almost always I have been invited to either demonstrate my tango skills or teach a tango workshop. With my decision not to dance, I also hoped to elude the psychosocial and emotional effect that the tango embrace tends to imprint on its dancing carriers—what some call the "addiction" to the tango hold.

Serious tango aficionados, known for happily succumbing to the tango trance, are often called "tango junkies" (or *les possédés* in France). They devote every free moment to tango activities, attend as many classes and practices as possible, and modify their daily routines (or even quit their jobs!), all to comply with the demanding schedule of the tango practice. Certainly, it is not enough to know the steps in order to be able to dance tango; performers must conform to the ritual of watching and being watched by others. This process implies joining the crowd of respectful tango regulars by devoting countless hours of practice during and after the tango milonga is over.

Many tango practitioners will dedicate any free time of the day, aside from working or doing basic household chores, to rehearsing tango steps either with a partner or alone in front of a mirror. They will spend hours on the Internet searching for new and glamorous tango events, while chat-

ting with others about local or worldwide tango festivals that take place almost concurrently. I had witnessed some of my Argentine friends give in to the "tango fever" by stopping everything they used to do before the tango took over their lives. Worried about losing control over both my sensorial persona and the social routine that discriminates between masters and apprentices, I decided to voluntarily remove myself from the tango floor once and for all.

Marta E. Savigliano refers to her tango writing as "nocturnal ethnographies" (Savigliano 2000). Dancing and writing when most people go to sleep at night is when the life of milongueros starts. Savigliano, as well as other remarkable tango scholars, has genuinely merged with her object of study, not only intellectually but also sensitively, by forging meaningful liaisons between the emotional and the sociopolitical aspects of the genre. Rather than jumping into the nightlife, I instead opted to remain in the tango's twilight zone. By not dancing tango, I dared to emotionally protect myself from getting "too involved" with my research participants. I still remember vividly my initial visits to the tango ballroom, shyly attempting to talk to tango regulars and artists while feeling that my research agenda had no place in an environment where I was seen, at best, as a tolerated outsider.

Here, it is pertinent to note how gender roles are defined in traditional Argentine tango. Tango dancing requires two partners united by an embrace that varies from very open to very closed. Despite its different styles, what characterizes the Argentine tango is the interpretation and improvisation that entitles the leading dancers (usually males) to hold, and lead, their female followers (who mostly dance backward) on the tango ballroom. The tango known as *salón* style, considered the most traditional and elegant, is characterized by a flexible embrace that opens to allow room for various figures and long steps. The milonguero style, allegedly originated in crowded bordellos, is defined by the two partners in a close chest-to-chest embrace that leaves room for the feet's movements (Maslak and Votrubra 2011). In any of its styles, the Argentine tango is framed around the belief that the couple must be a "heart with four legs"—a metaphoric notion that reckons partners' expected synchronicity along with their subtle negotiations involving the steps, twists, and figures to be performed on the dance floor.

In traditional milongas, men typically invite women to dance by using the famous *cabeceo* (nod). Historically, this was coined as an ingenious method to protect males' pride from the public gaze in case women rejected them, as the latter can ignore the invite without making it publicly

known. If the female dancer accepts the invitation, she will nod back and stand to join her partner on the floor. Scanning the room for potential partners, waiting, watching, and engaging in small talk encompass subtle elements of a complex tango orchestration to which the amateur may be oblivious. Changing partners is common at all milongas, unless tango regulars are already buddies, so gazing across a room while seeking potential partners is part of the tango protocol.

Truth be told, the "tango rules" are much more flexible in New York City than in Buenos Aires, where they also have been changing in recent years. New forms of socialization are evident in the novel ways in which the heterosexual etiquette is increasingly being challenged in cosmopolitan tango hubs. In Manhattan, in particular, teachers are expected to dance with their students so they openly take them to the floor, and regulars will easily engage in conversation with each other followed by open invitations to dance. Moreover, traditional gendered norms are particularly defied in gay and queer venues where women can select their dancing partners and join the floor whenever they please (Savigliano 2010).

Despite the tango's evolving etiquette, several female tango artists I met throughout the years bitterly complained to me about the "rite of passage" involved in the act of *planchar* (waiting to be asked to dance) at the milongas, partly because women tend to outnumber men. Given the seriousness involved with the tango practice, men are typically careful not to invite an unknown or inexperienced female to dance for fear of *pasar un papelón* (being ridiculed) in front of others. As I have noted elsewhere (Viladrich 2007b), being a woman without a tango partner at a traditional Argentine milonga, and with no intention of dancing even in the wee hours of the night, was not an easy stance for me to hold. Unsurprisingly, during fieldwork, I was occasionally mistaken for someone who was "wallflowering," (see Savigliano 2003, 2010). The wallflowering effect is sooner or later experienced by all female dancers, even by seasoned *milongueras* who are highly acknowledged in the tango field.

In retrospect, I wonder about the insights I may have missed in not having become a "real member" of the dancing crowd. Had I danced instead of remaining on the side, I would have probably gotten firsthand information on the inner dynamics pervading tango cliques (mostly unknown to outsiders), including tip-offs about social alliances and tensions I may have remained oblivious about. Nevertheless, if my conscious removal from the tango floor prevented me from having a deep involvement with the feelings and emotions to be experienced only through the tango embrace, over time it also provided me with some rewards. These included the op-

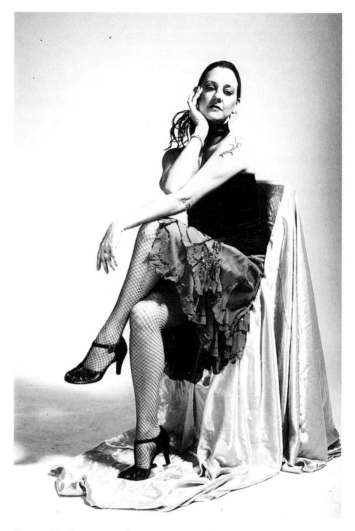

Figure 11. Dancer performing as a "wallflower"; an iconic representation of a female tango aficionado who is waiting to be asked to dance. (Photographer: Maike Paul; dancer: Virginia Kelly)

portunity to talk with all sorts of tango regulars, who would join me in between tango tunes to rest, drink, and eat.

My nondancing role also protected me from the subtle competition among female dancers as well as from participation in the tango's unspoken hierarchical structure, where performers measure their talents against others. Not only did my secluded position as an observer allow me to gain

a privileged sight line where I could discretely scrutinize my interviewees' "tangoified" social relationships, but it also bestowed upon me a protective shield against the tensions often drawn from gender dynamics, which include the competition for male dancing partners (Viladrich 2007b).

Little by little, suspicions were lifted, as my visits to the milongas became an opportunity to engage in open conversations with both men and women. To a certain extent, my identity as an Argentine immigrant (e.g., references to my past in Buenos Aires) and my familiarity with idiosyncratic cultural norms helped open the doors to my interviewees' lives. What other reason would be needed to justify my presence at the milongas than reinforcing my loyalty to the same national group to which I belong? Our shared homesickness for Buenos Aires often let us play a performance "as if" we were still there, as a theatrical mise-en-scène of vernacular social spaces. At last, the symbolic value of my exchanges with my tango comrades surpassed the formalities of a consent form, and it commanded my acquiescence to the rights and obligations attached to my membership status as a nondancing *tanguera* (female tango enthusiast).

In my previous work, I paid extensive attention to the gender dimensions that conflict in the dancing hall (Viladrich 2005). I also documented the gendered dynamics rhetorically recreated by tango lyrics. This line of research allowed me to examine the subverted ways through which female tango artists contest the tango's patriarchal karma by embodying alternative roles, as with women passing as men in the early twentieth century (Viladrich 2006). Concomitantly, a rising scholarship has questioned the unequal gendered dynamics taking place on the dance floor, which generally assumes the woman's passive role in the tango couple. One of the main arguments in this literature is that female dancers actively resist the heterosexual and patriarchal normative of the tango via the strategizing of their own agency. Scholars point out the gender politics of reverse seduction: women are, after all, deciding whether or not they want to accept men's invitations (Olszewski 2008; Savigliano 2010; Toyoda 2012). Rather than being passive objects of the male gaze, female dancers are assertively creative and autonomous in selecting their partners—they actually deploy subtle ways of seduction and manipulation while making themselves respected and attractive in the tango field (Olszewski 2008).

Despite the importance of gender as a key lens for examining the tango world, as either a male-dominant expression or a counter-female power strategy, I chose an alternative analytical path by paying close attention to the social relationships taking place outside the tango floor. Without ignoring the fact that gender inequalities do exist in the entertainment

industry—and particularly in the tango field—I decided to look at the commonalities of both male and female artists in their struggles to make a living, regardless of their stance in the tango ballroom.

Challenging Reciprocity Terms

Much of this project focused on unraveling the role of social capital in Argentines' lives, so I did not immediately realize that my own research study would face similar obstacles to the ones my research questions were trying to address. Overall, these involved the exchange of resources on the basis of reciprocity and nonmonetary transactions. As it is the case with many ethnographic studies, no financial compensation was provided to study participants. Given the fact that I was initially a graduate student with meager resources available for the project, I felt quite comfortable complying with the consuetudinary etiquette of fieldwork, which does not usually involve paying study participants. Soon after beginning to collect data, I was relieved to learn that most of my interviewees did not expect to be paid for their participation. Nonetheless, this did not mean that they would agree to be interviewed for free. Part of our subtle, albeit unspoken, contract was that they would be somehow compensated for their time.

Because of our nonfinancial relationships, amid the blurred definition of the ethnographer's role, I often found it hard to set clear limits to my work. Was I considered a researcher, a friendly compatriot, a counselor, a friend, or all of these roles? I often experienced the demand for reciprocal exchanges on a firsthand basis, as many of my tango friends would confide to me the struggles they ordinarily experienced while frequently expecting specific assistance in return. My "tango notes," below, written in 2002, reflected these tensions:

> Again, here I was dealing with them [tango respondents] feeling that our frontiers are blurred and I am not so clear about my role. I feel remorse for trying to obtain information on the topics I am interested in, but seeing what happens in the field has helped me feel better about the whole thing. Between the two of us [my tango friends and I], I let them talk. It is clear that my ability to listen, and even interpret, what is going on in their lives is a fair payment, but is it? Sometimes I feel it is not enough, but oftentimes they just blurt out their stories as if I am not even there. They just need to have somebody eager to listen to them,

regardless of who the "listener" is. They seem more than happy with me lending an ear and letting them talk.

The sentiments of deep gratitude I felt for my respondents' eagerness to share their lives with me were often followed by contradictory and unexpected waves of emotional saturation that I occasionally experienced when being in the field. Far from being an exception, participants' unanticipated demands came with the territory of their offering information for free while getting into the terrain where the ethnographer's roles become blurred. My feelings of guilt, which often arose when I could not find a practical solution to a participant's request, were frequently accompanied by a sudden disappointment when I occasionally sensed that some of my tango pals would not appreciate my help, as when they asked for favors that I could not easily comply with.

Lastly, the tango field symbolized an ideal niche where I was able to explore the ways through which social capital was shared; however, it also confronted me to social dynamics that I had not experienced in any other place. Social reciprocity, though not limited to those sharing the same nationality, is often translated into subtle rights and obligations in which the terms are not always clearly defined. My case was no exception. If it was true that there would be no monetary exchange between my respondents and me, the flexibility of our interactions meant that the unspoken agreements we held would often be blurred and imprecise.

As part of a discreet code of mutual trade, a few among my interviewees did generously share their stories in exchange for my services as translator, shopping guide, and unconditional listener to their everyday tribulations. Luckily, many study participants also appreciated other forms of compensation such as having coffee at the Argentine bakery in Little Argentina, receiving the pastries I brought to our meetings, and spending time together walking and running errands. In agreement with these unwritten codes, I followed some of my tango friends through their social and artistic treks in the city, often waiting for them at dancing academies and on milonga doorsteps during cold winter evenings. I accompanied them to different institutions and job venues, opportunities that gave me an acute sense of the resources they had and did not have, along with my witnessing of the often erratic emotional displays of their inner struggles to make ends meet. I visited nightclubs and restaurants where my tango comrades worked (as hostesses, waiters, and occasionally as dancers or singers) and listened to their life stories over *mate* (an herbal drink) and Argentine pastries at the coffee shops of Little Argentina in Queens.

Over time, my tango respondents and I shared more than questions and answers, as we became related through intangible ties supported by reciprocal trust. Our regular conversations ranged from accounts of their disenchantment with compatriots who had unreliably promised some help, to requests to solve a myriad of problems including the completion of health insurance applications or the gathering of information for their new visa applications. After all, if I wanted to obtain entry into my fellow citizens' circle of trust, I needed to come to grips with my sharing of their Argentine belonging, which meant accepting the rights and obligations that came with that membership.

CHAPTER THREE

Argentine Tango Artists

The Craft of Marketing Authenticity

The milongueras have never been as happy as they are today. After a century of dancing tango, they have never been looked at and admired as much as they are today. They have never had so much work; never did they have a passport to travel around the world as artists and masters. In a country such as Argentina with a high unemployment rate, where people over forty get excluded from any job opportunity, female tango dancers can read with satisfaction an announcement such as this one: "Casting: only tango dancers between 20 and 50 years old."

ESTELA DOS SANTOS, *DE DAMAS Y MILONGUERAS DEL TANGO*

"Tango immigrants" is the term I have chosen for a diverse group of talented and struggling tango performers (dancers, musicians, and singers) as well as tango entrepreneurs from Argentina who, for more than a decade now, have been seeking to fulfill a dream of success in the United States. Many of these artists, descendants of those creoles and Europeans who held tango as their birthright in Argentina more than a century ago, have been the ones in charge of bringing it abroad. Contrary to the earlier representation of the tango as a Spanish American dance in the United States, its rising global reputation as an Argentine artistic form since the late twentieth century has brought the genre to the summit of the cosmopolitan entertainment market. The complicated footwork amid controlled passionate embraces that the Argentine tango offers to foreign audiences has fed the worldwide demand for Argentine artists. The tango's popularity as "authentically" Argentine has been enhanced by a sublimated eroticism that is not comprised by other dances, even by more sexually explicit ones such as cumbia or salsa. Far from the sophisticated choreographies that

73

have continued to make tango popular in exhibitions and on television shows in the United States (e.g., *Dancing with the Stars*), the latest tango-mania has made of this genre an attainable pastime that is accessible to regular folks.

This chapter deals with the paths of the younger cohort of tango new-comers, who are twenty to forty-five years old, along with the discursive ways in which they claim a place in the artistic field. To this end, I rely on the concept of "ethnic capital," which combines the theory of social capi-tal with the properties of ethnic niches, to explain Argentines' dependence

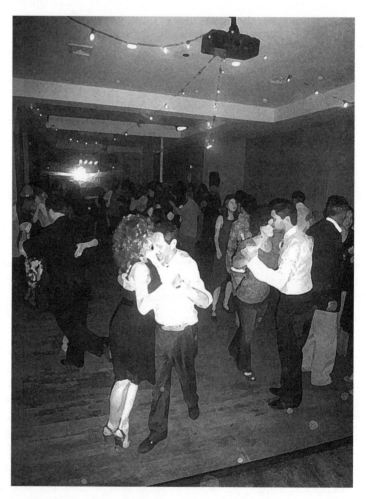

Figure 12. Argentine dancing parlor (milonga) in New York City. (Photographer: Anahí Viladrich)

on their peers to support their artistic trade. As Zhou and Lin (2005) note, newcomers who arrive in new destinations with limited human capital resources, such as English-language and marketable skills, count more on the social capital that comes from preestablished social networks.

In this chapter, the migratory trajectories of some of the most conspicuous tango newcomers are examined in detail. These include "tango converters," who have lately chosen the tango as a way of making a living; professional artists who regularly live in New York City; and tango visitors, who perform in the city when on tour (or when invited by their tango pals) and who may eventually settle there. Combined patterns of open ethnic solidarity and subtle interpersonal competition are at stake in these practitioners' eagerness to keep their common interests afloat. As a national group, Argentine artists strive to attain dominance in the tango field by relying on employment webs that allow the reproduction of their ethnic capital. This is achieved by a twofold strategy that leads artists to seek business opportunities with their compatriots on the one hand, and to their self-promotion as the genuine interpreters of the "tango passion" on the other. These combined features epitomize the practitioners' united front in fostering their leadership in the tango field over non-Argentine competitors.

By the time Argentine tango had regained success in the early 1990s, there were few professional tango dancers in the United States. As noted by Knauth (2005) in her study on Argentine tango in Pittsburgh, New York City soon became the main hub for Americans eager to learn tango from the "masters," whose steps would soon be studied and rehearsed in other US cities. Both dancers and tango aficionados from the country's inner core began looking for well-trained tango instructors, who lived in main cities on the East and West coasts. They were also seeking Argentine dancers or those trained in Argentine studios—even flying to Buenos Aires regularly in search of the tango's assumed authentic roots. Once again, the tango's foreign approval would become the main trigger of its domestic support. According to Windhausen (2001), the growing number of Americans interested in learning tango at the time encouraged the "importation" of both instructors and dancers from Argentina, a country that has claimed the tango as its own national signature.

While in the past tango dancing was mostly considered a pastime (or even a part-time occupation) for many struggling Argentine artists, it has progressively turned into a suitable career path for practitioners of all ages. As a result, increasing numbers of Argentines have become enthusiastic tango fans in recent years, hoping to rely on this genre either at home or

abroad. Individuals from dissimilar social origins and occupations strive to be acknowledged as tango performers, including those with no background or training in dance who have nevertheless reinvented themselves as tango artists. Likewise, many elderly musicians and singers who had been well-known tango interpreters decades ago also returned to the genre hoping to reap the benefits brought by its sudden popularity.

As noted earlier, the major outmigration flows from Argentina in the twentieth century were known as the "brain-drain" phenomenon, as it involved the departure of the Argentina intelligentsia. This process began in the 1950s, when middle-class professionals left their country either for political reasons or for a better standard of living abroad. Argentina's last dictatorship (1976–83) launched a second emigration stream, joined by both professionals and working-class Argentines escaping from state-sponsored political repression (Boccanera 1999; Marrow 2007; Zuccotti 1987). In contrast with those earlier emigration trends, none of the tango artists who participated in this study mentioned political reasons as a main motivation for leaving their homeland. Although several of my study participants expressed their dissatisfaction with recent Argentine governments, political persecution no longer seems to be Argentines' direct motivation for emigrating.

Explicit political violence, which in the 1970s became a main reason for thousands of middle-class Argentines to leave their country, was replaced, particularly during the 1990s, by a symbolic violence based on economic exclusion that drove large segments of the Argentine population into steady downward mobility. This violence, more silent but no less pervasive, has left enduring scars on the country's social fabric that are still palpable in high unemployment rates, unstable working conditions, increasing violence in civil society, and generalized pessimism regarding the legitimacy of the political apparatus.

Argentine artists today are largely motivated to emigrate by the consequences of social policies, which have hampered the dreams of large middle-class sectors as a result of steady unemployment, over qualification of the labor force, and the saturation of the labor market (Grimson and Kessler 2005). During Menem's neoliberal years in the 1990s, job insecurity became a state of affairs that led to the deregulation of labor (*flexibilidad laboral*) and the privatization of most national industries, which ended with the defeat of a long history of employers' civic and labor rights (Dávila 2012). Many artists who thrived in foreign territories at the time were escaping the ranks of the *nuevos pobres* (the new poor; see *La Nación* 2002). For the past ten years, an antiliberal national administration has attempted

to overcome the economic policies that ended with the crisis of 2001. Still, these measures have not been able to defeat the disparate distribution of wealth, income inequality (signed by rising levels of inflation), salary deflation, and unemployment in Argentina.

In this context, the artistic milieu generally and the tango world particularly have turned into desirable employment fields for Argentines, both at home and overseas. For amateur Argentine dancers, the possibility of making a living out of their tango practice (hopefully paid in dollars or euros) tends to be perceived as a chance to improve their fates—if not for good, at least temporarily. For professional artists living in Argentina, being invited to join a worldwide tour or teaching foreign patrons not only can translate into a juicy income, but may also allow them to make international connections that will eventually lead them to teaching and performing abroad.

New York City represents a desired shrine in the tango's global pilgrimage and a necessary stop in its jet-setting reproduction. Even after the terrorist attacks on September 11, 2001, the city has continued enchanting the Argentine imagination by offering a promising nest to those dreaming of a successful artistic career in a metropolis that is still considered a dominant cosmopolitan milieu. Foreigners visiting Buenos Aires have tango as a "must" in their dancing tours. For Argentines, the possibility of performing in New York City defines their acquisition of a status marker that grants them an international reputation in the tango field. As a result, flocks of Argentine dancers have been arriving in the city over the past fifteen years, either as guests of tango academies or as newcomers, hoping to make a living out of teaching and working in novel and recycled tango shows.

To a certain extent, New York represents today what Paris was for fin de siècle tango travelers. Yet there are several differences between that initial stream of tango migrants and this one. For one thing, a hundred years ago Argentina was at the peak of its expansion as a burgeoning nation in the Southern Cone. Free of internal wars and with plenty of natural resources, the nation promised an upward path to those who tried to make their fortune in the arts. Still, New York City somehow mimics that Parisian epoch by giving Argentines a right to self-proclamation as worldwide tango artists. A recent example of this trend was illustrated by the frenzy around the Broadway show, *Evita*, led by the Argentine performer Elena Roger and seconded by a "tangoized" Ricky Martin.

Now I turn to artists' shared tropes in promoting the authentic Argentine tango, which despite its endless variations is resignified as the performers' own signature brand. Artists do so by claiming possession of a

specialized knowledge along with an emotional ability to express the tango's inner feelings in convincing, dramatic, and skillful ways.

The Branding of the Argentine Tango

> You breathe tangos since you were born [in Argentina]. Whether you want it or not: the street cleaner, the grocery checker, you, and I were all raised listening to tango tunes. Here [in the United States] it is about Janis Joplin and dancing with the music they know and with what they feel they are most connected. But most [Americans] do not understand what the real tango is. And yes, it is an issue about your roots. (Pipo, male dancer and producer)

> It is easier to find a good tango dancer in Argentina than in Sri Lanka. You can talk about international rock but not about international tango. The Argentines still own the product branding. (Isidro, male artist and producer)

The remarks above, mostly voiced off the record, rest on an implicit understanding that the tango's inner spirit cannot be taught, only shared, for it needs to emanate from the dancer's inner soul. Although the practice of Argentine tango is conventionally assumed to be no longer the province of any single national group, behind closed doors Argentine artists still claim its ownership over practitioners from other countries. And this assertion is supported not only by a nationalistic pride but also by Argentines' collective effort to be acknowledged as the pioneers and leaders of the tango's worldwide reproduction.

Contrary to its reputation as a spontaneous dance characterized by bursts of expressive passion, the Argentine tango is performed as a serious enterprise that combines nostalgic expressions with splashes of zealous and refined sensuality. The tango's alleged difficulty requires many weekly hours of lessons and practice, for apprentices who must commit to a step-based rite of passage to overcome a "sacred ignorance" that, not without great dedication and effort, will bring them into mastery (Carozzi 2009). Therefore, most amateur dancers learn and practice tango as a serious matter, as they must endure a series of progressive and cumbersome stages before knowing how to correctly interpret its figures. Because the tango includes a lot of improvisation on the basis of rehearsing complicated steps, it is not enough to take periodic lessons. Practicing with

different partners is pivotal to improving one's technique. All of this train-
ing takes hours and hours not just of learning but, above all, of commit-
ting to tango practice. And it is because of this arduous routine that in-
structors are able to capitalize on their trade through tango lessons and
workshops.

Most performers earn much of their regular income from teaching pri-
vate and group classes, with the milongas, workshops, and prácticas be-

Figure 13. Tango couple I. (Photographer: Mayte Vi-
cens; participants: Mayte Vicens and MusaTango NY)

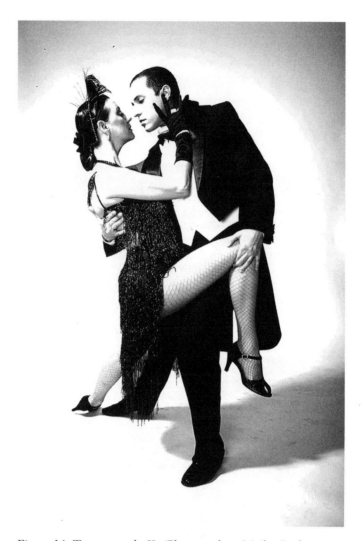

Figure 14. Tango couple II. (Photographer: Maike Paul; participants: Virginia Kelly and Walter Perez)

coming main hubs for their networking and marketing opportunities. Artists' regular tango routines involve a steady investment of time, energy, and even money, as they must attend tango parlors regularly for the sake of displaying their tango skills with peers, as well as dancing with current and potential students. In a way, there is a sort of catch-22 in the tango: instructors depend on the tango's practice to make a living, which means that

they have to be continuously present at tango venues in order to advertise and validate their expertise. In the words of Milton, a dance instructor, "You have to dance with all your students and always keep looking around to see if you can sell a class to a new one." This process takes hours of socializing with the same tango aficionados, in hopes that they will become students and followers at some point in time.

As noted earlier, Argentine practitioners are not a majority in the cosmopolitan tango world nor in the transnational tango economy. Consequently, they symbolically wrestle with artists from other nationalities to be acknowledged as the legitimate interpreters of the real language of the feet. As noted by Gavito, a late and well-known milonguero, "We are painters; we paint the music with our feet" (*Reportango* 2001: 7). Surely, as promoters of the tango's authentic passion, Argentines portray themselves as indisputable tango performers. Their overall self-representation as the natural interpreters of the tango steps helps them camouflage their internal conflicts while maintaining a public image of artistic agreement and cooperation. This works as a self-protective mechanism aimed at endorsing Argentines' stature as the best performers of the genre.

> Tango is like an embassy of the Argentine culture; it is the national image abroad, so people feel that they have to behave. And, yes, there is a sort of protective shield among us, a way of protecting our image [as Argentines] from dancers of other nationalities. If somebody shits on you but he isn't Argentine, it's more acceptable than if an Argentine does it. We prefer to be accomplices, because we don't want to hurt our reputations. (Chardoma, female dancer)

Having an Argentine passport and dancing tango has become a precious combination, a social guarantee to ensure that passionate tango will emanate from its original reservoirs.

> Being Argentine and teaching tango is a plus; we are expected to know about it, and it gives us an advantage over other tango teachers since tango is our national product. My passport seems to have a gold and velvet cover on it. . . . If you are Argentine and you know how to use it, this is worth a lot. The important thing is not to be a spectacular dancer but to *mamar el barrio* [suck the neighborhood]. (Cristal, female dancer)

Cristal's statement reflects a shared belief among Argentine tango performers. Regardless of their stylistic differences, most interviewees men-

tioned the importance of understanding the roots of the genre amid its passionate history, brewed in the inner skirts of the Buenos Aires harbor. In this vein, the popular idea of *mamar el barrio* implies that those who were born and raised in Buenos Aires are the ones best able to understand the tango's untainted spirit. In a sense, the recreation of the authentic tango is more than the representation of the real—it is the "really real" (Lindholm 2008) that is not only culturally but also emotionally connected to its essence.

Although practitioners from all nationalities have the potential to experience these feelings, Argentines market themselves as the tango's most genuine interpreters. To the extent that they claim to know and comprehend the genre's roots, they assess their familiarity with the styles being danced in Buenos Aires' old neighborhoods under the tutelage of the "old masters." Throughout this process of producing (and selling) the mystique of authenticity, tango is marketed as a cultural commodity that needs to be advertised, promoted, and experienced in the real *barrios* (neighborhoods) and in the company of genuine tango dancers.

As noted in the literature (Pietrobruno 2002; Urquía 2005), distinctions among legitimate and inauthentic appropriators of dance forms, such as salsa, reckon marketing devices aimed at disguising the power struggles existing in the artistic field. Furthermore, the assumed association between having tango expertise and being from Argentina is also shared with nationals from other Latin American countries, such as Uruguayan, Peruvian, and Brazilian performers who may be able to pass for Argentines. In fact, being acknowledged "as an Argentine" becomes a subtle brand that is also symbolically borrowed by other Latin American artists. In her study on the practice of tango in Pittsburgh, Knauth (2005) observes that being an Argentine, or passing for one, brings a halo of legitimacy to tango dancers and instructors who tend to be considered experts just because of their alleged nationality. In the end, as long as the tango practice invokes a stainless cradle, both Argentines and foreigners alike are assumed to embody a higher degree of wisdom and perfectionism. This has also led Argentine tango aficionados (and con artists) to pretend that they are dance masters based merely on their national origin.

The Tango United Front: Content Versus Form

Argentine artists speak of themselves as being committed to a pedagogical crusade in which they teach foreign students to appreciate the deep nu-

ances of the genre that go beyond its technicality, which purportedly prevails in the American ballroom dance culture. In the words of two of my interviewees:

> In the last ten years [in the United States], the teaching structure has been perfected: the trend has been to imitate the way of learning and teaching used in the swing and ballroom. . . . And the goal is that you will be dancing in just five classes. This doesn't exist for us [Argentines]. What is important for us are the gestures, the glance, and the mood you develop when dancing. And those who succeed are the ones who master both aspects. (Mateo, male dancer)

> The most difficult thing of working in the United States is first the language and then to make people aware of the tango's key aspects. It takes years to learn, but they want tricks, figures, jumps. I mean, they want form without content. And if you don't give them what they want, they leave you. They want the show because they didn't see their grandparents dance the tango so they don't understand what it is about. We [Argentines] know the difference and can transmit that to those open to receive it. . . . But it takes time to build the essential values. (Tiara, female dancer)

The comments above by Mateo and Tiara are echoed by almost every Argentine tango performer I spoke with; each of them believed that an overemphasis on the tango's technique among foreigners (what Argentines call the "form") has been a detriment to grasping its deeper contents. They agreed that most non-Argentine instructors, including some Argentines, want to sell quick tango lessons that disregard other key aspects of the dance, such as understanding the different tango styles of the Argentine orchestras. The most common trope uttered by my interviewees was that learning to dance tango goes beyond achieving technical mastery, as it requires the ability to grasp the inner spirit that is rooted in deep-seated Argentine sentiments. Learning about the beauty of improvisation and connecting with the tango's deep feelings of sorrow and sadness are necessary traits for mastering the tango's real soul.

> Americans want passion, but they don't understand the tango because passion is also [about] suffering. And they don't want the suffering side of it. So most professors here sell what they [Americans] want to buy: the acting of passion, which is not the real thing. (Azucena, female dancer)

For Argentines, the shared understanding of what good dancers are, and must be, invariably comprises an uncanny ability to express emotions in an authentic way, beyond mastering complicated figures and synchronized kicks. In other words, having technical skills is not the key to understanding the genre—being able to feel and express the tango is. The latest tango revival boosted the recovery of tango tunes that represent the Golden Age's artistic pinnacle and provide definitive proof of the tango's Argentine emotional roots. These songs are continuously played, in New York as well as in Buenos Aires, as paradigmatic icons of what indisputable tango is (and should be), as well as a living history of the tango's growing importance in the global imagination.

Argentines' united front when it comes to supporting the tango's content over its form is not to say that they agree on what tango is or on how it should be choreographed, interpreted, or taught. In fact, discussions between tango professionals and aficionados about the inner roots of the authentic tango are as popular as the ones about the tango's origins or Carlos Gardel's place of birth—some argue that he was born in Toulouse, others in Buenos Aires, and a third fable has it that he was born in Uruguay (Collier 1986). Certainly, as when discussing Argentine politics and soccer teams, debates about the qualities (and caveats) of particular schools and tango masters take over much of the tango's imagery.

Discursive battles regarding the tango's unadulterated style uncover a marketing tool aimed at attracting new students to one's *práctica*, while keeping the tango business alive and well. And within this process, Argentine artists continue to engage in fierce disputes concerning the tango's right (genuine) and wrong (inauthentic) trends. Regardless of Argentine artists' inner divisions, their shared nationality ultimately sustains their mutual acknowledgment of being interpreters of the tango's pristine soul. The ongoing need to prove mastery leads artists to develop their own dancing styles and teaching methods, which, in the competitive entertainment field, aim at keeping their services profitable. As a result, most Argentine tango performers claim to be both exceptional and different from their competitors for the purpose of grasping a bigger slice of the transnational artistic market.

The tension between emphasizing a common tango origin and developing a singular artistic brand has somehow become the engine that keeps Argentine artists in business. Given the variety of tango styles, it is fairly common for tango apprentices to take classes with several instructors (and even travel periodically to Buenos Aires) in order to have firsthand experi-

ence at legendary tango schools, while searching for the genre's irrefutable roots. Artists' parents and grandparents are referents of the old tango traditions that created *escuelas* (schools) among tango followers. Windhausen (1999: 30) recalls his experience in the tango world:

> Most [in reference to his peers] don't like to get into the acrobatics of the new school of tango dancing, which requires the stamina of a professional athlete and a terrific good memory to remember too many gymnastic steps. But we are, indeed, going back to the milongas—and bringing along friends in our age range. . . . In my particular case, I have been able to recover the steps my father taught me, although when I see myself by chance reflected in a mirror at a dance hall, I am frankly embarrassed. Compared to him, I feel like a pretty bad dancer.

Debates that typically revolve around the merits of different dancing schools and teaching styles are found in New York, London, Buenos Aires, and in many other global cities. Traditionally, diverse dancing styles are found in particular neighborhoods in Buenos Aires, where milongas are led by well-known tango masters whose skills have been later imitated, and further developed, by their apprentices and admirers. Even today, the Urquiza, Almagro, and Villa Crespo styles (alluding to the dancing distinctiveness of particular neighborhoods) and the Naveira and the Dinzel styles (in reference to the dancing techniques of two Argentine tango masters) represent some of Buenos Aires' main dancing variants that can be distinguished on the ballroom floor. Innovative forms of tango include the "open role exchange" and the "queer" and "gay" trends that have become quite popular in the transgender and gay communities, both in New York City and Buenos Aires, as dazzling expressions of the tango's evolving resourcefulness.

The immanent tension between "tradition" and "innovation," or between authenticating the old moves and melodies and accepting new fusions of styles (such as *tango nuevo*), is discursively resolved by a rhetorical stance in which Argentines claim to be the ultimate judges of all tango forms. Furthermore, as long as the discussion on the tango's search for authenticity stays alive, skillful and ambitious instructors and performers can rest assured that they will be able to continue selling their personal trademarks in the market of fashionable trends. Once again, it is the zealous involvement with the dance, regardless of its different steps and preferred orchestras, that makes the tango and its interpreters authentically "pure" and Argentine.

Figure 15. Tango demonstration of the "Dinzel School." (Photographer: Ramiro dell'Erba; participants: Virginia Kelly and César Rojas)

Tango Converters

As in other professional métiers, the tango's distinction between "doers" and "instructors" reveals a competition for market share, expertise, and resources. In tango, this dyad suggests two complementary fields. The doers are those who mostly perform onstage and tend to be staff artists in dance companies. The instructors, on the other hand, are typically those

Figure 16. The tango's avant-garde. (Photographer: Maike Paul; participants (from left to right): Leonardo Sardella, Virginia Kelly, and Walter Perez)

who claim expertise in *tango salón* (ballroom) and therefore teach and perform according to the rules of social etiquette, which entails the use of simpler steps and allows sharing of the physical space with other couples on the ballroom floor. The globalization of the genre, along with the artists' need to diversify their skills, has actually encouraged the merging of these two forms, with stage dancers becoming instructors and ballroom dancers learning acrobatics and tricks in order to be able to tour. In fact,

the broader artists' skills are, the greater their possibilities of making a decent living. Cristal epitomizes the second trend, as she was among the first dancers "imported" as a tango teacher in the mid-1990s. Although she had never left Argentina before arriving in the United States, her involvement with the Buenos Aires milongas led her to meet other Argentines who had already moved overseas, as well as some foreign tango aficionados who would regularly dance tango when visiting Argentina. Despite the fact that Cristal had never been a professional instructor or stage dancer in her home country, she soon became a popular coach of ballroom tango after moving to New York City.

> I met this guy, Piro [from Europe] at the milongas in Argentina, and he helped me a lot to come here. And then it was Norma, this girl [from Argentina], who let me stay with her when I decided to move there. My mother gave me the money for the first trip and then I continued traveling on my own, and my friend [Piro] and I began teaching together. Piro taught me that I had to charge even if I couldn't speak the language. At the beginning, I was embarrassed: How was I going to charge if I didn't know any English? And he would tell me: "They know that, but they keep asking [for] you! Yes, they want you to teach the classes." So that was it!

Cristal's statement summarizes some of the key properties of social networks and the valuable resources ingrained in them. Her social contacts actually became the catalyst that allowed her not only to travel abroad but also to become a professional tango instructor. "Tango conversion" is the term I use to describe the path chosen by artists like Cristal and many of her colleagues who entered the tango field as an alternative career path. When the prospect of having steady employment in a single field fades, the possibility of engaging oneself with different occupations becomes a new employment goal in itself (Grimson and Kessler 2005). Choosing to either teach or practice tango in order to make a living also becomes a part-time activity for already established artists in other fields. This is the case among musicians from different countries who play tango as part of their broader repertoire, which may include genres like jazz, world music, and folklore. Diversity and flexibility, which are translated into the ability to combine styles and shift professional gears, are the norm rather than the exception.

Because neither formal tango degrees nor licenses are necessary to either become or be acknowledged as a tango artist, Argentine entrepreneurs have grown into savvy marketers of the emerging trends within and

outside the artistic market. Job referrals are sought via word of mouth, and the ability of performers to impress their tango audiences with their moves and kicks is usually the only requirement needed to become a tango instructor or even a professional dancer. The two excerpts below illustrate this trend. Artemisa and Pipo were two middle-class individuals in their midthirties who had chosen tango as a dancing career shortly before they decided to migrate to the United States, about five years before I interviewed them. By getting in touch with Argentine artists already living abroad, they began touring in different cities until they decided to move permanently to New York City a few years after arriving. Both had developed successful, albeit struggling, trajectories in the corporate world before turning to professional tango dancing careers:

> I left everything for this [tango]. I had an MBA [and] worked in marketing for a few years, and now the only thing I do is dancing. What started as a hobby ended up taking over my life. Yeah, the tango is like an independent being that takes over your life. I love traveling, and at the beginning I was curious about the world, so I waited for the right opportunity. I was touring last year, and the last stop was New York City, and for the last two weeks of my stay here, I could not stop thinking: I cannot leave this place; the city is so lively. So I decided to stay. (Artemisa, female tango dancer)

> When I came here [New York City], I was forced to leave all my corporate work behind. I wanted to be an actor, and becoming a dancer was one way to do that. I didn't mind if I had to be hungry and poor, so I decided to try with the tango, and everything worked out great! I make a living from my tango classes, and I've begun acting in films. Look, I used to work for big companies, and then with a lot of humility and respect for [tango], I made it work for me. In Argentina, this environment is much more mediocre, there is no university education for it; many people [who dance tango] are trained in folk dances. There is nothing wrong with it, but it is a little bit *chato* [ordinary]. (Pipo, a male dancer)

With the help of small loans from friends and families, artists like Cristal, Artemisa, and Pipo came to New York City to see "what it was like," following the lead of colleagues who helped them meet other tango artists and get dancing gigs. They found in their Argentine webs an initial support system that welcomed them into the mainstream tango field. Despite the stiff dancing competition they encountered in the United States, these

performers noted that it was mostly through their Argentine acquaintances and colleagues involved with the Manhattan tango niche that they were able to get initial contacts for jobs—including giving free demonstrations and sample classes as guest artists in dance academies. This is not to say that these artists convey a rosy picture of the artistic world. As will be shown later, their discourses are tinted with contradictory statements regarding the help given and received by co-ethnics in the tango milieu.

Optimistic views regarding American prosperity and the availability of low-skilled jobs in the service economy also nurture the dreams of Argentine tango performers. In this line, the global market of entertainment in such cities as New York, Tokyo, and San Francisco has continued to be a magnet for immigrant labor forces (Sassen 1991, 1999). Although several artists and producers in my study were able to get employment as teachers and dancers, a significant number were forced to alternate their tango activities with a myriad of side jobs—from hosting at bars and restaurants to doing construction work.

New York City offers unique conditions for most job positions filled by tango newcomers, with employers who ask no questions regarding citizenship status in return for low wages and high turnover rates. A few tango artists in the mainstream niche would wait tables during the day and dance tango in the evenings. Their hope was to supplement their tango incomes while keeping themselves going until better opportunities arose. Being a part-time nanny has also become a job in high demand, because it usually does not require *papeles* (US visas or residency) and in some cases also resolves the problem of room and board. In fact, these dual employment paths are typical of artists' engagement with the informal service economy that most hope will be temporary until better opportunities arise.

From Tango Pilgrims to Settlers

Among some of the acclaimed tango artists I met during my fieldwork, several first visited New York City as members of dance companies but later on decided to remain in the city. Some of these performers had initially trained in ballet and folk dance, and they later chose the tango as a natural path in their professional careers. This trend has become more widespread as the tango began to be considered a matter of national tourism in Argentina.[1]

The transnational trajectories of many tango artists somehow call into question the very notion of the immigrant, as they travel the world by liv-

ing wherever they can dance and teach. This global artistic trade has reached remarkable proportions in an era of cheap airplane tickets and virtual connections (e.g., the Internet, phone, fax) that provide working opportunities on several continents at the same time. As has been noted with other immigrant communities (among Brazilians, see Braga Martes 2000; Margolis 2009), most of my tango respondents considered themselves sojourners, not immigrants. The global character of these practitioners complies with general definitions of transnationalism "from below" (Faist 2000), which characterize their practice as a border-crossing path that takes them to different physical and symbolic spaces, in which norms of exchange and reciprocity exist with members of sister tango communities around the world.

Nonetheless, the differences between transnational pilgrims and tango immigrants who decide to remain in New York City are not fixed, because tango artists change plans and expectations through time. Some live in Argentina most of the year and are intermittent visitors in the New York tango world, where they may perform either as guest teachers at dance academies or as temporary partners of tango locals. Others spend regular periods in New York and other cities, where they are hired as visiting instructors to teach workshops and give exhibitions.

For a handful of professional tango artists, the decision to make their headquarters in New York City resulted from distinctive life choices. Some faced the troubled decision of either going back to Argentina or remaining in the city with hopes of capitalizing, at the end of their employment contracts, the social contacts they had made overseas. For many, New York City became a symbolic headquarters from which it would be easier (and hopefully cheaper) to travel to other destinations. Although touring has many advantages, including visiting new countries and expanding one's international social networks, it also has drawbacks, particularly for performers seeking to settle down after growing tired of not having a place to call home. This latter trend is clearly spelled out by Sarza, a female artist who had recently moved to the city with her partner, also an acclaimed tango dancer:

> At the beginning [touring] was fun, but then we got tired of traveling from one place to another, so we decided to stay here. We still have contacts with dancers and companies [around the world], since everybody comes to New York City. And we also travel a lot, but at least we live in one place now, and people [tango producers, dancers, and students] know that we live here, so they can find us when they need us.

Getting married and deciding to start a family are important incentives for individuals who want to settle in just one place. The case of Esperanza, a dancer in her early forties, is paradigmatic. Formally trained in ballet, Spanish, and modern dance, she began to frequent milongas in Buenos Aires in the late 1980s, and she soon learned to dance tango well enough to join professional companies, both in Argentina and abroad. What had started out as a hobby led to a meteoric tango career that peaked with her becoming a principal dancer with some of the most important tango companies. After a few years of traveling around the world, she began dating another dancer who already was living in New York City. One of her Argentine friends, also a tango artist, recommended her to an important dance studio. Although Esperanza loved her life as a traveling dancer, she was keenly aware that time was passing, and she wanted a place to call home. Her connections and bridging capital (along with her reputed status as a tango star) allowed her to negotiate a favorable job contract in New York City, something that was a distant dream for many of her struggling dancer friends. As she explained:

> One thing led to another, and once I realized where I was, I was already traveling from country to country. But it got to the point that I felt I needed to have a nest somewhere. In one of my visits to see my boyfriend in New York City, my friend convinced me to make an appointment at his [dance] studio. They were looking for tango instructors, so I was at the right place and the right time.

Not everyone in the tango field is as lucky as Esperanza. Many of those wishing to continue developing their artistic portfolios must engage in menial jobs to make ends meet while keeping a two-way flow with Buenos Aires. For the purpose of remaining abreast with their transnational connections, some artists travel to Buenos Aires (and other cities) regularly, either to be judges or participants at tango competitions and shows or teach workshops. To that end, some resemble transnational agents by becoming involved in multicountry traveling paths, while engaging in both discourses and practices that transcend the nation-state (Guarnizo, Sánchez, and Roach 1999).

More recently, the currency exchange, which still highly favors the American dollar, has allowed performers to divide their time between the United States and Buenos Aires throughout the year. Some of these transnational tango artists have successfully developed business networks with their colleagues in Buenos Aires, London, or Madrid. Even those who have their formal residences in New York do not typically see themselves

living permanently in the city but rather consider their stays temporary. For instance, Sacristán, a seasoned tango dancer, had recently turned to touring as a way of staying on top of the business, a strategy that had given him some breathing space away from the already saturated tango field in New York City. When summarizing his life as a professional tango dancer, he reflected on his career as follows:

> I ask myself, do I really like living here [in New York City]? Oh well, I am here, but I am not, at the same time. I live on a plane, by traveling. And I prefer to earn two pesos [Argentine currency] but to be at peace with my soul. I don't want to *pisar cabezas* [to step on other people's heads]. So traveling is an option to that, even if not the best one, it keeps you moving and on the job market.

Many of Sacristán's colleagues are also globetrotters (a term used by Waters [1995]) who work in the United States for four or six months, then spend three months in Europe and stay in Buenos Aires the rest of the year. More than an imagined community (Anderson 2006), these artists resemble a nomadic society of people and products united by the tango's symbolic passion. They alternate their residences among different headquarters and see themselves as artistic pilgrims who travel to wherever working opportunities await them. Cities such as New York, Tokyo, London, and Buenos Aires are stops on a globalized circuit that brings tango performers together at different times throughout the year. Rather than thinking of themselves as being either here or there, these practitioners are both here and there while creating new products that keep them connected to different cities. By traveling around the world, tango artists are less exposed to market competition and are better able to diversify the venues where they can be hired and achieve international renown. Those able to adapt to the mercurial moods of show business, while building a reputation as great tango artists, are the ones who will most likely succeed in the global tango economy.

Do It Yourself: Self-Employment and Ethnic Entrepreneurship

For artists such as Sacristán and Sarza, who were introduced in the previous section, touring with tango companies initially seemed a dreamed gateway to the New York City entertainment business. The challenge was what to do next, because traveling and teaching tango classes are not al-

ways viable options, particularly when the competition is stiff. Among the "doers" (stage dancers or highly respected tango dancers), the expression "becoming your own boss" in the artistic field symbolizes a plausible employment strategy that allows them to remain involved with the mainstream dancing niche.

Among the artists who turned to self-employment, many of their business efforts represented small enterprises often sought in tandem with their compatriots. The modest size of their businesses (e.g., running a weekly milonga, tango school, or dance company) and the flexibility of their interests allowed them to brand themselves as self-made tango entrepreneurs. Conversely, social webs are multiple and expand to fields beyond tango practice, as in the case of Argentines who combine their teaching and performing with varied activities. In this vein, the refurbishment of the tango as an Argentine product has been manufactured in very concrete and commercial ways. For instance, an exchange economy of dwellings has developed in recent years between Buenos Aires and New York City. Fully furnished apartments, some located in "Buenos Aires' sexiest places," are posted in tango ballrooms, magazines, and on Internet websites, and people living in New York City earn commissions for referring tango fans to those locations.

Tango instructors can rent studios in which to teach classes, work on commission with other tango partners in Argentina, and create their own Internet branding, which may include the advertisement of tango kits (e.g., shoes) and real estate in the form of renting apartments and offering tango-friendly accommodations. Tango entrepreneurs living in the United States even sublease their own apartments to tango tourists from Buenos Aires with the help of friends who act as brokers, in exchange for either a commission fee or free room and board when visiting the United States. Tango producers promote tango paraphernalia by distinguishing their products as both singular and different from others (such as tango shoes specially handcrafted in Buenos Aires), on the basis of a diversified tango market fully devoted to the endorsement of multifaceted tastes.

In pursuing these endeavors, tango artists' expressions of mutual assistance are consistent with the enactment of bounded solidarity and the reinforcement of trust that goes beyond their financial or employment agreements. Nevertheless, running a tango business is far from being the solution for controlling the unpredictable moods of the dancing market. Given the volatility of today's entertainment field, the tango artists who occasionally become heads of their own tango brands are not that different from those who eventually turn into their employees. Although this is a

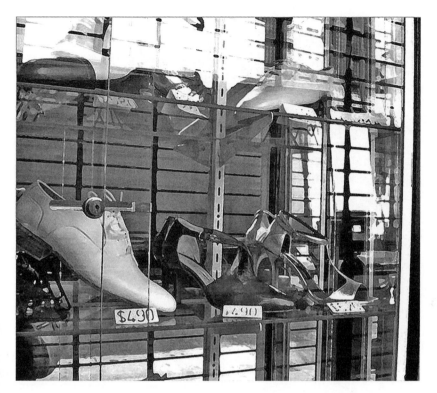

Figure 17. Tango shoe shop in El Abasto neighborhood. (Photographer: Celeste Castiglione)

feature shared with other ethnic niches, where family members and friends exchange roles, what is interesting here is the frailty of some of these business adventures.

Renata is a case in point that clearly epitomizes the experiences of transnational dancers who routinely live in New York City for a few months and then teach in Buenos Aires and London the rest of the year. She was a talented artist who, slowly but steadily, had made it up through the tango ranks. At first glance, Renata's trajectory looks like the seasoned career of an accomplished performer who was finally able to achieve her "tango dream." Coming from a family of artists who had been successful in show business, she joined the dance pipeline early on. After years of training, she had finally reached what many of her peers would consider the pinnacle of the tango world. Being fluent in many styles of dance—from Argentine folklore to Spanish flamenco—tango dancing soon became a natural path for her rising artistic career. Renata's artistic reputation was

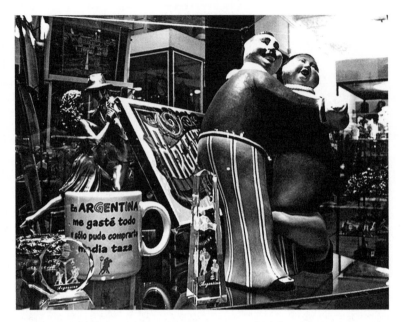

Figure 18. Tango souvenirs in the El Abasto neighborhood in Buenos Aires. (Photographer: Celeste Castiglione)

not matched by an upward economic path, however, a paradox that is quite common among artists who must seek other means to make a living. As with Renata, a sense of incongruous trajectory often prevails among immigrants from middle-class origins whose fraught social positions do not correlate with their professional achievements.

Renata's long-term dreams were beyond her immediate tango plans. Having been "exploited" by large tango companies for years, she felt that it was a stroke of luck when she first got a contract to create her own show. Due to her efforts and long-term dedication, at last she was able to put together a seasonal touring tango company. With the support of grants and private donors, she raised enough money to hire a few of her dance colleagues. What Renata called her tango company was basically a well-regarded artistic ensemble that would craft and present its work at selected festivals, with a rotating crew of Argentine artists who lived in both the United States and Argentina. Yet having a successful tango troupe was not enough for Renata to fully earn a living from it. Despite many years of trying to build her own tango signature, she still relied on various activities in order to make ends meet. Teaching, touring, and giving private lessons

were the three main contributors to her daily survival. If it was true that her individually based venture had paid back, it also meant that she had to continually secure the financial means to hire her Argentine colleagues—from dancers to musicians. In the end, she was the only person responsible for the final outcome of her business endeavor.

Artists like Renata, who are in the position of hiring their co-nationals, often feel the burden of having to deal with most of the risks along with all the losses. Yet the possibility of producing their own shows, or even creating small dance companies, has become a feasible alternative to the unstable swings of the entertainment market, allowing Argentine performers to gain a sense of control over their labor conditions. By producing their own artistic brands, some fortunate dancers and producers are able to continue profiting from the social contacts they have made in the artistic field, while claiming an upgraded social status as independent agents. As noted by Zhou (2004), it is by seeking ethnic entrepreneurship that immigrants can achieve a sense of pride and self-value, which will eventually allow them to join mainstream circuits as dignified and accomplished actors. Still, their challenge is how to continue generating a regular source of income out of their tango activities without having to rely on informal jobs to make ends meet. What is common to stories like Renata's is that, within the tango world, these artists move up through the ranks in their chosen fields.

As examined earlier, given the difficulties of the tango industry, many entrepreneurs combine their artistic activities with other financial ventures, such as working regular jobs in restaurants or nightclubs or sponsoring other dancing styles. All in all, the tango represents to them a blend of financial enterprise, a long-term life commitment, and a medium for recreating a familiar space that can be shared with other compatriots. Finally, self-employment and job diversification have become two of the most salient features among tango artists, who find viable alternatives both in their private practice (e.g., classes and exhibitions) and in the creation of small tango companies.

Tango Visitors: A Breath of Fresh Air in the Tango Field

On one occasion, Sahara, a hostess at a celebrated milonga, was describing "the rite of passage" experienced by Trinidad, a tango newcomer she had met a few years back.

So I approached Trinidad and told her, "Do not look here for clothes, for travel, or to send money back home. This is the deal here: you have to get a cell phone, and you tell those you meet here, 'I can teach you, here is my cell phone.' So you have to check your messages and e-mails every day. And if you don't think that this is the right moment, the person goes away, so you cannot lose time looking for a piece of paper or a pen. You must have your [business] cards ready, get their information right away and be ready to call them the following day around noon, and no later. And you'll say: 'Hi, what is your schedule like and what is your preferred time to meet?' You rent a studio for twenty dollars, and you will be working in five minutes. The tango is just like that, and your *vidriera es la pista* [your showcase is the dance floor]. You come here [to Sahara's milonga], I let you dance and give an exhibition, and you'll tell them [tango students] that you are from Buenos Aires, not from Paso del Duende [a small town in Argentina's Northeast]."

The excerpt above clearly illustrates the importance of the milongas as social spaces where visitors and locals get together to exchange skills and exhibit their work in front of potential students and regulars. Sahara's quote also plainly summarizes the process of apprenticeship through which tango locals choose newcomers as their protégées. Given the rivalry between Buenos Aires and the country's inner provinces—reflected in the tango's alleged character as a predominantly urban dance—Sahara admonished Trinidad not to disclose her place of origin, a small rural area in an inner province. Passing for a porteño is an important step in gaining the title of genuine tango interpreter, along with being able to understand (and display) its cultural nuances. Predictably, Argentines from other provinces are encouraged to hide their geographical origins if they want to be acknowledged as rightful tango artists.

If entering the Manhattan tango world represents a necessary condition for performers to turn into successful agents in the tango business, feeding an Argentine tango market is crucial for the reproduction of their ethnic capital. Although Argentines may not openly disclose this trait, hiring and welcoming compatriots in New York City allows them to continue claiming the tango as their national artistic trade. It is true that the growing supply of tango artists in the city somehow prevents most tango entrepreneurs from welcoming new arrivals. Nonetheless, the circulation and visits of Argentine tango artists are central to their remaining key actors in the reproduction of the tango economy. And it is precisely through networks of

colleagues, friends, and co-ethnics that recent immigrants are able to get their feet into the tango world.

For locals, the sponsoring of such informal guest programs has turned into a successful strategy through which they are able to sponsor the Argentine tango franchise, on the basis of a self-employed labor force that claims a preferred place versus their non-Argentine competitors. It also provides them with the opportunity to advertise novel and upcoming tango stars who will attract new students and practitioners. Reciprocity terms also feed ongoing and future joint business ventures—as when co-organizing tango tours to Argentina or staging collaborative shows. Tango hosts take advantage, to a certain extent, of visitors as a way of nurturing their transnational liaisons (and of upgrading their business endeavors) by promoting those who bring in "fresh air from Buenos Aires," to use a typical Argentine expression. By showing new faces in the tango field, locals make sure that their individual brands will be continuously renewed, even though this may lead to higher competition among compatriots. In the words of Carmela:

> You see, the Argentine *milongueros* have *meado* [marked] their territory, so there is little rotation of dancers, and it's difficult to get new people in. But at the same time, they need new dancers because these are the ones who bring new styles and attract students.

Tango guests also visit New York City to see what it is like to work and live there. As noted earlier, many of those who eventually settled in this city did so after having visited the country a few times, as guest dancers, or while performing with tango groups and dance companies. Thanks to the Internet and its expanding social media (e.g., Facebook, Skype, YouTube), arranging visitors' shows and inviting them as guest instructors have become common practice between tango locals and their Argentine guests. This actually represents a win-win deal, as visitors often agree to perform for free while promoting their practice with no strings attached. For those living in New York City, their sponsorship of tango invitees means the possibility of relying on a mobile labor force that has little leverage for salary negotiations and benefit packages.

During fieldwork, I noticed that those who visited the city (with the sponsorship of Argentine tango locals) would teach and perform with their hosts, often sharing their commissions and fees with them. In exchange, guests would receive free room and board, with locals arranging all the

details of their visits, including advertisements and the recruitment of students. In these cases, tango guests do not have to worry about language (as hosts often act as translators and interpreters) or about arranging the trips' details. Nevertheless, stories of things going sour between out-of-towners and their hosts are not unheard of. Some visitors, particularly those who live in Buenos Aires, may impose their authority by stressing the differences between the tangos danced and learned in Argentina versus the versions practiced in New York City. Some tango guests are blamed for coming to the United States either to show off and denigrate their comrades or to take advantage of their transitory stay to get their own gigs on the side. Things become even more complicated when the visitors' real intentions are to remain as tango locals in the city. Sacristán, for instance, who had become a mentor for his younger Argentine colleagues, referred to a typical mistake that prospective tango immigrants make when trying to get jobs in the Manhattan tango field:

> Look, you become more attractive [to the local tango world] if you are a guest. Let me give you an example: a few months ago some of my [Argentine] friends came here looking for jobs. I didn't hear from them for a while, and one day one of them called me: "Hey, Sacristán, we cannot get any jobs." So I asked them, "What did you say, how did you introduce yourself?" "That we want to stay here." "No!" I replied, "you should have never said that!" All depends on how you present yourself: the *vidriera* [showcase] is really important. You just have to say that you are just visiting and then move from there.

Some tango guests may decide to remain in New York City either as independent partners or as employees of their colleagues' business enterprises. The latter option has many advantages, particularly when artists know little or no English and are able to get sponsored for a visa or be hired off the books to teach tango—a skill that is not easily transferred to the mainstream entertainment niche. To a certain extent, these performers arrive in familiar neighborhoods where they are channeled into an informal tango network that mirrors their interests and needs. Despite the low pay they may earn, most are being compensated with the opportunity to learn the business from scratch, including the different strategies involved in the tango entrepreneurship (such as advertisement, teaching, and demonstration techniques) while improving their language skills and making themselves known in the tango milieu.

Working with other Argentines becomes an easy way to learn the "tricks of the trade" while being channeled up onto an apprenticeship ladder. Things often turn out well, particularly if new arrivals agree to work with their hosts on the basis of sharing their fees or getting a salary. The practice of employing co-ethnics normally turns out to be advantageous for both parties. As happens in other ethnic businesses, both workers and employers benefit from engaging in reciprocal relationships (Morokvasic, Waldinger, and Phizacklea 2006). While bosses get trustworthy low-wage workers, the latter are hired in a field that allows them to remain in the United States, while learning and practicing valuable skills and expanding their web of contacts.

Compatriots easily become "partners in crime" by working off the books, evading taxes, and not reporting all their income. These informal transactions bring them closer together in terms of mutual obligations and gratitude that allow ethnic businesses to survive. For instance, a tango visitor may be willing to provide exhibitions and teach classes for a small fee in exchange for temporary room and board, or for sharing a percentage of his or her off-the-books income. By hiring and giving a hand to their compatriots, Argentines can count on a cheap and loyal labor force that shares their cultural values and emotional capital, and which allows them to continue marketing a refreshed tango practice.

Revisiting Argentines' Patterns of "Ethnic Solidarity"

The global selling of tango's authenticity works like an elixir for foreign tango aficionados who seem hungry to grasp the "real" thing, which theoretically would let them express their inner passionate feelings. Argentine artists enter the Manhattan dancing field ready to offer a taste of authentic tango to foreign patrons by having at their disposal a unique resource: their nationality, which goes hand in hand with the tango's alleged know-how. However, if the growing commitment of Argentines to the tango is vivid evidence of the genre's growing importance in the global economy, dancing tango for a living is not an easy endeavor.

Besides being emotionally taxing, practicing tango requires being on the spot and investing in a dazzling (and often sensual) image in order to lure new students while keeping the old ones. As will be examined in chapter 5, travel visas have become increasingly difficult to procure for many artists from Argentina who, unless they are able to get financial

sponsorship by a foreign company or a dancing studio, may encounter multiple legal and bureaucratic barriers to traveling overseas. Much of the tango employment in New York City, Buenos Aires, or Paris is *en negro* (not declared), which makes it difficult for prospective travelers to prove that a formal sponsor will indeed underwrite their presentations in the United States.

Now we return to one of the main issues that I address in this volume: namely, Argentine artists' patterns of interpersonal solidarity and conflict in making a living out of their tango practice. The notion of ethnic capital is useful here in illustrating how Argentines, despite their inner differences, work together to hold on to the tango brand. They do so in two main ways: by promoting themselves as the authentic interpreters of the genre and by getting involved with a range of artistic and business endeavors with their compatriots, both at home and abroad. In classic immigration network theory, the term "economic saturation" (based on the pull-and-push paradigm) assumes that the supply of employment opportunities will eventually create a natural limit to the volume and size of immigration (for a critique, see Light and Bhachu 2009). Rooted in neoclassical theory, this concept implies that a new arrival is only able to get a job when somebody in the network leaves and creates a vacancy. Against the purely economic ground of saturation paradigms, network theories (that are based on access to social capital) recognize the role of individuals' webs in diversifying employment opportunities and in finding alternative ways of making a living, including getting housing and other forms of assistance (Massey and Riosmena 2010).

In this view, Argentine artists and entrepreneurs in New York City have managed the "saturation crisis" that otherwise would have led them to either terminate or relocalize their migration webs (Light and Bhachu 2009). As noted earlier, despite the US recession that peaked in 2008, tango venues in New York City have continued to flourish, with larger number of tango aficionados (albeit of different nationalities) entering the field. The secret to this endurance rests on a combination of networking, diversification of products, and transnational connections. Diversification highlights the creative ways through which tango artists tend to rely on more than one activity, either in the tango and service industries or in the fashioning of distinctive artistic products.

During fieldwork, I met several tango producers who, in some cases, had been held responsible (and gotten credit) for having launched the "tango fever" in New York City. Although most of them did express an initial optimism regarding the endless possibilities of the tango, some were

aware of its limited potential and therefore attempted to diversify both their professional and entrepreneurial interests. They acknowledged the fact that, sooner or later, other genres might eventually replace the tango in the arbitrary hierarchy of trendy art forms.

The informal tango market rests on an interpersonal referral system of recommendations in which "putting a word in" for others is key in the decision-making process of employing fellow citizens. Artists' mutual assistance in intra-hiring represents a resourceful way to support their ongoing engagement with the tango economy. This pattern also ensures trust and loyalty, as tango workers risk their own status by bringing their compatriots into the labor force. These results agree with the vast literature on ethnic niches that points out employers' reliance on social networks to hire immigrant workers through co-ethnics. Studies on ethnic solidarity have compellingly showed that economic survival becomes a strong basis for immigrants' relationships of mutual help (Bonacich and Model 1980; Min 2008; Waldinger et al. 2006). Co-ethnic hiring tends to reduce the cost of recruitment and self-selection of those who share similar know-how (Bailey and Waldinger 1991; Brettell and Alstatt 2007; Falcón 2007; Massey et al. 2005).

The above findings should not lead us to conclude that Argentines' patterns of ethnic solidarity are inclusive of all who consider themselves tango artists. In fact, not all performers count on the same opportunities to join the tango's main core. Those who are already excluded from it, as in the case of some elderly tango artists, are not likely to benefit from either the field's intra-hiring practices or from its transnational liaisons. To a certain extent, "centrifugal" and "centripetal" forces are combined in Argentines' artistic networks. While competition with outsiders works in a centripetal way by encouraging ethnic solidarity, the increasing rivalry among Argentine artists promotes centrifugal tensions due to the rising supply of artists in the tango field. Diversity, in terms of the tango products being offered, along with traveling and keeping abreast with their transnational liaisons are key to enabling artists' informal ties of solidarity and collaboration. This is even more so as the tango niche in New York City has become increasingly drenched, following the cyclical economic recessions in the United States, which has resulted in fewer work opportunities for newcomers (Viladrich in press).

Finally, contrary to the ritualized glamour of the practice of tango, the lives of most tango performers are not as flamboyant as their external personas might suggest. Tango artists are often forced to perform a "dual life" by combining their roles as alluring artists with employment in less desir-

able low-skilled occupations. Even if they are living legally in the United States, those who have decided to make their fortune in the entertainment field are exposed to the vagaries and variability of show business, which often makes them vulnerable to unfair contractual obligations by their employers. To illustrate this path, we now turn to the lives of older tango immigrants, a group that portrays the unstudied (and hidden) universe of the tango's glitzy representation.

Elderly Newcomers and the Tango's Vulnerable Image

At the beginning, it was hard to sell my discos [compact disks, CDs] here and there. But with Manolo's help [an Argentine musician] and the extra money I now make selling them, I finally got into it. Just the other day, I sold thirty-five CDs at a tango party! A guy there [the organizer] was touched by the way I sang, and he came up to my table after the show and said: "Just leave the CDs there, next to the speakers and you'll see, they will sell out in no time." And so I did. Now, I always take them along, just in case. . . . You have to try everything to make a living here.

BARTOLO, TANGO SINGER

Bartolo's remarks poignantly illustrate the efforts of many Argentine artists, young and old, who creatively utilize their resourceful tango portfolios to make ends meet. Hitherto, when thinking about tango artists, the picture that frequently comes to mind is that of a sensual young tango dancer who enjoys a seemingly flamboyant, if not bountiful, life. This portrait is typical of tango postcards colored by clichés of seductive femme fatales and irresistible "Valentinos." This study revealed a more complex universe of tango actors embedded in multiple social webs. Among the tango newcomers I initially met during fieldwork, I purposely chose to explore the lives of those who in spite of their advanced age (sixty-five years old, on average) had also arrived in the United States in recent decades.

Bartolo, a seasoned tango singer in his midsixties, had left his family in Buenos Aires in early 2000, with promises of bringing them to the United States within a few months. I met Bartolo for a first interview on a warm spring day in May 2001, when we got together for coffee close to the restaurant where he was performing at the time. I had heard him singing

there a few nights earlier and decided to invite him to be part of my re-
search project. He gladly accepted, although he would not allow me to
buy his compact disk and, instead, gave it to me for free. As a proper *cabal-
lero* (gentleman), he would not take money easily from a fellow Argen-
tine—a struggling graduate student at the time—willing to lend a sympa-
thetic ear to his plights.

My informal follow-up encounters with Bartolo later on helped me
gain a fresh perspective on the purpose of my research study. As a social
scientist eager to decipher the efforts of Argentine performers to succeed
overseas, Bartolo's tango trajectory reinforced my commitment to provid-
ing an in-depth analysis of the social determinants of immigrants' accom-
plishments, and disenchantments, as they pursued their careers in the
United States. At a time when many of his contemporaries in Argentina
were already harvesting the fruits of their long-standing artistic careers,
Bartolo had boldly embarked on a hope-filled journey abroad, lured by the
growing popularity of the tango in one of the global cities in the North.

For the most part, elderly newcomers in this study did not enjoy the
advantage of having a US permanent resident visa at the time of the inter-
view and—in contrast with their younger colleagues—they were not danc-
ers but rather musicians and singers. Unlike the senior citizens represent-
ing the old tango guard, who came to the United States in the late 1950s
and 1960s, the prevalence of these two long-standing groups of tango im-
migrants (younger and older) in New York City has been characterized,
until recently, by the relative absence of middle-aged milongueros, a phe-
nomenon known as "the generation gap" (Windhausen 1999). Notwith-
standing the salience of elderly tango performers in this study, they have
remained almost invisible in the United States, as it is often assumed that
the young and the healthy are more prone to migrate.

In the following pages, I present the life trajectories of a few of these
older tango interpreters, who conspicuously epitomize the hazardous ex-
periences many artists endure overseas. The process of migration is itself a
network-building enterprise in which different roles are played before,
during, and after the settlement process. Distinctions between different
types of networks are as important as understanding the changing roles
they play in immigrants' lives over time (Portes and Bach 1985). This
chapter reveals how the social webs that helped some of my elderly respon-
dents arrive in the United States somehow differed from the highly con-
nected ties that involved many of their younger colleagues. Finding em-
ployment in the mainstream tango world is particularly challenging for
older artists who lack bridging social capital, as in the case of those mostly

involved with nonartistic and low-income social ties. I begin by examining the migratory path of an elderly male artist I will call "Billy," whose experiences provide us with a glimpse of the contradictory ways in which elderly immigrants take advantage of their social webs before and after moving to New York City.

Billy: Following the Pied Piper of Hamelin

The legend of the Pied Piper of Hamelin, which purportedly arose in the Middle Ages, involved the departure and presumable death of all the children living in the town of Hamelin, in today's Germany (Browning 2011). The earliest references to this story describe a musician wearing colorful clothes who led the spellbound children away from their town, never to return. Although my tango respondents were not kids leaving home in a mesmerized trance, the metaphor of the Pied Piper speaks to the courses of many prospective migrants who end up following their peers overseas without a clear idea of what they will encounter. Billy's account of his migratory path clearly illustrates this trend.

Billy was a *cantor de tango* (a tango singer) who had decided to migrate to the United States, enchanted by the tango success stories he had heard from fellow artists who were living abroad at the time. With a few dollars in his wallet and knowing just a dozen English words, he came to New York City inspired by the glowing accounts shared by his older tango comrades (mostly musicians) who had traveled and even moved to the city during the golden years of the Visa Waiver Program. As you will learn in chapter 5, this program allowed Argentines to enter the United States without a visa and remain in the country for up to three months, for either business or tourism purposes. When Billy arrived at John F. Kennedy International Airport in the year 2000, he told immigration officials that he would be visiting the country for just a few days. Neither his age—he was in his midsixties when I first met him—nor his formal demeanor made him suspect for an unauthorized overstay. However, Billy hoped to remain in the United States for a few years in order to save enough money to either bring his family to America or go back to Argentina and set up a tango bar.

Billy expected to succeed in the United States in his artistic métier, despite the fact that the tango's reputation outside Argentina has been mostly entrenched in its dancing and accompanying musical forms. It is important to note that all Argentine tango lyrics are written in Spanish and

that many of them contain several lunfardo words, which usually mean little to a mostly non-Spanish-speaking audience of global followers. For many tango lovers, listening to tango *chansonniers* (professional singers) is of no special interest unless it is accompanied by tango dancing. Consequently, most milongas in Manhattan by the late 1990s either hired musicians or relied on recorded music; the latter has become the norm in recent years because it is too expensive for most tango organizers to hire bands.

For the first couple of months, Billy got free room and board in New York City by living with some Argentine pals whom he had known for years when performing back in Argentina. But this arrangement was temporary. Most of his friends were also older immigrants who depended on day-to-day shows to make ends meet. Therefore, Billy tried to get acquainted with the casual web of artists and producers involved with the Manhattan tango world. Unfortunately, after a few months, the only stable gig he had been able to get was a once-a-week show at a popular Manhattan restaurant where he performed *a la gorra* (passing the hat), which means working just for tips.

In one instance, Billy told me about one of his last presentations at a restaurant on Long Island, whose Argentine owner had decided not to rehire him because of his little success in attracting a larger number of clients. They parted company on good terms and said good-bye as friendly acquaintances. One evening when he was feeling lonely, Billy decided to show up at the restaurant to say hello. The restaurant's owner, who at first seemed surprised, soon became defensive: "What are you doing here? I told you not to come here anymore." "Don't you want me to sing here, even for free?" Billy replied. "I am here just to talk and have a good time." After that painful incident, Billy realized that he had no choice but to take menial jobs on the side, mostly painting houses and doing landscaping, despite the fact that the cold weather in the city and the long working hours chronically hurt his baritone voice.

During my visits to a coffee shop in Little Argentina, I would often sit down with Billy and some of his peers to brainstorm on how to help him out. On one occasion, I learned that a couple of Argentine entrepreneurs in the Manhattan tango field were planning a tango festival that would welcome a few tango singers as guest artists. They had agreed to invite Billy to an informal audition, and I offered to contact him in person. When I bumped into Billy the following Saturday at noon at the same coffee shop, I was happily anxious to break the good news to him. To my

surprise, his reaction could not have been more contrary to what I had hoped for. In an angry tone of voice, he yelled, "By no means will I allow this group of beginners to test my talent! How dare you come here and ask me to do an audition!"

Billy was a seasoned artist with a long roster of performances in the most celebrated cabarets of Buenos Aires and even in Latin America, where he had toured for a few years. The idea of being treated as an "amateur" by those who were not even consummate tango producers, but younger and less experienced compatriots, was perceived as a threat to his artistic persona. It was one thing to work as a construction worker, where anonymity would protect him under the illusion that this would be just a temporary activity, and another to be judged and compared by his fellow nationals in the tango field. During our conversations, Billy would rant against his colleagues who had supposedly exaggerated the promises that were presumably waiting for him in the United States—or what he called the "mafia of those who manage the tango business." He did not see the help of his peers, in the form of referrals for informal jobs, as a big effort on their part but rather as a moral obligation for having encouraged him to come to the United States in the first place. "This is like *pan para hoy y hambre para mañana* (bread today and hunger tomorrow)," he would often mutter, referring to his unsteady jobs along with the uncertainty that the future would bring to him.

> The Argentines only keep the gigs to themselves, do not share with others. They are not like the Colombians or Ecuadorians—you see them putting stuff together. Here, *cada uno va a la suya* [everybody goes their own way], and nobody really wants to help you out.

Billy's claim of bounded solidarity, shown in the passage above, was not uncommon and summarizes many of my respondents' discursive attempts to stress the purported selfishness of their national collective, vis-à-vis the intragroup assistance they allegedly found in other ethnic groups. The latter were often portrayed as holders of moral and ethical codes entailing reciprocal obligations to which Argentines would not conform. Contrary to multiplexial networks, which are wider and more successful in connecting their members with a diverse set of resources, the strong net of friends that Billy belonged to provided him with limited social goods. It was not that he did not appreciate their help; the problem instead was that his expectations of assistance were beyond his peers' capabilities.

Federico: The Charms of Anonymity

During fieldwork, I witnessed a couple of tango players performing one day in subway stations and later that week at a popular Manhattan restaurant. Federico was one of these artists, a musician in his late sixties, who had moved to New York City for the first time in the mid-1980s, following the success of the show *Tango Argentino*. Although he was already a senior citizen when I first met him in the late 1990s, he had continued working since "a retirement is worth nothing in Argentina" and he also felt compelled to *dar una mano* (give a hand) to his adult children, some of whom were in a difficult financial situation.

For the past two decades, Federico and his wife returned to the United States each time their economic situation had worsened in their home country. Not long before, Federico had managed a small grocery shop that he had built in front of their house in a lower-middle-class neighborhood in Buenos Aires. Between the earnings from this store and Federico's sporadic performances, he and his family had been able to make a modest income. Still, soon after the Argentine economic crash in 2001 things went sour for Federico's children, and he decided to lend the store to them. Because Federico had no other means of supporting his family, he and his wife decided to migrate to the United States to try fortune, once again hoping to make a living from Federico's tango performances.

Artists like Federico often consider their stays in the United States as temporary, for the purpose of earning enough dollars to supplement their low Argentine pensions and even to send money to relatives back home. Though he had performed in the United States with many renowned artists in the past, he chose to play on the streets of New York City. Most of our informal conversations took place at one of the subway stations where I would find him almost every day. He was always happy to see me and would greet me with "Hola, Argentina!" Contrary to the sophisticated outlook he would display at the evening milongas, where he routinely dressed in a tuxedo, Federico disguised himself on the street by almost always wearing an oversized sport jacket, baseball cap, and sunglasses. During our impromptu conversations in the subway station, he would often mention the precious freedom he experienced when playing in public venues, since he worked at his own pace without bosses or schedules. Nevertheless, his insistence on the advantages of street work also revealed the underlying stigma that exists for this practice, particularly among his Argentine colleagues:

I play in the subway as if I were playing in the Colón [the most important theater in Argentina], so I can make good money whenever I want to. Also, I prefer to play alone, since all the tango players out there are *improvisados* [amateurs]. You also make contacts in the subway. Like the other day, this rich woman saw me in the subway and asked me if I would play in her fashion show. So we negotiated the price, then we arranged the time and place and that was it!

Federico's latest migration to the United States illustrates the role reversal currently taking place between downwardly mobile parents and their children in Argentina. While in the past, adult children were in charge of helping their parents, increasing financial constraints and unemployment among Argentine youth have lately forced the elderly population to keep working long past retirement. This story also highlights the role of agency in making sense of an uncertain future. Elderly immigrants are eager to convey acceptable portrayals of themselves by recounting stories that both highlight their successful careers in the past and their tango fellows' accomplishments at the present time.

Federico's efforts to disguise his street performances encompass a double meaning that can be extended to other immigrants. Anonymity makes them vulnerable and fragile in the big city; however, it also provides artists with valuable freedom to explore new employment venues that some would not dare try in Argentina, such as playing instruments or singing in the street. Being invisible in New York City also brings the additional advantage of working at one's own pace, with no boss and no schedule, while remaining flexible in terms of travel or relocation plans and job perspectives. Furthermore, tango performers can go back to Argentina and truthfully say that they have played in New York City. Unsurprisingly, they will probably omit the fact that that they have done so on a subway platform, as a safe way of reckoning a social aura of prestige among their family, friends, and peers.

Rather than being marginalized in the tango economy, Federico was highly connected with rich tango social webs. Even so, he was very shy and did not speak English, limitations that severely hurt his chances of being hired by non-Spanish-speaking entrepreneurs. Therefore, most of his relationships were limited to dealing with other Argentines who, like himself, were also looking for jobs. Survival as a struggling artist and being older is not a good combination, as musicians like Federico know all too well. Outside of the small tango world, players like Federico are

seen as just older fellows with limited knowledge of English, low incomes, and artistic skills only appreciated within the tango subculture. Some elderly tango artists even voiced their disenchantment with having to start all over again in New York City, at a time when they felt closer to the end of their artistic careers. They often complained about what they called the American ignorance regarding the prestigious artists and singers "we have" in Argentina, which reflects their frustration at being in a country where only American pop idols and a handful of Latino American artists (non-Argentines) are acknowledged.

Contrary to their younger peers, immigrants like Federico often felt too worn out to start a new profession, and they lacked the flexibility of their younger comrades for adapting to a competitive market in which energy and versatility are required. As in the case of their younger peers, older artists alternated between different jobs, including weekly performances at various milongas, clubs, and restaurants; teaching private lessons; and working such part-time jobs as security guard and construction worker. By combining the limited revenues they earned from all these occupations, which in most cases excluded them from social and health benefits, some of these performers were able to make a decent, though unstable, income.

Flor: "I Am Here Just to Finish My Tango Tour"

Flor, a singer in her midsixties, had arrived in New York City in the late 1990s, chasing an enduring dream of success. Like many of the working-class newcomers at the time, she had become a social survivor whose energy and wits helped her make ends meet in spite of her difficult life circumstances. As a woman who traveled alone, Flor had to confront additional challenges to the already hazardous trilogy of being older, poor, and undocumented. At a time when many of her comrades in Argentina were seemingly content with their positions as housekeepers, wives, and grandmothers, Flor was challenging all these roles by crafting an adventurous and independent life for herself. If Flor's life story provides a clear example of the hardships endured by disadvantaged female immigrants in the United States, her commitment to succeed epitomizes the strength of tango performers to confront adversity.

Flor came from a Middle Eastern family of immigrants who arrived in Argentina at the turn of the nineteenth century. As a young woman, she had always loved singing and dancing but had to work hard to support her family. It was only after her husband left her with three young children

that she attempted a career in the Buenos Aires tango world. By the time Flor was in her midthirties, she was singing in cabarets and pubs, activities that she alternated with her jobs as a hotel cleaner, waitress, and food caterer. She recalled having been arrested by the police during the military dictatorship in the 1970s on several occasions when returning home after singing in cabarets:

> You see, I was a tango singer, not a prostitute. But of course I was singing in the cabaret there, in Córdoba Avenue, where you have anybody. And I would dress nicely and leave late at night, so they would take me for a prostitute. It was tough. My mother did not understand it either, but I wanted to sing and also needed money to support my children.

During the 1980s, Flor worked as a tango singer throughout Argentina, and when she returned to Buenos Aires in the mid-1990s she found the genre flourishing everywhere. The promising stories told by friends and acquaintances regarding their triumphant paths overseas fed her dreams of success. It was then that she decided to leave Argentina to begin her tour: "So I decided to leave. . . . I always dreamed of touring around, always waiting for the right moment, and I never did it. Then I decided to start a tour by myself so I could go back and be respected among my peers." Flor began her journey through South America in 1996, hoping to eventually go back to Argentina and harvest the fruits of her success abroad. In just a few years, she traveled through several countries (including Chile and Colombia) where she sang tangos, though she made most of her income from working as a housecleaner and bar attendant.

After living in Venezuela for a while Flor decided to travel to the United States, encouraged by colleagues who insisted that the tango was becoming increasingly popular there. Flor entered the United States thanks to the Visa Waiver Program and, once in New York City, she remained as an unauthorized immigrant by working as a nanny, cleaning lady, housekeeper, and freelance cook of Argentine empanadas that she sold at Argentine events. Flor lived day by day, hoping that a change of fortune would compensate her for all her current sufferings. When she did not have enough money to eat, she ate either bread she baked for herself or discarded food from a McDonald's close to where she lived.

At the time I met Flor, her expectations of becoming an acclaimed tango singer in New York City were virtually inconsistent with her living circumstances: she was an undocumented immigrant who did not speak English, had no relatives in the United States, and had made very few

connections within the tango industry. In spite of her limited economic and social capital, Flor had challenged her fate by dreaming of a better destiny. Her interactions with members of the Argentine tango community were often problematic and did not help her become an esteemed figure in the tango field. Flor's social ties mostly involved the outer borough milongas and Latino networks, where tango gigs represent a pastime and not a suitable way to make a living. A few of her singing presentations came about thanks to referrals from a couple of members of the tango's old guard in Queens, who eventually helped her land a gig at a Latino restaurant where she would perform on the weekends, often just for a plate of food. She believed that her older age, her looks, and her recent arrival in New York City were the reasons for being "discriminated" against by her tango comrades:

> You see, this woman [Argentine restaurant owner] introduced me to this guy [Argentine tango entrepreneur] but he did not want to deal with me. Probably he was expecting somebody much younger or with a different look. He could have helped me but he didn't want to. . . . The same happened with other Argentines, like this guy whom I had to beg to let me sing in his restaurant. Also, they [tango entrepreneurs] help people who live here and not those who are here *de paso* [for a while].

By watching Flor interact in social venues, I was able to witness her difficulties in dealing with other artists and tango entrepreneurs. Although she blamed her bad luck on her being a *tanguera vieja* (old tango artist), her rasping personality and poor networking skills were at odds with her dreams for success. If becoming a singer in the Manhattan tango world was not easy, her demeanor was closer to that of an *arrabalera* (a strong and unpolished working-class tango character) than to the flamboyant, sensual tango diva more attuned to the Manhattan tango field. To make things worse, Flor's continuous drifting between different jobs, along with the high emotional cost of the uncertainties of her everyday life, had a deleterious effect on both her physical and psychological health. She had begun experiencing progressive glaucoma in both eyes that was getting worse due to her lack of financial means: "I went to the consulate to ask them for help, just to buy the drops, but they turned me away. I was not begging for things, I just needed some help for my problem, but they did not care about it."

Flor counted on a strong supportive network of Latino friends—followers of the Pentecostal Church—with whom she regularly interacted and shared emotional capital. Indeed, it was through the church's "brothers

and sisters" that she was finally able to get eye surgery at an affordable price. Flor's religious fellows were instrumental in helping her fill out the forms and applications that made it possible for her to obtain affordable health care. This finding coincides with other studies that point out the importance of religious-related involvement as a source of social support for both church members and clergy (Abraído-Lanza 1997; Viladrich and Abraído-Lanza 2009). While some of Flor's friends would help her with logistic matters (e.g., providing proof of her residence in New York City), others would become her translators and companions anytime she had to go to the hospital.

> Luckily, I did not have to show them [hospital administrators] anything, neither passport nor any other identification. I only had to prove that I live at this address. So my roommate [also a church friend] wrote a letter in English proving that I live here with her. And that was it! But I prepared myself for this surgery; I kept saving money and had thirteen hundred dollars after a few months, so I could be without working for a little while and have some time to recover after that. And so I did.

Flor's health problems were not over after surgery partly because of both the heavy physical demands of her housecleaning job and the stress arising from her difficulties in making ends meet. She suffered from high blood pressure and varicose veins, phlebitis in one leg, and hair loss. Above all, she experienced a continuous state of anxiety, which she described as feeling *algo aquí arriba del estómago como que me quema* (something on the top of my stomach that feels like it's burning me). Despite all her difficulties, Flor still expected to succeed as a tango singer in New York City and continue her tour to Europe:

> I don't want to remain here. I would like to continue to France, but now it is not going to be easy. I don't want to remain here illegally forever. But even if I go back to Argentina, I don't want to show up there *con una mano adelante y la otra atrás* [empty-handed]. I would love to go back to Argentina by any means, but one is proud. I want my children to be proud of me, of their mom becoming a famous tango singer. You will see how they [the tango world] will appreciate me when I go back after my tour is over.

Flor's personal circumstances are not unique; rather, they accurately reflect some of the challenges faced by elderly immigrants in the United States, in terms of their frail health status and the social jeopardies that

make them the most vulnerable of all. Finally, Flor's meaningful yet limited informal support net mostly symbolizes a survival web linked to religious services. And although Flor had not been fortunate in expanding her social capital via her fellow citizens, her low-income Latino friends ended up becoming key in her ability to find affordable housing, temporary jobs, and health care.

Román's Networking Path: A Success Story at Last

Not all elderly artists' stories were as poignant as those of Flor and Billy. Román, a lovely man in his late sixties, illustrates the ingenious ways through which a handful of older newcomers were able to make it in the tango industry. He had been a tango musician and *bandoneón* player for nearly forty-five years when he first came to the United States in the late 1990s, after living in several Latin American countries. A case in point is needed here to call attention to the fact that bandoneón players are highly regarded in the tango world, where they are often considered maestros possessing an exceptional ability to perform on a difficult instrument—a skill that is basically learned through an oral tradition kept mostly in Argentina.[1]

Although artists like Román were already senior citizens or close to the age of retirement, their financial difficulties often led them to remain in New York City, if not permanently, at least for long periods of time. Román's social world was joined by *los muchachos* (young men), a group of elderly immigrants who shared similar problems: irregular incomes, language limitations, temporary visa status, and loneliness. Surviving as a struggling artist and being older is not a good combination, as Román knew all too well. Therefore, despite what he called "his good fortune" of being able to make a living from his tango practice, Román also frequently mentioned the many obstacles he encountered in the United States, including language barriers and his lack of health insurance.

Given his long-term connections with the artistic realm, Román soon met a few of the Argentine artistic producers living in New York City, as well as a handful of tango performers with whom he had played and worked in the past. Some of his tango comrades had also been well-known *bandoneón* players, music composers, and singers who used to perform in renowned orchestras and films decades ago. With the help of one of his friends, a Broadway producer, he was granted a visa as an exceptional performer that fostered his legal status and eventually led him to establish US residency.

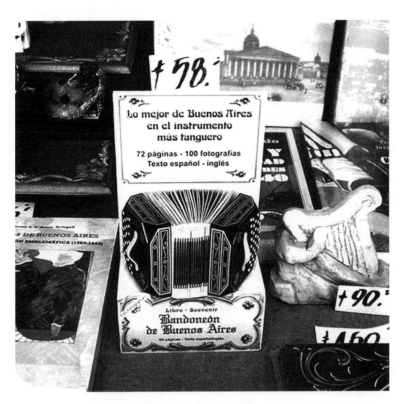

Figure 19. Souvenir book representing a bandoneón displayed at the Librería del Colegio (the School Library) in Buenos Aires. The sign reads: "The best of Buenos Aires is the most tango-like instrument." (Photographer: Celeste Castiglione)

Román's pleasant demeanor, great sense of humor, and professionalism soon became crucial assets that made him popular in the Manhattan tango world. The key to Román's success could be first traced to his artistic network prior to migration, which allowed him *caer de pie* (land on his feet), along with his ability to expand his bridging social capital once he entered the Manhattan's artistic niche. Well-liked by both younger and older tango musicians and dancers, he soon became the musician of choice any time a tango troupe needed a last-minute performer or when an artistic ensemble decided to launch a new tango show. Over time, Román's resourceful web of colleagues helped him secure regular employment opportunities within the United States, with connections to both Latin America and Europe. In the end, Román's flexibility to adapt

to different artistic networks became his ticket to securing a steady line of jobs that allowed him to make a modest yet stable income.

Elderly Artists: Common Plights Amid Challenging Paths

This chapter provided a snapshot of the migratory experiences of elderly artists at a very particular point in their lives, just as they were trying to find a place in the tango niche on American soil. Because this was a cross-sectional study that did not follow immigrants' careers through time, it did not provide a case-by-case account of their diverse individual trajectories. Anecdotally, I learned that some of the elderly, as well as younger, tango newcomers I met during fieldwork later on either returned to Argentina or continued their journeys overseas. Tougher employment and legal conditions in the United States, along with its cyclical economic recessions, became decisive factors in these artists' evolving migratory paths.

Still, as illustrated by Román's story, not all of the elderly's trajectories ended up in undocumented status nor in departure from the United States. Román's case actually exemplifies the resourceful ways through which agents may combine human expertise with rich social connections. Similarly, performers who successfully overcome the barriers to legalization, while skillfully marketing their artistic skills, are able to launch successful migratory careers even at an older age. By all counts, older artists' tales of hope and commitment to their tango trade are illustrative of immigrants' resilience against adversity. The case studies presented in this chapter exemplify the main difficulties experienced by elderly newcomers, as well as the importance of social networks for paving their paths to success. While Billy's account portrays the limitations of arrival webs at helping newcomers develop meaningful working liaisons, Flor's life history shows the importance of nonartistic ties for those who are somehow excluded from the tango's mainstream niche. And despite the fact that most of these artists did not know each other before migrating to the United States, their stories seem to coincide on more than one level.

All of my elderly respondents were in their sixties when I first met them and had already performed for decades. They were older than the typical tango artist and had taken similar paths in terms of their immigrant careers in the United States. They were more vulnerable to physical illness than their younger peers, and counted on fewer coping resources against the impact of everyday stress on their lives. They were also in greater need of

health services than their younger comrades and, for the most part, had no peers to act as their interpreters or to guide them through the maze-like US health-care system. Contrary to the members of the old tango guard, they had neither children nor other relatives in the United States to care for them. They all had limited English skills, and most held nonresident status or were undocumented at the time, earned low incomes, and depended on day-labor jobs to make ends meet. With the exception of a handful of artists deemed eligible for "exceptional" artist visas, most were not suited for visa-sponsoring jobs.

Things are not easy when it comes to paying bills, obtaining affordable health care, and negotiating reasonable living arrangements with people that artists do not know and may not like. Elderly newcomers in this study eventually experienced a clash between the image they hoped to project to others, as well-known and respected artists in Argentina, and the one they were routinely confronted with in the United States—as vulnerable old immigrants (Goffman 1997). Some among my older interviewees were also concerned about falling into a depressed state, particularly since their ability to get jobs in the artistic field somehow depended on their predisposition to project an aura of success. In addition to being newcomers in a hostile environment, these performers often experienced the added burden of being seen as old and, consequently, less capable than their younger peers at succeeding in a competitive artistic market where considerable amounts of energy, mental concentration, flexibility, and personal appeal are required. Even under the best of circumstances, elderly artists in vulnerable situations are forced to negotiate two self-images with themselves and others: their role as maestros in the tango world and their susceptible status as elderly immigrants.

As illustrated by the stories of Federico, Billy, and Flor, most tango artists will not easily reveal the series of part-time occupations (e.g., babysitting and construction) that they may be engaged with, a fact that may preclude the observer from assessing their actual success in the tango field. The impersonal social realms found in global metropolises such as New York City, London, or Paris offer both a protective shield against suspicions of social failure and an entry ticket to the tango's social hubs. Even if tango artists are forced to work in low-prestige niches, the anonymity of the urban milieu protects them from making public their vulnerability.

Temporary jobs in the service and blue-collar economy (e.g., as a waitress, housecleaner, or construction worker) are not as stigmatizing in the developed world as they are in the developing one. Examples in this chapter were provided by Federico, who, though earning a regular living from

his subway performances, had a website that publicized his accomplishments in New York City; and by Flor, who, despite being a nanny and cleaning lady by day, boasted about her tango singing by night. By disguising their dependency on the informal job market, not only did these tango interpreters hope to "save face" in front of their colleagues—particularly other Argentines—but to also become marketable and dignified agents in the highly competitive tango field.

Despite their similarities, the migrant careers and job trajectories of Román and Flor could not have been more different, a fact that reveals their belonging to two different tango domains. Román had a unique talent that was highly valued in the artistic field. As a player of several instruments, his performing career had allowed him to remain legally in the United States. Flor, instead, had a unique voice, but her working-class demeanor and strong personality did not help her make friends in the mainstream tango circle. Certainly, while Román had been able to forge meaningful liaisons in core artistic enclaves, Flor was openly rejected by many who considered her "nice, but a little bit crazy," as one of the milonga organizers once told me.

In Billy's case, his initial opportunities had been tainted by his friends' distorted perceptions about the possibilities awaiting tango singers abroad, which somehow led him to overestimate his actual opportunities in the United States. Having access to informal networks of peers is often key in getting newcomers a roof and a warm plate of food upon arrival but not in making the precious social contacts that will eventually gain them entry into the mainstream tango niche. In the end, one of the most pernicious effects of tango immigrants' low-prestige jobs is the potential to restrict their bridging social capital, as in the case of Billy and Flor who mostly remained trapped in low-salary jobs in the construction and service industries that limited their participation in the artistic field.

Tango Artists' Embroidered Tales of Success

Quite often during my fieldwork, I was surprised to learn about tango artists who seemed to have "burned their bridges" in Argentina for the sake of trying their fortune abroad, with little information about the impending obstacles they would encounter in the United States. Immigrants such as Billy often decided to come to New York City, after being lured by the stories they heard from their colleagues living overseas that often underestimated the costs of their migratory paths in an English-speaking land. As

in Mahler's study of Salvadorians (1995), the accounts that fellow immigrants often bring back home tend to nurture a mythology that downplays the struggles many actually face in the United States.

An important trend in fostering immigrants' international recognition is to show their peers that they have been able to make it abroad. In the same way that "nobody is a prophet in her own land" (a celebrated Argentine saying), claiming one's triumph overseas turns into a one-way ticket to status recognition back home. While the tale of the American dream fuels immigrants' expectations of success, at the same time, it awakens anxieties regarding their future options. Some tango artists feel the pressure to keep up a successful image while living overseas as the price they must pay for having left their country. By the same token, relatives and friends in Argentina often become faithful reminders of the flourishing paths that those living abroad should follow.

As a result, while some study participants attempted to hide the difficult living circumstances they experienced in New York City—in order to protect themselves from their peers' unrealistic expectations—others were fond of inflating their successes by either exaggerating their achievements or by surreptitiously hiding their scuffles and failures. The latter entails minimizing the difficulties artists may encounter in making a decent living, downplaying the competition for tango gigs, and exaggerating their incomes. Chardoma, for instance, shared with me the story of one of her colleagues who had come to Manhattan to teach and perform for just a few years. Back in Argentina, he would tell his friends that he had a three-bedroom house located on Broadway. Instead, it was a rented studio where he taught a weekly class as an adjunct instructor.

Many prospective tango immigrants would like to believe that they can easily get legal jobs in the United States, regardless of the complicated procedures involved in qualifying for a visa or the perils of remaining as an unauthorized immigrant. As in the case of Billy, some artists decided to try their fortune in the United States based on "what they have been told" in Argentina, although they had gathered little factual information concerning the procedures by which to find jobs and housing, or even the skills and paperwork needed to become eligible for working visas. Even if some tango locals warn their comrades about the increasing difficulties of making a living in New York City, particularly after September 11, 2001, the perceived advantages of working in "the Big Apple" are frequently seen as far more numerous than its shortcomings, particularly for those facing a difficult economic situation in Argentina.

Exaggerated narratives of success also become a means for émigrés to

counter the frustration, amid a diminished self-esteem, that many experience when living overseas. Once their initial jobs are no longer seen as temporary, newcomers' enthusiasm is often replaced by despairing stories of social stagnation and status depreciation. This is a trait also shared by younger artists, particularly those from middle-class backgrounds, who are still struggling to launch their tango careers while trying to avoid downward mobility.

The chronicles of disillusionment illustrated in this chapter are not random but are actually woven into very specific circumstances. Social networks take on a life of their own, even after the initial purpose of migration and its incentives vanish (Falcón 2007; Massey 1993). The patterns of tango immigrants' relocation are consistent with resource-in-place support, which means that social webs send immigrants to where networks are already in place. And it is precisely due to the lively strength of Argentine social ties that many artists have continued to try their fortune in the United States, notwithstanding the country's cyclical economic recessions in the past decade.

Limitations to immigrants' skills and human capital also play a key role in restricting their opportunities, as in the case of elderly newcomers who do not speak English and whose talents (e.g., singing) are not highly in demand. Even those who have earned more money in the United States than they could have probably made in Argentina are often dazed by the incongruity between their roles as tango artists and the menial job positions they have to accept in New York City. For some tango performers, these activities are seen as a temporary adjustment period or *derecho de piso* (literally translated as the right to use the floor), which entails the payment of a symbolic toll that will allow them to succeed, sooner or later, in America.

Legal Trajectories and the Elusive American Dream

As I rushed to open the door of my apartment on a chilly Saturday morning to let Carmela in, I felt that something was wrong. Carmela, a gorgeous female tango dancer in her early thirties, looked pale and anxious, with dark circles under her big, beautiful eyes. Clearly, I thought, she had not slept well the previous night. I was wrong. I soon learned that she had hardly *pegado un ojo* (didn't sleep a wink) for the last couple of weeks and that her erratic sleep habits had become the norm rather than the exception. I immediately hurried to make *mate* and prepare bread with honey, which she ate ravenously, as she began unraveling the events of the past few weeks amid a cathartic outpouring of words. Her application for a nonimmigrant visa extension had been denied; therefore, she was now facing the difficult choice of either going back to Argentina or overstaying and becoming an unauthorized immigrant.

Carmela was one of the most talented dancers I had met during my tango excursions. For many years, I had witnessed her adventurous life in the artistic field as I tried to make sense of its intricacies as seen through her eyes. Like a magician who pulls rabbits out of hats, Carmela's impromptu attitude led her to follow many creative paths in the city where tango venues never seem to sleep. She had struggled to achieve success and had worked hard for it. Yet, despite Carmela's talent and her hopes for the future, the difficulties that the economic downturn had wrought on the entertainment business had had a negative impact on her ability to make ends meet. Along the way, she had not hesitated to take side jobs,

from being a babysitter to a part-time cashier, in order to get by in one of the most expensive cities in the world. Artistic survivors like Carmela, I kept telling myself, always make it despite their seemingly unstable personal circumstances. Stories like hers are not only emblematic of the many struggles that freelance immigrant artists generally endure to make a living, but also of the ongoing legal barriers that many of them face in America.

This chapter reckons the complex paths followed by Argentine tango artists in getting, and maintaining, legal status in the United States. It delves into the contributing factors that both aid and prevent immigrants from advancing their legal trajectories, including the social networks that grant them contacts for jobs and visa sponsorships. This approach challenges the widespread idea of immigrants as having a fixed legal status, as either legal or unauthorized aliens. In the following pages, the term "legal trajectory" conceptualizes an immigrant's course through a series of steps during a stay in the United States—ranging from being undocumented (e.g., due to overstaying a visa) to obtaining US citizenship.

Despite the fact that most of my respondents followed progressive careers in which the length of stay usually accompanied their paths toward US residency, several described stagnant or retroactive trajectories. This was particularly the case for those who either had lost their US permanent resident status and reentered the United States as nonimmigrant visitors later on, or remained in this country after their visas expired. Lawful permanent residents, popularly known as "green-card holders," may lose their status when remaining outside the United States for more than six months at a time. Argentines' legal trajectories in this study basically contemplates four distinct possibilities: their eligibility for a nonimmigrant visa that may eventually turn into US permanent residence; their unauthorized status, mostly due to overstaying; their eventual return to Argentina; and, finally, their moving to Europe. The latter has lately become more commonplace particularly among Argentines who are eligible for European citizenships on the basis of blood ties.

The idea of a dynamic legal career (progressive and regressive) allows us not only to conceptualize tango immigrants' diverse patterns of social incorporation—including their access to legal and social rights—but also to explore the importance of social capital in shaping their residence and citizenship options. The notion of retroactive legal careers also challenges widespread beliefs that assume an immigrants' forthright assimilation into mainstream American culture. As pointed out by Itsigsohn (2009), in his

study on first- and second-generation Dominicans in Providence (Rhode Island), racialization and social polarization have remained as pervasive barriers for Latin American's successful integration (both legal and economic) in the United States.

The term "legal trajectories," as used in this chapter, is inspired by Erving Goffman's notion of the "moral career" endured by patients in mental asylums.[1] According to Goffman (1961, 1997), patients in mental institutions experience a psychosocial adaptation through which they incorporate the roles and social expectations regarding their new positions by progressively abandoning their previous identities. The process involved in a patient's entrance into and permanence in the asylum is defined by a tension between the outside and the inside, and by conscious and unconscious rituals of passage that have an effect on the roles and beliefs concerning the self and others. Although Goffman employed the term "career" to describe the institutional path of a mental health patient, and not the life of an immigrant within the United States, the notion of legal careers or trajectories is useful here to reckon Argentines' efforts to maintain a legal presence while pursuing their artistic endeavors. These paths are also accompanied by changes in immigrants' self-image, as many face unprecedented obstacles to working and performing overseas.

Following Goffman's symbolic interactionism approach, Argentines' legal paths in the United States are influenced not only by their social positions, such as socioeconomic and legal status, but also by their self-representations. Hence, the concept of a legal career also alludes to conscious and unconscious rituals of passage that shape immigrants' roles, duties, and rights, as well as their self-image reinforced by their surrounding milieus. Even though I could not predict who among my interviewees would become legal immigrants, the synergies between social connections and skills (social and human capital) seem a powerful dyad in assessing their legal trajectories in any direction. Artists' personal grapevines, represented in the saying *"dime con quien andas y te diré quien eres* (tell me who you're with and I'll tell you who you are)," epitomize the informal arrangements that allow immigrants to gain temporary visas as students and creative performers or even as business partners.

Next, I analyze the Visa Waiver Program (VWP), which eased the influx of tango artists from Argentina to the United States, beginning in 1996. Its termination in early 2002 was preceded by both the terrorist attacks in New York City on September 11, 2001, and the Argentine sociopolitical crisis that took place in December of the same year.

Political Turmoil and Immigrants' Hurdles to the American Dream

After the terrorist strikes in the United States on September 11, 2001, a few things were about to change for the protagonists of this story. For the first time, the reputation of New York City as a "promised land" among immigrants was seriously compromised. Some of the tango artists I met during fieldwork considered returning to Argentina, frightened by the idea of new violent acts against the United States. With the passing of the antiterrorist laws of October 2001, immigrants also became more vulnerable to detention and deportation, and some feared that their future mobility would be compromised. In most cases, these concerns were not enough to persuade tango artists to return to their home country, nor did it stop the stream of those coming to the United States (*La Nación* 2001). September 11, 2001, not only raised concerns about the increasing numbers of unauthorized immigrants in the United States but also focused attention on the frontiers of Brazil, Argentina, and Paraguay. In the months following the attacks, newspaper articles covered the United States' interest in better controlling Argentina's borders, which were suspected as easy terrain for the operation of terrorist cells (Bleta 2001).

Amid these events, the VWP that had benefited Argentines for more than five years had come into jeopardy. The VWP had been created in 1996 for the purpose of encouraging tourism and business between high-income countries and the United States. Argentina was chosen to join this program along with twenty-eight other countries considered to be low risk, a profile measured on the basis of low rates of rejection of tourist visas (Siskin 2004). The waiver allowed citizens of these selected countries to visit the United States, for either tourism or business purposes for up to three months, with the only requirement being having a valid passport. Although a nation's political and economic wealth does not predict eligibility for the VWP, the program favors countries with stable economies that are in good standing with American interests (Siskin 2004). The VWP is also considered beneficial for the United States, because it saves money in consulate personnel while promoting tourism.

In the year 2000, President Bill Clinton reframed the extension of the VWP between Argentina and the United States, which had been renewed annually for the prior four years, and passed it as law. Argentina's entry and permanence in the VWP coincided with neoliberal policies that greatly benefited commercial agreements with the United States. The VWP simplified the journeys of Argentine citizens considerably, particularly among

those who would otherwise have encountered difficulties in obtaining US visas.

Contrary to popular belief, being the beneficiary of a visa waiver or having a visa does not guarantee legal entry to America. In fact, a visa only serves as preliminary permission to seek admission at a designated port of entry in the United States. It is at the border crossing, typically an airport, where travelers seeking admission must face agents of the US Customs and Border Protection. More than anyone else, these inspectors recognize the power of immigrants' social webs as incentives to migrate. Therefore, the questions they pose to Argentine travelers landing on American soil include whether they have relatives in the United States and what hotels or residences they are planning to stay at. Responses that may reveal visitors' family ties in the country, or staying with friends and family, can be a red alert for officials who may suspect their intentions to remain illicitly (Margolis 2009).

The VWP was enacted at a time when the tango's renaissance was echoing worldwide, so many of the seasoned and wannabe tango artists I met during those years typically relied on the VWP to enter and leave the United States on a regular basis. Nonetheless, when immigration agents suspected the travelers' intent to overstay, they would send visitors back to their country of origin. On average, between four and six Argentines were returned per day from John F. Kennedy International Airport to Argentina during the year 2000 alone (Aizen 2000).

The VWP also limited immigrants' medium- and long-term migratory plans, particularly because tango artists had to leave the United States before the three-month threshold was over in order to keep their legal status. This strategy had become widespread among artists of different nationalities, so immigration officers became suspicious anytime travelers' passports showed too many entries within a short period of time. In fact, the longer Argentines relied on this method, the higher their chances of being questioned about the real purpose of their trips and being deported on the spot. Relying on the VWP was not only risky but also expensive, as it required considerable investments of money and effort to maintain an active business both domestically and overseas, including buying plane tickets regularly and procuring room and board in at least two countries. Once tango artists began approaching their waiver's expiration date, they would typically begin to reevaluate their options. The lucky ones would return to Argentina with a job contract in hand, ready to start the paperwork for a work or performing visa; others would seek alternative contracts in Europe, Latin America, or Japan.

The end of the VWP arrived in early 2002, soon after the socioeconomic crisis in Argentina that had taken place just a couple of months earlier. Argentina, a country that was among the ten richest nations of the world in the early twentieth century, had fallen to one of the most financially troubled by the dawn of the twenty-first (Marrow 2007). December 2001 was one of the most difficult holiday seasons in Argentine memory, both at home and abroad (Felix 2002). Political unrest and social riots followed the freezing of bank accounts, with thousands of people marching in the streets protesting their stolen funds. The resignation of the democratically elected president Fernando de la Rúa followed a barbarous police repression that ended with a half-dozen people dead and more than twenty wounded. A steady economic recession followed, with unemployment rising to 21.5 percent and 55 percent of the population falling below the poverty line (Jachimowicz 2003).

In December 2001, the *New York Times* ran front-page articles picturing respectable Argentines digging into garbage cans for leftover food—images that shocked people all over the world (Rohter 2002). An unprecedented wave of Argentine emigration followed this debacle. By the turn of 2002, rumors of the impending end of the VWP became a reality, and on February 21, 2002, it was finally terminated (Barón 2002). The US Justice Department justified this decision on the basis of an alleged increasing number of Argentine citizens entering the United States for the purpose of remaining illegally, as a result of their country's rising unemployment rates and its recent economic collapse (Barón 2002). Additional concerns included the ease with which Argentine national identity documents were counterfeited to facilitate entry into the United States by drug carriers (*mulas*) of Asian origin and the lack of control at Argentina's borders, particularly in the triple frontier with Brazil and Paraguay—areas where US intelligence suspected the existence of terrorist cells (Gerschenson 2002). The rationale for the termination of the VWP was plainly summarized as follows:

> Since December 2001, Argentina has been experiencing a serious economic crisis, including defaulting on loans by foreign creditors, devaluation of its currency, and increased levels of unemployment and poverty. As the economic climate deteriorated in Argentina, the Immigration and Nationalization Service has experienced a pronounced increase in the number of Argentine nationals attempting to use the VWP to enter the United States to live and work illegally. (Federal Register Publications [CIS, ICE, CBP] 2002)

The effects of the VWP in shaping Argentines' traveling plans to the United States are evident when examining their forms of entry, for either business or pleasure, before and after Argentina was barred from the program. While 25,877 Argentines utilized the VWP to arrive in the United States in 1996, this figure rose exponentially in the following years (along with the number of unknown/missing entries), reaching 443,058 in 2001. This number fell to 79,889 in 2002, concomitant with the expiration of the VWP in February of that year. Informal accounts suggest that by the time the VWP ended, thousands of Argentines who had entered the United States as tourists had become unauthorized immigrants by overstaying (Bernstein 2005).

New creative ways to travel to the United States, mostly supported by artists' reliance on nonimmigrant visas, followed suit. This is evident by looking at the steady increase in the number of Argentine visitors who arrived in the United States from 2002 on for either business or pleasure (with B1 and B2 visas, respectively). The modest number of visas for temporary workers and their families almost quintupled throughout this period, from 554 in 1996 to 2,592 in 2010. Finally, a growing number of Argentine citizens have lately turned their gaze to Europe, as a few European countries (including Spain and Italy) continue to hold Visa Waiver Programs with Argentina and even extend citizenship rights to Argentines on the basis of blood ties.

Uneven Legal Paths

Carmela, introduced at the beginning of this chapter, had initially visited New York City in 1999 by relying on the VWP. She did so by carrying an impressive portfolio of pictures and press releases for her shows, along with letters of recommendation from colleagues and notes of praise from students. For a couple of years, she had done quite well as a tango instructor by teaching and giving demonstrations in different dance studios. As had many of her tango comrades before her, she managed to regularly travel to the United States by relying on a series of traveling options: she would spend a few months each year teaching and performing in Argentina and Spain, where she would also get in without a visa, and then come back to New York City on a regular basis. For Carmela, as for many of her colleagues, Manhattan had turned into her "main center of operations," a locale intrinsically linked to the rest of the tango world and a place where it had become relatively easy for her to seek promising artistic gigs.

Table 1. Nonimmigrant Admissions by Country of Citizenship (Argentina) and by Selected Class of Admission, 1996–2010

Year	Total (1)	Visa Waiver and Missing/ Unknown (2)	Temporary visitors for business (B1)	Temporary visitors for pleasure (B2)	Temporary workers (3)	Other classes of admission
1996	428,737	25,877	60,838	318,186	554	23,266
1998	544,158	282,651	42,219	175,943	924	42,421
1999	539,304	329,619	30,935	127,527	962	50,261
2000	546,796	411,010	22,118	83,039	1,579	29,050
2001	541,493	443,058	14,304	48,278	1,848	34,005
2002	252,333	79,889	34,880	77,155	2,325	58,084
2003	241,352	1,983	55,605	118,229	2,779	62,756
2004	242,103	2,029	58,510	130,518	2,674	48,372
2005	256,680	2,739	60,831	144,360	2,603	46,167
2006	275,778	2,251	65,671	161,331	2,670	43,855
2007	337,511	3,172	72,782	214,441	2,742	44,374
2008	383,803	3,107	77,062	261,448	2,846	39,340
2009	395,781	3,672	58,324	297,180	2,747	33,858
2010	482,637	4,411	68,189	374,957	2,592	32,488

(1) Data for 1997 do not appear due to inconsistencies in the Nonimmigrant Information System (NIIS/DHS).
(2) Argentina was removed from the Visa Waiver Program in February 2002; therefore, the numbers beginning in 2003 only correspond to missing/unknown entries.
(3) Temporary workers include internationally recognized athletes or entertainers (P1); artists or entertainers in reciprocal exchange programs (P2); artists or entertainers in culturally unique programs (P3); spouses and children (P4); temporary workers with extraordinary ability/achievements (01); and temporary workers accompanying/assisting in performance (02).
Source: This table is based on data drawn from the *Yearbook of Immigration Statistics* for the years 2006–10, of the US Department of Homeland Security, http://www.dhs.gov/yearbook-immigration-statistics.

In any event, Carmela's course of action progressively began to lose its attractiveness, as it required unsustainable amounts of energy to maintain a tango business in many places at the same time. And like many other young women, Carmela soon realized the difficulties of what she called her "gypsy lifestyle," which had prevented her from finding a partner (both in dance and in life) and starting a family. Therefore, by the turn of the new century, she had decided to settle in New York City, at least for a few years. For tango artists who wish to remain in the United States, the main priority is to find a temporary job while seeking a prospective visa sponsor. The search for the latter often becomes an exhausting hunt that eventually raises interpersonal tension between artists and potential employers and foster opportunities for exploitation and abuse, adding to performers' prevailing fears that suitable employers may withdraw their applications at any time.

My respondents' search for reliable visa sponsors in the informal entertainment economy was usually a difficult task, not only because many employers would prefer to hire "illegal aliens" but also because of the numerous requirements for work eligibility. Employers and entrepreneurs are actively discouraged from formally hiring foreign citizens, even if they are legally in the United States, due to the possibility of being penalized if their protégées are charged with any kind of misdemeanor or other criminal activity.

An immigrant's motivation to regularize her or his legal status has to be strong in order to keep investing resources (mostly time, energy, and money) into future promises of legality. It is not uncommon for tango artists to borrow money from relatives and friends in order to afford their visa paperwork. Soon after arriving in New York City, some will seek temporary employment in nonartistic jobs in order to finance their immediate expenses such as housing, food, and transportation. Yet, in most cases, survival in the city is harder than initially expected, since "dollars in the United States do not grow on trees," as many Argentines claim their peers back home believe otherwise.

The increasing barriers to obtaining US visas in recent years, along with their mounting costs, have contributed to lessening artists' employment opportunities, even if temporary, in the United States. The legal hurdles that newcomers now experience contrast with the stories told by the tango's old guard, whose members arrived in the 1960s and 1970s and who still remember their relatively swift passage from being visitors to becoming US residents and citizens. Legal requirements in recent de-

cades have privileged those with specialized skills and higher education credentials. Following September 11, 2001, rising fees and tighter eligibility regulations have made the overall process more difficult for visa applicants, including endurance of longer delays and higher rates of visa denials.

For instance, in 2009, Orquesta Kef, a musical group of young fellows from Buenos Aires, which blends Argentine tango and folk tunes with klezmer music (an Eastern European tradition of Jewish origin), was denied a visa by US immigration officials. This was despite the fact the group had been formally invited by a US organization to perform in Los Angeles. The US government's determination to refuse to give the so-called performance visa (P3) to this band was based on the assertion that its music was not "culturally unique," a necessary requirement for this type of visa (NBC News 2012). Public outcry followed this decision, including postings on blogs and social media petitions, which led to a retroactive visa approval that came too late—the Hanukkah event where Orquesta Kef was scheduled to perform had passed, and the group never got to play in the United States. The visa denial also became a viral joke on the web as illustrated by a blog that was sardonically entitled "Keeping America Safe from Latin Klezmer Bands" (Keating 2009). On the bright side, the US Office of Citizenship and Immigration Services soon after announced a modification of the "culturally unique" concept. It now includes fusion genres that pertain to more than one culture or region. The new definition applies to reviews of future applications for P3 visas from foreign artists and entertainers, including tango artists who perform hybrid styles.

Argentine artists are not the only ones to encounter tighter regulations to legally enter the United States. Recent cases of denied visas include those for a Brazilian hip-hop group, a Mexican indie-rock band, and a Canadian modern dancer (Keating 2009). In 2006, this escalating situation led the renowned cellist Yo-Yo Ma, who made Astor Piazzola's tango music internationally famous in the 1990s, to testify in front of the US House Committee on Government Reform. This was part of a strategic appeal to force the American government to ease entry for foreign musicians. Ma spoke on behalf of the musicians joining the Silk Road Project, a company he founded more than a decade ago, which brings together artists from across Central Asia and the Middle East. His main argument highlighted the pernicious consequences that US visa delays and rejections have caused to the global artistic community (Wakin 2006).

Juggling Legal Options

The end of the VWP in 2002 did not stop the flow of Argentines to the United States. The rising reputation of Argentine tango artists worldwide, along with steady competition from a larger number of professional dancers from all over the world, helped professionalize the tango métier, which, in turn, led to an increasing demand for nonimmigrant visas. Despite the rising restrictions Argentines encounter to apply and be granted nonimmigrant visas, the fact is that visas for tourism and temporary workers—organized around variations of the letter P (P1, P2, and P3)—have continued to rise. This is particularly the case among artists, athletes, and families who visit the United States to participate in cultural and artistic events, including Reciprocal Exchange Programs (US Citizenship and Immigration Services 2012).

Holders of P visas typically include tango and flamenco dancers, and musicians who play traditional folk music. Applicants must be sponsored by arts and entertainment organizations in the United States, which are held responsible for all the activities involving their guests' performances, teaching, and coaching activities—either as individual entertainers or as part of a group—in culturally unique initiatives. Although the maximum amount of time artists may apply for is one year, the visas may be renewed a number of times.

Tourism and business visas and those for special occupations (known as working visas or H-1B) are additional legal instruments sought by tango artists, who either visit the United states periodically or seek to remain legally in this country while alternating their tango endeavors with other occupations. Visas for business or work qualify foreigners to undertake employment and conduct entrepreneurship transactions in the United States, and to eventually seek permanent residency. A limited number of exceptional visas, O-1, also known as "genius" visas, are granted to artists with unique abilities in their fields of expertise. These are typically issued to musicians who perform on difficult and rare instruments, as in the case of bandoneón players and world-renowned tango dancers. Some tango entrepreneurs can self-petition for a US visa without the need for a sponsor. To that end, they must meet the statutory criteria for extraordinary ability by proving they are the best in their respective fields (US Citizenship and Immigration Services 2012).

In all cases, the odds of successfully obtaining a business or working visa rest squarely on having rich artistic and business contacts and proof of

sponsored financial support, along with established artistic skills. Changing one's visa status from one type to another is commonplace throughout Argentines' legal trajectories. Visa extensions and applications in different nonimmigrant categories may also be granted without having to leave the United States—depending on the type of visa and the applicant's specific circumstances.

Being issued a nonimmigrant visa involves a complex, multistep process that starts with the employer filing an application with US Citizenship and Immigration Services in the country of origin. Prior to obtaining a visa, applicants must accompany their sponsor's petition with a job contract and demonstrate evidence of their skills in the chosen field. Failure to obtain an approved petition (within six months before the proposed show) may hamper the artists' trip, including having to postpone or cancel all scheduled shows. In all cases, performers must appear for an interview with a consular officer in their homeland to show that they have appropriate qualifications for the particular visa being requested.

Critical aspects in the visa application process involve providing convincing evidence of the candidate's qualification to teach or perform in the United States, proof of financial support to cover the performer's travel expenses, and the time and effort needed to collect all the necessary documentation. This process will not be completed without a comprehensive professional dossier that validates the candidate's training, trajectory, and experience in the selected field. Valid records include tango artists' promotional materials and flyers, photographs, videos, media reviews, awards, letters of support (written by bosses, colleagues, partners, and students), and proof of income from past performances.

Even when artists are able to find suitable visa sponsors, their temporary legal status and the flexibility and vagaries of show business often make them vulnerable to unfair contractual obligations to their employers. The latter may take advantage of immigrants' legal vulnerability by paying them lower wages and demanding long work schedules. As a result, a few of the artists I met in the field ended up trapped in the same jobs for many years in order to continue the legal procedures (and paperwork) for a US residency. These performers usually did not have health benefits and were often afraid of taking days off due to a resulting loss of income. Unfortunately, they had little or no opportunity to change their situations, because quitting (or changing) jobs could imply losing any steps already achieved toward their US residency. In some cases, the unfavorable conditions of their job arrangements became the price to be paid for advancing their

legal trajectories toward becoming lawful immigrants sooner or later. The testimonies below are eloquent in this regard:

> I was hired by this academy to teach tango full time, but they did all sorts of illegal things. For example, I was supposed to sign blank receipts, and they exploited me, since they only paid me for a few hours of teaching although I was there all day. But because they gave me the visa [a working visa], I could not go anywhere. I was trapped, and they did not keep their promises. (Carmela)

> They know that we need the job, they know that we need the visa, so *te negrean* [they treat you like a slave]. They pay you two dollars, and if you don't like it, you may leave. (Manuela)

As in Manuela's excerpt, several artists mentioned the word *negrear* when referring to the unfair working conditions they endured at some point in their legal careers. The term *negrear* derives from the word *negro*, which, as mentioned earlier, is typically employed to name dark-skinned individuals. In this context, it is also used as a pejorative term to describe abusive working conditions for which immigrants—regardless of their skin tone— have little or no control.

Not all artists' stories about their sponsors were as negative as the above quotes suggest. Given the importance of the tango field as a unique social resort, some performers were often able to find creative ways by which they remained in the United States, typically through colleagues and peers they met (both Argentines and Americans) in the entertainment and media businesses. Ironically, because of the daunting process of visa sponsorships, which poses potential sanctions to both visa applicants and their sponsors, informal arrangements between parties become the best safeguard that each side will keep up its end of the deal. Through an exchange of mutual favors, a visa sponsorship becomes a binding contract between the associates as a sort of omnipresent reminder of their reciprocal ties, even when no formal employment exists.

For instance, a producer may agree to sponsor the visa of a tango dancer in exchange for setting up joint entrepreneurial ventures, including co-organizing festivals or nomadic milongas. An Argentine or American entrepreneur may serve as the visa sponsor of an Argentine artist, even when no professional services or salary are involved except a mutual agreement to launch a touring tango show. In many cases, having a colleague or

friend willing to pass for a legal sponsor is crucial to a performer's ability to remain legally in the United States. Finally, as noted earlier, becoming an independent entrepreneur, as in the case of tango artists launching their own dance companies, allows them to self-sponsor for work visas and then become their own bosses.

Seeking the European Dream

Aracely was a vivacious twenty-six-year-old tango instructor when I first met her in 2000. She had vividly recalled the day, two years earlier, when she and her boyfriend, Fito, decided to leave Argentina, encouraged by the VWP. They had hoped that their European looks would help them pass the official interrogation process at the US airport, and they were right. Having rehearsed the questions and answers on the phone with friends already living in New York City, they were able to successfully outmaneuver the immigration officer's tough questionnaire. Unable to find a visa sponsor, Aracely and Fito then decided to overstay at the end of the three-month waiver period. Once settled in Queens, they both got jobs in the service economy of food and entertainment—Fito as a pizza cook and Aracely as a hostess at a Dominican restaurant—while she began looking for venues in which to teach and practice tango.

As with other immigrant populations, the streams of Argentines who landed on American shores over the past decade have been welcomed in the immigrant economy, particularly the tertiary sector of services. While for many tango immigrants this often leads to off-the-books jobs that pay in cash, for employers, this means hiring cheap labor in fields not typically attractive to the native labor force. Young people like Aracely have flocked to New York City in recent years to work in any job that will back up their tango endeavors. Although the law known as IRCA (Immigration Reform and Control Act), passed in 1986, made it a crime to hire undocumented immigrants, this did not stop employers from hiring them and, instead, encouraged creative ways to circumvent the law. Employers are expected to ask potential employees for identification to prove their legal status, but IRCA does not require verification of its authenticity.

As reported by other scholars, unauthorized immigrants may buy or borrow Social Security cards or green cards, which in some cases are provided by employers themselves (Chávez 1992; Margolis 2009). Despite tighter immigration controls in recent years, employers in New York City seem to prefer undocumented laborers, particularly in the sector of

services that largely rely on an immigrant labor force. While these jobs are often considered ephemeral opportunities to make good money, the same occupations that initially seem a gateway to the American dream later on become obstacles to immigrants' upward mobility in the artistic field.

A couple of years after Aracely's arrival in New York City, I sat with her at the Italian restaurant where she was working as a hostess. While sipping a cappuccino, she shared with me the uncertainties about her legal path in the United States. She still felt fortunate to be able to continue making a living off the books in the restaurant industry. With her European looks and youth, she had been able to camouflage her unauthorized status by passing as "another white Italian in town." Nevertheless, Aracely's alleged whiteness had become an *arma de doble filo* (double-edged sword) in moving her career forward. If, on the one hand, her physical appearance had somehow protected her from the fear of detention and deportation; on the other hand, her unauthorized status had hurt her social mobility. Anytime she had gotten close to being selected for a tango tour, her unauthorized status had turned into a barrier for her to be finally chosen over other tango artists. And she was painfully aware that time was flying by while her life was still on hold.

Feeling homesick for her family and friends in Argentina, and without having a clear idea of what the future would hold, she had become stuck in the United States. Aracely's tango career was at a standstill. The many hours she had spent working in the restaurant industry had left her, in the end, with little time to practice tango and, consequently, she had hardly attended any milongas in the past year. Not being on the spot meant not having the opportunity to publicize her tango practice among colleagues, producers, and potential students. As noted earlier, "to see and be seen" at the milongas is the sine qua non condition for artists to make sure they will remain visible and active within the tango core.

A few months after our conversation, I again stopped by Aracely's restaurant to say hello, and I encountered a very different situation. That same day, Fito had boarded a plane for Spain. Growing tired of his pizza job and knowing he had little chance of legalizing his status in the United States, he had mobilized his family network in Argentina and Spain and had finally become a Spanish citizen. With his new passport, he felt like the beneficiary of a winning lottery ticket. A skillful trader in the field of migrant portfolios, Fito was not planning to stay in Europe for good, or at least not immediately. In the worst-case scenario he would reinitiate the path of yo-yo travel between Spain, the United States, and Argentina as a

legitimate member of the European Union and not as a surreptitious Argentine émigré.

Aracely now seemed confused about leaving the United States for Spain. As an Argentine citizen, she was planning to return to Buenos Aires, get a new passport, and enter Spain, thanks to the visa waiver that the latter still had with Argentina. But why do so, if Spain was even more difficult to navigate than the United States? What if she could not find a good job? By the time I attended Aracely's farewell party about three weeks later, I learned that many of my Argentine friends, and a few tango artists, had already become (or were in the process of becoming) European citizens. Both in New York and Buenos Aires, the news of these newly minted Europeans would provide an opportunity for impromptu celebrations to honor the holders of this "citizenship capital," as if they were the lucky recipients of a juicy inheritance.

As in the case of other ethnic groups in Latin America, Argentines of European descent are increasingly seeking European citizenships and may opt to settle in their ancestors' countries of origin (mostly Spain and Italy) as Euro-Argentines on the basis of their eligibility for membership into the European Union, supported by blood links (*jus sanguinis*). Because Spanish and Italian nationalities can be passed from one generation to the next, even by individuals living abroad, and may be held concurrently with an Argentine nationality, this phenomenon has been more marked in the past decade (Cook-Martín and Viladrich 2009a, 2009b). Thanks to bilateral treaties between Spain, Italy, and Argentina, eligible Argentine citizens can enter those countries without a visa and usually begin the eligibility process for a dual citizenship once they have settled, and even overstayed, in Europe.

Cyclical economic recessions in the United States, along with the increasing obstacles to obtaining visas, have complicated immigrants' legal and employment options. Therefore, holding a European passport has become an alternative path to enter the United States, thanks to the VWP held between the United States and several European nations, including Italy and Spain. This trend became more marked after September 11, 2001, when many tango artists lost the possibility of back-and-forth travel between Argentina and the United States, along with the meager work opportunities they found in both countries. In the end, for some tango immigrants a European passport does not mean moving to Spain, Italy, or Germany for good. Instead, it gives them freedom to routinely enter Europe and the United States on the basis of their EU citizenship. For a

handful of Argentine artists, this has become the most plausible alternative to regain legal entry to the United States.

Overstaying and the Undocumented Trap

In the past few years, I have often asked myself this question: if undocumented status brings so many disadvantages, why did some among my tango respondents decide to overstay in the United States in the first place? Overstaying was the most frequent category found among those of my interviewees who thereafter became unauthorized immigrants in this country. Rather than being a planned trajectory, this was often the result of previous failed attempts to keep a legal status. Although most tango artists' stories seem to follow an optimistic path, in which the length of stay in the United States positively correlates with the achievement of legal rights, I also encountered retroactive legal careers. This was the case for those who lost their US resident status by staying away from the United States for more than six months, were unable to switch or extend their visas at the end of their work or study program, or had their requests for a visa extension denied.

Any cross-sectional study will be necessarily biased toward foreigners who have remained in the United States, even unlawfully, and against those who returned to their countries, either voluntarily or not. Some of the tango performers who ended up overstaying in the United States faced a conundrum between remaining there illicitly and going back to their home countries. After a certain number of years, they found that the obstacles to simply making a living in New York City were insurmountable. Over time, I have seen a few tango artists go back to Argentina for good, particularly when they lost hope of regularizing their legal situations and were unable to secure ongoing employment in their fields. In almost all cases, once tango artists become undocumented, it is usually very difficult for them to later change their legal status, an issue that makes their dreams of social incorporation and upward mobility even more unattainable.

Among my study participants, those who decided to overstay at the time of the VWP did not initially consider their unauthorized status as permanent, and were prone to believing that sooner or later their legal trajectories would resume, as in the case of those hoping for an amnesty. In fact, their urge to make quick money to make ends meet, amid the weight of

loans sought from friends and acquaintances back home, was a powerful motivator to overstay. Even when tango artists were lucky enough to get hired within three months, they still had to go back to Argentina to process the paperwork in the US consulate, and they might still have their applications denied and not be eligible for a working visa within the calendar year.

Once tango immigrants decided to overstay, their alternatives included finding off-the-books jobs, either in or outside the tango field, and relying on somebody else's identification. A handful of the performers I met at the time had obtained counterfeit documentation in fields that typically recruit informal labor: restaurants, delivery, construction, gardening and landscaping, and domestic chores. Human agency naturally finds its way and slips through the ambiguities and uncertainties of legal restrictions and, as Argentines like to say, *hecha la ley, hecha la trampa* (once the law is made, the trick is also made). With a borrowed Social Security number, an employer might still obey the law by reporting the employee's tax information to the Internal Revenue Service. In any case, newcomers were not randomly selected as candidates for undocumented status. In contrast with their peers from the upper and middle classes, who more often counted on credentials and social contacts to obtain visa sponsorships and legal jobs, immigrants with little formal education (typically from lower-income groups) were more likely to remain unlawfully in the United States.

Many of the life histories I collected during fieldwork, even from famous tango figures, did not quite fit with the image of the easy "rags-to-riches" career path that the media and the popular literature have popularized. The stories of Carmela and Aracely in this chapter show the subjective experiences of immigrants who somehow felt that their lives in the United States had been paralyzed because of their legal tribulations. They would typically attempt to hide their unauthorized status or, at a minimum, pretend that it did not interfere with their professional careers and everyday lives. Although unauthorized immigrants often pay taxes, their lives are often invisible because their struggles, work, and contributions do not add up to any record under their own names. And, in the end, they embody what mainstream society rejects and blames as the source of its inner problems.

Becoming undocumented has both objective and subjective consequences for tango émigrés. Assessments of individual success are both relational and comparative, as they relate to one's point of departure vis-à-vis others' social positions (Ortner 2003). As noted in chapter 4, unauthorized

immigrants tend to portray themselves as being situated between invisibility and marginality in US society, aspects that suggest paradoxical images regarding their self-representation. While invisibility is a prerequisite for these immigrants' safety, it also becomes an everyday reminder of the unlawful legal circumstances that hinder their social trajectories. Unauthorized artists in this study rightly assessed the discrepancy between their salaries—which are comparatively better in the United States than in Argentina—and their low-prestige occupations. Some even experienced a process of double downward mobility by also being socially removed from resourceful social networks that could have helped nurture their dreams of success in the arts and entertainment industries.

Keeping up a glamorized demeanor in the tango field helps artists attract tango fans and students while avoiding calling unnecessary attention to themselves. As Aracely put it, "The more you show what you do, the less they will think you are staying illegally in this country." This is particularly the case among fair-skinned individuals who, as in the case of Aracely, find it easier to pass for Italians or Eastern Europeans. This camouflaging strategy not only protects immigrants from being identified as "undocumented aliens" but also preserves them from the social sanctions, even coming from other Argentines, associated with the stigma of illegality. These individuals will find few advantages and many disadvantages in sharing the difficulties brought on by their unauthorized status. Even for those embodying European looks, endurance of undocumented status over time hampers their dreams of upward mobility and reinforces their negative self-images as disenfranchised individuals in US society. In the end, immigrants' banned stays in the United States claim a continuous negotiation between their visibility and their social marginality, as a dialectic struggle endured daily for the purpose of fulfilling their own versions of the American dream. The following account, based on a tango dancer's retroactive legal path, further illustrates this point.

Cristal's Path

Cristal, whom I introduced in chapter 3, was a lively tango instructor and dancer in her late twenties when she first arrived as a tourist in New York City in the mid-1990s, encouraged by a couple of her international tango friends she had met in Argentina. Despite the fact that she had danced tango in Argentina as an amateur, she had become a paid tango instructor once she moved to New York City, at a time when the demand for

tango dancers from Argentina was at its peak. Cristal's entry to the Manhattan tango field opened a new career for her. Although she had initially relied on the VWP to travel to the United States as a tourist, she was soon able to get a vocational student visa (M1) to study English under the sponsorship of a cultural organization in Buenos Aires. Yet, this visa did not grant her permission to either work legally or change her status to a US working visa. Through time, Cristal found it almost impossible to continue paying for her classes—a basic requirement for remaining as a legal foreign student in the United States. Meanwhile, she had been unable to find a suitable visa sponsor. While Cristal was still trying to figure out her best legal alternatives, she ended up overstaying, after her visa expired.

> I mean, I got tired of going back to Argentina and starting all over again. I kept renewing the [student] visa every time, and at the end I requested an extension and did not get it. At some point, I had sought the possibility of getting a job contract and applying for the visa in Argentina. But what if I go back and they don't want to give me the visa anyway? It is a risk that I don't want to take.
>
> The thing is, I don't recommend my situation to anybody. Anytime I see anyone who is about to become illegal [due to overstaying], I tell them, "Go back right now, don't stay here, go back now!" But I got tired of doing it for myself all the time, and I became illegal.

Although Cristal had consulted with approximately five lawyers, she felt hopeless and confused, as they disagreed on how to solve her case:

> They gave me contradictory opinions. For instance, I went to see this lawyer with one of my friends who is in the same situation. We ended up having a fight with him. Do you know what was his suggestion? "Girls, you are so beautiful that you should get married and solve the problem right away." We couldn't believe it, and we left. He is a lawyer; he was not supposed to tell us that! I think he did not understand anything at all. He also told us that we could go back and forth [via the VWP] and nothing would happen to us.
>
> However, another lawyer told me that it was very risky to do something like that [in reference to the VWP]. What would happen if that morning the immigration official you have to deal with in the airport woke up in a bad mood, had a bad breakfast, and decides to send you back? You see, this is a gamble. . . . I know two Argentine guys who have

been here illegally and went back and forth and had no problems. One of them had been here illegally for almost six years. He went back to Argentina and returned with a new passport to the United States, just like that. The reasoning is that since Argentines do not need visas to enter this country, they won't be chasing us to see if we are here legally or not.

Cristal's comments illustrate three important aspects concerning immigrants' legal trajectories: the attempts and difficulties that many face in finding suitable sponsors for nonimmigrant visas; marriage as an assumed shortcut to obtaining a US permanent residency visa; and the role played by counselors (including lawyers) in shaping immigrants' legal careers. First, although Cristal had developed multiple social liaisons in New York City's tango world, her scant tango curriculum had become a main hurdle in her ability to prove intellectual and artistic proficiency—both necessary conditions for getting a work visa. Within Bourdieu and Passeron's (1979) theory of the certification system, degrees are a form of cultural and human capital that allows agents to trade their value in the professional and employment markets. With the excess of diploma holders taking over positions previously held by those unqualified, the market has had an adverse effect on those who do not hold such diplomas. Despite the fact that Cristal counted on resourceful contacts in the tango field as proof of her bridging capital, she lacked the necessary human capital assets in the form of university diplomas and academic certifications.

Because visas for temporary workers are issued to those who, in theory, will not pose any competition to US workers, the more highly educated and specialized an applicant is, within a highly demanded employment sector, the better his or her chances of being eligible for a performing visa. Although some of the artists I met during fieldwork were eager to upgrade their credentials (e.g., via board exams or master's degrees), many did not have the time, money, or necessary English skills needed to improve their education via certification. In addition, as a result of recent economic recessions, growing numbers of performers and artists have turned to graduate education in the United States, leading prestigious institutions to accept a lower percentage of applicants and offer less financial assistance.

Second, the possibility of getting married to a US resident or citizen is a common tale in the migratory repertoire of many of my interviewees, but such marriages are nowhere as frequent as the public would imagine. For the most part, my study gave voice to the first wave of artists who began arriving in New York City at the beginning of the tango boom in the 1990s.

Most of these performers handled their immigration cases on their own and, to my knowledge, only a few had married American citizens who petitioned on their behalf.

Finally, a few among the tango performers I met during my fieldwork told stories about unscrupulous immigrant lawyers, a fact that has been reported by other authors as well (Mahler 1995; Margolis 2009). Legal paperwork takes time, and even under the best of circumstances a lawyer's willingness to accept a case does not guarantee its success. Furthermore, it is common practice for lawyers to charge a prearranged fee, including a retainer, to assist foreigners with immigration procedures even if their cases do not prosper in the long run. Still, several interviewees told me stories of deceptive lawyers who allegedly took the money and ran away with it. Their accounts varied from paying high sums of cash in exchange for visas that never existed to unsuccessful procedures that set their cases right back where they had started. Quite often, artists found out that their paperwork had never been submitted or were incomplete. Filing incorrect and incomplete applications are two of the typical legal problems that may lead to the official rejection of a US visa petition and even to a deportation proceeding.

In most cases, artists would insist on finding a proficient lawyer to help them out. Immigrants' reliance on legal counselors and colleagues familiar with US immigration laws is paramount to advancing their legal trajectories, particularly since many of them know little about their rights. Above all, immigrant laws are complicated, change often, and require training and ability to be successfully interpreted. Finally, lawyers tend to inspire hope in immigrants' lives by providing assurance that each particular case will be solved through the analysis of the shortest and easiest legal road to US residency.

Untangling Immigrants' Legal Paths: Between Social and Human Capital

While revisiting Carmela's story at the beginning of this chapter, I could not help but ask myself as I had done a few times in the past: why do some talented artists make it while others keep struggling through menial jobs? Why do some Argentine immigrants seem to encounter endless hurdles to becoming eligible for a work visa, while others appear to have a stroke of luck and get a visa sponsorship right away? These questions haunted me during a great part of my fieldwork and, I must acknowledge, they involve

not just tango artists but immigrants in general. Many Argentine artists, like Carmela, faced endless stumbling blocks throughout their artistic trajectories in the United States; some even ended up quitting their artistic endeavors altogether, changing fields, or returning to their homeland when things did not work out.

Nevertheless, even after the 2002 termination of the VWP, the transit of tango artists to the United States has continued. The unparalleled popularity of Argentine tango worldwide, amid the stature of Buenos Aires as a main tango factory, has continued feeding the demand for both seasoned and rising Argentine tango stars. If in the past the VWP made it easier for Argentines to regularly travel to the United States, the broader worldwide impact of tango has continued boosting the demand of Argentine artists abroad. The growing number of professional tango dancers of all nationalities has also helped professionalize the dancing and musical métier, and Argentine artists eager to perform in the United States need to prove—more than ever before—their talents and skills in order to get sponsored work. Concomitantly, stronger visa requirements have tightened the market for performing and working visas in America, making it more difficult for aspiring immigrants to launch their legal paths.

The concept of legal trajectories in this chapter challenges the notion of unauthorized immigrants as a frozen category. This latter view fails to acknowledge changes in artists' legal status through time, amid their continued search for windows of opportunity to remain legally in America. Contrary to the popular stereotype that portrays undocumented immigrants as purposely entering and remaining illegitimately in the United States, this study revealed the efforts of both seasoned and aspiring tango artists to become eligible for jobs that would allow them to keep a lawful status.

Most of my respondents' attempts to become US legal residents were motivated by a sort of legal pragmatism aimed at removing themselves from unfavorable categories (e.g., illegal alien and undocumented immigrant) and leaping into ones that would entitle them to civil, social, and political rights in the United States. Thus, artists' overstaying their visas or waivers was mostly an unintended consequence of the impossibility of obtaining visa sponsorships by other means. Even when Argentines expressed their willingness to return to Argentina, most hoped to *blanquear* (clean up) their legal situations. By the same token, participants' search for European citizenships—particularly among descendants of Spaniards and Italians—was less grounded on emotional ties to their ethnic heritage and closer to their eagerness to have access to first-world citizenship rights that

are mostly denied to Argentine nationals. Whether Argentine performers are upper-middle-class professionals or unskilled workers inserted in the service economy, their permanence as undocumented immigrants in the United States will more likely direct them onto a downward social path (Marrow 2007).

Immigrants are not randomly selected as candidates for an unauthorized status, a statement that, although seems obvious, reveals the complex factors that place allegedly similar groups of artists into dissimilar legal trajectories. Regardless of the common hurdles that tango artists may encounter upon arrival in the United States, their similarities tend to fade through time. Those with the right skills and contacts will more likely follow a progressive legal path and eventually gain US resident status. They will also be ready to trade their resources (mostly human and social capital) in the symbolic market of capital exchange.

Within the dialectic nature of social conditions and individual agency, immigrants' connections—along with their artistic talents, skills, and commitment to their trade—seem to be the foundation of their dissimilar legal trajectories. Study participants that would more often slip into the undocumented track not only lacked special tango or entrepreneurial skills, which made them less attractive candidates for US visas, but also did not count on valued social ties (in the form of bridging capital) within the entertainment field.

The Manhattan tango world, a rich social milieu par excellence, depends on an international membership of individuals, some of whom are eager to join artistic and commercial ventures in exchange for visa sponsorships. Having supportive social networks (and bounding liaisons) does not necessarily imply that tango artists will have access to more valued resources, because it is not a matter of how many contacts one has but of their nature and the strength of the bridging capital. As in Aracely's case, one of the most pernicious effects of immigrants' full-time involvement in the service economy—at the expense of nurturing their artistic ties—is the potential to limit their social capital. This is also the case of middle-class individuals who remain hooked in stagnant locations that restrict their professional and artistic connections (Newman 1999). Still, interpersonal agreements are not enough to guarantee artists' safe passage to permanent legal status, as they may be exposed to exploitation and abuse on the part of their visa sponsors.

The findings in this chapter confirm the dual synergy that exists between human and social capital. Investments in the first can provide opportunities to expand the second, as in the case of certifications that en-

able individual membership in exclusive professional clubs (Bourdieu and Passeron 1979). Tango immigrants' possibilities to advance their legal trajectories rely on a combination of their social capital (that allows foreigners to find suitable visa sponsors) and on their human capital, which is translated into technical skills and academic credentials. Inspired by patterns of cultural versatility, successful legal trajectories are more prevalent among those able to perform in different cultural milieus, who are fluent in at least two languages (Spanish and English), and who seem familiar with the social habitus and cultural traits embodied by an international upper- and middle-class tango clientele (Bourdieu 1984). Well-connected individuals, with proven artistic skills and certified credentials, are the most likely candidates for progressive legal careers on the basis of their long-term visa-sponsored employment.

The Social Geography of New York's Tango

The milongas continue to be very popular here, and people from every place, age, country, and employment field are dancing it. However, there is a classed and racial issue here. I have hardly seen any African Americans there ever, and I wonder: who can come after nine-thirty or ten o'clock in the evening, on a weekday, to pay $15 just to get in, for the sake of enjoyment? When I got there today, I was already tired. . . . It was cold outside, although everybody seemed vibrant inside. . . . I think that this is the point: it is about having the time and enough money—and significant doses of loneliness—to be willing to abandon yourself to tango dancing for hours and hours into the evening.

ANAHÍ VILADRICH, UNPUBLISHED FIELD NOTES

Although the notes above were jotted down in 2002, they could have been written today. Milongas are rich social fields where individuals from different nationalities, occupations, and professions get together for the sake of socializing while throwing themselves into a tango embrace. While in theory tango venues welcome practitioners from all social strata and racial backgrounds, usually it is a cosmopolitan, middle-class clientele (including Americans, Asians, Europeans) that is most likely to enjoy the tango's cosmopolitan glamour. The flamboyant tango circuit in New York City reveals an inner core of tango artists (dancers, instructors, musicians) and producers who, for the most part, strive to make a living from their tango endeavors. And they do so through a careful elaboration of the right tango image that requires wearing attractive outfits, showing off at the cool milongas, and dancing with both proficient colleagues and amateur practitioners.

This chapter explores the phenomenon through which Argentine per-

formers belonging to the Manhattan tango field have grasped the tango genre as their own, while achieving a kind of resistance identity (as "whitened" practitioners) somehow removed from the Latino entertainment world. I ask how Argentines' racial and social ascriptions merge with the dynamics of inclusion and exclusion that are reproduced in the tango's mainstream niche. To answer this question, I examine how the embedded tropes of race and class elicit rhetorics of belonging to two distinctive tango venues: the Manhattan tango field, which represents a white and upscale cosmopolitan artistic milieu, and outer borough Argentine events that denote a mostly blue-collar (and Latino) one. While Argentines' involvement with the Manhattan tango world becomes an emblematic vehicle for tango artists and practitioners to be part of diverse and affluent social webs, the outer borough field depicts a "Little Argentina" that attracts the tango's old guard as well as other Latino groups.

More than asking what race, ethnicity, and racism are (or are not), this chapter explores how Argentines utilize these categories in order to portray themselves in favorable terms, while exerting discursive domination upon others via an intertwined process of belonging and exclusion from rich social webs. As noted in chapter 1, the rise and triumph of tango in Argentina was possible due to the upper- and middle-class hegemonic appropriation that made it a national (albeit porteño) genre. Throughout a long period of domestication, the tango experienced a whitening transformation through which the creole and black populations were relinquished to the hegemonic construction of a mirrored European nation in the Southern Cone. In consonance with the tango's social history, the racialized and class differences that distinguish Argentines back home have been somehow transplanted to the informal tango networks of their compatriots abroad. Even though the Manhattan tango field somehow mimics the city's diversity, which welcomes a variety of ethnic and social origins, it also privileges an Argentine clientele that subtly bars a certain type of Argentine (mostly the darker skinned) from lower social strata. Almost like reproducing the tango's fate, the whitening process of contemporary tango dancing has become the key recipe for its success as a cosmopolitan best seller in the city of New York.

Argentine Uniqueness

The Argentines are a bunch of Italians speaking Spanish who wish they were British and act like they are French. (Anonymous graffiti)

For most tango immigrants of European heritage, their "social geography" of race was one in which racism did not exist, as long as they were surrounded by a mostly urban and white majority. By "social geography," Frankenberg (1993) refers to a physical landscape where individuals engage mostly in social, rather than physical, spaces. In this view, race shapes people's lives not only in a relational perspective but also as a subjective experience with and within the world.

Discourses about racial neutrality among Argentines support the misconception that they belong to a white country, where social differences are set in terms of socioeconomic markers (e.g., economic and political power and prestige) rather than race. As members of the white majority in Argentina, many of the performers and habitués of the Manhattan tango world never experienced racism when growing up in Argentina and, in some cases, believe that theirs is not a racist country. Racial stereotypes are also reproduced in the ways in which Argentines conceive the ethnic division of labor in the urban milieu. In the words of Sahara, a female tango dancer introduced earlier, "You see that the Mexican washes dishes, the Ecuadorian and Guatemalan are busboys, the taxi driver is either Arab or Hindi, and Argentines are commonly scientists, of course, tango dancers, as well." And Pipo, a male tango producer and instructor, made this even clearer:

> Argentines in New York City are not considered Latinos. They are not Latinos as Mexicans, Ecuadorians, oh no! They are seen in a much more sophisticated way. New York is a multicultural city in permanent construction, and Argentines are a minority, but a white minority!

These remarks illustrate the mainstream trope of middle-class whiteness that provides Argentines' entry and membership into an allegedly homogeneous national collective, and that ultimately disregards their country's racial and ethnic rainbow. In coincidence with the analysis of Oboler (2005) in Peru, the "foreignness of racism" among many of my interviewees discloses a sort of ambivalence about its formulation, practice, and effects. If, on the one hand, most tango immigrants would agree that racism exists in Argentina, they would also have a hard time acknowledging the existence of racial labels, and even discrimination, either within or outside the tango world. Their shared understanding is that this is a problem that affects other groups, including blacks and whites in the United States, but "not us."[1]

Once in New York City, Argentine tango artists are introduced to the

rubric of American racial and ethnic categories, and they quickly learn how to play the racial game in order to represent themselves and others vis-à-vis their imported frames of reference. Many among my study participants, particularly the fair-skinned ones, disputed their inclusion into the Latino/Hispanic category. To a certain extent, their arrival in the United States implied a double process of disjointed identity, marked by the symbolic loss of their citizenship rights along with an ethnic and racial dislocation: from being part of the white majority in Argentina, they hastily joined an imprecise Latino minority in the United States. Jacinto's comment is emblematic of this trend: "We are Argentines, we don't see ourselves the way things are here in America, with all the fuss about being blacks and Latinos. We don't have that sort of thing in our country. We are just Argentines, this is what counts" (Jacinto, male tango musician and producer).

For the most part, tango immigrants consider that the American colored hierarchies simplify ethnic/racial differences, by placing individuals within arbitrary racial bins that misrepresent them in the statistics. Consequently, most fair-skinned Argentine immigrants tend to highlight their belonging either to a national homeland or to the mainstream white population in the United States. Argentines' primary self-identification is defined by their country of origin and secondarily by ethnic heritage (e.g., Italian, French, Spanish, creole). A conspicuous example of this trend is the case of an Argentine tango musician who normally introduces herself as an Italian national, who happened accidentally to have been born in Argentina. In their comprehensive study of Argentines in New York City, Wilman-Navarro and Davidziuk (2006) also observed that their interviewees insisted on the fact that they were not Latinos and, therefore, contested the American trend to label them as such. In the end, Argentines' discursive tropes aimed at weighting their European heritage bare an ostensible effort to differentiate themselves from other Latino groups.

Some of my interviewees relied on the so-called cultural divide to support their claims of cultural difference (and superiority) by identifying themselves as members of a model minority and as being more sophisticated and polished than other Latinos. Expressions such as "We're seen as more educated than the Hispanics in the city" or "Americans know the difference between us [Argentines] and them [other Latinos]" are two of the common tropes that I often heard in the field. Multicultural techniques in the social imagery tend to establish a hierarchy between minorities, which is more complex than the bipolar model of black-white racial subordination (Gotanda 1996). By portraying themselves as different from

other Latino groups, Argentine artists hope to be placed closer to the model (white) majority, while distancing themselves from the sort of projective hysteria that blames immigrants for all US problems (Chávez 2008; Newton 2008; Viladrich 2012a).

Tango immigrants' ethnic and social hierarchies do not necessarily suggest a comparison between minorities against a majority but, rather, a contrast between a model Argentine minority and the Latino population, which at the end is also monitored by an invisible white majority. If struggling Argentines feel that they deserve better, their references to their racial and cultural heritage are there to support their rights in the United States. In sum, the "whiteness strategy" and the "cultural divide" constitute two important rhetorical devices, which not only place Argentine artists closer to the white majority but also challenge their perceived racial and socioeconomic dislocation in mainstream America.

Ethnic and racial tensions are not static but relational, situational, and paradoxical, as they reflect interpersonal alliances in terms of patterns of social belonging and ethnic identification. Tango artists may emphasize their Europeanness, their argentinidad, or even their Latino background, depending on specific circumstances. While it is true that many tango artists and regulars will stress their distance from the Hispanic community, they will also take advantage of this association by claiming inclusion in the Latino entertainment field, as a means to highlight their professional stature and visibility in the city. Sharing the same language, on the one hand, and being the object of the same migratory policies, on the other, are powerful drives to bring Argentines back to their Latino comrades anytime they agree to embark on common projects, such as recruiting their communities' support for philanthropic causes.

In spite of all the segmented representations I have described so far based on skin color, class, and cultural categories, most Argentine performers will claim their Argentine origin whenever they want to underscore their national and cultural singularity within the Latino minority. Nevertheless, the fact that Manhattan milongas mostly represent a white niche does not mean that darker-skinned Argentines, and other Latinos, are excluded from them. The Caucasian/Argentine/European triad and the darker-skinned creole/Latino dyad are actually complementary social constructs that achieve particular, and changing, meanings among Argentines in the United States. These categories attain a stronger significance within the racialized ballroom culture in the United States, in which tango is placed "in between" modern and Latin dances (Bosse 2007). The next section delves into the ways through which racial and ethnic diversity

are negotiated in the form of assumed sophisticated traits, embodied by darker-skinned performers who successfully participate in the mainstream tango field.

The (Mis)Uses of *Negritud* (Blackness)

Pedro and Isidro were two darker-skinned interviewees who, for more than a decade, had been active members of Manhattan's mainstream tango networks. They had worked hard to be acknowledged as multitalented tango dancers and interpreters and, overall, had not experienced racial or class prejudice from their peers. They would tell different stories about growing up in Argentina, where their looks had often been the source of discriminatory remarks—as when they were not admitted into discotheques or were looked down upon at casting calls and dance competitions. As noted earlier, the historical roots of Argentina's color stratification can be traced back to the foundation of the Argentine modern state, erected under the spells of an equal-opportunity mantra that pretended to overlook skin tonalities. Rather than racism being erased, phenotypical traits in Argentina became subsumed into a more complex scheme of social stratification, under the presumption that only personal merit serves to judge individuals' social achievements.

As Oboler (2005) notes in the case of the word *cholos* in Peru, the words *negro* and *cabecita negra*, particularly in Buenos Aires, merge a dark skin color with being poor and uneducated. Calling someone *negro* becomes an offensive epithet only when used with a deprecating tone, thus becoming a metonymic indicator of belonging to lower social and cultural strata. In its sneering denotation, the word *negro* is closer to a moral character (or lack of) than to phenotypical features, as it refers to individuals who allegedly lack social décor and cultural capital. It is when individuals gain entry into a respected social milieu, as in the case of being acknowledged as esteemed members of an intellectual group, that the expression *negro* loses its pejorative meaning among Argentines. This dual use of racial terminology speaks to the paradoxes of a country that, although it denies the existence of its African population, amply utilizes the term "black" to either qualify or debar those who carry darker-skinned and creole features. Interpreters such as *La Negra Sosa*, in reference to the late singer Mercedes Sosa, or *El Negro Olmedo*, a deceased comedian whose artistic name was Alberto Olmedo, are just two examples of the positive utilization of the term *negro/negra* in Argentina.

Within their inner circles, Pedro and Isidro were known as *El Negro Pedro* (Black Peter) and *El Negro Isidro* (Black Isidro), respectively, in rather affectionate ways. By becoming active and respected members of the Manhattan tango guard, both Isidro and Pedro were living proof that they had been able to whiten themselves via educational and cultural capital, skills, and membership into successful artistic and social webs. It is through upward mobility and full linkage to the cream-of-the-crop circles that the meaning of blackness changes from one that is derogatory to one that is affectionate, as has been found among other black and darker-skinned populations, including Brazilians and Haitians (Buchanan Stafford 1987; Margolis 2009).

Once in the United States, tango artists are soon introduced to the game of American racial and ethnic categories and have to learn the rules quickly in order to represent themselves and others. Darker-skinned tango performers can actually whiten their skin color by virtue of their artistic reputation and popularity among colleagues and milonga habitués. Immigrants such as Isidro and Pedro are dark enough to be considered exotic but white enough—in terms of their tango skills, social demeanor, and cultural capital—to conform to the upper-class norms of tango etiquette. In the same way in which members of the tango's old guard may benefit from their association with the Manhattan tango field, the so-called negros are able to maximize the mélange between their individual distinctiveness and the ethnic eccentricity drawn by the genre's worldwide glamour. In the end, the cosmopolitan character of Manhattan milongas contributes to dilute Argentines' color hierarchies. If, as Oboler (2005) suggests in the case of Peruvians, money does not whiten Argentine immigrants in the United States, dancing tango within middle- and high-class circles does.

The distinction between city and countryside also suggests regional, ethnic, and class differences among my interviewees. While tango immigrants born in Buenos Aires are typically associated with white middle-class groups, those coming from Argentina's inner provinces are more often assumed to be creole from lower strata. For instance, Pierina's ethnic origin was reflected both in her darker skin color and her region of birth. She was originally from the province of Corrientes, and through time she had been able to overcome the "disadvantage" of being from *el interior* (the provinces) by working hard and getting a university degree. Pierina acknowledged that, to a certain extent, it had been easier for her to become a self-sufficient tango entrepreneur in the United States, where the stigma of being from the provinces does not seem to count.

While in Buenos Aires, Pierina's speech accent and looks could raise

prejudices against her (she was seen as *la morocha*, or the darker-skinned woman from the borderlines), these markers were invisible in New York City's broader tango community. She referred to a popular saying, *"de noche, todos los gatos son pardos* (at night, all cats are grey-brown)," to suggest that Argentines' social and cultural differences would fade in Manhattan's multicultural environment. By being accepted into the leading tango core, darker-skinned Argentines (particularly those from lower-income backgrounds) are able to upgrade their own images as cool middle-class urbanites. To be sure, Manhattan milongas allow a sort of ethnic camouflage by providing a European-like look to all Argentines who dance it. In Chardoma's words:

> Argentines who look more like Latinos [that is, darker-skinned] take advantage of the connection between tango and its European look, even if they are very dark. This is an advantage for them, since they profit from the higher status of tango, in comparison with other Latino music, such as salsa.

Chardoma's straightforward remarks tell us a great deal about two simultaneous processes. If it is true that social codes change in the societies of destiny, Argentines measure each other according to shared social hierarchies based on status markers and skin color. Still, the singularities that tango artists may find among themselves (e.g., differences in skin color and social origin) vanish in the global milongas, where their idiosyncratic markers of identification turn somehow invisible for individuals of other nationalities. If having dark features and dancing tango can help some artists brand themselves as "exotic" practitioners, it is the glamour of the field that democratizes the origin of both tango performers and regulars.

Behind closed doors, Argentines tend to disclose their shared codes of stratification, which often remain hidden to outsiders. A subtle double standard actually exists *para adentro* (for insiders) and *para afuera* (for outsiders). By *para adentro*, I refer to Argentines' shared racial and class hierarchies. Argentines are quick to categorize one another based on social position, place of origin, status, and skin tone. Although these categories are being carried from their homeland, immigrants somehow adapt their hierarchical frames of reference to the racialized codes that they ultimately encounter in the host environment.

Most Argentines will not publicly acknowledge their mutual process of selection (acceptance and exclusion) within their social webs. For in-

stance, seemingly innocent questions that they may ask each other will actually serve as proxies for mapping their classed and ethnic social geography (e.g., What is your last name? What neighborhood are you from? What school did you attend?). Answers to these queries convey implicit meanings that allow Argentines to identify themselves in relation to their peers, in tandem with a stratified map that transports them back to shared symbolic backgrounds. For instance, belonging to a certain neighborhood in Buenos Aires or to a social club can provide clues to a person's social origin. In this vein, tango artists' insertion into the Manhattan tango field is resignified according to a hierarchical, albeit subtle, process of ethnic and social classification to which I now turn.

From Open Belonging to Subtle Exclusion

In the global market of commodities, Argentine artists are surely less privileged than many of their international colleagues. For the most part, they do not hold passports that offer them free access to the first world as do their American, Norwegian, British, and even Japanese counterparts. They usually possess less entrepreneurial capital and scantier financial means—aspects that pose serious obstacles to their joining a first-rate global artistic market. Still, Argentines have skillfully learned to maximize the benefits of belonging to the tango subculture by accessing and sharing social resources within tango webs. Becoming a tango practitioner (even an amateur one) gives Argentines a new status as modernizing agents of an old tradition that is blessed by the tango's renewed international popularity.

One of the most striking features of the tango field is its ability to grant social inclusion to members coming from very different social worlds. Once on the tango floor, physicians, financial analysts, college professors, and lawyers may (and will) exchange embraces with restaurant employees, cashiers, and part-time construction workers. Although the social relationships that take place during the tango practice are not necessarily extended outside of it, wealthy patrons may pay the unauthorized dancer for private tango classes, and business executives will invite waitresses (now turned into tango queens) to corporate or philanthropic events. These are just some examples of the exchanges taking place among individuals who would not probably get together, even by chance, in the light of day. And it is precisely through these informal arrangements that many of the needs

of tango immigrants get resolved—from getting affordable housing to accessing low-fee health services.

Practicing tango and *ver y ser visto* (to see and be seen) at the milongas involves a ritualized happening in which artists exchange information about themselves, promote their services among students, and seek new business opportunities. Tango followers choose their instructors based not only on their proven artistic proficiency but also on open and subtle markers of shared traits that involve displaying similar cultural interests and tastes. The fact that tango aficionados find themselves as sojourners across continents speaks of the literal creation of a wide-reaching network of sybarites and transnational workers, who enjoy the illusion of sharing a democratized field (Dávila 2012; Savigliano 2010).

As mentioned previously, those who practice tango for leisure purposes (today as in the past) are not the marginal classes in Argentina, which are mostly darker skinned and represented in tandem with bordering immigrants from Bolivia and Paraguay. Tango is not part of the emotional repertoire of the inner city or the provinces where locals hear and dance other rhythms, including *cuarteto, cumbia, chacareras,* and *zambas.* Tango in New York City has become, once again, an uplifting fashion in the hands and feet of a mostly white American and foreign elite that has turned into the main economic force feeding the Argentine tango frenzy.

In his book *Distinction,* Pierre Bourdieu (1984) provides a vivid analysis of the role of *habitus* (i.e., cultural preferences, tastes, hobbies) in shaping access to a high-class social membership. Elite members display sensorial and intellectual ways to appreciate the cultural products that make them unique, along with identifying the agents that better match their social origins and cultural identities. The tango world feeds an international advantaged class that links dancing with the consumption of other upper-scale commodities: opera and theater events, worldwide music festivals, ethnic cuisines, fashion trends, museum hopping, ecologic tours, and so forth. The tango's social habitus is expressed in intangible ways, from liking sushi to knowing about the hip movies being shown at the Tribeca and Sundance film festivals. The "highbrow culture" in tango is therefore translated into slim bodies, sophisticated outfits, and the sharing of a cultivated knowledge. This kind of cosmopolitanism is mostly available to those with leisure time (and economic capital) who are both eager and able to spend countless hours on tango practice.

In Bourdieu's terms, even though all agents in a field may be competent to play by the rules, some are a better fit than others in terms of the

demands of their positions and the roles they are required to perform. It is not enough to have technical and artistic ability; instead, tango performers must show versatility and appreciation for exotic places, multicultural goods, and eclectic artistic trends. By sharing their clients' cultural capital and social habits (e.g., dressing preferences, cultural mannerisms, and the like), tango instructors symbolically win a one-way ticket to becoming acknowledged as legitimate interpreters on the dance floor. As noted in the dancing literature (Bryson 1996; Peterson and Kern 1996; Urquía 2005), artists carve their paths into successful networks not just by sharing specific skills but also by exhibiting a multifaceted knowledge, or what is called multicultural capital. Struggling tango performers, both amateurs and professionals, are savvy interpreters of these social codes for the purpose of gaining approval by the most devoted, and hopefully affluent, tango patrons.

One way to get a comprehensive picture of the process of inclusion into the Manhattan milongas is observing who is being left out. As noted earlier, older and struggling newcomers have fewer opportunities to join the Manhattan tango field than their younger counterparts. And this is not necessarily due to open exclusionary practices, such as interpersonal rejection. Tango practitioners' self-removal from the artistic field is often subtle, albeit deeply embedded with racial and class markers. For instance, performers' inability to speak English, lack of money for transportation, long distance between their homes and the Manhattan milongas, and conflicting working hours may keep prospective dancers from joining the mainstream tango world. As suggested in my opening field notes, being at the milongas is not a matinee endeavor but mostly a nocturnal activity that is out of reach for many.

Patterns of social exclusion also become evident when observing who is systematically absent from the tango parlors. Publicity aside, Manhattan milongas are not the only places to dance tango in New York City, nor do they represent all Argentines living in the city. By relying on ethnographic mapping (see chapter 2), I was able to retrace the tango's urban patterns that reflect the extent to which class and ethnic differences are articulated in its social geography. In doing so, I soon discovered the presence of outer borough events that are mostly held by older Argentine organizations in New York City. In this environment, tango becomes part of a cultural legacy that has been kept alive through time, even during periods when it was not fashionable. Argentines' social tensions, in terms of ethnic and racial distinctions, could not be seen in a better light than by examining these two tango worlds.

During fieldwork I heard a couple of participants of the Manhattan milongas refer to their working-class peers—who joined the Argentine gatherings in Queens—as *mersas* and *grasas* (unrefined and uncultured people); and a handful of working-class immigrants named the Manhattan tango crowd as *finolis* (people with high-class pretensions), in direct reference to their presumed lavish, high-class mannerisms. In a way, darker-skinned tango entrepreneurs from lower-income groups must try harder to overcome racial prejudice from their compatriots. Although not always out in the open, veiled forms of social exclusion and inner discrimination result in not being chosen to teach at the "right" tango parlor, not being invited to give a demonstration, and not being asked to join the dance floor. Lucy, a working-class *morocha* who, along with her husband, taught and danced tango in the outer borough tango world, explained the tango rivalries in colored terms:

> We wanted to deal with this guy [a tango dancer and producer who frequented the Manhattan milongas]. We wanted to do something with him, but he discriminated against us. . . . You see, he is a *blanquito* [little white man] and looks down on us; he does not want to have anything to do with us at all.

Although Lucy and her husband considered themselves professional tango dancers, their social origin, class status, and ethnic identity clearly differed from those of their peers at the Manhattan milongas. They both defined themselves as *trabajadores* (working class) whose tango activities had allowed them to supplement their income by teaching private classes and dancing in community events. Contrary to Isidro and Pierina, in the sections above, they could not count on cosmopolitan tokens of cultural capital as the "open sesame" that would grant them entry into the tango's mainstream world. Fulgencio, the entrepreneur and older tango dancer to whom Lucy referred above, was quick to indicate his distaste for the outer borough milongas, by pointing out their apparent unsophisticated demeanor and low cultural level. His remarks were nothing more than an indirect reference to the racial, cultural, and class differences dividing these two tango worlds: "I used to go to the milongas in Queens many years ago . . . but I don't go there anymore. I like the environment here [referring to Manhattan milongas]. It is too *mersa* there, and I don't like it at all."[2]

The Manhattan tango world represents the quintessential niche where the dancing of Argentine tango underscores the upscale whiteness of its

practitioners. Tango performers accomplish this by stressing their association between being Argentine and having European roots, and by distancing themselves from the Latino aggregate. In more ways than one, the Manhattan tango field provides a symbolic vehicle for Argentines' upward mobility by allowing those belonging to lower-income groups to enjoy a sort of social camouflage within its boundaries. Through a public representation that welcomes "cool" and proficient tango practitioners to their premises, Manhattan milongas are able to whiten their Argentine carriers, even if they are physically more identified with creoles. As a result, darker-skinned and low-income Argentines and Latinos are a minority in the Manhattan tango field.

The Tango's Old Guard: A Pledge Against Color Blindness

> Once a friend told me: what do you expect from a country [Argentina] if the old ones believe that they are Europeans and their children pretend to be American? (Homero, a seventy-one-year-old member of the old tango guard)

Regulars of outer borough Argentine events provided, for the most part, a different version of the well-known Argentine whiteness trope, as they were more aware of the racial and ethnic inequalities that crossed their own lives as well as others'. Marcelino's case is paradigmatic. Being a long-term member of the tango's old guard, he held a respected place among his Argentine network of comrades and the larger Latino aggregate. A well-dressed man in his seventies, with blue eyes and delicate features, he combined a European ancestry (northern Italians and Spaniards on his father's side) with his mother's side, as she was "a good creole from the pampas."

I first met Marcelino in early 2000 and felt immediately awed by his clear understanding of how his light skin color had opened doors for him, both in Argentina and the United States. Growing up in a working-class, nonwhite household, his lighter skin soon revealed itself as a racial privilege that was unattainable for his darker-skinned relatives and peers. Passing for white had been a plus for him, not just among Americans but also among Argentines who, even in the United States, would look up to him. Contrary to some of his darker-skinned colleagues, Marcelino—as well as other whiter members of the old guard—found it easy to transition between Manhattan and outer borough milongas. Yet he argued that he had

not deserved his "good fortune," which was grounded on his phenotypic characteristics. The fact that he had been the only blond child among his poor relatives had made him the beneficiary of positive discrimination that eventually helped him achieve upward mobility:

> Everybody in my family is dark-skinned, with the exception of a blond grandfather, whom I resemble. . . . My parents died when I was eight. We were very poor, and we ended up moving with an uncle who happened to live in a rich area. I remembered being teased by other children because we were very poor. But also, I was the only *blanquito* [little white boy] in my family, and that opened the doors for me everywhere. One of my cousins was jealous of me because she was afraid that my uncle would love me more, as I was the only blond in the family. Of course, there were more blond children around, but they were rich. And I was a rarity, a poor blond child. . . .
>
> I always felt I had good fortune, as I had all the women I wanted. . . . When I turned eighteen, a lady told me: "Do you know how much you will make women suffer with those eyes?" And in fact, I always felt that I had doors opened for me because of my skin color and my blue eyes. Even here, *la migra* [immigration officers] let me in [to the United States], and I am sure it was because I am blond.
>
> It is like an image: if you are blond and white you are accepted for no reason, even if you have done nothing to deserve it. One can be a son of a bitch and still be accepted. . . . Instead, a good *morocho* [dark-skinned Argentine] will not be looked upon nicely, because he is a *morocho*. They think that I must be okay, but what do they really know about me? I may be a bad person or a criminal but it really doesn't matter; that is because I look white, so they think that I must be a good guy.

In Argentina, as in other Latin American societies, the higher the socioeconomic level, the lighter the skin color, and vice versa. Still, as in the case of Brazil, there is no complete correspondence between skin tonalities and social class adscription (Margolis 1994). Among my respondents, I found darker-skinned informants belonging to middle- and upper-middle-class sectors and lighter-skinned informants placed in lower social ranks, as with Marcelino's example. In any case, skin color (including skin tonalities) was one of my informants' closest proxies to their expected social locations.

Darker-skinned tango artists and members of the tango's old guard were generally more aware of the color hierarchy that exists among Argentines,

either before or after migrating to the United States. They did not have to leave their country to learn about discrimination and prejudice since, in many cases, they had experienced these at home. Given the fact that they felt already excluded from the Argentine white majority, with its unified representations of nationhood, they were less appalled than their lighter-colored peers by their inclusion in the Latino minority. Emiliano, a tango musician in his late fifties, clearly remembered having been discriminated against when he was growing up in Argentina. He had been very poor and had made his way up to a better standard of living through hard work: "As a child, I was the blue-eyed anti-ideal child. Having Arabic ancestry and liking folklore [associated with the rural provinces] in the early 1940s, kids used to tease me, calling me names such as *cabecita negra* and *negro*."

Feliciano, a seventy-five-year-old member of the old tango guard with whom I would occasionally chat at the *peñas* (folkloric Argentine parties) in Queens, was from the province of Misiones in Argentina's northeast. Born into a poor family, he had migrated to Buenos Aires during Perón's era. Rather than identifying himself as an Argentine, he seemed at ease with his self-description as a Latino and made forceful statements against the alleged whiteness of many of his compatriots. Feliciano had grown up hearing people call him *cabecita*, and once in the United States he had soon become aware of the dismissive way in which many of his lighter-skinned compatriots referred to creoles, like himself, as well as to other Latinos.

Marybel, an interviewee in her late sixties, shared a similar experience. She was originally from a very poor family in Jujuy, a province located in northwestern Argentina, and although being the product of mixed heritage (aboriginal, Spanish, and Lebanese), she self-identified as a provincial creole. Marybel initially arrived in the United States to serve as a nanny in the mid-1970s and had continued working as a domestic servant since then. She had had a hard life both in Argentina and in the United States and still remembered the days when her compatriots in Buenos Aires would discriminate against her because of her looks:

> Back there, I had to bear being called *cabecita negra* and *muerta de hambre* [dead from hunger]. That was the way people in Buenos Aires treated me. Here, Cubans tell me that Argentines are unbearable, but I tell them "I am not like them [people from Buenos Aires]. I am from the countryside, and I don't use the *shea* [a speaking modality in Buenos Aires], and I don't discriminate [against] people as they do!"

According to Marybel, the pervasive ideology of racial discrimination exist-
ing in Argentina had also followed her to the United States:

> You see, the *porteño* discriminates [against] people from the provinces.
> I feel welcomed by Americans but don't feel comfortable with Argen-
> tines, in general. They are selfish, badly spoken, and they discriminate
> against me. One of them once told me that I have a half an Indian
> face.

Marybel, Feliciano, Emiliano, and other members of the old tango guard
were quite aware of the subtle patterns of exclusion prevalent in Argentine
mainstream social webs. By joining Latino groups, they challenged their
demoted social representations as lower in status than their whiter compa-
triots. If middle-class Argentines might attempt to pass for whites in the
United States, dark-skinned ones from lower social strata would actually
gain representation and legitimacy by identifying themselves as members
of the Latino minority. The American categorization of all Argentines as
Latinos ultimately worked in favor of those who not only experienced prej-
udice in their homeland but also felt discriminated against by their lighter-
skinned compatriots. As Marybel put it, "Now, they [whiter Argentines]
can feel what it is not to be the center of the world; they are now the ones
excluded from the rich and famous." I now turn to unveiling the social
characteristics of the outer borough Argentine networks, where tango has
remained alive as part of the ethnic celebration of the Latin American di-
aspora.

Embodying the "Other" Tango World

While Manhattan milongas represent the tango's new guard and interna-
tional regulars, the outer borough tango field unveils an alternative social
milieu, a more intimate and humble one, run by senior immigrants from
working-class and lower-middle-class backgrounds, who have kept the
tango alive within more secluded social spaces. These Argentines, who
mostly arrived in the United States in the 1960s and 1970s, worked hard to
make a modest middle-class living. They danced tango as part of normal
socialization during their early years, while attending social gatherings,
family parties, and community events. Through the decades, they contin-
ued dancing and listening to tango tunes as a way of re-creating their as-

sumed cultural heritage, while participating in the organization of cultural and entertainment outings.

Argentine community organizations provide an ethnic reference for many blue-collar immigrants living in the city. They operate as a sort of cultural enclave or surrogate community for a particular group of Argentines, who are at a numerical disadvantage with other Latinos and also consider themselves less successful than their fellow citizens of middle- and upper-middle-class social strata. Most leaders of community groups have been long-term residents in New York City and have joined, and even created, several Argentine organizations since their arrival in the United States. They are mostly manual and semiskilled workers and retirees. In many cases, they are aware that their class positions in New York City have reached levels that would have been impossible in their own country. During fieldwork, I met (in alphabetical order) Argentine domestic workers, construction workers, contractors, delivery employees, electricians, hairdressers, housewives, mechanics, painters, pastry makers, plumbers, restaurant employees (of all types), and superintendents.

In spite of their diverse social identities, these Argentines adhere to a class-oriented rhetoric that defines them as trabajadores. They are also aware that their careers are restricted by their limited English skills and slim employment credentials. Therefore, tango dancing in outer borough sites is not a global but a local phenomenon, mostly performed by Argentines and other Latin Americans fond of the genre who, for the most part, speak only Spanish at these events. The Latino audience that gathers at these venues connects to the nostalgic tales portrayed by tango lyrics, in which singing and playing music are almost as important as dancing. In fact, a complete community celebration cannot be planned without having a small tango or folklore musical ensemble. These Argentine events are imbued with a resilient ethnic spirit (Portes and Bach 1985), which involves the recreation of national icons and Argentine cultural traditions for the purpose of reaffirming their members' personas in a foreign society.

Outer borough milongas welcome Argentines and other Latinos who find in these sites a vehicle to express their personal achievements in the form of charitable efforts. In agreement with a sort of diaspora philanthropy, these community gatherings sponsor small fund-raising campaigns in support of diverse causes—from sending stationery and books to rural schools, to donating clothes and shoes to impoverished aboriginal groups in Argentina. In this way, community members can fulfill moral obliga-

tions with their fellow citizens and also reiterate their own social achievements in the United States. Community gatherings offer a unique opportunity to building a collective sense of identity and belonging to similar roots, side by side with other Latino groups, while recreating a community of memory (Anderson 2006; Jones-Correa 1998).

A few Argentine cultural and civic associations function on the basis of informal arrangements, without legal nonprofit status or salaried staff members. These groups actually provide a good example of an "ethno-class" (Chen 1992), as they gather fellow citizens and other Latinos on the basis of shared cultural values that are supported by their common class and cultural origins. In the absence of a physical enclave, Argentine organizations visualize an ethnic world that parallels the one left behind a long time ago. Social events in which tangos, Argentine folklore, and tropical melodies follow each other throughout the night craft unique opportunities for immigrants to hear and dance to the same tunes they used to enjoy in Argentina, while submerging themselves in a virtual representation of what they left behind. Despite the distinctions between Manhattan and outer borough tango events, some performers participate in both fields, as in the case of musicians and singers who get hired to perform tango among a more diverse Latino crowd.

The outer borough tango field is not without inner conflicts and power struggles, however. Among its members' most common cross-accusations is that rival groups' motivations are solely based on selfish interests, at the expense of legitimate causes. These arguments are rooted in competition for social respect and legitimacy in terms of who represents the Argentine community's public voice. When working for common goals, these organizations tend to put their differences aside, as in the case of arranging relief efforts or broader celebrations, including their participation in the Hispanic Columbus Day parade.[3] Furthermore, the goals of these charitable groups, as well as the events they organize, serve the interests of immigrants who are well established in New York City and mostly overlook the needs of newly arrived Argentines. The fact that most newcomers find information about visas, housing, and jobs through the "grapevine" of their informal social webs tells us a lot about the meager responses provided through more standard and formal channels. As in the case of the Manhattan milongas, it is mostly through the familiar links of camaraderie and friendship that vulnerable immigrants seek and obtain information about housing, jobs, and referrals for medical practitioners who may charge them lower fees.

The Tango's Grandparents:
Building Generational Alliances

For the past fifteen years, some members of the tango's old guard have been literally crossing bridges, from the outer boroughs of Queens and Brooklyn to Manhattan, for the purpose of bringing together these two tango worlds. By practicing tango dancing in mainstream venues, these two groups take advantage of their Argentine legitimacy. Young and elderly Argentine tango performers need each other in order to enhance Argentines' images as the authentic practitioners of the genre. While the old need the young to pass along their techniques and to be able to show off in front of a much higher class audience, the young need the old in order to bring legitimacy to their tango parlors. As Violeta, a lovely lady in her early seventies, told me during an interview:

> We are like the tango's grandparents, and tango dancers and other artists always contact us when they come here because we have been here for many years and we know a lot of people. Americans who dance tango go dancing wherever we go; it is almost like we improve a milonga with our presence. . . . We bring the *calor de hogar* [warmth of home] and make people feel as if they were in Buenos Aires. That is why everybody who organizes milongas wants us to come.

Older milongueros find in the Manhattan milongas a place to practice tango in addition to family parties, home, or the secluded spaces of the outer borough events. Denise, a nice woman in her late sixties, also became a regular at some of the Manhattan milongas, where she danced and chatted with a younger generation of tango followers:

> Americans go where Argentines go to dance tango. You know, we [in reference to her husband] come here to support the young people; yes, to help them continue the tango tradition, passing along this to new generations. . . . They don't charge us a cover [to get in], but I don't want to come empty-handed, so I always cook something for everybody: cake, *pan dulce* [a sweet bread with raisins and nuts], *bizcochitos* [salted cookies].

Claudio, an interviewee of Italian heritage in his early eighties, with blond hair and blue eyes, was publicly acknowledged as one of the oldest milongueros in the Manhattan tango crowd. He had grown up in a lower-

middle-class neighborhood in Buenos Aires and had learned tango with the first generation of tango masters, when the genre was still a recent creation. Along with most of his male peers in Buenos Aires, Claudio had practiced the tango from a young age by dancing with other boys during school breaks and later on at his neighborhood milongas. Soon after the start of the tango renaissance in Manhattan in the 1990s, Claudio became an enthusiastic fan of the new tango guard as well as a supporter of young talents in New York City.

Members of the tango's old guard, who are not only whiter but also more cosmopolitan (as in Claudio's case), feel somehow entitled to greater privileges than their darker-skinned peers, more commonly associated with other Latinos. Although years ago Claudio would hang out at the milongas in Queens, he considered their regulars as mersas. Therefore, the tango revival in the 1990s became his golden opportunity to immerse himself in a new international world. He began hosting tango globetrotters in his rent-controlled Manhattan apartment, where his guests would stay while dancing, teaching, and exploring job opportunities in New York City. Claudio did not charge for room and board, but he expected favors in return, including social connections and invitations to tango parties and other events. His frequent visitors also brought new friends and acquaintances, who introduced him to new tango venues that helped him expand his supportive tango web. By accepting tango guests at home and by spending considerable amounts of time at the milongas, Claudio placed himself at the center of the tango scene, particularly since his visitors often felt obligated to compensate him in both social and emotional ways.

Claudio, Denise, Violeta, and other *abuelos del tango* (tango grandparents) incarnate a generation of Argentines who have remained faithful to their tango roots despite their many years within the United States. They have known each other for decades, from the time when they hosted milongas in their homes and attended events organized by the legendary *Asociación Amigos del Tango* (The Tango Friends' Association).[4] For this group of older tango lovers, the revival of the genre in the mid-1990s became a way to reinstate the tango's popularity, which had faded amid the "Latinization" of the Argentine enclave in Queens. They acknowledged the importance of the new guard in bringing the tango back to life in New York City, where not so long ago it had seemed to be condemned as *música de viejos* (elders' music).

All in all, the Manhattan tango world brings together younger and older generations of Argentines connected through relationships of trust, friendship, and reciprocity. This generational mixture is reminiscent of the scene

in Buenos Aires, where the older generation of masters has been in charge of passing the tango's oral tradition to the youth (Carozzi 2005). As mentioned earlier, it is traditionally assumed that seasoned dancers learned the tango as it was originally conceived without the tainting of foreign influences. Consequently, among the latest generations of tango performers, many have trained with old performers in Argentina, who in most cases were not professional teachers but masters *de la calle* (of the street). The glamour of being an Argentine artist is enhanced by the idea of a generational passage that takes place in dreamy environments, such as the neighborhood and the community club, where tango masters teach their tango techniques to younger apprentices—thereby ensuring that their artistic heritage will remain alive. This transference of tango capital, from the elderly to the young, is one of the most remarkable marketing tools advertised by older Argentine practitioners in the promotion of their artistic personas. By the same token, younger generations of artists are now the ones in charge of keeping alive the original tango styles. Predictably, the curriculum vitae of many young dancers feature a long list of masters (including "Pepito Avellaneda" and even "El Cachafaz") with whom many presumably studied and practiced.

Re-mapping the Tango's Social Geography

The contrast between the Manhattan tango field and the outer borough Argentine world, as explored in this chapter, reveals a social geography of Argentines' inner differences. The whitening and darkening qualities of the tango suggest two distinctive Argentine milieus in New York City: the upscale cosmopolitan field of the international (mostly white) Manhattan milongas, and the local world of outer borough events that take place across the Queensborough Bridge. Principles of social exclusion are embedded into these two separate tango fields that, for the most part, either ignore or disregard the existence of the other.

Manhattan milongas concoct a unique social ambiance where Argentines and international urbanites, from different generations and social worlds, get embedded into interpersonal exchanges as members of the same tango community. As with globalized forms of leisure, tango dancing in Manhattan venues becomes another stop in the transnational construction of the genre. By reuniting an international clientele with a multiplicity of resources, Manhattan milongas provide a symbolic vehicle for Argentines' exposure to a fashionable social circuit, even if only when in-

teracting in the tango field. As a genre interpreted by seemingly middle-class Europeans, tango in Manhattan parlors resolves Argentines' ambiguous self-representation by whitening the images of those who claim to be members of an all-cosmopolitan tango environment.

The glamour of Manhattan milongas contrasts with the sobriety of the dancing venues in Queens or Brooklyn, which somehow reproduce a figurative "virtual Argentina"—side by side with other Latino communities—signifying this world's separation from English-speaking America. While Manhattan milongas mostly welcome a white and upper-middle-class audience, outer borough milongas are more often hosted by older working-class Argentines who reunite other Latinos as well. And while Manhattan milongas elicit global tangos, epitomized by their international clientele, outer borough events host local tangos represented by neighborhood members who also enjoy dancing and listening to Argentine folkloric tunes and Latino rhythms.

Darker-skinned Argentines from the tango's old guard did not have to migrate to the United States to learn about racism or prejudice, since in most cases they had experienced them at home. Therefore, they do not claim to be part of the white US majority and they are also less dumbfounded, than their lighter-skinned fellow citizens, by their de facto inclusion within the Hispanic/Latino aggregate in the United States. This is not to say that these two different worlds remain separate at all times, as some of their members interact in venues shared by both tango fields. As shown in this chapter, some of those affiliated with the tango's old guard also participate in Manhattan milongas, where they are considered holders of the honorary titles of masters and tango grandparents. This is also the case among tango musicians, dancers, and singers who are invited to perform in both tango enclaves. The existence of such crossings between these two social fields does not invalidate the fact that each setting responds to very different ethnic and class constituencies that, for the most part, do not acknowledge the existence of the other.

CHAPTER SEVEN

Paradoxical Solidarities in the Tango Field

Argentines, by nature, are not a gregarious type; there is not solidarity among them or formal networks. You may have a friend [from Argentina], and that is the end of it. There is neither organization nor mutual help, in the sense that there is not like "today for you, tomorrow for me." This is both good and bad, because in the same way in which nobody responds for you, you don't have to respond for anybody.

JACINTO, MALE TANGO MUSICIAN

There is no solidarity among us [compatriots] because of the competition. It is this idiosyncratic thing the fact that we all came from different boats. So, as a result, we don't have a sense of nationalism, and on top that, we are exiles, so everybody looks out just for himself.

CHANIN, MALE TANGO DANCER AND CHOREOGRAPHER

The quotes above illustrate one of the main challenges I faced during fieldwork, which revolved around how to make sense of the intricate ways in which tango artists' discourses and practices of intragroup solidarity conflicted with generalized assumptions about their national collective. As discussed in previous chapters, racial and class categories greatly determine Argentines' social differences through processes of inclusion and exclusion from the tango's mainstream field. Complaints about their peers' "lack of solidarity" were rampant among artists who were either peripherally involved with the Manhattan tango domain (as in the case of some elderly singers) or openly excluded from it (as with some dark-

170

skinned members of the tango's old guard). Nevertheless, I also heard these negative remarks from immigrants who were fully involved with artistic ties and who also profited from the tango field.

Even more confusing was the fact that some of the most successful tango performers were often the ones who whined the most about the lack of solidarity of their compatriots. These rhetorical conundrums led me to examine the shared notions of support and reciprocity involving Argentines' national aggregate vis-à-vis other collectives. Rather than trying to find unilateral answers to my interviewees' conflicting claims, my work aimed at addressing their roots. Thus, this chapter explores the complex ways through which Argentine tango artists' discourses of solidarity and mutual help reveal their contradictory demands and unmet expectations.

Instead of questioning what ethnic or national solidarity is or is not, I uncover how tango artists see each other as either providers or recipients of help. To that end, I first address the generalized trope of Argentines' alleged lack of solidarity followed by two complementary frames: the one that portrays their role as donors of assistance, and the one that constructs them as recipients of help. While bonding and bridging ties are certainly key in ensuring successful participation in reciprocal exchanges, self-perceptions of downward mobility and social stagnation often play against feelings of mutual reciprocity. Close to the end of this chapter, I explore tango artists' celebratory solidarity in terms of their commitment to charitable efforts, despite their conflicts for prestige and power within the tango field.

The Tango's Self-Made Tale

I begin this section with a general question: To what extent does the "lack of solidarity" trope among Argentines reflect something deeper, and less obvious, regarding their needs and expectations as a national collective? While Argentine performers tend to display a unified image as the tango's legitimate interpreters, they are also fond of portraying their compatriots as crossed by competition, self-centeredness, and an individualistic ethos that is supposedly more pronounced than among artists from other nationalities. Those who are proficient in their artistic métier, speak multiple languages, and are highly connected with resourceful social webs will more easily insert themselves into the tango's commercial core. Yet it is through Argentines' self-comparisons with others that they define their social locations vis-à-vis their peers (Ortner 2003).

Tango performers' status incongruencies between what they were back home and what they have become in America are key determinants of their verbal moaning concerning the lack of solidarity they allegedly find in their compatriots. Argentines' own awareness of their inherent differences, in terms of status disparities, crashes against the idealized version of an Argentine nation in exile. By appealing to claims of intragroup solidarity, many hope that their differences will vanish for the sake of a common national origin. In this view, the "lack of solidarity" frame becomes a rhetorical device aimed at restoring in the discursive imagination Argentines' moral obligation to assist their fellow citizens. The favors and tips that many artists in this study received from Argentine mentors and colleagues—from, say, an invitation to be part of a last-minute gig to coteaching a workshop with colleagues—were not seen as exceptional but rather as normal expressions of bounding duties and obligations that seasoned and well-established Argentines owed to their junior colleagues. Given the fact that Argentines' expectations toward their co-ethnics are greater than among other groups, I found that their complaints about one another were stronger than the ones directed to other national collectives. A related notion implies that it is worse to be betrayed by a compatriot than by members of other national groups. As Carmela puts it:

> You don't expect to be helped by people from other nationalities, and when you get help you are happily surprised. If a Pole shits on you, you tell yourself: What do you expect? He is Polish anyway. . . . But if an Argentine does it, we make a big deal out of it.

Beyond the belief of Argentines' alleged lack of solidarity, I found a subtle demand for a supra-unity supported by an "imagined community," in Anderson's terms (2006), that defies the actual existence of a dispersed Argentine minority abroad. Miranda's statement below is emblematic of what Argentines often tell each other concerning their assumed cultural values as a national entity:[1]

> I do everything on my own. No, the Argentines don't help you at all; I don't expect solidarity from the Argentines. You can expect help from other [national] groups, but not from other Argentines. The ones [Argentines] who are in the tango in the United States are just trying to get by; so I have no choice but to follow my own path. Yes, I do collaborate with them every now and them for tango presentations, but I don't count on them at all. (Miranda, tango dancer)

Miranda, a beautiful dancer in her twenties, could be portrayed as one of the successful tango cases. Tall, slim, and blond, she added to her portfolio of youth the fact that she came from a middle-class family that would give her a hand in case of need. Despite her skeptical vision about other Argentines, she owed much of her successful tango career to the artistic collaborations forged with her compatriots. Two-thirds of the colleagues featured in her artistic curriculum vitae were from Argentina, including some who were actively involved in her transnational activities. Although statements such as Miranda's were somehow typical among tango artists, a different story typically arose when I inquired about their modalities of mutual assistance. It was then that exemplary expressions of reciprocal help were articulated. In this view, my respondents' discursive contradictions often became evident when comparing their general discourses of intragroup solidarity with their specific narratives and the actual practices of mutual help.

In spite of their overall success, and almost as a counterintuitive pattern, dancers such as Miranda were often the ones most prone to uttering the lack-of-solidarity mantra. To begin with, these artists had devoted much of their energy, talent, time, and money to succeeding in the tango field, despite the fact that they often felt that their investment had been greater than the returns they had received from it. Quite often, their exposure to working with other Argentines in high-risk businesses had been lengthy and exhaustive. They had also experienced both the glories and the miseries of their long-term involvement with the tango industry. Therefore, they were less idealistic and more grounded regarding their actual possibilities within it. Many of Miranda's friends worked for large and small tango companies, created their own shows, traveled and lived in several cities and countries, and in many cases had already hit the artistic ceiling of what the tango market could offer them. All in all, they had striven to make a name for themselves and experienced mixed feelings toward one another while trying to move up the artistic ladder.

The flexibility of social ties in the tango field often led participants to overlook its density (and intensity) as both an emotional and social enclave. Artists' presence in the tango world entails interpersonal exchanges at many different social and emotional levels. This is supported by the fact that they tend to spend endless hours working and traveling together when on tour. Once in the United States, most tango newcomers lack extensive family networks as well as webs based on relationships of *compadrazgo* (godparenting) and long-term friendships, which in Argentina operate as buffers against daily distress. Despite the fact that I have seen the

compadrazgo system reproduced in New York City, the bonds created through these affinities are never as strong or enduring as the ones characterizing immigrants' support systems back home.

Tango artists and practitioners often become friends, counselors, allies, bosses, employees, and even lovers, boyfriends or girlfriends, and spouses— not necessarily in this order. Performers may suddenly become roommates, share towels, and even the same bed when on tour even though they had not known each other before. As a result, artists' boundaries often get diffused among their seemingly endless expectations of mutual help. Those who can help tango performers the most may be the ones who can also hurt them the most, partly because their interpersonal liaisons are condensed in a few individuals rather than on wide social webs. Argentines' relationships with their compatriots tend to be as fruitful as they are conflicting and as rewarding as they are painful. And, partially due to their higher expectations in terms of interpersonal returns, tango practitioners tend to keep a detailed record of the negative outcomes drawn from their social liaisons.

The individualistic character of the artistic trade is rooted in a moral imperative that underscores immigrants' self-made ego ideals. Artists are prone to verbally diminishing the impact of social capital in their lives, while stressing their own skills, personal talents, and cultural backgrounds (human and cultural capital) as the main, and often only, reasons for their successful trajectories both at home and abroad. Even when it was clear that my interviewees' paths had been carved out with the help of others, as in Miranda's case, they would often use expressions such as "I've done it by myself" or "Nobody has helped me." These self-reassuring mottos highlight their own talents and merits without any interference from third parties.

Tales reframing Argentines' alleged lack of unity are not just concocted in the United States but are drawn from a broader cultural repertoire they have grasped early on in Argentina—a country that has experienced deep social inequalities in recent decades amid the effects of political repression, which has left open and hidden tears in the social fabric. Most Argentine artists come from Buenos Aires or other large urban centers, where individualism and self-sufficiency symbolize a do-it-yourself ethos. Consequently, their self-made rhetoric of triumph is deeply woven into a meritocratic paradigm that rests on the assumption that tango performers should be acknowledged for their own accomplishments without the help, or interference, of others.

I Am the Tango Field's "911"

> They don't thank you when you give, and you are not allowed to say no, and there is no room for you to ask. It is often draining. . . . As with this guy who showed up in my class with nothing just a few years ago. He came here from being an *empleaducho* [a small teller] in Argentina, and he didn't even dance tango well. But he stole my dancing technique and my speech, and he now has a website better than mine where he sells himself as a choreographer. (Teresa, female tango dancer)

Teresa was an accomplished tango dancer who had lived in New York City for a few years when I first interviewed her in 2000. She was one of the first to acknowledge the help that she had received from the international tango community, particularly from her compatriots, when she joined the Manhattan tango field in the mid-1990s. By defining themselves as donors of interpersonal assistance, tango artists such as Teresa claim a higher stature in the meritocracy structure—despite the fact that they are also in the position of competing for resources. Providing help and asking for it often resembles two conflicting sides, particularly when those who see themselves as givers of social capital are also in a situation of need.

Portes (1998) distinguishes among those who donate social capital, those who receive it, and the resources being offered and accepted, aspects that are not always sorted out in studies on the subject. Donors' motivations to render social capital lie along a continuum that ranges from instrumental aims, as a way of obtaining a specific benefit in exchange, to altruistic motives based on rewarding social compensation. Nevertheless, providers of social capital may become recipients (and vice versa) through the circularity of social capital, an issue that has received little attention in the literature.

Over time, I was able to see that some performers felt they were being asked too often for help with no corresponding reciprocity. In some cases, their public representation, as accomplished artists, made them feel obliged to continue aiding their colleagues while having little room to ask in return. Artists such as Teresa had become informal referents for those still struggling to make a living from their tango métier. They had been involved with the tango world for a longer period of time than many of their colleagues, traveled as members of prestigious companies, and eventually founded small dancing and musical troupes on their own.

Renata, introduced in chapter 3, had recently created her own tango

company. She echoed Teresa's complaints by noting the continuing demands she often received from her peers, who not only did not reciprocate favors but also, in some cases, even sabotaged her efforts:

> Besides, they kill me with all their demands, they ask and ask! I have never asked for anything, and everything I got cost a lot of effort. But people [her Argentine peers] take advantage of the situation, because of their endless need. They use and abuse. . . . It seems that I am selfish, but what kills you is not the work itself but the attitude of the people you work with. They act as if what I give them is easy to get—like they don't realize how much time, effort, and money I have put into it!

Renata's case is paradigmatic as it portrays a status disagreement between the resources she had invested in the tango trade and what she allegedly received in return. She had to be on call for potential students who might want to take a tango lesson at a moment's notice, although she still did not have a place of her own that she could call home. In fact, immigrants' self-employment entrepreneurship is not necessarily a symptom of their success but, rather, a skillful way to carve an employment niche outside the mainstream economy (Eckstein and Nguyen 2011; Raijman and Tienda 2000). Particularly for those whose tango endeavors resulted in years of investment in social relationships, creating their own tango troupes turned out to be the most viable way to capitalize on their skills.

Renata described the ways in which some of the artists hired by her tango ensemble had taken advantage of the visas she painstakingly had secured for them—only to leave her at once to work somewhere else in the United States. She complained about money being stolen by one of her colleagues and about dancers who left her company without notice to work with others. Renata overall bemoaned the envy of those who considered her a *trepadora* (ambitious and unscrupulous woman). More recently, she had become careful, even fearful, of sharing too much information with others regarding her artistic ideas and social connections. Concerns about colleagues taking over one's tango business are not a paranoid illusion but a reality rooted in a competitive market where every single opportunity counts.

The above is not to say that those who mostly consider themselves as givers of favors necessarily resent their protégées—a few acknowledged the many secondary benefits that helping others granted them in the form of reciprocated assistance. Sacristán, introduced in chapter 3, a seasoned performer in his forties with an impressive dance résumé across several art

forms, could also be considered a donor of social capital. Partially because of his long-standing involvement with the tango world, he was in a position to mentor his peers, particularly newcomers and junior artists, who would ask him for advice, referrals, and even jobs. Despite Sacristán's frequent complaints about most of his Argentine comrades' egoistic endeavors and lack of *espíritu de grupo* (group spirit), he had developed close emotional relationships with many of those with whom he had toured and worked in the United States, Europe, and Argentina.

Most of Sacristán's best friends were Argentine tango artists with whom he exchanged mutual favors, such as covering classes for teachers who were away or making last-minute calls to invite colleagues for impromptu tango shows. Sacristán enjoyed playing a mentoring figure and being a sort of godfather who would advise his younger compatriots. This was the case despite his repeated complaints about the niche he had helped create, which was unjustly paying him back with higher competition for jobs, lower fees, and deteriorating working conditions. Contrary to many of his tango colleagues, who were single or whose families were in Argentina, he was married and had children to support. Partly because Sacristán considered himself a breadwinner and had many bills to pay, the tango gigs he usually got were just enough to get by in an expensive place like New York City. While Sacristán prided himself on being able to help others, he also resented the increasing number of young (and talented) artists who had been moving up fast in the artistic field:

> The tango producers take advantage of people's need and because of their need, they [tango artists] allow themselves to be taken advantage of; so the seriousness of the whole thing is lost. The thing is that there is a transit of people [dancers and musicians]. There are too many of us here, and this hurts the market. But like my father used to say, to be a dancer is synonymous with being poor, so here I am!

The case studies examined in this chapter provide a paradigmatic example of the contradictory ways in which artists both appreciate and resent their peers, for what they believe has become an unfair reciprocity of terms in a tight employment market. Artists like Sacristán are aware of the social conditions that hurt reciprocity links and webs of assistance. Although Sacristán missed Buenos Aires terribly, he ended up settling in New York City, a city that he defined as a headquarters from where he could easily, and rapidly, travel to other locations at a moment's notice.

Tango artists are quite aware of the importance of their social connec-

tions to become (and remain) respectable figures in the field. In many cases, relocation can be instrumental in maintaining personal status, particularly when one's career owes much to the tango's global networks. It is precisely among those who feel threatened by unemployment and lack of opportunities in their homeland, as in Sacristán's case, that transnational possibilities are expanded the most.

Clashing Waves in Bonding Liaisons

Chardoma was a self-employed and aspiring tango performer and entrepreneur who had found an alternative business path by becoming an intermediary, a tango broker, between musicians (and tango producers) and her friends in need of jobs. Many of the latter were newcomers with few formal skills, contacts, or even temporary visas. During one of our encounters, she recalled a frustrating experience with an Argentine tango producer with whom she had worked in the past:

> The agreement was that I would be in charge of organizing the dance numbers in the show. Mr. García [the producer] agreed to pay me a bulk sum so I'd arrange the whole thing. So I went out and hired two [dancing] couples, whom I paid directly. The thing is, that this girl, Marietta [an unauthorized immigrant], needed money, and since she was still new in the *ambiente* [tango environment], I said, "Fine! You can dance with us." We did it for almost a month, and then one day, Mr. García calls me with his bla-bla-bla. He began complaining about my budget, saying that it was too high. But I said, "No, I cannot earn less because I cannot pay them less, and I need to save some money for taxes," which my dancers didn't pay because they didn't have [legal] papers. So guess what! The following week I get a text message from him, telling me that our deal was over. Fine! But the truth was that Marietta had taken over the whole thing. She had agreed to work with him and hired others for almost nothing! After what I had done for her, she took the gig away from me!

Chardoma's comments reveal a common tale among those who get involved in casual arrangements and hire vulnerable newcomers who, as in the case of Marietta, accept work for much lower pay than many of their colleagues would. Resource mobilization among networks of kin and co-ethnics is key to the success of small ethnic entrepreneurships

(Morokvasic et al. 2006). Artists usually perform and work together in informal settings, and even if promoting ethnic loyalty, this often elicits a sort of ambiguity regarding the implicit hierarchies they are subjected to. The ethnic solidarity existing in the co-ethnic job market is not without a price, as those who become employees often enjoy less favorable conditions than their friend-employers. As noted by Kim (1999), the same process that may initially open up possibilities for older residents and newcomers can exacerbate their competition and potential antagonism in the long run. The fear of training tomorrow's competitors also exists among tango artists. Their shared feeling is that, sooner or later, hired artists will turn into one's bosses in a legitimate attempt to move up the status ladder (Gold 1994). In fact, contractual agreements are often challenged when the employee decides to part ways by becoming a tango competitor.

Within an ethnic economy, successful entrepreneurs also become unintentional role models for less experienced co-ethnics through patterns that reinforce the latter's ambition for upward mobility (Boissevain et al. 2006). As Carmela says, "You learn the business, and it is just a matter of time before you follow suit." The tango's small entrepreneurial model allows employees to become versatile and savvy readers of the tango trade. In addition, it is not difficult for tango practitioners to learn most aspects of business management within a relatively short period of time. To make things worse, the informality of the tango field means most transactions work *de palabra* (by giving your word), so that verbal agreements often lead to misunderstandings and ambiguous clauses. From arranging a tango tour to agreeing to teach a class for a given fee, most business transactions have no other means of enforcement other than a verbal deal between the parties. In the words of Sacristán:

> I don't sign contracts. Everything is based on trusting your word, like my father used to do. The two parties have to take care of each other. It is a compromise between the two, and if we don't comply, it will be bad for both of us. I am the other way around: I first set an agreement with you and only then we can talk about money.

This oral tradition is embedded in the features of social capital in which the honorability of trust becomes the currency for relationships to remain rooted in interpersonal treaties. Such fragile verbal agreements are only possible within a system of assumed reciprocities, in which broken deals are severely fined by public sanctions. Yet, misunderstandings and unclear contractual terms were the two most mentioned sources of conflict be-

tween tango artists. Believing in a colleague's word is easier when cash is flowing and when there is a shared sense of confidence about the steady expansion of one's tango enterprise.

The growing number of tango performers visiting New York City in recent years, some of whom eventually decided to settle there, has also led to increasing competition among local practitioners, particularly when newcomers arrive with an impressive portfolio that makes them look like a novelty on the local tango scene. Stories of artists not getting paid for teaching classes, or earning less than was initially agreed upon for an exhibition, have become more common in recent years mostly due to the continued shrinkage of tango budgets—in the midst of recessive conditions—which may force producers to cancel gigs at the last minute. Adding to artists' perennial difficulties in making ends meet, the 2008 recession worsened the tango market. Some of those involved in reciprocal business relationships were forced to break their deals and even pay lower fees to their employed co-ethnics.

For some study participants, the chain migration process that has continuously brought their peers to the United States has lately turned into one of the main determinants of the tango field becoming increasingly saturated. The lack of professional or academic certifications in tango has also become one of the pervasive ways through which Argentines' reputations have been challenged. As a result, the basis of ethnic solidarity, defined by Argentines' preferences for hiring their compatriots, has been increasingly challenged by day-labor shortages and competition for jobs. In the words of Rinaldo, a tango artist and producer:

> Everybody [Argentines and non-Argentines] now teaches. Regardless of how good they are, they have all begun teaching for a living. With so many Argentine loudmouths passing for dancers, the message they sent out was "Hey, I can also do this!" The result is that we now have more [tango] instructors than students and more milongas than practitioners. That brought the prices down, and now they are willing to teach for even two dollars!

Among instructors, the lack-of-group-solidarity ethos is also linked to the perception of *sálvese quien pueda* (save yourself if you can). Milton, a tango instructor, puts it the following way: "There are more chiefs than Indians here, and they are all fighting for breadcrumbs." Meanwhile, non-Argentine artists have learned the tricks of the trade by becoming excellent dancers, musicians, and business managers, and they thereby claim a

larger slice of the tango's local and international market. Argentine artists' numeric disadvantage in comparison with other groups appears to have deepened because of the entrepreneurial mismatch. In Isidro's words, the lack of Argentine unity has been detrimental to his group's ability to expand its ethnic capital. Meanwhile, nationals from other countries (including many Americans) have become proficient in making the tango a lucrative and sustainable business. In the next section, the tango trajectories of Dionisio and Sahara reveal a counterpoint to the lack-of-solidarity mantra, one that relies on alternative discourses for making a living in the artistic field.

"The Tango Gave Me Everything": Artists as Recipients of Help

Undocumented, albeit blond and blue-eyed, Dionisio was one of the young dancers who hoped to follow a promising path in the Manhattan tango world. Coming from a middle-class family that had experienced steady downward mobility in Argentina, he migrated to the United States in the early 2000s. His entry into the Manhattan tango niche soon became a sensation. Looking like one of the angels in a Rubens painting, he did not fear legal apprehension while circulating freely in the city, and he seemed to have no worries about being identified as an unauthorized individual: "I know that my looks have helped me a lot. Nobody would imagine that I have no papers or that my bosses are actually those who look more like my employees."

During the day, Dionisio would work as a construction worker and as a busboy in several restaurants, and he would turn into the tango's Little Prince at the evening milongas. There, he had become *el niño mimado* (the pampered child) of older American ladies who would hire him as an informal taxi dancer, ready to patiently rehearse the tango's sensual and complicated steps while being embraced in his strong arms. Dionisio had subtly taken advantage of his pale skin and blond hair to go places others would have not dared to. If being blonde was not the only way for Dionisio to be able to make it into the tango world, it was at least a way to camouflage himself as an American while being indulged by the tango's international world of regulars and aspiring artists who easily mingled with well-off retirees, professionals, and seasoned producers of all sorts.

Through time, Dionisio had learned to dance well, a skill that eventually became his ticket not only in seeking a successful legal trajectory—he

ended up marrying another tango aficionado—but also for making a living from his tango performances. Being younger than most of his peers, he was not seen as a threat by any of the established tango artists in New York City. In fact, Dionisio benefited from the impromptu classes he would take with some of the best tango visitors, by being on the spot and always eager to help when the tango parlors would overflow with dancers and he would be asked to move chairs and tables. Through time, his humbleness and dedication paid off. With his wife's help, he founded his own touring group and began dancing tango in several small towns in the Northeast. Unlike other aspiring artists, Dionisio's career expectations had not been unrealistically raised by promises of stardom. He had found an alternative route for making a living within a tango niche where both flamboyancy and anonymity could be turned into individualized signatures of success.

Sahara was another talented dancer, a gorgeous morocha who was keenly aware of the benefits the tango Argentine community had bestowed upon her:

> Here [in the Manhattan tango world] you have a supporting circle of people: dentists, psychologists, and gynecologists. It is like an Italian family that does not exist otherwise. There is this famous saying: If you make it in New York, you can make it anywhere. And it is a kind of a family [the tango field] with lots of support. Yes, many are from Argentina but also from other countries.

Like Dionisio, Sahara was an unauthorized immigrant who, despite her status, had been able to forge a respected place in the Manhattan tango world, where she was considered a gifted, albeit unthreatening, member. Sahara's and Dionisio's views of the tango community in general and the Argentine minority in particular were positive overall. Although they were aware of the limitations that their unauthorized status had posed to their dreams of success, this did not stop them from reaping the many benefits of their belonging to a support network of Argentine and international tango fans. As is the case with other disadvantaged immigrants, they considered themselves as being upwardly mobile in New York City, as long as they were able to make enough money to pay for their basic expenses.

Both Sahara and Dionisio had been able to position themselves in core areas at a time when tango was still blossoming in the early 2000s. In doing so, they had concocted a special job niche for themselves as instructors of tango salón. Contrary to other tango artists who were legally in the United States, they would not dare to show up at a formal casting call or

travel many miles outside the city. They also did not become professional tango dancers in Argentina, where the competition is stiffer. Instead, they mastered the tango trade in New York City, where they had taken advantage of the genre's growing demand for Argentine artists. Consequently, they felt grateful for having been able to benefit from the ethnic career ladder that allows immigrants to learn job skills from their peers already living abroad.

Sahara's positive view of her tango comrades did not mean that she expected others to solve her many financial problems. As an unauthorized immigrant, albeit in the core of the Manhattan tango field, she was aware of the difficulties (and limitations) she and her colleagues without "legal papers" endured in order to live and work in the United States. Therefore, her prospects of upward mobility were, to a certain extent, lower than for many of her tango friends. According to Sahara, those who complained about Argentines' lack of solidarity did not realize the personal costs and effort that most struggling tango artists experienced in the United States:

> Someone can give you a hand when you come in. Yes, we'll tell you where to go to perform; we can even offer a couch for you to crash for a few days, even a month. But then you are on your own. We are all struggling here, so it is up to each of us to find the ways to make it work.
>
> You have to *ponerte las pilas* [get your act together] because you will not get help forever. But if something really bad happens to you: if you lose your job and you don't have a place to sleep and *los viejos* [in reference to the ones who migrated earlier] find out about it, they will approach you and tell you "talk to that person" and they'll find a place for you to sleep. I mean, there is material and economic help among us.

"Dressing to kill" is a necessary trait in the tango field, particularly for those whose attractive images will work as a spell against derogatory social portrayals. Sahara, with her gorgeous dark features and big eyes, had made good use of her tango characterization by becoming a celebrated dancing partner who, as a magnet, attracted a plethora of students. Still, despite her glamorous persona, she lived in a single-room apartment with one bathroom on the whole floor, which she shared with other residents. She would munch rice and beans when she had no money for groceries but would then eat well after securing one or two wealthy tango pupils.

As noted in chapter 5, despite their personal abilities and inner commitment to their métier, undocumented immigrants face a paramount obstacle to stepping up the social ladder. Unauthorized immigrants, like

Sahara and Dionisio, were somehow protected by friends and colleagues by whom they were seen as gifted, albeit unthreatening, players in the tango field. In a similar vein, when referring to Pedro and Clara (two unauthorized immigrants), Chardoma pointed out the lower competition that they represented to their colleagues:

> They are so nice, everybody loves them, but they are low key. The ones [tango dancers] who go away over the summer let them teach their classes, because they are not competitive. In any case, these are classes for beginners, and neither Pedro nor Clara fight to be the stars of the show.

While artists like Clara, Dionisio, and Sahara were well liked by the tango's mainstream clique, they were not in a position to either negotiate favorable contract clauses or to get stable jobs, as in the case of their colleagues formally involved with dance academies and tango troupes. They would get gigs here and there but mostly as friends of those holding legal papers in the United States. Above all, they did not act as professionals in their own right; instead, they positioned themselves as candidates for second-tier replacements in Off Broadway and low-budget tango shows. The bohemian demeanor of these immigrants mimicked a well-rehearsed feature that was shared with many of the artists I met throughout the years: an air of selfless detachment from their own tango careers. This aloofness was adroitly deployed as a useful subterfuge to underplay the obstacles they commonly faced in pursuing their artistic dreams in the United States.

Seeking Community Solidarity: Beyond the Common Good

Isidro, who was introduced in chapter 6, had moved quickly from being a tango aficionado (who only performed as an amateur) into being an insider and producer of tango shows. He was a good-looking, dark-skinned fellow who knew how to use his histrionic personality and exotic looks in his favor by creating a distinctive character. He was fun to watch onstage, and although his tango figures seemed more entertaining than skillful, he usually called full attention to his persona on the basis of his passionate expressions and dramatic moves. By teaching himself about tango history and lyrics, he even managed to sell his intellectual capital by performing as a tango lecturer at different universities and dance academies, thus

earning additional credits for his artistic portfolio. Being darker skinned than most of his colleagues, he had perfected the stylistic manners of an enchanting Latin fellow, both onstage and at the dancing parlor. As a result, he had been able to utilize his phenotypical features in his favor by attracting a wide cadre of cosmopolitan followers to his shows.

Isidro had also become popular within the Argentine tango community as someone who would help others. On two particular occasions, his role as an informal community organizer particularly stood out when he, along with many others in the tango field, had decided to launch an initiative informally named *colectas* (fund-raising events) on behalf of two Argentine tango artists who were in urgent need of cash. The reasons were anything but minor. Rinaldo had suddenly fallen ill and needed surgery, although he had neither health insurance nor the money to afford the hospital bills. At almost the same time, Román was also in deep financial trouble. By counting on his past experience as a nonprofit fund-raiser, Isidro soon put together a website and an e-mail list through which he organized a couple of tango shows and raffles *a beneficio* (all the money raised would be donated to his two tango pals in need).

The Argentine community, and the tango field at large, considered Isidro's actions remarkable but not exceptional. Most study participants agreed that people would help each other for the sake of *dar una mano* (giving a hand to others in need) or *la gauchada*, which entails doing things for others without expecting direct compensation, as good gauchos would. These expressions are inspired by the tacit obligation of helping those who belong to either the same national group or community of interest. Although these demonstrations of solidarity fueled my informants' reciprocal sense of belonging to an esteemed artistic niche, it did not mean indiscriminate aid to compatriots or a lack of expectations in return.

A year after Isidro had organized the fund-raising events, he began a business venture with both Román and Rinaldo, which mostly led to a modest tango show that they performed at a small restaurant in Pennsylvania. Once a week they traveled there together to present their tango *varieté* of music, dancing, and singing. The restaurant's owner (an Argentine from Isidro's province of origin) had agreed to pay a similar rate to the three of them, an arrangement that worked well for a while. Nevertheless, Román and Rinaldo's financial troubles continued, leading to their endless search for new artistic gigs in hopes of raising more funds. One day, the restaurant's owner phoned Isidro to let him know that a plot was being con-

cocted behind his back. "Watch out. They want to charge more, but they told me not to tell you anything and to reduce your fee."

When retelling the episode above, Isidro emphatically insisted upon the fact that he could not believe that his friends had tried to get a better financial deal for themselves by leaving him out of the loop: "Where is all the talk about respecting each other's rights and being loyal to our comrades? And after what I have done for them!" Nevertheless, Román and Rinaldo's understanding of the same event was quite different, and this revealed the inner hierarchies that Isidro's sudden stardom had somehow exposed and challenged. They complained about his arrogant demeanor and the fact that he acted as if *llevándose al mundo por delante* (he was pushing the world ahead). Deep inside, they considered themselves to be the deserving and seasoned artists on the show, the ones who had already demonstrated a professional and steady commitment to their artistic craft. In the end, they did not see Isidro as a tango professional but rather an energetic amateur, a fellow whose interest in tango was mostly a fashionable hobby.

Prestige and respect in the tango world are conquered via a complex word-of-mouth fashion through which those who are older and more experienced agree to teach—as well as play instruments and dance with others—on the basis of an implicit hierarchy that defines who is in and out the tango's protected circle. Becoming a tango professional, even a respected tango fan, demands countless hours of practice that implies turning into a *figurita repetida*, which means having a steady presence in the tango world. For aspiring professionals, this is necessary not only to make contacts and practice tango but also to test the mettle of their devotion to it. For many seasoned artists, the younger and less experienced ones must pay the *derecho de piso*, which implies being at the milongas regularly, even when it is cold and late, and agreeing to work for little or no money so audiences can learn to appreciate one's craft.

Isidro's story speaks to the contradictions existing between different levels of ethnic solidarity, one that could be labeled as community (or celebratory) solidarity versus immigrants' intrapersonal assistance based on strategies of mutual help. Community solidarity in the tango field is enacted via public expressions of social bonding for specific causes. This is not unique to Argentines and represents a trait shared by other national collectivities (Guarnizo et al. 1999). During the mobilization of these ethnic causes, Argentines like Isidro become de facto referents for others, thus ensuring their popularity and respect in the tango world. Through the organization of special events, including philanthropic causes, tango per-

formers reinstate their membership in a strong and cohesive field brought together for charitable efforts—as with fund-raising campaigns to support the victims of a natural disaster. This celebratory ethnic solidarity often vanishes once the crisis is over.

Ethnic expressions of charitable goals also enhance Argentines' self-fulfillment as they orchestrate noble activities that indirectly help them build a steady reputation as donors of resources. On these occasions, immigrants tend to portray themselves as genuine members of the Argentine tango collective through a shared sense of identity that, at least for a while, rises above and beyond their inner differences. Finally, immigrants' relationships are not quiescent and may suffer from exaggerated expectations, misunderstandings, and overwhelming demands to group members. Isidro's story above coincides with the findings by other authors, who point out the evolving alliances and conflicts that co-ethnics experience through time (Alberts 2009; Menjívar 2000; Ochoa 2000).

Ethnic Solidarity at Stake in the Tango World

By turning into proficient entrepreneurs, tango artists like Renata, Teresa, or Chardoma were able to launch new business ventures that involved their compatriots both at home and abroad. Their efforts to own the tango's artistic reproduction drove them to recruit co-ethnics as a business strategy that allowed them to claim the genre as their rightful national trade. Additionally, based on their contacts and trustworthiness (e.g., paying on time and respecting their agreements), they had access to a generous pool of co-ethnics, particularly among those who might otherwise encounter difficulties finding jobs.

These findings coincide with the literature on ethnic entrepreneurship that underscores the value of self-employment via ethnic social networks in guaranteeing immigrants' economic inclusion and social mobility (Brettell and Alstatt 2007; Min 2008; Raijman and Tienda 2000). This body of work highlights the role of ethnic entrepreneurship as key for immigrants' success in foreign societies, as in the case of Cubans in Miami (Alberts 2009; Portes and Stepick 1993), Koreans in New York (Min 2008), and Japanese Americans in California (Bonacich and Modell 1980).

As noted in chapter 3, by hiring co-ethnics and welcoming guest artists, tango locals guarantee the expansion of their ethnic capital in wide transnational directions (Brettell 2005). Ethnic networks provide a steady supply of reliable job applicants that turns into a win-win situation for both

employers and future employees (see Waters's 1995 critique). Co-ethnic employers and job seekers benefit from helping each other: the first by relying on an available, trustful, and cheap labor force; and the second by gaining training in a promising field (Chin 2005; Kim 1999; Zhou and Lin 2005).

However, ethnic solidarity cannot be taken for granted. By stressing its positive side, we might be tempted to underplay the liabilities that excessive obligations and demands may impose on entrepreneurs and their employees. The ethnic solidarity hypothesis is also contested by existing inequalities between bosses and workers, with the latter earning below-market salaries. For instance, in a study on apprentice entrepreneurs in the restaurant sector, Ram and colleagues (2001) question the idea that working in a co-ethnic firm serves as newcomers' apprenticeship toward self-employment later on. Major barriers such as high startup expenses, lack of know-how, and intense competition keep employees from becoming entrepreneurs. Furthermore, Kim (1999) shows how Korean employers have turned away from employing compatriots in New York City and instead prefer to recruit Mexicans and Latinos who are cheaper, less competitive, and hold lower expectations of social integration in the ethnic niche. In this vein, my study shows how patterns of ethnic solidarity are not reproduced evenly across social fields, as rules of inclusion make clear who is left out of the picture.

Most Argentine artists and producers would concur that tango connections are, to a large extent, informally based both on being liked by others, and on getting involved with reciprocity norms that are not necessarily shared outside the tango's inner circle. Particularly during tight economic times, peer-to-peer recommendations often play a crucial role in the decision making of helping and hiring fellow nationals. Complaints about *amiguismo* (cronyism based on friendship), a term utilized in rather derogatory ways, suggest that tango gigs are shared among those belonging to selective cliques within the artistic field. In the words of Milton: "A lot has to do with the network and with your personality. If they like you, they will give you a hand, but if not, forget it: nobody will open a door for you." And in Chardoma's opinion: "Being in the tango clique means that you have to be everywhere, to be *figureti* [to be seen] to play the game."

By underscoring the contradictory nature of ethnic ties, my research on tango immigrants has expanded the general knowledge on both the barriers and incentives impinging upon immigrants' mutual assistance within social fields. In the terrain of interpersonal support, this means that im-

migrants provide assistance to each other in certain areas (e.g., giving a referral for renting an apartment) but not in others (e.g., getting a job) and that tango peers may reciprocate on one level but contend on another. The episodic nature of exchanges may also lead us to overlook the fact that relationships evolve through time. My interviewees' complaints about their Argentine friends did not stop them from going into business with them later on, even sharing gigs, tours, and homes. In the end, the increasing competition within the tango field, along with the rising supply of instructors and producers, draws opportunities for both ethnic support and inner divisions within the tango field.

Beyond the Realm of Paradoxical Solidarities

> To stick to your brother is the first old law
> that will help you in many dangers;
> remember it, boys, and hold together
> in fair as well as in stormy weather.
> When a family fights among themselves
> they're soon eaten by strangers. (Hernández [1936] 1977: 297)

The idea to end this chapter with José Hernández's passage above was not gratuitous. Hernández's famous epic poem *El Gaucho Martín Fierro* (The Gaucho Martín Fierro) epitomizes the ultimate axiom in Argentines' embedded sense of national unity, rooted in blood and friendship ties, which has remained alive as part of a shared folkloric repertoire. Argentine expressions such as *ser un buen gauchito* (to act as a little good gaucho) reckon moral compromises that publicly reward the offering of help without expecting anything in return. As explored in this chapter, tango artists' demonstrations of ethnic solidarity do not fully embrace any particular social field or reach the Argentine minority as a single aggregate. In fact, the social capital circulating within any social realm sets clear limits on who is included and excluded from its benefits. Immigrants' positions as either insiders or outsiders of the mainstream tango world are tightly connected to class and racial geographies, which set clear limits to the tango field's inclusiveness.

The various discourses analyzed in this chapter speak to different levels in immigrants' perceptions regarding the social assistance expected and received from their peers. While the tango's norms of inclusion demand that its members convey a public discourse of unity and agreement, be-

hind closed doors Argentine performers often resent each other on the basis of what they perceive to be an unjust employment distribution in the artistic realm. Even under the best circumstances, the tango field has limits to what it can give back to its players. In fact, much of the artists' verbal frustration, as exemplified in this chapter, symbolizes a sort of "status incongruence" between what they feel they deserve as accomplished artists, and the lower social and financial rewards they end up receiving. To a large extent, Argentines' sense of interpersonal unfairness emerges from their experiences when working in a fragmented and unprotected field, where there are more professional tango artists than suitable gigs or students to teach. In a sense, the pressure placed on informal contacts is greatly determined by the structure of the specific opportunities existing in the host society.

Within the tango world, there is no tango union or legal office to advocate for artists' rights; there is not even a tango association aimed at channeling artists' needs and demands abroad. Therefore, when things do not turn out as expected, it is often easier to blame one's peers rather than acknowledge the meager social opportunities that exist in the tango market. In their study on the Argentine minority in New York City, Wilman-Navarro and Davidziuk (2006) pointed out the absence of official agencies and voluntary groups in charge of providing Argentines with systematic assistance on migratory issues, from health care to public transportation, particularly for newcomers and the undocumented. This vacuum is even more prominent given the number of Argentine civic organizations existing in the city, many of which focus on philanthropic efforts back home.

Despite the artists' overstated frustrations, most of their discourses and practices of mutual aid described in this chapter do not correlate with mainstream images of their ethnic collective as lacking intragroup solidarity. Even when study participants endorsed representations of their peers as egoistic and uncaring toward each other, much of the help they offered and received involved their fellow countrymen. Nevertheless, most felt that they got less in return than what they bestowed; narratives of disappointment and even betrayal were not uncommon when telling stories of unpaid favors. Still, and contrary to the overspread skepticism regarding their interpersonal solidarity, which is popularized through the maxim "Argentines are not as united as other Latino communities," tango artists interact with one another via contradictory waves of mutual assistance and interpersonal contention.

As seen in this chapter, the lack-of-solidarity trope was more rampant

among those who experienced social incongruities between their previous social positions and their current ones in the United States. By the same token, those who appreciated their co-ethnics the most, despite their lower social origins and unauthorized legal statuses, held more optimistic outlooks regarding their chances in the tango milieu. Tango artists could be darker skinned but exotic and sophisticated, as in the case of Sahara, and undocumented but blond enough, as in the case of Dionisio. In the end, those who seem most satisfied with the tango world are the ones who take the most advantage of its social capital while keeping their expectations low.

Artists' self-representations as either donors or recipients of interpersonal assistance epitomize two sides of the same coin, in the form of an exchangeable role playing that discloses mutual alliances and rivalries. Despite conflicts over jobs and prestige, Argentines' circulation of favors is highlighted by the exchange of singular skills (human capital) within specific social fields. As members of the same national collective, Argentines look ahead to a redeemable kit of favors and enforceable trust. Both of these mechanisms aim to ensure that group members will behave according to the norms and values collectively shared—or be sanctioned in case of disapproved behavior. In the end, many of the artists' complaints about the lack of interpersonal assistance from their peers conveyed a warning toward keeping, and restoring, reciprocal liaisons in their socially imagined community (Zhou 2004).

By belonging to the same ethnic community, donors of social capital guarantee that favors will be paid back one way or another. In Chardoma's words, *una mano lava la otra* (one hand washes the other), meaning that Argentines' exchange of favors is embedded in shared codes of reciprocity. The expression *hoy por ti, mañana por mi* (today for you, tomorrow for me) is another popular maxim deployed to reinforce notions of interpersonal assistance and community solidarity. Being both a member of the tango field and an Argentine citizen creates a double bind between providers and recipients of help.

Although the explanations for the contradictory discourses discussed in this chapter are complex, one of the main roots rests in Argentines' symbolic claims as being members of the same national collective. The rising competition among Argentine artists, amid their increased number in the tango field, becomes a feeding ground for ethnic conflict and inner divisions. This is even more so as the tango niche has become gradually saturated and newcomers are finding fewer opportunities for developing their

tango careers. In the end, many of my respondents' complaints about the alleged lack of solidarity of their compatriots symbolize a plea for interpersonal obligations on the basis of their belonging to the same country of origin.

The intricacy of the above findings is somehow a warning against simplified models of ethnic cohesion. At last, Argentines' representations of intrasolidarity are not univocal but paradoxical. A careful analysis of immigrants' contradictory discursive levels, along with their multifocal practices of comradeship, should prevent us from making erroneous assessments of their actual needs amid their overrated demands. In order to assess the magnitude and impact of immigrants' complex expressions of mutual help, it is imperative to look at how its different dimensions are played out depending on a variety of circumstances and changing contexts (Alberts 2005). Had I accepted my interviewees' general complaints regarding their peers' lack of solidarity, I would have probably misread their prevalent and endearing expressions of mutual support, love, and friendship.

Finding the Cure Through the Grapevine

Tango Brokers and Alternative Sources of Help

I got hurt and nobody [in the dance company] took responsibility for it. I ended up in the emergency room on my own, bleeding terribly. . . . So I asked myself, what kind of job is this? You are supposed to use your hands, arms, and legs to make a living but if something happens to you, you are dumped. You may lose your job right away. And on top of all of this, I had to pay for the hospital bills because they [the producers] would not even acknowledge that you work for them!

MATEO, MALE TANGO DANCER

The excerpt above did not come from either an unauthorized immigrant or an artist working off the books in the informal service economy. Rather, this is just one of the several remarks conveyed by tango artists who had no choice but to learn about the vulnerability of their trade the hard way. More than other workers in the artistic field, tango dancers rely on their bodies, which demand continuous care and investment, as a source of income. Most fear getting hurt when dancing because it could lead to twisted ankles, fractures, and even chronic physical problems. Good physical health is a prerequisite in a tight job market where artists survive day by day and have neither health insurance nor social benefits (e.g., sick leave) to protect themselves in case of illness. Serious injuries, if not cared for properly, can derail careers either temporarily or for good. This is particularly a concern among performers of fantasy (or stage) tango, for whom physical strength and acrobatic ability are a must.

193

A lack of health insurance represents the tip of the iceberg that calls attention to the fragile working and living conditions experienced by many of the tango practitioners I met during fieldwork. The US health insurance system depends heavily on employment status, and public programs have suffered severe cuts in recent years; therefore, most of the newcomers I interviewed (even those legally in this country) did not have health coverage and counted either on their own resources to cover medical costs or on alternative ways to resolve their health problems, usually via their informal

Figure 20. Fantasy tango I. (Photographer: Maike Paul; dancers: Virginia Kelly and Leonardo Sardella)

Figure 21. Fantasy tango II. (Photographer: Ramiro dell'Erba; participants: Virginia Kelly and César Rojas)

webs. One of the most interesting findings in this study was artists' reliance on their networks of care to address their most urgent health needs. As noted in my previous work, immigrants' utilization of their informal ties make them rely on a variety of health services—from highly Westernized treatments, such as psychoanalysis, to folk healing systems and esoteric practices including chiromancy and divination (Viladrich 2005, 2007a).

This chapter explores tango artists' utilization of a variety of medical services and healing practices, including biomedical and lay providers who belong to their informal social webs. Within this framework, the tango field is conceptualized as a health reservoir in which tango artists obtain health resources, including free or lower-cost consultations, from a plethora of formal and alternative providers. Along this line, some of this study's most interesting findings were drawn almost serendipitously during fieldwork. As part of my initial research project on access to health care among Argentine immigrants in New York City, I began by gathering standard responses on tango artists' health status, including their insurance coverage, the steps they followed during emergencies, and the types of health-care practitioners they sought.

When visiting Manhattan milongas, every now and then I would hear stories about medical doctors and other practitioners (e.g., psychologists, dentists, alternative healers) who would either not charge artists for their services or would perform services for lower fees in exchange for tango lessons or practice. Still, this information was not easily volunteered during our formal interviews, an issue that kept me wondering how to approach the matter in a different, and perhaps less threatening, manner. The key to this mystery was revealed to me one day when a tango dancer showed up with a broken finger that had been immobilized with an unassuming though efficacious splint. I asked her what had happened, and she responded that she had fallen during a dance routine. So I asked, "Did you go to the doctor?" "No, no doctor," she answered. "I was practicing with Reed [a resident at a local hospital], who fixed my problem on the spot."

After that enlightening episode, I realized that the clue to unraveling my respondents' health resources was to inquire about the presence of friends, acquaintances, and colleagues who might provide specific health assistance in times of need. Much of what I learned later on about the role of social webs in immigrants' lives came not from formal interviews, but from casual conversations in which tango artists would share the impromptu ways they managed their most pressing needs; typically, they did

so by bartering resources with peers, acquaintances, and students with whom they routinely interacted. For instance, a tango dancer would agree to perform at a studio free of charge in exchange for permission to practice at the premises, or a provider of alternative medicine would trade acupuncture treatments for a certain number of tango lessons at no cost. These informal exchanges (based on trust and reciprocity) are paradigmatic examples of the social capital literally seen "in action."

In the following pages, I present a cultural model of health-seeking be-

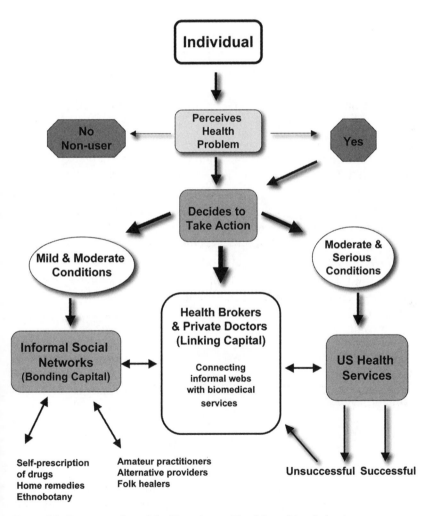

Figure 22. Conceptual model of immigrants' health-seeking behaviors.

haviors that is supported by the influence of social networks over diverse health resources, including US biomedical services. This theoretical approach relies on categories aimed at capturing the provision, reception, and circulation of health assets via social relationships. Rather than considering this sort of health capital as the solution for all maladies, I analyze its disadvantages, including unspecified obligations among parties that may lead to misunderstandings and disappointments; uncertain time horizons in terms of reciprocity; and the potential violation of exchange norms (Bourdieu 1986; Portes 1998).

I begin by examining the figure of the health broker, defined as a medical doctor sharing resources in the tango field, which is probably the most prominent finding of my study with respect to the role of informal health networks. This notion disputes some of the assumptions regarding immigrants' patterns of health service utilization, such as their alleged dependence on emergency rooms for treating routine problems or the strict separation between formal health systems and informal social webs. Contrary to popular misconceptions, immigrants tend to seek alternative ways to solve their health problems and often arrive in the emergency room as their last resort (Fahs, Viladrich, and Parikh 2009; Viladrich 2007a, 2012). The importance of lay healers (or amateur practitioners) is then examined in the context of the lives of vulnerable tango immigrants, who are more likely to be excluded from mainstream tango networks. Rather than idealizing these informal health resources, I discuss the underlying reasons for their preeminence amid artists' efforts to find trustworthy health practitioners in the United States. The chapter's final section addresses both the advantages and caveats inherent in immigrants' therapeutic eclecticism, defined by their reliance on a variety of healing systems to solve their most urgent health needs.

Health Brokers: Immigrants and Physicians Sharing Fields

> You can find all the resources you need in the tango world. (Cristal, female tango dancer)

Chardoma, introduced in chapter 3, began working as a tango instructor in one of the many dancing studios in Manhattan in the late 1990s. She had arrived for the first time in New York City at the beginning of the latest tango boom in the mid-1990s, thus becoming one of the many artists who,

in the following decade, would enchant students by teaching them how to perform alluring embraces and dexterous tango kicks. During one of her guest visits to a dancing academy, she was offered a full-time job as a tango instructor in exchange for a performance visa. Despite her drive for success, Chardoma's dream of becoming a renowned tango artist soon seemed to be shattered, as things did not work out as originally planned. Not only was she enlisted to teach innumerable classes in exchange for a minimal wage, but the tight clauses of her job contract did not allow her to either work or dance at other studios or take private students on her own.

Chardoma's work opportunities did not end there. She met several tango regulars at the Manhattan milongas, including other Argentines who eventually helped her find alternative solutions to both her legal and job tribulations. One of her acquaintances was Dr. Laureano, an Argentine medical practitioner licensed in the United States and a committed tango fan who would eventually become Chardoma's informal business partner. Because Dr. Laureano had an established medical practice, he was in a unique position to offer either low-cost or free consultations to some of his tango friends, which included the provision of prescription drugs (e.g., antibiotics and pain killers) on demand.

Dr. Laureano had been an amateur tango dancer in his youth, so his entry into the Manhattan tango world soon became a second chance for improving (and displaying) his dancing expertise, without the pressure of having to make a living out of it. Being financially well off, this also became his opportunity to practice with the crème de la crème of the tango field. Impressed by Chardoma's artistic ability and moved by her employment situation, he finally offered to sponsor her for a visa in exchange for working together in diverse tango productions. Although none of these joint ventures meant a formal job for Chardoma, they allowed her to build a façade of legitimate employment that eventually let her remain legally in the United States.

Over time, Dr. Laureano's sponsorship became Chardoma's ticket to freedom, as she was able to renew her performance visa several times without having to endure harsh working conditions. Meanwhile, as with most of her colleagues, she continued earning a regular income by teaching private lessons and going on tour. Through time, Dr. Laureano continued being Chardoma's legal sponsor as well as her dancing partner and main medical advisor. Chardoma, like most of the tango artists I met in the field, utilized a battery of health resources—including alternative practices, psychotherapeutic treatments, and sporadic visits to her family doctor when traveling to Argentina. Nevertheless, given her lack of health coverage,

Chardoma's reliance on Dr. Laureano for medical emergencies had become her "life insurance" in case of need. The following remarks illustrate her experience:

> You see, he [Dr. Laureano] is not *encajetado* [closed-minded] with a tie; yes, he travels to conferences, sees patients, and then he goes to the milongas in the evenings. He has patients who don't pay, me being one of them. And he always gives rides to women after the milongas. If you have a [health] problem, you can ask him, and he will orient you about what to do.

At the time I began conducting this research project, one of the conundrums I faced was how to define the relationship between Chardoma and Dr. Laureano, as it mostly remained limited to informal exchanges taking place either in tango settings or in other social venues. I chose the term "tango brokers" to name a particular type of doctor-patient relationship built on the intangible exchange of key resources in nonclinical settings. Although the term "health broker" has been utilized before, it has a particular meaning in this study as it involves the overlying features of biomedical services in immigrants' informal networks (Viladrich 2007a). This line of work is supported by previous research on medical pluralism, which shows that in most societies medical treatments are not utilized in isolation but are combined with alternative and folk healing options (Finkler 2001; Freidenberg 2000; Kleinman 1980; Young and Garro 1994).

In the field of medical anthropology, Kleinman's work (1980) has been seminal for underscoring the role of the popular sector, represented by patients' reliance on their informal social webs in deciding their main course of health-seeking actions. Kleinman's analysis of the three sectors of care (the professional, the folk, and the popular) speaks to the creative ways through which individuals negotiate the usage of different health systems. The health-broker model provides a paradigmatic liaison among Kleinman's three sectors on the basis of physicians' belonging to informal tango webs. Likewise, the term "health broker" combines the notion of "gatekeeper" (which stands for the formal sector) with that of "lay advisor" (which represents the popular realm). Among Latin American cultures, the figure of *promotores de salud* (lay health advisors) is pivotal in connecting individuals with scarce health resources (Wasserman et al. 2006). Still, while the word "gatekeeper" is customarily utilized to define the role of primary health specialists, usually a general practitioner or family doctor

serving as the main point of entry into the health system, the term "lay advisor" typically refers to an informal health counselor.

Although Chardoma considered herself fortunate, she did not see Dr. Laureano's help as an exception to the rule but rather as an expression of mutual favors and obligations, which bond compatriots and dancing aficionados within the tango field. This implies their engagement with different forms of reciprocity on the basis of friendship and comradeship. Without knowing it, Chardoma was referring to the term "bounded solidarity" that I examined previously. This involves informal exchanges between agents without expecting direct or immediate reward, as these are rooted in codes of trust and reciprocity. Not all private doctors with whom tango artists interact may become their health brokers, however, and not all immigrants are as lucky as Chardoma. For health brokerage to take place, artists and professionals must be involved in reciprocal relationships that supply symbolic gains for both parties. In Kleinman's words (1980), clinical practice must be detached from "clinical reality," which somehow requires challenging the power inequality demarked by patient-provider roles as it is typically played in the medical encounter.

Access to health brokers is not an easy task; in fact it means being a member of rich webs entrenched in the core of the tango world. As discussed in chapter 6, the abilities to create an attractive and sensual look as well as to display cultural refinement, as in the case of artists of disadvantaged social status, is critical for gaining acceptance into the tango's main core. What Chardoma and many of her friends had in common was a self-presentation based on a gaudy demeanor that made them attractive as both colleagues and dance partners. Artists like Chardoma exuded images as flamboyant, yet sophisticated, dancers that were in high demand (as partners, teachers, and friends) within the Manhattan tango field. While Dr. Laureano had turned into Chardoma's informal health broker, she had become his steady dancing partner and seemed happy to help him improve his dance skills. She would even partner with him in free tango demonstrations so he could shine as a performer "in the making."

From the professionals' point of view, the tango world offers an ideal marketing opportunity and a place to collect the benefits of extra-clinical liaisons in the form of publicity, professional respect, and social recognition. Dr. Laureano and other professionals I met during fieldwork found in the tango niche an entertainment net where they were able to interact with esteemed and skillful artists, while developing a potential network of patients for their medical practice. Within tango networks, person-to-

person referrals to specialists represent a widespread marketing strategy. Because physicians' reputations are greatly supported by public acknowledgment, their involvement with informal webs (either in the tango field or ethnic shops) provides an ideal setting from whence to collect returns on social capital. The latter come back not necessarily as favors or payments from the direct beneficiaries but from the community at large in terms of prestige and potential referrals. Besides, while tango immigrants may receive medical services at a low cost or even for free, doctors benefit from being in the company of revered dancing partners, which helps them enhance their reputations as skillful amateur dancers in the tango field and as trusted professionals in the clinical realm.

All in all, the tango milieu is not the only place where health brokerage comes about. In my larger research on Argentines in New York City, I found a few other social niches that welcomed such transactions. In Queens's "Little Argentina," the existence of a long-established, informal Argentine enclave encouraged exchanges between newcomers, senior residents, and professionals in all fields as they routinely gathered to play cards, watch soccer, or buy Argentine delicacies in the area. Finally, counting on a health broker does not imply exclusivity or loyalty on the artists' part, since many combine different health resources according to their specific life circumstances. Even insured respondents will try to find Argentine practitioners as *médicos de cabecera* (primary health physicians) within their insurance plans. In fact, due to health brokers' reliable and confidential ways of accessing biomedical services, they are even more attractive to insured immigrants. In these cases, physicians often turn into their health consultants by providing second opinions regarding procedures prescribed by their colleagues.

The Search for *Tratamiento Humano*

When I met Nadir, a female tango instructor in her midthirties, she had no health insurance despite the fact that she had been working legally (with a performance visa) with a dance company for several years. She seemed stressed, as she was working many hours a day for too little money and received no compensation for sick leave or time off for medical appointments. During one of her tango practices, she met Dr. Pérez (another Latino immigrant) who soon became her private tango student and occasional health counselor. Although Nadir had previously seen an Argentine provider, who also treated many of her acquaintances and whom

she considered more appropriate as a general physician, her financial situation ruled out the possibility of seeing him on a regular basis. Nadir explained:

> I could not afford to pay for his consultations and for the tests on top of that. This guy [her Latino friend] does not charge me, and it is a kind of *trueque* [bartering] what we have. I don't charge him for the extra lessons, and in return he prescribes me medications for free.

To get a swift diagnosis at the lowest cost was a priority for Nadir, as well as for many of her colleagues who were also short of cash, had no health insurance, and could not afford to pay for health care. Therefore, Nadir counted on Dr. Pérez as a source of good health care. In critical situations, such as an ear infection, Dr. Pérez prescribed antibiotics that allowed her to go back to work quickly and saved her from spending money on expensive medical tests. In addition, Nadir felt that her health broker's lack of pecuniary interest was a guarantee that she would receive good and caring treatment. Nadir's emphasis on the genuine concern that her friend showed for his patients is not an isolated case. The figure of the broker is actually representative of an old model of medical practice in which physicians are assumed to spend quality time with their patients, while encouraging them to ask questions and talk about their health problems and concerns. Among the qualities most valued in a physician, my respondents mentioned *el tratamiento humano* (humane treatment) and personal flexibility for payments and referrals. In addition, tango immigrants would ensure that they were in good hands by reaching out to physicians who were known to their Argentine friends and acquaintances. For instance, Chardoma noted:

> Here [in the United States], they have devices, and they don't care about what cannot be measured. There is no *dolómetro* [pain meter] available to measure pain; therefore, they don't even consider it. If they can't measure it, it can't exist! A doctor should internalize other forms of medicine, different from the university. He should have openness beyond the scientific! They believe [in the United States] that they know everything because they studied it, and whatever they haven't studied doesn't exist. In Argentina you have everything, but here it is much more structured.

Pierre, a tango instructor and producer, observed:

Doctors [in the United States] should connect with the individuals, besides having technical knowledge; bedside manner is something they lack in the United States. They don't teach that at the university, and doctors have no clue how to treat us, their patients.

The preference for Spanish-speaking medical providers among many of my respondents reveals some of the main obstacles they faced in utilizing the US medical system. Counting on Latino and Argentine physicians, whom they hoped would protect their health interests, was seen as a counter strategy to overcome the barriers to accessing US health services. By being able to communicate in Spanish, those who were undocumented and had limited English skills hoped to build symbolic bridges with the medical profession in order to reduce prejudice and social distance. Immigrants' reliance on Latino doctors was also seen as a defense against potential discrimination based on their limited English skills, and on the stigma of being viewed as Hispanics in the United States.

The presence of language barriers underscores the weight of nonmedical hurdles in the medical encounter. In particular, lack of English skills hinders immigrants' ability to negotiate cheaper health practices, including eligibility for charitable services. Even among artists who spoke English well, some preferred to express themselves in Spanish with their medical providers, as they considered themselves prone to forget the English they knew during those encounters; felt too nervous to articulate their health problems in English; or did not know (or had doubts about) the medical terminology, especially since health terms differ in both languages. In the end, immigrants' overall preference for Spanish-speaking doctors reflects their attempts to overcome the "double hurdle" of language regarding both their limitations in communicating in English and in using medical terminology that differs from everyday speech. Thus, it is a matter of not only knowing everyday English but also understanding more arcane medical terms.

Counting on either Argentine or Latino doctors was not necessarily seen as a safeguard against their monetary speculation. Rather than defending Latino and Argentine doctors versus their American peers, most study participants portrayed a model of doctor-patient relationship summarized by the old-fashioned image of the "family doctor." They frequently referred to the grand past of Argentine social medicine, which served as a rhetorical device to support a patient-centered model of biomedical care. As in most Latin American countries (e.g., Mexico; see Finkler [2001]), where Western medicine has historically been the norm in the provision

of both private and public health care, Argentina has a long tradition of biomedical technology in highly specialized fields, including heart surgery and fertility treatments.

Many participants expressed a contradictory relationship toward the US health system, which was evident in their overall appreciation of the American top-tier medical technology along with their distrust of its delivery system. They considered the US medical model an exemplary case of the global pervasive changes in physicians' roles: from caregivers to managed care providers or employees. It is not that Argentina has escaped such transformations and, indeed, most participants were aware that the Argentine public health system has slowly been replaced by a for-profit health system closer to that of the United States. Yet they still were longing for a patient-centered health-care model that represents the "gold standard" of service provision, ideally supplied by family doctors.

Even among those interviewees who distrusted physicians in general, doctors seen as friends were regarded as a guarantee that medical encounters would be worthwhile. Respondents noted the increasing dependency of medical practice on administrative regulations and insurance policy, as doctors were often identified as for-profit employees of health organizations. Most of my interviewees' narratives revealed a dialectic opposition between the old-fashioned physician, considered as a caring and honest figure, and the corporate doctor-employee type, supposedly motivated by corporate and pecuniary interests. According to this dual representation, the former will use all necessary resources (e.g., tests, specialized practices, and time) to seek her or his patients' best interests, while the latter will save as much money and time as possible for the sake of financial profitability. Teo, a male tango entrepreneur, summarized this belief as follows:

> We pay taxes, we don't have insurance, and on top of that they charge us a fortune for treatments and medications that should either be covered or given to us for free. This is a big economic scam, and we [uninsured immigrants] get into the trap of getting services without even knowing how much they will charge us in the end. It is like a penalty for being immigrants and poor!

Teo's statement is not unusual, and it agrees with other studies (Davis 1991; Feld and Power 2000; Horton 2004) that show that hospitals avoid admitting the uninsured. Furthermore, among tango newcomers who had little experience with the US health-care system, the costs of medical pro-

cedures seemed exorbitant in relationship to the services provided. For most study participants, medical options were seen as based on insurance companies' for-profit endeavors and not on patients' best interests; and even logistic problems, such as increasing the number of doctor visits for a single treatment, ultimately would be regarded as a business stratagem for taking advantage of patients' limited out-of-pocket means.

The Mixed Meanings of Trust

Most tango interviewees sought brokers or primary health-care practitioners who would not only cure them but also care for them (Good and Good 1993). These physicians were represented as holders of an old model of clinical practice and as advocates of a patient-centered paradigm in which extra-clinical characteristics were appreciated the most. These traits seemed even more manifest among unauthorized immigrants, who were more fearful of being reported to immigration authorities and eventually deported. As a framework erected on the notion of trust, the health brokerage model achieves a threefold meaning in this study. While it suggests that tango artists have confidence in their doctors' proficiency, it also implies physicians' commitment to providing the best possible treatments beyond financial gains. A third meaning implies finding reliable practitioners who will provide a safeguard against potential discrimination or threats of deportation. Hessi, a tango producer and amateur dancer, emphasized the latter connotation when referring to one of her health brokers, a Latino physician who would go out of his way to treat some of her friends:

> My friend Anastasia was feeling bad, and this guy [her health broker] told me to take her to the hospital, and once there he told us how to do it so she did not have to pay for anything. She had no papers and no insurance, and we did not even have twenty dollars to pay something extra when we went to the hospital! We got there, and someone gave us a form; so she wrote another name on it (like he told us) and then we went upstairs to see my friend. He is like that, always trying to find ways to cut through the system and help us [immigrants] out.

Not only did Hessi's broker follow an alternative model of medical care, but he also defied the dominant health system on behalf of vulnerable individuals. Physicians' alleged pecuniary interests, along with their lack of

tratamiento humano, were the obstacles most frequently mentioned by my insured interviewees that often led them to switch health providers, seek second opinions, and doubt their doctors' competence. Hessi put this emphatically:

> I got fed up [with doctors] here: nobody asks you what you eat, what you drink; yes, I hate doctors here. You get into a *corral* [doctor's office], and nobody looks at you. While a doctor is with you, he is also looking at another person. Everything is very pretty and cute [referring to a typical doctor's office], but it is like entering a machine of ill people. I don't like doctors in general, but I don't like the way they treat you here, the speed they treat you with.

Participants' preference for Latino and Argentine doctors was not rooted in an ethnocentric trait but in their search for humane treatment within the doctor-patient relationship. This finding challenges multicultural paradigms that assume that immigrants feel more comfortable among their own kind. In other words, tango immigrants did not idealize Latino or Argentine physicians as being the counter-image of money-seeking American doctors. Instead, they expressed their frustration with the US healthcare system in ethnic terms, either by portraying the health practitioners in whom they had faith as the "gold standard" to imitate or by longing for (and romanticizing) the socialized medicine they once had access to in Argentina.

A handful of tango artists also favored American practitioners due to their previous negative experiences with either Argentine or Latino doctors, which led them to avoid the latter altogether. In these cases, the benefits of choosing Latino providers were often not enough to overcome their disadvantages, particularly when participants felt they were being preyed upon by Latino doctors' monetary greed or suspected dubious ethical practices. Given that the health-broker model is based on informal codes of reciprocity, a few of my interviewees lost their health brokers when their social relationships went sour or when they stopped sharing the same tango venues.

Tango artists' search for trustworthy providers is symptomatic of the global and societal changes in health services, in which doctors no longer enjoy the prestige they once had (Wolinsky 1993). Study participants often complained about physicians' insensitivity and professional neglect, which they blamed on an increasingly pervasive for-profit biomedical culture. Even insured informants objected to the US health system's pursuit of

profits, which was described as causing a chain reaction in other health-care aspects: from doctors' conflicts of interests to their poor bedside manners. These phenomena are congruent with overall changes in the medical profession under the dominance of managed care, which has led to increased organizational pressure on physicians' clinical performance while somehow neglecting their communication skills.

Between Mistrust and Uncertain Efficacy

The salience of the health-broker model in this study raises some questions about its singularity: are health brokers an unusual breed of practitioners that differs from mainstream health professionals? Are they advocates of a solidarity ethos or preachers of a special culture of caring? Are Latino and Argentine doctors more oriented toward the health-broker model than US natives? Although I do not have comprehensive answers to all these questions, a few interesting conclusions can be drawn from the study findings. Rather than incarnating a special kind of biomedical professionals, health brokers are practitioners mostly embedded in mainstream health-care organizations. What makes these doctors brokers of a particular sort is not their specific clinical expertise, but the types of relationships they develop with tango artists, based on their informal exchanges and the reciprocal bonds they forged in the form of interpersonal trust.

Not all of my study participants told stories that were as lucky as those of Chardoma and Nadir. And not all of those who shared informal webs counted on the same health professionals—an issue related to artists' different exposure to resources (and power) within social realms. To a certain extent, access to health brokers reveals the social inequalities embedded in the tango field. For instance, elderly immigrants who were somehow excluded from the tango's mainstream networks (such as Lucy, her husband, and Flor) did not have the opportunity to interact with doctors on a personal basis. Having access to health brokers in the tango world also entails the ability to display class and racial traits that are tactfully deployed via shared social codes (Bourdieu 1984). As noted earlier, Manhattan milongas have a unique way of disguising class and racial markers by allowing a certain camouflage through which working-class individuals, from tango grandparents to construction workers, will be acknowledged as esteemed dancing guests, tango partners, and companions. High-profile professionals (including physicians, corporate executives, and independent inves-

tors) tend to befriend individuals with whom they will share dancing, as well as cultural and social interests, regardless of their social origin.

Martinique, for instance, had become close to a couple of professional individuals in the tango field, one of them being a medical practitioner. Although she acknowledged counting on this doctor's help anytime she injured herself while dancing—she had broken a toe and had torn a ligament on two different occasions—she would also complain about the "dual standard" of power existing inside and outside the tango realm. Practitioners like Martinique are among the ones enjoying the highest popularity in the mainstream tango field, particularly due to their graceful personalities and the skills and knowledge they display on the ballroom floor. At the tango parlors and dancing workshops, Martinique and her friends would transform themselves into tango queens and kings, becoming the center of attention and magnets for well-off customers such as Dr. Tezza, the female doctor who treated her.

In addition to working as a part-time tango instructor, Martinique was a hostess and bartender at one of the restaurants where Dr. Tezza had become a regular client. While at the milongas Martinique and Dr. Tezza would interact under an apparent halo of democratic equality, this agreement would eventually be challenged outside the protected tango milieu. In the end, Martinique had not been able to contest the doctor-patient relationship outside the tango field. Ultimately, she came to resent the fact that she was always available to practice with Dr. Tezza without charging her:

> What pisses me off is that I never charged her for the practice [informal classes], and I've been always willing to help her out with some of these [difficult] steps. She dreams of being a dancer someday, and she may be a great doctor, but she is not a great dancer, let me tell you! And then she acts like that, as if she didn't even know me.

The "who's who" in the tango milieu somehow uncovers an alternate power hierarchy that may not be transferred to participants' everyday lives. Martinique's disenchantment stemmed from her realization of the illusion of social equality that was broken by her doctor's reminder of their actual social differences. Immigrant artists and tango amateurs who might not even meet otherwise (and who differ in terms of social adscription and human capital) may eventually become colleagues, partners, and friends on the basis of sharing the same tango interests. The rupture of trust, particularly when immigrants' expectations are not met, is a collateral damage

drawn from actors' divergent hopes and expectations in terms of their frustrated interpersonal returns inside and outside the tango field. In Mateo's words, "They build you up fast; they make you believe that you are special and that you have a special talent. This [illusion] bursts when the next one comes around, and then you crash against reality!"

Amateur Practitioners: The Next Best Thing

What happened when my interviewees lacked health brokers, had no health insurance, and found themselves in need of immediate health care? Although health brokers provided an important link between the tango field and the US health system, their absence did not rule out artists' access to biomedicine via other means. With the exception of pregnant women and their children, who qualify for need-based entitlements such as Medicaid or other state-sponsored health programs, most of my uninsured respondents depended on their own financial means to treat most of their health conditions. In case of medical emergencies, many went to community clinics and public hospitals, which in New York City offer primary health care on a first-come, first-served basis. Some of these institutions are well known through the tango grapevine, including the Ryan Nena community health centers, Bellevue Hospital Center, and Metropolitan Hospital Center. Furthermore, my interviewees' menu of health options extended beyond biomedicine and included alternative healers, mental health counselors, and fortune-tellers.

Participants who were somehow marginal to the tango core seemed more inclined to rely on amateur practitioners as substitutes for biomedical practitioners. Those with higher educational backgrounds, and multiple social connections, leaned toward alternative and verbal therapies as a complement to Western medicine. I use here the terms "amateur practitioners" and "health consultants" to refer to ad hoc health practitioners who apply principles of biomedicine without having a US license to perform. Counting on these providers is a major health strategy among immigrants with little social and economic capital. None of these health practices seem to be exclusive, however, because tango immigrants often combine health resources while searching for the most effective (and often the fastest and cheapest) resolution to their health problems.

Elina, sixty-six, was a lively woman married to Federico, an elderly tango musician. As noted in chapter 4, they were both undocumented and struggled to make ends meet while missing their children and grandchil-

dren who had remained behind in Argentina. While Federico played tango in subway stations and a couple of milongas, Elina babysat at home. Although I interviewed both of them, it was Elina who usually spoke of their health matters in detail. She had been a tango singer in her youth and over time had become Federico's steady companion. While Elina suffered from a chronic kidney problem, she was able to obtain medicines brought by relatives and friends from Argentina who sporadically visited her.

Like other immigrants, the couple also recruited health practitioners from their tango connections. During one of Federico's tango performances, they became acquainted with a Cuban physician who, knowing of their difficult living circumstances, offered them free but limited healthcare services. Sometime before our interview, Elina had a toenail infection. She decided to visit this Cuban doctor and, although he did not charge her for the consultation, he referred her to a podiatrist who wanted to charge Elina nearly three hundred dollars, a sum of money she could not afford, to clean the affected area and extract her toenail. Instead, she called one of her Argentine friends who referred her to an unlicensed Uruguayan podiatrist, who agreed to treat her and follow up during her recovery. After finishing the dosage of penicillin given by her physician for free, Elina went to see the unlicensed podiatrist who charged only twelve dollars for the complete extraction procedure.

Santoro's narrative also conspicuously illustrates immigrants' strategies to resolve their health problems by combining (and negotiating) all the resources available to them via their social networks. Having left the United States many years ago to try a career as a tango artist in Puerto Rico, Santoro decided to return to America in the late 1990s, hoping to make enough money to send back to his family that had remained there. At the time I met Santoro, he was mostly working off the books in a variety of jobs, particularly in the construction business and landscaping. One day, he began experiencing intermittent pain in one of his legs, a problem that gradually became an obstacle to his everyday activities.

I met Santoro at this point, when he felt that his world would crumble because he was unable to achieve the simplest tasks, such as working, cooking, and cleaning. Because he was undocumented and lived hand to mouth, Santoro did not have the luxury of remaining at home until feeling better, so he attempted to solve his problem by different means. As in the case of other musicians involved with the tango's old guard, Santoro would hang out at the relatively small Argentine enclave in Queens, where he would watch the Argentine news and play cards with many of his compa-

triots at the Argentine social club. When Santoro got sick, some of his friends (including shop owners and clients) mobilized their health capital to help him out.

In at least two of my visits to the barbershop of Wilfredo, a highly respected and informal community leader, I participated in long debates of mostly elderly men regarding the best solution for Santoro's health problems. While some recommended painkillers and changing his posture, others mobilized health resources by calling doctors and nurses they knew to help him relieve his pain. Santoro's social network operated as a buffer not only against his physical problems but also against his loneliness. A couple of weeks after his health problem had begun, Santoro's friends arranged for him to be treated by an Argentine nurse, who injected him with a corticosteroid—an anti-inflammatory medicine. In the meantime, he visited a private Argentine doctor who, for an affordable fee, prescribed him additional drugs. These treatments, along with long periods of rest, kept him going until he finally got better. He visited the emergency room only once, where he was diagnosed as having a rheumatic condition that he already knew about.

It is mostly because of the advantages of availability, inexpensive service, and effective access that some immigrants, like Santoro, would rely on amateur practitioners. These providers can be formal (like the Argentine nurse) or informal, as in the case of friends who have some knowledge of first-aid treatments. Amateur practitioners are affordable and easily available, either in person or over the phone, speak Spanish, see patients at their homes or in an ethnic shop (e.g., Wilfredo's barbershop or Pedro's bakery), have flexible contractual clauses, and, above all, provide expeditious solutions to health crises without prescribing costly procedures. They are also less threatening than mainstream health services. Despite their lack of US licenses or certifications, they embody the human face of healing based on a personalized approach.

Amateur practitioners can also be defined as the ultimate caretakers of the most vulnerable of all, as in the case of struggling immigrants who either are removed from resourceful tango networks or cannot afford a physician's fees. Finally, amateur health practitioners symbolize the epitome of health-related capital, because they are known and referred to by word of mouth within ethnic social networks. In any case, these practitioners are not a substitute for biomedicine. Even when some of my interviewees decided to rely on informal providers, they often returned to their social networks for help or decided to see a licensed medical doctor when their health problems continued.

Therapeutic Eclecticism: Singular Problems, Multiple Solutions

Tango immigrants shared with me the different ways in which they utilized various health resources via informal channels. Far from being passive agents of their living circumstances, most sought alternative ways to have their health needs met, not always successfully but always actively. They did so by "shopping around" among different health systems while looking for the most efficient and cheapest solutions for their ailments. The cultural model of health-seeking behaviors proposed here epitomizes the overlapping properties of social networks across formal and informal health systems. When feeling sick, the pressure to get well by any means leads tango immigrants to develop ingenious strategies to solve their health problems. As explored in this chapter, counting on a health broker does not imply artists' exclusivity or loyalty since many of them combine different health resources, depending on their specific life circumstances. Even insured respondents may try to find Argentine practitioners as médicos de cabecera within their insurance plans.

Artists' reliance on health brokers exemplifies "the strength of weak ties" (Granovetter 1974) that are embedded in cosmopolitan tango fields, where struggling tango newcomers get connected with professionals from different disciplines, including medical doctors and alternative healers. Contrary to most common frameworks that distinguish social networks' resources as distinctively apart from the US health system, the main contributions of the health-broker model can be summarized in two of its overlapping features: being a member of multiplexial (rich) social networks and becoming engaged with reciprocal liaisons in extra-clinical social fields, including trading health assistance for tango lessons or partnerships. Although the importance of the private doctor in facilitating immigrants' access to the US health system has been thoroughly examined before (Freidenberg 2000), the novelty in this study is the role of "immigrants treating immigrants," in which doctors join their patients' networks as peers and tango partners. From a policy perspective, the figure of health brokers is of paramount importance, because it challenges taken-for-granted assumptions regarding immigrants' services utilization. These include media images emphasizing their use (and abuse) of welfare benefits and emergency rooms (Viladrich 2012a) and the strict division between professional healing systems and social networks.

A note of caution is needed here to avoid idealizing the health-broker model over other medical options. Overstating its importance among dis-

enfranchised populations can unintentionally lead to the portrayal of certain populations as "exotic," or holders of special health needs, while setting the stage for a double standard of care between a mainstream majority and ethnic/racial minorities. No matter how useful some health brokers might have been for my respondents in need of immediate health care, their salience in this study underscores the insufficient response provided by organized medicine to vulnerable populations in the United States. For most study participants, health crises were the catalysts that activated their health-related networks. Typically, they did not visit their health brokers for screening tests and checkups, and only sought their help during episodes that prevented them from performing everyday tasks.

The health-broker model also reveals some of the disadvantages involved in the exchange of social capital in which the doctor-patient relationship is not based on contractual terms, thereby leaving room for misunderstandings and unmet expectations. Surely, health brokers are not necessarily the best professionals to treat immigrants' specific health conditions, nor do they provide the best advice in all circumstances. The preeminence of mutual trust in the patient-provider relationship may lead tango artists to overlook their own checklist for practitioners' accuracy and efficacy. As a result, codes of reciprocity and friendship, along with the advantage of getting cheap or free health care, may make it difficult for artists either to contradict their doctors' opinions or to switch providers.

Most tango immigrants would not consider their health brokers as "doctors" but rather as friends or acquaintances with whom they shared nonclinical interests and who would purposively help them in times of need. In any case, these physicians tend to occupy very differential social positions in mainstream society: while medical doctors are inclined to retain both their biomedical knowledge and financial prowess, tango instructors proudly stick to their premium tango skills. And although artists and health-care brokers may be engaged in bartering relationships, their reciprocity exchanges hold true as long as they are members of the tango domain. Finally, the tango as an equalizing field reveals the social differences (e.g., social status and cultural capital) that exist in the outside world. While the hierarchical relationships between doctors and their potential patients may be suspended on the ballroom floor, at times they may be palpable outside of it. Paradoxically, although the health-broker model appears to defy the unequal relationships that typically take place in the medical encounter, it also promotes new forms of interpersonal power.

In the absence of health brokers or private doctors who charge moderate fees, amateur practitioners are tango immigrants' next choice, particu-

larly since they are easily available via informal webs. They are also less threatening than formal services because they speak Spanish, charge moderate fees, provide fast healing treatments in informal settings (even at their patients' homes), and offer flexible payment arrangements. Both amateur and alternative healers embody the paragon of health-related capital, as not only do their names circulate within immigrants' social webs, but they also belong to them. Even when my interviewees regarded amateur or alternative practitioners as their first or most frequent option, they usually returned to their social networks for help—and even ran to the emergency room when health problems became severe. In all cases, biomedicine was still the priority in the treatment of chronic and severe illness episodes.

The successful stories presented in this chapter should not minimize the fact that none of these health resources represent a complete substitution for biomedicine. As this research project did not focus on outcomes, we do not know how immigrants' symptoms might have improved or worsened by artists' reliance on different healing practices. The advantages of health brokers and amateur practitioners based on their *tratamiento humano*, price, and accessibility may conceal drawbacks in terms of their treatments' efficacy, accuracy, and safety.

My respondents' therapeutic eclecticism, characterized by their utilization of different healing services and practices, also becomes symptomatic of the deficiencies of the US biomedical system that fails to provide holistic, accessible, and efficient responses to health crises while overlooking the most vulnerable groups. If, as this study suggests, health brokers and amateur practitioners play the role of either formal or informal primary care practitioners, efforts should be made to coordinate these resources while promoting preventive practices among disadvantaged populations. Doctors performing as health brokers may be key in facilitating immigrants' access to health services as well as in promoting both positive and negative health-seeking attitudes and practices.

CHAPTER NINE

Conclusions

From Bonding to Bridging Ties

It was just a matter of time before the renewed international interest in tango dancing, which timidly began to arise by the early 1980s, would spur a second tangomania that soon enchanted tango aficionados around the globe. This time around, however, the tango craze embraced its Argentine roots through a complex process in which performers, from all over the world, gradually became savvy marketers of an artistic trade eager to feed the postmodern need for the "exotic," expressed in sophisticated dance forms. Throughout this process, the tango quickly returned to its germinal source, in the shoes of Argentine tango artists and entrepreneurs who have, since then, branded themselves as its ultimate packaging device.

Hobsbawm's notion of inventing traditions (1994) speaks to the symbolic creation of a modern continuity with the past in order to provide a frame of reference, in which shared beliefs and cultural norms elicit emotional bonds with current social and artistic artifacts. This, in turn, creates a sense of nostalgic attachment to a distant epoch that elicits romanticized encounters with a premodern type of society. In line with Hobsbawm's conceptualization, the postmodern search for the real tango—amid a romanticized history that mixes tough guys with sensual prima donnas—has inspired much of the global interest in recovering its Argentine roots through those who have trained, and grown up, in the Buenos Aires harbor. In a global economy where commodities seem to have been detached from their original birthplaces, the most appreciated goods are those that emanate from untainted reservoirs while retaining the label of a genuine ethnic fashion. Far from being a colonized response to a worldwide econ-

216

omy, the marketing and performativity of tango passion has become Argentine artists' rational attempt to profit from the international economy of feelings (Savigliano 1995).

The American dream of dancing like an Argentine (Gift 2009), on the basis of rehearsing fleshly yet stylish embraces, suggests a cosmopolitan

Figure 23. Tango embrace II. (Photographer: Mayte Vicens; dancers: Mayte Vicens and Tioma Maloraski)

hunger for authenticity that, under the leadership of a global leisure class, made the genre rebound with a vengeance in New York City in the mid-1990s. Since then, the Manhattan tango crowd has remained hooked into searching for the tango's sensual moves, its raison d'être being found in the closeness of male and female bodies moving together with uncanny synchronicity.

As a therapeutic trip of enlightenment, foreigners who dance tango become acculturated (Toyoda 2012) in their own way by learning not just about tango steps but about Argentines' cultural expressivity that is translated into openly affectionate displays, lessons about tango history, and even the use of lunfardo terms. Throughout this process, Argentines have found themselves in an interesting position: although they are at a numerical disadvantage in both New York and the global tango field vis-à-vis an international cadre of tango artists, they have made good use of their privileged status as the creators and assumed best interpreters of the tango.

As in the case of other ethnic economies, Argentine performers depend on their informal liaisons to capitalize on the tango trade as their own ethnic and national product. In a sense, Argentine artists have mastered their own "ethnicization" in the labor force, by the taken-for-granted assumption that they are especially qualified for one type of job within the ever-growing worldwide demand for garish pastimes. Contrary to the growing popularity of salsa as a transnational artistic commodity that represents the ultimate Latinization of all rhythms from the Americas (Urquía 2005), tango music and dance rely on Argentine citizens as the performers of an uncorrupted artistic ethos. Paraphrasing Savigliano's pioneering work (1995), it could be argued that if tango passion becomes an emotional merchandise that is appropriated, imitated, borrowed, circulated, bought, and sold, it is through its original Argentine carriers that it can be extracted over and over again. As a result, the tango has become more Argentine than ever before.[1] The saying *"nadie baile el tango tan bien como un Argentino* (nobody dances the tango as well as an Argentine)"* reflects this assertion plainly.

In the cosmopolitan, Zen-like search for the "right tango," the underlying anxiety Argentines secretly share revolves around curbing the globalizing trend that threatens to make the tango universal and no longer the property of a single national group. If Argentines are going to remain dominant in the tango field, despite their meager numbers in comparison with their non-Argentine competitors, it is by reminding the world of their natural right to exert the tango's genuine spirit. In this effort, they ultimately join forces to claim a leading place in the tango's worldwide reproduction.

While the future of this genre will probably resolve its paradoxical character, as either an evolving Argentine trend or a worldwide hybrid, the latest tangomania has revealed Argentines' ability to capitalize on its seemingly endless possibilities.

Until now, much of what was known about Argentine tango practitioners had remained camouflaged under the spell of their artistic personas, both at home and abroad. Most tango performers deploy diverse job and business strategies: from self-employment and working for peers in the tango business (as organizers, dancers, and instructors) to trying alternative careers. In this vein, this study shed light on one of the most surreptitious dimensions of the tango world, defined by Argentines' engagement in the service economy to make ends meet.

As discussed in this book, artists' participation in the entertainment and service industries, either as conspicuous performers or quasi-invisible low-skilled workers, goes hand in hand with the social inequalities brought by economic globalization, which offers low-paid and unstable jobs along with little social and economic security. Likewise, rather than becoming the consumers of the tango's entertainment capital, Argentine tango artists are its producers: the ones who render the labor force that serves a transnational leisure class. To the extent that many Argentine performers depend on low-skilled jobs, this study showed the pervasive ways in which the tango's entertainment field in New York City reproduces the taxing employment conditions already existing in immigrants' homeland. These findings reveal one of the main features of the transnational entertainment field that spurs ingrained social inequalities even in the richest cities on earth.

Behind Intangible Social Webs:
The Manhattan Tango Showcase

We are now left with a few additional queries regarding the role of immigrants' social networks within the artistic realm: What have we learned in terms of the importance of the tango field as a resourceful social milieu for Argentine tango artists in New York City? What are the bases for Argentines' contradictory patterns of intragroup solidarity within the entertainment field? What are the implications of these research findings regarding the role of social networks in providing valuable resources to their members?

To begin with, the tango field is conceived here as a suitable domain for

the exchange of valuable resources on the basis of belonging to the same entertainment realm. It operates as both an employment fair and a talent show, which allows Argentines to recruit students for private classes and display their skills while meeting potential clients and producers. In a market characterized by transient and irregular incomes, artists' reliance on their informal webs—though not unique to the tango field—is pivotal for the diversification of their employment possibilities in the artistic milieu. Thus, informal ties are essential in building the career paths of both professional and amateur practitioners.

The Manhattan tango field serves not only as an economic niche for tango artists and entrepreneurs but also as an exemplary rich and diverse (multiplexial) social network among Argentines from diverse social strata and professions. Probably the single and most striking finding in this volume has been the milongas' role in linking Argentines with an international crowd of artists and well-off tango practitioners, on the basis of belonging to the same community of interest. Manhattan milongas are unique social venues where the highest expression of cosmopolitanism takes place on the basis of attracting a diverse clientele: from professionals seeking to learn tango skills with attractive dancing partners, to Argentine waiters and unemployed newcomers rehearsing tango steps with peers, to aspiring tango stars hoping to persuade potential students to take lessons with them. Tango parlors bring together performers, amateur dancers, and students from different social and professional worlds, many of whom might not otherwise meet each other.

The subtle text of the tango's grapevine reveals the multiple social webs that make its dancing parlors an all-inclusive employment fair where new students can be hooked, potential producers wooed, and new partnerships for tango adventures forged. Most tango artists join New York City's dancing milieu the "old-fashioned" way, meaning that they still must make face-to-face contact by either visiting tango workshops hosted by colleagues or following up leads and referrals handed over by casual acquaintances. Making oneself known in the tango niche means being willing to give demonstrations for free and teaching for little money in order to get a foot in the door.

Most dancers agree with the importance of "seeing and being seen" as a necessary condition for securing a regular income. Their efforts to gain public visibility are also reinforced through a word-of-mouth process—who you know, who has referred you to whom, and to whom you are connected in the tango realm. This triple role of the milonga (as dancing field, social networking venue, and employment niche) is not unique to

tango but has barely been studied as an epiphenomenon of the leisure industry along with its bonding and bridging properties.

The bonding potential of social capital rests on artists' mutual help in getting jobs and information about housing, visa applications, and free or affordable access to health care in exchange for tango classes and comradeship. This also entails performers' reliance on their co-ethnic ties to continue feeding their businesses either by regularly traveling to Buenos Aires and other cities, or inviting their co-nationals to the United States to promote their practice. These exchanges ensure trust and loyalty because artists put their own status at risk by taking fellow citizens into the tango market. Tango instructors residing in Madrid, Tokyo, or San Francisco expand their bridging capital by making new contacts in the Manhattan milieu as a way to enact their belonging to a transnational tango community.

The contested dancing scene in New York City makes artists work hard, and join forces, for the purposes of not only bringing new students and practitioners to the tango practice but also claiming the superiority of Argentine tango over other dancing types. For most participants in this study, their ethnic identification as Argentines carried out an implicit agreement of mutual obligations and shared rights in the form of enforced assistance and reciprocity. As a result, a sort of double-bounded solidarity links Argentines in the Manhattan tango milieu on the basis of their belonging to the same tango community on the one hand, and of sharing the same nationality on the other. This reflects a main feature of immigrants' social webs, which mostly recruit a tango labor force through co-ethnics who are symbolically subpoenaed to share resources, under the tacit agreement that they will be committed to reciprocating favors in the long run. In the end, by promoting their compatriots in the tango field, Argentine artists and entrepreneurs not only reproduce a sort of ethnic solidarity but also reaffirm their presence and leadership in the tango's mainstream market.

The Realm of Paradoxical Solidarities: The Challenges Ahead

The dynamic liaisons that bring Argentines together in the tango field by no means represent a univocal phenomenon. On the contrary, immigrants' reliance on each other is crossed by "paradoxical solidarities," defined as an intricate process of intra-ethnic alliance building and competition vis-à-vis the exchange of favors and services between Argentine tango

artists and their fans. Ethnic solidarity can be better defined as a multidimensional and changing, rather than static, process that is built on the diverse demands of network members. Against the tendency to underscore social webs' positive effects, this study revealed the shortcomings of interpersonal liaisons including artists' unmet expectations, broken loyalties, and the fracture of their reciprocity exchanges.

While artists' interpersonal ties are reinforced by the branding of the tango as their own national product, at the heart of their conflicts lie their individual struggles to make ends meet. Argentines' public self-presentation as a homogeneous front is threatened by a parsimonious artistic market, which promotes intra-ethnic rivalries for jobs and competition for personal reputation in the tango field. Tango immigrants' unmet needs are at the root of their tensions and divergences. The same individuals who may work together to help pay the hospital bills of a colleague at some point in time may also contend, and even undermine each other's talents, just for the benefit of being chosen for a tango gig later on. And those who would not get together in plain daylight may end up mingling at tango parlors for the purpose of sharing sweaty embraces and intricate moves—all for the sake of making a living from their tango practice.

The rules of social capital set clear limits for those who are its beneficiaries, a fact that reveals its dual potential as a trigger of both ethnic solidarity and social inequalities in the artistic field. Bounded solidarity and enforceable trust ensure that group members will protect each other according to the norms and values collectively shared, and that will be sanctioned in cases of disapproved behavior. Ethnic solidarity will then coexist with performers' social differences as long as their exchanges do not threaten their unequal locations in the artistic field. There is nothing really startling in the way in which networks' members are invited to join the artistic pipeline. If at the group level, access to social capital depends on its bridging power—namely, its ability to connect individuals sharing common interests in diverse fields—then, at the individual level, there are specific limits to its reach based on differences in social status (including income and education), race, cultural identity, and even demographic features such as age. While artists belonging to the Manhattan tango field are more likely to find jobs, housing, and health resources via their tango webs, those barred from mainstream circuits (such as Flor, one of the elderly artists I introduced in chapter 4) are less likely to count on those assets.

The dual principle of inclusion and exclusion from the artistic field is palpable in the differences between Manhattan and outer borough Argentine events, which disclose a hidden class and racial hierarchy as a meta-

phor for Argentines' socioeconomic and ethnic differences. An upper-class and cosmopolitan (mostly white) tango clientele gathers at the English-speaking Manhattan milongas, which somehow support the employment careers of a vast crowd of tango instructors and performers. Across the Queensborough Bridge, outer borough dancing venues do not attract mainstream tango dancers but, instead, darker-skinned Argentines and other Latinos (mostly from working-class origins), who get together for the purpose of enjoying tango music and dancing to other Latino rhythms as well.

A note of caution is needed here to pin down the power of social capital categories. The literature questions the importance of social capital as a resource for social integration and community empowerment, as well as an enhancement of health and social indicators (Cattell 2001; Kawachi et al. 1997). Those interested in promoting social capital at the community level raise concerns about the disruption of community bonds, the increasing levels of violence and crime, and the pervasive loss of America's social capital represented in the image of the individual "bowling alone" (Putnam 1995). This study has concluded that Argentines do not bowl alone, but their richest sources of social capital are not found in formal organizations or community groups, such as tango unions or advocacy organizations. Instead, artists' most valuable social assets (from recommendations for jobs to referrals to affordable health care) are drawn from their loose, and often volatile, social ties.

Informal networks are in no way a universal panacea for tango immigrants' needs; instead, they somehow mirror the structure of the artistic field where most jobs and gigs are secured via the tango's grapevine, on the basis of "who you know" inside and outside of it. In spite of tango artists' everyday expressions of mutual help, most participants invariably agreed with the general belief that Argentines lack basic community ideals including intra-solidarity, ethnic unity, and concern for their fellow citizens. Among the several iterations of this phenomenon, I found that artists' tendency to blame the national aggregate for their trials and tribulations became a surrogate for the effects of neoliberal market conditions, which often crashed their dreams of success while making them vulnerable to informal working contracts.

The fact that most of my interviewees found information about visas and jobs through casual ties and kinship networks tells us a great deal about the meager responses delivered by more standard and formal channels. It is mostly through their interpersonal links of camaraderie and friendship that Argentines are able to obtain information about housing or

referrals to health practitioners who will charge them lower fees. Nevertheless, given the structural constraints that tango immigrants face, it is often easier to blame their peers for their own frustrations—particularly those who are perceived as more successful and luckier than they are. Although in recent years the tango has been refurbished as Argentina's national symbol, in an effort to exploit ethnic nostalgia and bring tourist dollars to the country's shore, most tango artists point out the absence of both the public and private Argentine sectors in supporting their trade. Concomitantly, tango performers count neither on unions nor on political representation to advocate for their rights either at home or abroad.

More studies are needed to connect the theory on social capital with the specific fields where it actually takes place. We need data on which networks either facilitate or constrain the circulation of social resources, including who is accounted for and who is excluded from social capital's benefits. This involves distinguishing networks that do or do not promote immigrants' health-seeking behaviors (Derose and Varda 2009). As discussed here, artists' connections with tango brokers, and with other alternative health providers, epitomize the power of bridging capital that ultimately does not replace having health insurance coverage and regular access to health care. Future research should address the role of health brokers in facilitating immigrants' informal access to the US health system, which may be disregarded if rigid distinctions between social networks and health systems are drawn—an issue that may contribute to the invisibility of health brokers in the public imagination.

In the end, informal networks are not an enduring substitute for the formal channels (e.g., job insurance, comprehensive health benefits, government programs) that should provide access to needed resources. The fact that interpersonal webs are doing, even if partially, what other formal channels are not tells us something crucial about tango artists' unmet needs; this information may be essential for the design of policies aimed at improving the working and living conditions of immigrant populations in the United States.

Notes

Introduction

1. Argentine, Argentinian, and Argentinean are three of the most common terms, usually used interchangeably, to refer to both individuals and products that come from Argentina. In order to be consistent, I use the terms "Argentine" (singular) and "Argentines" (plural) throughout this text.

2. Exceptions to this trend are seen in the English-language pieces by Freidenberg and Masuelli (1998) and Marshall (1988). Furthermore, beginning in 2001, an incipient attention began to be paid to a new wave of disadvantaged economic emigrants as a result of Argentina's third major emigration phase (Marrow 2007).

3. The journeys and migratory paths of educated middle-class Argentine émigrés are seen in works by Aruj (2004), Barón and colleagues (1995), Boccanera (1999), Melamed (2002), Viñas (1998), Wilman-Navarro and Davidziuk (2006), and Zuccotti (1987). For example, Viñas offers a fascinating historical and literary account of some remarkable middle- and upper-class Argentine visitors to the United States, in the nineteenth and twentieth centuries, that included politicians, artists, writers, and so forth.

4. The Spanish words *criollo* (singular) and *criollos* (plural) were originally utilized to name those who were born in the colonies but were of Spanish origin. Through time, this term became popularized to identify individuals of mixed heritage, including Amerindians. Today, the word *criollo* is commonly translated into creole in English, although the latter is utilized to categorize many different ethnic groups in the United States and is not related to any colonial system in particular.

5. Carlos C. Groppa is an Argentine illustrator and writer living in the United States who, for more than fifteen years now, has edited the magazine *Tango Reporter* in Los Angeles. His book *The Tango in the United States: A History* (2004) helps demystify the notion of the Argentine tango as a fairly recent phenomenon in the United States. Beginning with a chronicle of the first tangomania in the 1910s, Groppa's book exam-

ines the tango's dancing boost in this country, first launched by Vernon and Irene Castle and followed by the figures of Rudolph Valentino, Arthur Murray, and Xavier Cugat, who popularized the genre in the 1920s and 1930s.

6. The romanticized ethos of this new tangomania was represented in the film *The Tango Lesson* (1997), directed by Sally Potter, in which the ultimate postcolonial agenda is expressed via subtle forms of sexual tourism, spiced with psychological drama and constructed cultural sensitivity (Savigliano 2005).

7. A revival of the show *Tango Argentino* played at an open-air venue to an audience of more than twenty thousand in Buenos Aires' downtown area in February 2011 (*Reportango* 2011).

8. Bourdieu (1986) initially coined the term "social capital" in the 1970s for the purpose of qualifying the power of social webs in granting access to valuable assets. According to Bourdieu, social capital is conceived as a fungible reserve that, in tandem with other forms of capital, can allow social mobility while reproducing social inequalities.

9. Coleman's rational model sees social capital as a means to sustain group cohesion and social order versus Bourdieu's theory of practice, which conceives the distribution of social capital as a means for maintaining the inequalities of the capitalist system (Edwards, Franklin, and Holland 2006).

Chapter 1. The Tango's Social History in a White-Imagined Argentina

The poem excerpt at the beginning of this chapter is from "Para dormir a un negrito" (Lullaby for a Little Black Child) by the Argentine poet Germán Berdiales (1896–1975). The translation is mine from Berdiales 2006.

1. "Los esclavos *negros*: ¿*Por qué se extinguieron?*" *Todo es Historia* (cover page), Buenos Aires (2000), 393.

2. The *candombe* was born out of Batu African drumming, which was brought by African slaves to Uruguay and Argentina.

3. As Farris Thompson (2005: 10) observes, "That most *tangueros* today are white no more hides the original—and continuing—black presence than Elvis Presley conceals the heritage of Robert Johnson, or Benny Goodman masks the contributions of Fletcher 'Smack' Henderson and Count Basie."

4. CONADEP's Nunca Más (Never Again, 1984) reported that the *detenidos-desaparecidos* (Argentines who were detained or disappeared) were reflected in all occupational groups. Factory employees and manual workers were among 30 percent of the disappeared, a number that was much lower among the exiled. Intellectuals, professionals, and artists mostly composed the latter group. Mexico, Paris, and New York were all stops on these émigrés' journeys during this period (1976–83).

5. A *boleadora* is a set of three ropes, weighted at the ends by heavy balls, which was used by Argentine gauchos for capturing cattle by entangling their legs.

6. The scary *pardo* man in the tango could be replaced today by the criminal who listens to *cumbia villera* (cumbia music from the slum) or by *el barra brava* (the violent soccer supporter) (Castro 2001).

7. The terms *negro* (masculine) and *negra* (feminine) are also utilized as forms of endearment, even among those who identify themselves as white.

Chapter 2. Welcome to the Argentine Tango World

Modified English excerpts are from Planet Tango (http://www.planet-tango.com/ lyrics/mibuenos.htm). The song quoted at the beginning of this chapter, "Mi Buenos Aires querido" (My Beloved Buenos Aires), was part of the film *Cuesta Abajo* (1934), shot in New York City and produced by Paramount Pictures, with music by Alfredo Le Pera and lyrics by Carlos Gardel, the film's inspiring star.

1. In their research project on Argentine immigrants in New York City, Wilman-Navarro and Davidziuk (2006: 33) also found that many of their participants got to liking the tango once they moved to New York City. One of their interviewees points out the following: "You realize you're Argentine when you're abroad. That's why it's so common to see people dancing or listening to tango when they're in New York. You see them doing things here that they wouldn't dream of doing there, but here they do it to stay in touch with their roots."

2. Leeds (1996: 391) observes that Argentines in Jackson Heights were the first Latino group in the area in the 1960s. "When the affluent Argentineans dispersed to Forest Hills and Rego Park, Colombians were the next new Latins on the block and the Peruvians and Ecuadorians were waiting in the wings."

3. I also frequented milongas hosted by Americans and other international tango fans. On one occasion, an American tango hostess suggested that I should visit milongas held by Argentines in the city: "Don't come here, go where Argentines like to hang out, where they can drink and smoke and where tango is just part of it all."

4. My dissertation project was subject to approval by the Institutional Review Board that regulates the research activities of the Mailman School of Public Health at Columbia University.

Chapter 3. Argentine Tango Artists

The epigraph at the beginning of the chapter is my translation of a quotation from Dos Santos (2001: 169).

1. Eleonora Casano, an artist in her forties who did not participate in this study, has become the most emblematic example of this phenomenon. After being a prima ballerina in Argentine ballet for decades, she moved on to become an acclaimed tango producer and dancer.

Chapter 4. Elderly Newcomers and the Tango's Vulnerable Image

1. The *bandoneón*, an instrument that is similar to the concertina, became popularized in Argentina and Uruguay as the ultimate musical representation of the tango music. Invented by a German in the mid-1860s, it was brought to Argentina by Ger-

man sailors in the late nineteenth century. It is considered one of the most important, and complex, musical devices of the genre's repertoire.

Chapter 5. Legal Trajectories and the Elusive American Dream

1. Goffman's book *Asylums: Essays on the Social Situation of Mental Patients and Other Inmates* (1961) was based on his fieldwork conducted at St. Elizabeth's Hospital in Washington, DC.

Chapter 6. The Social Geography of New York's Tango

1. As noted by Oboler and Dzidzienyo (2005), unlike in the United States, rarely is it the case in Latin America that race is considered to be the main signifier of experience. Citizens within Latin American countries mostly rely on sociocultural and class markers to define social differences, a fact that openly contradicts the actual existence of colored and phenotypic prejudices.

2. The word *mersa* comes from the Argentine *lunfardo* and is often used to refer to unrefined individuals, presumably from low-income groups, who lack manners and education.

3. According to the *Guide for Argentine Immigrants* (see Consulado General de la República Argentina 2005), there are twenty-two Argentine organizations in the New York metropolitan area. These associations hold diverse interests, ranging from diasporic philanthropy efforts to religious celebrations and professional promotion.

4. The Tango Friends' Association (a nonprofit group) was created in 1977 in Queens and experienced its peak of activity in the 1980s. Among its goals, the association committed itself to popularizing tango music and arranging shows, lectures, and parties, along with strengthening the bonds and contacts with Buenos Aires. At the time of writing this book, some of its former members were attempting to relaunch the association's activities.

Chapter 7. Paradoxical Solidarities in the Tango Field

1. The belief about Argentines "not trusting each other" is also supported by the literature (see Wilman-Navarro and Davidziuk 2006; Zuccotti 1987).

Chapter 9. Conclusions

1. While hybrid expressions of tango (e.g., the "nomad tango," in Pelinski's terms [1995]) have been territorialized according to various cultural and geographic contexts, the marketing of Argentine tango stresses an original brand: "made in Argentina"—similar to products such as French-made champagne and Roquefort, rather than generic sparkling wine and bleu cheese.

Glossary

abuelos del tango literally means "tango grandparents"; term used to name the Argentine elderly who still practice tango.

argentinidad shared experience of being an Argentine citizen.

bandoneón an essential tango musical instrument in Argentina and Uruguay, similar to the concertina.

barrio neighborhood.

cabecitas negras "little black heads"; a derogatory term coined during Perón's first government to label the rising working class, mostly dark-skinned creoles from rural origins.

derecho de piso literally translates as the right to use the floor. It symbolizes the struggles and difficulties that newcomers experience when entering a new field.

gaucho herdsman from the Argentine pampas. The plural is *gauchos*.

lunfardo Spanish jargon from Buenos Aires; it was initially coined by European immigrants and their descendants who inhabited the inner neighborhoods.

mate herbal drink made with *yerba mate* that is widespread in Argentina, Uruguay, Paraguay, and the south of Brazil. It is served in a calabash gourd and drank with a straw (called *bombilla*).

milonga social parlors aimed at tango dancing; term also used to name a fast tango rhythm that credits the Afro-Argentines' contributions to the genre.

milonguera, milonguero female and male tango regulars respectively. It also defines a close tango dancing style (chest-to-chest) that originated in crowded salons with little room for couples to maneuver. The plural is *milongueros*.

mersa derogatory term that refers to individuals and tastes considered simple and unrefined.

negra, negro literally means black (female and male, respectively). It is used, in its derogative and laudatory forms, to informally name darker-skinned Argentines.

pampas plains; Argentine fertile lowlands located in Buenos Aires and other provinces.

porteña, porteño female and male Buenos Aires natives.

práctica (singular), *prácticas* (plural) dancing event intended for practicing tango in a more relaxing atmosphere than in *milongas*—the latter usually have stricter rules regarding dancing protocols, musical sets, clothing, etc.

tangomanía tangomania; a word that combines "tango" and "mania" to label the worldwide enthusiasm (and obsession) for tango music and dancing.

tango canción tango song.

tanguera, tanguero female and male tango dancer and enthusiast. The plural is *tangueros*.

tratamiento humano humane treatment; it features a patient-centered health system, specifically physicians who have great bedside manners and care for their patients' health.

trabajadores workers; a term coined to define the Argentine working class born during the first government of Juan Domingo Perón.

References

Abraído-Lanza, Ana F. 1997. "Latinas with Arthritis: Effects of Illness, Role Identity and Competence on Psychological Well-being." *American Journal of Community Psychology* 25:601–27.

Actis, Walter, and Fernando O. Esteban. 2007. "Argentinos hacia España ('sudacas' en tierras 'gallegas'): el estado de la cuestión." In *Sur-Norte: Estudios sobre la emigración reciente de Argentinos*, edited by Susana Novick, 205–58. Buenos Aires: Catálogos.

Agar, Michael H. 1980. *The Professional Stranger: An Informal Introduction to Ethnography*. Orlando: Academic Press.

Aizen, Marina. 2000. "Nueva York: Cada vez hay más Argentinos ilegales." *Clarín*, October 14. http://edant.clarin.com/diario/2000/10/14/s-06015.htm.

Alberts, Heike C. 2005. "Changes in Ethnic Solidarity in Cuban Miami." *The Geographic Review* 95:231–48.

———. 2009. "The Missing Evidence for Ethnic Solidarity Among Cubans in Miami." *Journal of Immigrant & Refugee Studies* 7:250–66.

Anderson, Benedict. 2006. *Imagined Communities*: Reflections on the Origin and Spread of Nationalism, new edition. London and New York: Verso.

Andrews, George Reid. 1980. *The Afro-Argentines of Buenos Aires, 1800–1900*. Madison: University of Wisconsin Press.

———. 2004. *Afro-Latin America, 1800–2000*. New York: Oxford University Press.

Appelbaum, Nancy P., Anne S. Macpherson, and Karin A. Rosemblatt. 2003. *Race and Nation in Modern Latin America*. Chapel Hill: University of North Carolina Press.

Archetti, Eduardo P. 1999. *Masculinities: Football, Polo and the Tango in Argentina*. Oxford: Berg.

———. 2003. "O 'gaucho,' o tango, primitivismo e poder na formação da identidade nacional Argentina." *Mana* 9:9–29.

Aruj, Roberto. 2004. *Por qué se van: exclusión, frustración y migraciones*. Buenos Aires: Prometeo Libros.

Azzi, María S. 1996. "Multicultural Tango: The Impact and the Contribution of the Italian Immigration to the Tango in Argentina." *International Journal of Musicology* 5:437–453.

Bailey, Thomas, and Roger Waldinger. 1991. "Primary, Secondary, and Enclave Labor Markets: A Training Systems Approach." *American Sociological Review* 56:432–45.

Barón, Ana. 2002. "Los Argentinos, obligados a tener visa para ir a EE.UU." *Clarín*, February 21. http://edant.clarin.com/diario/2002/02/21/s-03001.htm.

Barón, Ana, Mario del Carril, and Albino Gómez. 1995. *Por qué se fueron: Testimonios de Argentinos en el exterior*. Buenos Aires: Emecé.

Beecher Stowe, Harriet. 1852. *Uncle Tom's Cabin: Or, Life Among the Lowly*. Boston: John P. Jewitt.

Behar, Ruth. 1996. *The Vulnerable Observer: Anthropology That Breaks Your Heart*. Boston: Beacon Press.

Berdiales, Germán. 2006. "Para dormir a un negrito." In *Poesías, canciones y juegos*, edited by Mabel Nelly Starico de Accomo. Buenos Aires: Editorial Kimeln.

Berg, Bruce L. 1995. *Qualitative Research Methods for the Social Sciences*. Boston: Allyn and Bacon.

Bergad, Laird W. 2007. *The Comparative Histories of Slavery in Brazil, Cuba, and the United States*. New York: Cambridge University Press.

Berkman, Lisa F., Thomas Glass, Ian Brissette, and Teresa E. Seeman. 2000. "From Social Integration to Health: Durkheim in the New Millennium." *Social Science & Medicine* 51: 843–57.

Bernard, H. Russell. 1994. *Research Methods in Anthropology: Qualitative and Quantitative Approaches*. Thousand Oaks, CA: Sage Publications.

Bernstein, Nina. 2005. "Once a Frightened Newcomer, Argentine Consul Now Seeks to Guide Immigrants." *New York Times*, July 29. http://www.nytimes.com/2005/07/29/nyregion/29guide.html?pagewanted=print.

Bleta, Atilio. 2001. "El gobierno quiere apurar la confección de un nuevo DNI." *Clarín*, October 1. http://edant.clarin.com/diario/2001/10/01/p-00301.htm.

Boccanera, Jorge. 1999. *Tierra que anda*. Buenos Aires: Ameghino.

Boissevain, Jeremy, Jochen Blaschke, Hanneke Grotenbreg, Isaac Joseph, Ivan Light, Marlene Sway, Roger Waldinger, and Pnina Werbner. 2006. "Ethnic Entrepreneurs and Ethnic Strategies." In *Ethnic Entrepreneurs: Immigrant Business in Industrial Societies*. Vol. 1 of *Sage Series on Race and Ethnic Relations*, edited by Roger Waldinger, Howard Aldrich, Robin Ward and Associates, 131–56. Newbury Park, CA: Sage Publications.

Bonacich, Edna, and John Modell. 1980. *The Economic Basis of Ethnic Solidarity: Small Business in the Japanese American Community*. Berkeley: University of California Press.

Bosse, Joanna. 2007. "Whiteness and the Performance of Race in American Ballroom Dance." *Journal of American Folklore* 120:19–47.

Bourdieu, Pierre. 1984. *Distinction: A Social Critique of the Judgment of Taste*. Cambridge, MA: Harvard University Press.

———. 1986. "The Forms of Capital." In *Handbook of Theory and Research for the Sociology of Education*, edited by John G. Richardson, 46–58. New York: Greenwood.

Bourdieu, Pierre, and Jean-Claude Passeron. 1979. *The Inheritors: French Students and Their Relation to Culture.* Translated by Richard Nice. Chicago: University of Chicago Press.

Bourgois, Philippe. 2003. *In Search of Respect: Selling Crack in El Barrio.* 2nd ed. Cambridge, UK: Cambridge University Press.

Braga Martes, Ana C. 2000. *Brasileiros nos Estados Unidos: Um estudo sobre imigrantes em Massachusetts.* Sao Paulo: Paz e Terra.

Brettell, Caroline B. 2005. "Voluntary Organizations, Social Capital, and the Social Incorporation of Asian Indian Immigrants in the Dallas-Fort Worth Metroplex." *Anthropological Quarterly* 78:853–83.

Brettell, Caroline B., and Kristoffer E. Alstatt. 2007. "The Agency of Immigrant Entrepreneurs: Biographies of the Self-employed in Ethnic and Occupational Niches of the Urban Labor Market." *Journal of Anthropological Research* 63:383–97.

Briones, C. 2002. "Mestizaje y blanqueamiento como coordenadas de aboriginalidad y nación en Argentina." *RUNA* XXIII:61–88.

Browning, Robert. 2011. *The Pied Piper of Hamelin.* Seattle: CreateSpace.

Bryson, Bethany. 1996. "'Anything but Heavy Metal': Symbolic Exclusion and Musical Dislikes." *American Sociological Review* 61:884–99.

Buchanan Stafford, Susan. 1987. "The Haitians: The Cultural Meaning of Race and Ethnicity." In *New Immigrants in New York*, edited by Nancy Foner, 159–93. New York: Columbia University Press.

Cáceres, Juan Carlos. 2010. *Tango negro.* Buenos Aires: Planeta.

Carozzi, María Julia. 2005. "La edad avanzada como valor en el tango bailado en Buenos Aires." *Cuestiones Sociales y Económicas* 3:73–86.

———. 2009. "Una ignorancia sagrada: Aprendiendo a no saber bailar tango en Buenos Aires." *Religião & Sociedade* 29:126–45.

Carpi, Daniel. 2002. "Dancetango.com Presents New York's Most Successful Series of Tango Evenings." *ExploreDance.com*, August 8. http://www.exploredance.com/article.htm?id=892.

Carretero, Antonio M. 1999. *El compadrito y el tango.* Buenos Aires: Continente.

Castells, Manuel. 1997. *The Power of Identity.* Vol. 2 of *The Information Age: Economy, Society and Culture.* Malden, MA: Blackwell.

Castro, Donald S. 1991. *The Argentine Tango as Social History, 1880–1955: The Soul of the People.* Vol. 3 of *Latin American Series.* Queenston, UK: Edwin Mellen Press.

———. 2001. *The Afro-Argentine in Argentine Culture: El negro del acordeón.* Lewiston, NY: Edwin Mellen Press.

Cattell, Vicky. 2001. "Poor People, Poor Places, and Poor Health: The Mediating Role of Social Networks and Social Capital." *Social Science & Medicine* 52:1501–16.

Chamosa, Oscar. 2010. *The Argentine Folklore Movement: Sugar Elites, Criollo Workers, and the Politics of Cultural Nationalism, 1900–1955.* Tucson: University of Arizona Press.

Chávez, Leo. 1992. *Shadowed Lives: Undocumented Immigrants in American Society.* New York: Harcourt Brace Jovanovich.

———. 2008. *The Latino Threat: Constructing Immigrants, Citizens, and the Nation.* Stanford: Stanford University Press.

Chen, Hsiang-Shui. 1992. *Chinatown No More: Taiwan Immigrants in Contemporary New York.* Ithaca, NY: Cornell University Press.

Chin, Margaret. 2005. *Sewing Women: Immigrants and the New York City Garment Industry*. New York: Columbia University Press.

Cirio, Norberto P. 2006. "La presencia del negro en grabaciones de tango y géneros afines." In *Temas de Patrimonio Cultural 16: Buenos Aires negra, identidad y cultura*, edited by Leticia Maronese, 25–60. Buenos Aires: Ministerio de Cultura, Gobierno de la Ciudad de Buenos Aires.

Coleman, James S. 1988. "Social Capital in the Creation of Human Capital." *American Journal of Sociology* 94:S95–S121.

Collier, Simon. 1986. *The Life, Music and Times of Carlos Gardel*. Pittsburgh: University of Pittsburgh Press.

CONADEP. 1984. *Nunca más*. Buenos Aires: EUDEBA.

Consulado General de la República Argentina. 2005. *Guía del inmigrante Argentino en Nueva York*. New York: Consulado General de la República Argentina.

Cook-Martín, David, and Anahí Viladrich. 2009a. "The Problem with Similarity: Ethnic Affinity Migrants in Spain." *Journal of Ethnic and Migration Studies* 35:151–170.

———. 2009b. "Imagined Homecomings: The Problem with Similarity Among Ethnic Return Migrants in Spain." In *Diasporic Homecomings: Ethnic Return Migration in Comparative Perspective*, edited by Takeyuki Tsuda, 133–58. Stanford: Stanford University Press.

Cornelius, Wayne A. 1982. "Interviewing Undocumented Immigrants: Methodological Reflections Based on Fieldwork in Mexico and the U.S." *International Migration Review* 16:378–411.

Corradi, Juan, E. 1997. "How Many Did It Take to Tango? Voyages of Urban Culture in the Early 1900s." In *Outsider Art: Contesting Boundaries in Contemporary Culture*, edited by Vera L. Zolberg and Joni Maya Cherbo, 194–214. Cambridge: Cambridge University Press.

Cottrol, Robert J. 2007. "Beyond Invisibility: Afro-Argentines in Their Nation's Culture and Memory." *Latin American Research Review* 42:139–56.

Cranford, Cynthia. 2005. "Networks of Exploitation: Immigration Labor and the Restructuring of the Los Angeles Janitorial Industry." *Social Problems* 52:379–97.

Crow, Graham. 2002. *Social Solidarities, Theories, Identities and Social Change*. Buckingham, UK: Open University Press.

Dávila, Arlene. 2012. *Culture Works: Space, Value, and Mobility across the Neoliberal Americas*. New York: New York University Press.

Davis, Karen. 1991. "Inequality and Access to Health Care." *The Milbank Quarterly* 69:253–73.

Del Priore, Oscar, and Irene Amuchástegui. 2010. *A mí se me hace cuento: Historias ocultas del tango*. Buenos Aires: Aguilar.

Derose, Kathryn P., and Danielle M. Varda. 2009. "Social Capital and Health Care Access: A Systematic Review." *Medical Care Research and Review* 66:272–306.

Di Marco, Massimo, and Monica Fumagalli. 2007. *Carlos Gavito, su vida, su tango*. Milan: NYN Opera Tango.

Domínguez, Silvia. 2011. *Getting Ahead: Social Mobility, Public Housing, and Immigrant Networks*. New York and London: New York University Press.

Dos Santos, Estela. 1994. *Las cantantes*. Vol. 13 of *La historia del tango*. Buenos Aires: Corregidor.

———. 2001. *De damas y milongueras del tango*. Buenos Aires: Corregidor.

Eckstein, Susan, and Thanh-Nghi Nguyen. 2011. "The Making and Transnationalization of an Ethnic Niche: Vietnamese Manicurists." *International Migration Review* 45:639–74.

Edwards, Rosalind, Jane Franklin, and Janet Holland, eds. 2006. *Assessing Social Capital: Concept, Policy and Practice*. Newcastle, UK: Cambridge Scholars Press.

Fahs, Mimi, Anahí Viladrich, and Nina S. Parikh. 2009. "Immigrants and Urban Aging: Toward a Policy Framework." In *Urban Health and Society: Interdisciplinary Approaches to Research and Practice*, edited by Nicholas Freudenberg, Susan Klitzman, and Susan Saegert, 239–70. San Francisco: Jossey-Bass.

Faist, Thomas. 2000. "Transnationalization in International Migration: Implications for the Study of Citizenship and Culture." *Ethnic and Racial Studies* 23:189–222.

Falcón, Luis M. 2007. "Social Networks and Latino Immigrants in the Labor Market: A Review of the Literature and Evidence." In *Latinos in a Changing Society*, edited by Martha Montero-Seiburth and Edwin Meléndez, 254–72. Westport, CT: Praeger.

Farris Thompson, Robert. 2005. *Tango: The Art History of Love*. New York: Vintage.

Federal Register Publications (CIS, ICE,CBP). 2002. Termination of the Designation of Argentina as a Participant under the Visa Waiver Program [67 FR 7943][FR 7–02]. http://www.uscis.gov/ilink/docView/FR/HTML/FR/0-0-0-1/0-0-0-79324/0-0-0-83564/0-0-0-85305.html.

Feld, Peter, and Britt Power. 2000. *Immigrants' Access to Health Care after Welfare Reform: Findings from Focus Groups in Four Cities*. Paper prepared for the Kaiser Commission on Medicaid and the Uninsured. Washington, DC: Henry J. Kaiser Family Foundation.

Felix, David. 2002. "After the Fall: The Argentine Crisis and Repercussions." *Foreign Policy in Focus. Regions/ Latin America and Caribbean*. http://www.fpif.org/articles/after_the_fall_the_argentine_crisis_and_repercussions.

Fernandes, Sujatha. 2011. *Close to the Edge: In Search of the Global Hip Hop Generation*. New York: Verso.

Fernández Kelly, Patricia. M. 1994. "Towanda's Triumph: Unfolding the Meanings of Adolescent Pregnancy in the Baltimore Ghetto." *International Journal of Urban and Regional Research* 18:88–111.

———. 1995. "Social and Cultural Capital in the Urban Ghetto: Implications for the Economic Sociology of Immigration." In *The Economic Sociology of Immigration: Essays on Networks, Ethnicity and Entrepreneurship*, edited by Alejandro Portes, 213–47. New York: Russell Sage Foundation.

Finkler, Kaja. 2001. *Physicians at Work, Patients in Pain: Biomedical Practice and Patient Response in Mexico*. 2nd ed. Durham: Carolina Academic Press.

Foner, Nancy. 2000. *From Ellis Island to JFK: New York's Two Great Waves of Immigration*. New Haven: Yale University Press.

———, ed. 2001. *New Immigrants in New York*. Revised edition. New York: Columbia University Press.

Franco, Marina. 2008. *El exilio: Argentinos en Francia durante la dictadura*. Buenos Aires: Siglo XXI.

Frankenberg, Ruth. 1993. *The Social Construction of Whiteness: White Women, Race Matters*. Minneapolis: University of Minnesota Press.

Fraschini, Alfredo E. 2008. *Tango: Tradición y modernidad*. Buenos Aires: Editorial del Calderón.

Freidenberg, Judith N. 2000. *Growing Old in El Barrio*. New York and London: New York University Press.

Freidenberg, Judith N., and Edit Masuelli. 1998. "Argentines in the United States." In *Encyclopedia of American Immigrant Cultures*, edited by David Levinson and Melvin Ember, 38–42. New York: Macmillan.

Frigerio, Alejandro. 1993. "El candombe Argentino: Crónica de una muerte anunciada." *Revista de investigaciones folklóricas* 8:50–60.

———. 2000. *Cultura negra en el Cono Sur: Representaciones en conflicto*. Buenos Aires: Ediciones de la Universidad Católica Argentina.

———. 2006. "'Negros' y 'blancos' en Buenos Aires: Repensando nuestras categorías raciales." *Temas de patrimonio cultural* 16:77–98.

———. 2008. "De la 'desaparición' de los negros a la 'reaparición' de los Afrodescendientes: Comprendiendo la política de las identidades negras, las clasificaciones raciales y de su estudio en la Argentina." In *Los estudios Afroamericanos y Africanos en América Latina: Herencia, presencia y visiones del otro*, edited by Gladys Lechini, 117–44. Buenos Aires: CLACSO.

Gálvez, Alyshia. 2011. *Patient Citizens, Immigrant Mothers: Mexican Women, Public Prenatal Care and the Birth-Weight Paradox*. New Brunswick, NJ: Rutgers University Press.

Garcia, Carlos. 2005. "Buscando Trabajo: Social Networking Among Immigrants From Mexico to the United States." *Hispanic Journal of Behavioral Sciences* 27:3–22.

Garramuño, Florencia. 2007. *Modernidades primitivas: Tango, samba y nación*. Buenos Aires: Fondo de Cultura Económica.

Garzón, Luis. 2007. "Argentinos y ecuatorianos en Barcelona y Milán: Trayectorias, Dimensión Urbana y Capital Cultural." *Revista de Sociología* 85:195–99.

Gerschenson, Ana. 2002. "Decisión del gobierno de Bush: el 1 de Marzo, EE.UU. volverá a exigir visa a los Argentinos." *Clarín*, February 7. http://edant.clarin.com/diario/2002/02/07/p-02001.htm.

Gift, Virginia. 2009. *Tango: A History of an Obsession*. North Charleston, SC: BookSurge.

Goertzen, Chris, and María Susana Azzi. 1999. "Globalization and the Tango." *Yearbook for Traditional Music* 31:67–76.

Goffman, Erving. 1961. *Asylums: Essays on the Social Situation of Mental Patients and Other Inmates*. Garden City, NY: Anchor.

———. 1997. *The Goffman Reader*. Edited by Charles Lemert. Malden, MA: Blackwell.

Gold, Steve. 1994. "Patterns of Economic Cooperation Among Israeli Immigrants in Los Angeles." *International Migration Review* 28:114–35.

Gómez Schettini, Mariana, Analía Almirón and Mercedes González Bracco. 2011. "La cultura como recurso turístico de las ciudades: El caso de la patrimonialización del tango en Buenos Aires, Argentina." *Estudios y Perspectivas en turismo* 20:1027–46.

González Jansen, Ignacio. 1983. *La triple A*. Buenos Aires: Contrapunto.

Good, Byron J., and Mary-Jo Del Vecchio Good. 1993. "Learning Medicine: The Constructing of Medical Knowledge at Harvard Medical School." In *Knowledge, Power*

and Practice: The Anthropology of Medicine and Everyday Life, edited by Shirley Lindenbaum and Margaret Lock, 81–107. Berkeley: University of California Press.

Gotanda, Neil. 1996. "Multiculturalism and Racial Stratification." In Mapping Multi-culturalism, edited by Avery F. Gordon and Christopher Newfield, 238–52. Minneapolis: University of Minnesota Press.

Granovetter, Mark. 1995. Getting a Job: A Study of Contacts and Careers. 2nd. Edition. Chicago and London: The University of Chicago Press.

Grimson, Alejandro, and Gabriel Kessler. 2005. On Argentina and the Southern Cone: Neoliberalism and National Imaginations. New York: Routledge.

Groppa, Carlos, G. 2004. The Tango in the United States. Jefferson, NC: McFarland & Company.

Guarnizo, Luis Eduardo, Arturo Ignacio Sánchez, and Elizabeth M. Roach. 1999. "Mistrust, Fragmented Solidarity, and Transnational Migration: Colombians in New York City and Los Angeles." Ethnic and Racial Studies 22:367–95.

Guber, Rosana. 2002. "'El cabecita negra' o las categorías de la investigación etnográfica en la Argentina." In Historia y estilos de trabajo de campo en Argentina, edited by Sergio Visacovsky and Rosana Guber, 347–74. Buenos Aires: Antropofagia.

Guy, Donna J. 1991. Sex and Danger in Buenos Aires: Prostitution, Family, and Nation in Argentina. Vol. 1 of Engendering Latin America. Lincoln: University of Nebraska Press.

Hannerz, Ulf. 1980. Exploring the City: Inquiries toward an Urban Anthropology. New York: Columbia University Press.

Hawe, Penelope, and Alan Shiell. 2000. "Social Capital and Health Promotion: A Review." Social Science & Medicine 51:871–85.

Healy, Claire. 2006. "Review Essay: Afro-Argentine Historiography." Atlantic Studies 3:111–20.

Hernández, José. (1936) 1977. The Gaucho Martín Fierro. Translated by Walter Owen. Reprint, New York: Gordon Press.

Hobsbawm, Eric J. 1994. The Age of Empire, 1870–1914. London: Abacus.

Horton, Sarah. 2004. "Different Subjects: The Health Care System's Participation in the Differential Construction of the Cultural Citizenship of Cuban Refugees and Mexican Immigrants." Medical Anthropology Quarterly 18:472–89

Itzigsohn, Jose. 2009. Encountering American Faultlines: Class, Race, and the Dominican Experience. New York: Russell Sage Foundation.

Jachimowicz, Maia. 2003. "Argentina's Economic Woes Spur Emigration." Migration Information Source, July 1. http://www.migrationinformation.org/Feature/display.cfm?ID=146.

Jones-Correa, Michael. 1998. Between Two Nations: The Political Predicament of Latinos in New York City. Ithaca, NY: Cornell University Press.

Karush, Matthew B. 2012. "Blackness in Argentina: Jazz, Tango and Race before Perón." Past and Present 1:215–245.

Kawachi, Ichiro, Bruce P. Kennedy, Kimberly Lochner, and Deborah Prothrow-Stith. 1997. "Social Capital, Income Inequality, and Mortality." American Journal of Public Health 87:1491–98.

Keating, Joshua. 2009. "Keeping America Safe from Latin Klezmer Bands." Foreign Policy. http://blog.foreignpolicy.com/posts/2009/12/10/keeping_america_safe_from_latin_klezmer_bands.

Kim, Dae Young. 1999. "Beyond Coethnic Solidarity: Mexican and Ecuadorian Employment in Korean-owned Businesses in New York City." *Ethnic and Racial Studies* 22:581–605.

Kleinman, Arthur. 1980. *Patients and Healers in the Context of Culture: An Exploration of the Borderland Between Anthropology, Medicine, and Psychiatry*. Berkeley: University of California Press.

Knauth, Dorcinda C. 2005. "Discourses of Authenticity in the Argentine Tango Community of Pittsburgh." Master's thesis, University of Pittsburgh.

La Nación. 2001. "Detienen a argentinos en EE.UU." October 27. http://www.lanacion .com.ar/346324-detienen-a-argentinos-en-eeuu.

———. 2002. "La clase media bonaerense, ansiosa por la asistencia social." April 6. http://www.lanacion.com.ar/386534-la-clase-media-bonaerense-ansiosa-por-la-asistencia-social.

Lancee, Bram. 2010. "The Economic Returns of Immigrants' Bonding and Bridging Social Capital: The Case of the Netherlands." *International Migration Review* 44:202–26.

Leeds, Mark. 1996. *Ethnic New York: A Complete Guide to the Many Faces and Cultures of New York*. 2nd ed. Chicago: Passport Books.

Leigh, Andrew K., and Robert D. Putnam. 2002. "Reviving Community: What Policy Makers Can Do to Build Social Capital in Britain and America." *Renewal* 10:15–20.

Levitt, Peggy, and Nadya B. Jaworsky. 2007. "Transnational Migration Studies: Past Developments and Future Trends." *Annual Review of Sociology* 33:129–156.

Li, Peter S. 2004. "Social Capital and Economic Outcomes for Immigrants and Ethnic Minorities." *Journal of International Migration and Integration* 5:171–90.

Light, Ivan, and Parminder Bhachu, eds. 2009. *Immigration and Entrepreneurship: Culture, Capital, and Ethnic Networks*. 2nd ed. New Brunswick, NJ: Transaction.

Lin, Nan. 2001. *Social Capital: A Theory of Social Structure and Action*. Cambridge: Cambridge University Press.

Lindholm, Charles. 2008. *Culture and Authenticity*. Oxford: Blackwell.

Loue, Sana. 2011. *My Nerves Are Bad: Puerto Rican Women Managing Mental Illness and HIV Risk*. Nashville, TN: Vanderbilt University Press.

Luker, Morgan J. 2007. "Tango Renovación: On the Uses of Music History in Post-crisis Argentina." *Latin American Music Review* 28:68–93.

Maffia, Marta, and Gladys Lechini, eds. 2009. *Afroargentinos hoy: Invisibilización, identidad y movilización social*. Buenos Aires: Ediciones IRI-UNLP.

Mahler, Sarah J. 1995. *American Dreaming: Immigrant Life on the Margins*. Princeton: Princeton University Press.

Maletta, Hector, Frida Szwarcberg, and Rosalía Schneider. 1986. "Exclusión y reencuentro: aspectos psicosociales del retorno de los exiliados a la Argentina." *Estudios Migratorios Latinoamericanos* 1:293–321.

Margolis, Maxine L. 1994. *Little Brazil: An Ethnography of Brazilian Immigrants in New York City*. Princeton: Princeton University Press.

———. 2009. *An Invisible Minority: Brazilians in New York City*. Revised and Expanded edition. Gainesville, FL: University Press of Florida.

Maronese, Leticia. 2008. *De milongas y milongueros*. Buenos Aires: Comisión para la Preservación del Patrimonio Cultural de la Ciudad Autónoma de Buenos Aires.

Marrow, Helen B. 2007. "South America: Ecuador, Peru, Brazil, Argentina, Venezuela." In *The New Americans: A Handbook to Immigration since 1965*, edited by Mary C. Waters and Reed Ueda, with Helen B. Marrow, 593–611. Cambridge, MA: Harvard University Press.

Marshall, Adriana. 1988. "Emigration of Argentines to the United States." In *When Borders Don't Divide: Labor Migration and Refugee Movements in the Americas*, edited by Patricia R. Pessar, 129–41. New York: Center for Migration Studies.

Martínez, Tomás Eloy. 2004. *El cantor de tango*. Buenos Aires: Planeta.

Martínez Sarasola, Carlos. 2005. *Nuestros paisanos: Los indios: Vida, historia y destino de las comunidades indígenas en la Argentina*. Buenos Aires: Emecé.

Maslak, Mary Ann, and Stanley Votruba. 2011. "'Two to Tango': A Reflection on Gender Roles in Argentina." *Gender Forum* 36. http://www.genderforum.org/issues/consequences/two-to-tango.

Massey, Douglas S. 1993. "Latinos, Poverty, and the Underclass: A New Agenda for Research." *Hispanic Journal of Behavioral Sciences* 15:449–75.

Massey, Douglas S., Joaquín Arango, Graeme Hugo, Ali Kouaouci, Adela Pellegrino, and J. Edward Taylor. 2005. *Worlds in Motion: Understanding International Migration at the End of the Millennium*. New York: Oxford University Press.

Massey, Douglas S., and María Aysa-Lastra. 2011. "Social Capital and International Migration from Latin America." *International Journal of Population Research*. http://www.hindawi.com/journals/ijpr/2011/834145.

Massey, Douglas, and Fernando Riosmena. 2010. "Undocumented Migration from Latin America in an Era of Rising U.S. Enforcement." *Annals of the American Academy of Political and Social Science* 630: 294–321.

Melamed, Diego. 2002. *Irse: Cómo y por qué los Argentinos se están yendo del país*. Buenos Aires: Sudamericana.

Menjívar, Cecilia. 2000. *Fragmented Ties: Salvadoran Immigrant Networks in America*. Berkeley, Los Angeles, London: University of California Press.

Merritt, Carolyn. 2012. *Tango Nuevo*. Gainesville: University Press of Florida.

Min, Pyong Gap. 2008. *Ethnic Solidarity for Economic Survival: Korean Greengrocers in New York City*. New York: Russell Sage Foundation.

Morokvasic, Mirjana, Roger, and Annie Phizacklea. 2006. "Business on the Ragged Edge: Immigrant and Minority Business in the Garment Industries of Paris, London, and New York." In *Ethnic Entrepreneurs: Immigrant Business in Industrial Societies*. Vol. 1 of *Sage Series on Race and Ethnic Relations*, edited by Roger Waldinger, Howard Aldrich, Robin Ward and Associates, 157–76. Newbury Park, CA, London and New Delhi: Sage Publications.

Navitski, Rielle. 2011. "The Tango on Broadway: Carlos Gardel's International Stardom and the Transition to Sound in Argentina." *Cinema Journal* 51:26–49.

NBC News. 2012. "Immigration Decision Could Make It Easier for Foreign 'Fusion' Bands to Play in US." http://usnews.nbcnews.com/_news/2012/05/17/11735665-immigration-decision-could-make-it-easier-for-foreign-fusion-bands-to-play-in-us?lite.

Newman, Katherine S. 1999. *Falling from Grace: Downward Mobility in the Age of Affluence*. Berkeley, Los Angeles, London: University of California Press.

Newton, Lina. 2008. *Illegal, Alien, or Immigrant: The Politics of Immigration Reform*. New York: New York University Press.

New York City Department of City Planning. 2000. "Table SF1 P-8: Total Hispanic Population by Selected Subgroups. New York City, Boroughs and Census Tracts. Part 1 of 2. Population Division, 2000 Census." http://home2.nyc.gov/html/dcp/html/census/demo_tables.shtml.

———. 2010. "Table SF1-P8–2 NYC: Total Hispanic Population by Selected Subgroups New York City and Boroughs. Population Division, 2010 Census." http://home2.nyc.gov/html/dcp/html/census/demo_tables_2010.shtml.

Novick, Susana, and María G. Murias. 2005. *Dos estudios sobre la emigración reciente en la Argentina*. Working Document 42. Buenos Aires: Instituto de Investigaciones Gino Germani, Facultad de Ciencias Sociales, Universidad de Buenos Aires.

Oboler, Suzanne. 1992. "The Politics of Labeling: Latino/a Cultural Identities of Self and Others." *Latin American Perspectives* 19:18–36.

———. 1995. *Ethnic Labels, Latino Lives: Identity and the Politics of (Re)Presentation in the United States*. Minneapolis: University of Minnesota Press.

———. 2005. "The Foreignness of Racism: Pride and Prejudice Among Peru's Limeños in the 1990s." In *Neither Enemies nor Friends: Latinos, Blacks, Afro-Latinos*, edited by Anani Dzidzienyo and Suzanne Oboler, 75–100. New York: Palgrave Macmillan.

———. 2008. "The Racial Drops of Culture." *Latino Studies* 6:373–75.

Oboler, Suzanne, and Anani Dzidzienyo. 2005. "Flows and Counterflows: Latinas/os, Blackness, and Racialization in Hemispheric Perspective." In *Neither Enemies nor Friends: Latinos, Blacks, Afro-Latinos*, edited by Anani Dzidzienyo and Suzanne Oboler, 3–36. New York: Palgrave Macmillan.

Ochoa, Gilda L. 2000. "Mexican Americans' Attitudes toward and Interactions with Mexican Immigrants: A Qualitative Analysis of Conflict and Cooperation." *Social Science Quarterly* 81:84–105.

Olszewski, Bandon. 2008. "El Cuerpo de Baile: The Kinetic and Social Fundaments of Tango." *Body and Society* 14:63–81.

Ortner, Sherry B. 2003. *New Jersey Dreaming: Capital, Identity, and the Class of '58*. Durham: Duke University Press.

Parker, Richard G. 1999. *Beneath the Equator: Cultures of Desire, Male Homosexuality, and Emerging Gay Communities in Brazil*. New York: Routledge.

Pelinski, Ramón A. 1995. "Le tango nomade." In *Tango nomade: Etudes sur le tango transculturel*, edited by Ramón A. Pelinski, 25–70. Montréal: Tryptique.

Peñaloza, Fernanda. 2007. "Mapping Constructions of Blackness in Argentina." *Indiana* 24:211–34.

Perri, Gladys. 2007. "De mitos y historias nacionales: La presencia/negación de negros y morenos en Buenos Aires." *História unisinos* 10:321–32.

Pessar, Patricia R. 1995. "The Elusive Enclave: Ethnicity, Class, and Nationality Among Latino Entrepreneurs in Greater Washington, DC." *Human Organization* 54:383–92.

Peterson, Richard A., and Roger M. Kern. 1996. "Changing Highbrow Taste: From Snob to Omnivore." *American Sociological Review* 61:900–907.

Pietrobruno, Sheenagh. 2002. "Embodying Canadian Multiculturalism: The Case of Salsa Dancing in Montreal." *Revista Mexicana de Estudios Canadienses* 3:23–56.

Pooson, Sylvain B. 2004. "Entre Tango y Payada: The Expression of Blacks in 19th Century Argentina." *Confluencia* 20:87–99.

Portes, Alejandro. 1998. "Social Capital: Its Origins and Applications in Modern Sociology." *Annual Review of Sociology* 24:1–24.

Portes, Alejandro, and Robert L. Bach. 1985. *Latin Journey: Cuban and Mexican Immigrants in the United States*. Berkeley, Los Angeles, London: University of California Press.

Portes, Alejandro, and Robert D. Manning. 1986. "The Immigrant Enclave: Theory and Empirical Examples." In *Competitive Ethnic Relations*, edited by Susan Olzak and Joane Nagel, 47–68. Orlando: Academic Press.

Portes, Alejandro, and Alex Stepick. 1993. *City on the Edge: The Transformation of Miami*. Berkeley, Los Angeles, London: University of California Press.

Portes, Alejandro, and Min Zhou. 1992. "Gaining the Upper Hand: Economic Mobility Among Immigrant and Domestic Minorities." *Ethnic and Racial Studies* 15: 491–522.

Putnam, Robert D. 1995. "Bowling Alone: America's Declining Social Capital." *Journal of Democracy* 6:65–78.

Raijman, Rebeca, and Marta Tienda. 2000. "Immigrants' Pathways to Business Ownership: A Comparative Ethnic Perspective." *International Migration Review* 34:682–706.

Ram, Monder, Tahir Abbas, Balihar Sanghera, Gerald Barlow, and Trevor Jones. 2001. "'Apprentice Entrepreneurs'? Ethnic Minority Workers in the Independent Restaurant Sector." *Work, Employment and Society* 15:353–72.

Ramos-Pinto, Pedro. 2006. "Social Capital as a Capacity for Collective Action." In *Assessing Social Capital: Concept, Policy and Practice*, edited by Rosalind Edwards, Jane Franklin, and Janet Holland, 53–69. Newcastle, UK: Cambridge Scholars Publishing.

Remeseira, Claudio I. 2010. "Carlos Gardel in New York." In *Hispanic New York: A Sourcebook*, edited by Claudio I. Remeseira, 457–60. New York: Columbia University Press.

Reportango. 2001. "Tango Is a Shared Moment." Interview with Carlos Gavito. http://web.ics.purdue.edu/~tango/Articles/Gavito.pdf.

———. 2011. "Tango Argentino." *Reportango* 87:6–15.

Rohter, Larry. 2002. "Old Rules Gone, Argentines Brace for the Unknown." *New York Times*, January 9. http://www.nytimes.com/2002/01/09/world/old-rules-gone-argentines-brace-for-the-unknown.html?pagewanted=all&src=pm.

Romero, Luis A. 1994. *Breve historia contemporánea de la Argentina*. Buenos Aires: Fondo de Cultura Económica.

Sassen, Saskia. 1991. *The Global City: New York, London, Tokyo*. Princeton: Princeton University Press.

———. 1999. *Globalization and Its Discontents: Essays on the New Mobility of People and Money*. New York: The New Press.

Savigliano, Marta E. 1995. *Tango and the Political Economy of Passion*. Boulder, CO: Westview.

———. 2000. "Nocturnal Ethnographies: Following Cortázar in the Milongas of Buenos Aires." *Trans*-Revista Transcultural de Música, 5. http://www.sibetrans.com/trans/a245/nocturnal-ethnographies-following-cortazar-in-the-milongas-of-buenos-aires.

———. 2003. *Angora Matta: Fatal Acts of North-South Translation*. Middletown, CT: Wesleyan University Press.

———. 2005. "Destino Buenos Aires: Tango-turismo Sexual Cinematográfico." *Cadernos Pagu* 25:327–56.

———. 2010. "Notes on Tango (as) Queers (Commodity)." *Anthropological Notebooks* 16:135–43.

Schávelzon, Daniel. 2003. *Buenos Aires negra: Arqueología histórica de una ciudad silenciada*. Buenos Aires: Emecé.

Scolieri, Paul. 2008. "Introduction Global/Mobile: Re-orienting Dance and Migration Studies." *Dance Research Journal* 40:5–20.

Siskin, Alison. 2004. "Visa Waiver Program (2004)." *Federal Publications* paper 60. Cornell University, ILR School. http://digitalcommons.ilr.cornell.edu/key_work place/60.

Small, Mario L. 2009. *Unanticipated Gains: Origin of Network Inequality in Everyday Life*. New York: Oxford University Press.

Solimano, Andrés. 2003. *Development Cycles, Political Regimes and International Migration: Argentina in the 20th Century*. Santiago: United Nations, CEPAL/ECLAC.

Solomianski, Alejandro. 2003. *Identidades secretas: La negritud Argentina*. Rosario, Argentina: Beatriz Viterbo Editora.

Spradley, James P. 1980. *Participant Observation*. New York: Holt, Rinehart and Winston.

Steingress, Gerhard, ed. 2002. *Songs of the Minotaur: Hybridity and Popular Music in the Era of Globalization: A Comparative Analysis of Rebetika, Tango, Rai, Flamenco, Sardana, and English Urban Folk*. Münster, Germany: LIT Verlag.

Taylor, Julie. 1997. "Accessing Narrative: The Gaucho and Europe in Argentina." *Cultural Critique* 37:215–45.

———. 1998. *Paper Tangos*. Durham: Duke University Press.

Theis, Peter. 2004. "Black Not Like Me." *OffOffOff Film*. http://www.offoffoff.com/film/2004/afroargentinos.php

Toyoda, Etsuko. 2012. "Japanese Perceptions of Argentine Tango: Cultural and Gender Differences." *Studies in Latin American Popular Culture* 30:162–79.

Urquía, Norman. 2005. "The Re-branding of Salsa in London's Dance Clubs: How an Ethnicized Form of Cultural Capital Was Institutionalized." *Leisure Studies* 24:385–97.

US Citizenship and Immigration Services. 2012. "Official Portal." http://www.uscis.gov/portal/site/uscis/.

Vila, Pablo. 1987. "Tango, folklore y rock: Apuntes sobre música, política y sociedad en Argentina." *Cahiers du Monde Hispanique et Luso-Brésilien* 48:81–93.

———. 1991. "Tango to Folk: Hegemony Construction and Popular Identities in Argentina." *Studies in Latin American Popular Culture* 10:107–39.

Viladrich, Anahí. 2005. "Tango Immigrants in New York City: The Value of Social Reciprocities." *Journal of Contemporary Ethnography* 34:533–59.

———. 2006. "Neither Virgins nor Whores: Tango Lyrics and Gender Representations in the Tango World." *Journal of Popular Culture* 39:272–93.

———. 2007a. "From 'Shrinks' to 'Urban Shamans': Argentine Immigrants' Therapeutic Eclecticism in New York City." *Culture, Medicine and Psychiatry* 31:307–28.

———. 2007b. "Ethnographic Rendez-vous: Field Accounts of Unexpected Vulnerabilities and Constructed Differences." In *Extraordinary Anthropology: Transforma-

tions in the Field, edited by Jean-Guy A. Goulet and Bruce Granville Miller, 103–23. Lincoln: University of Nebraska Press.

———. 2012a. "Beyond Welfare Reform: Reframing Undocumented Immigrants' Entitlement to Health Care in the United States, a Critical Review." *Social Science & Medicine* 74:822–29.

———. 2012b. "The Tango's Full Circle." *The Poems from Exile*, unpublished.

———. 2012c. "Tanglish." *The Poems from Exile*, unpublished.

———. In press. "Los migrantes del tango en la Argentina: Explorando el campo artístico desde una perspectiva transnacional." In *Migraciones Internacionales: Reflexiones y Estudios Sobre la Movilidad Territorial Contemporánea*, edited by Gabriela A. Karasik. Buenos Aires: Ciccus.

Viladrich, Anahí, and Ana F. Abraído-Lanza. 2009. "Religion and Mental Health Among Immigrants and Minorities in the US." In *Determinants of Minority Mental Health and Wellness*, edited by Sana Loue and Martha Sajatovic, 149–74. New York: Springer.

Viladrich, Anahí, and Rita Baron-Faust. 2012. "Medical Tourism and Health Care Outsourcing in a Global World." *Advances in Medicine and Biology*, Vol. 61, edited by Leon V. Benhardt. 159–170.Hauppauge, NY: Nova Science.

Viladrich, Anahí, and Andrés A. Thompson. 1996. "Women and Philanthropy in Argentina: From the Society of Beneficence to Eva Perón." Special issue on Women and Philanthropy. *Voluntas* 7:336–49.

Viñas, David. 1998. *De Sarmiento a Dios: Viajeros Argentinos a USA*. Buenos Aires: Sudamericana.

Wade, Peter. 1995. *Blackness and Race Mixture: The Dynamics of Racial Identity in Colombia*. Baltimore, MD: The Johns Hopkins University Press.

Wakin, Daniel J. 2006. "Yo-Yo Ma Testifies on Capitol Hill about Artists' Visa Problems." *New York Times*, April 25. http://www.nytimes.com/2006/04/05/arts/music/05visa.html.

Waldinger, Roger, Howard Aldrich, Robin Ward and Associates. 2006. *Ethnic Entrepreneurs: Immigrant Business in Industrial Societies*. Vol. 1 of *Sage Series on Race and Ethnic Relations*. Newbury Park, CA, London and New Delhi: Sage Publications.

Wang, Qingfang, and Wei Li. 2007. "Entrepreneurship, Ethnicity, and Local Contexts: Hispanic Entrepreneurs in Three U.S. Southern Metropolitan Areas." *GeoJournal* 68:167–82.

Wasserman, Melanie R., Deborah E. Bender, Shoou-Yih Lee, Joseph P. Morrissey, Ted Mouw, and Edward C. Norton. 2006. "Social Support Among Latina Immigrant Women: Bridge Persons as Mediators of Cervical Cancer Screening." *Journal of Immigrant and Minority Health* 8:67–84.

Waters, Malcolm. 1995. *Globalization*. London: Routledge.

White, William F. (with the collaboration of Kathleen King White). 1984. *Learning from the Field: A Guide from Experience*. Beverly Hills, CA: Sage Publications.

Wilman-Navarro, Alys, and Alejandra Davidziuk. 2006. *Discovering the Diaspora: Los Argentinos in New York City*. New York: The Argentina Observatory, The New School Graduate Program in International Affairs.

Wilson, Tamar, D. 1998. "Weak Ties, Strong Ties: Network Principles in Mexican Migration." *Human Organization* 57:394–403.

Windhausen, Rodolfo A. 1999. "The Generation Gap in Tango." *El Once Tango News*, Summer: 28–30.

———. 2001. "El fenómeno del tango en Nueva York." *La Gaceta*, sección literaria, February 28. Tucumán, Argentina..

Winter, Brian. 2007. *Long after Midnight at the Niño Bien: A Yanqui's Missteps in Argentina*. New York: PublicAffairs.

Wolinsky, Frederic D. 1993. "The Professional Dominance, Deprofessionalization, Proletarianization, and Corporatization Perspectives: An Overview and Synthesis." In *The Changing Medical Profession: An International Perspective*, edited by Frederic W. Hafferty and John B. McKinley, 197–210. New York: Oxford University Press.

Yankelevich, Pablo. 2010. *Ráfagas de un exilio: Argentinos en México, 1974–1983*. Buenos Aires: Fondo de Cultura Económica//El Colegio de México,

Young, James C. and Linda C. Garro. 1994. *Medical Choice in a Medical Village*. Prospect Heights, IL: Waveland Press.

Zhou, Min. 2004. "The Role of the Enclave Economy in Immigrant Adaptation and Community Building: The Case of New York's Chinatown." In *Immigrant and Minority Entrepreneurship: Building American Communities*, edited by John Sibley Butler and George Kozmetsky, 37–60. Westport, CT: Praeger.

Zhou, Min, and Mingang Lin. 2005. "Community Transformation and the Formation of Ethnic Capital: Immigrant Chinese Communities in the United States." *Journal of Chinese Overseas* 1:260–84.

Zuccotti, Juan Carlos. 1987. *La emigración Argentina contemporánea*. Buenos Aires: Plus Ultra.

Index

Page numbers in italics refer to figures.

aboriginal and indigenous populations, 20, 29, 33, 36
addiction (to tango), 65; "tango fever," 66, 102; "tango junkies" (or *les possédés* in France) 65. *See also* tango-mania
African and black roots of tango, 20, 26, 31, 32; 226n3, African *comparsas* (dancing troupes) 26. *See also* candombe
Afro-Argentines (*Afroargentinos*), 27–32, 43–45, 226n1
amateur: dancers from Argentine, 77, 109, 141, 148, 156, 158, 184, 186, 199, 202; healers, 198, 210–12, 214–15; tango dancers, 14, 52, 54, 57, 77–78, 109, 156, 158, 209, 220
Andrews, George R., 28–29, 33
anonymity (among tango artists), 109–11, 119, 182. *See also* invisibility
Argentine, Argentinian, and Argentinean (exchangeability of terms), 225n1
Argentine Anticommunist Alliance (AAA), National Security Doctrine, 41. *See also* military

Argentine community, in New York: 56, 58, 60, 185. *See also* Argentine enclave; community
Argentine emigrants: émigré, 6, 23, 48, 121, 138, 225n2, 225n3; exile (feelings of) 47, 170; exiled artists, 41–42, 226n4; self-exiled (Libertad Lamarque), 39; tango émigré, 8, 140
Argentine enclave, 49–60, 167, 202, 211. *See also* Little Argentina
Argentine nation, 8–9, 29, 33–34, 44, 77, 172; Argentine national identity, 48, 128; *argentinidad*, 5, 21, 29, 36, 152; Catholic religion, 36, 51; nationalistic discourse, 8, 9
Argentines' self-identification: European, 6–7, 23, 34, 136–37, 141, 150–52, 155, 160, 181; racial dislocation, 151; similar and different from other Latinos, 22–23, 150–51, 155, 162–65, 167, 169
Argentine tango: early Argentine performers in the United States, 8–12, 225–26n5; origins, 20, 31–36; renaissance, 12–15

authenticity: Argentines as the tango's genuine and legitimate interpreters, 21, 75, 81–82, 84, 158, 171; branding of Argentine tango, 78–82, 216, 221; innovation in tango, 85; passing for a *porteño*, 98; in tango, 73, 77, 82, 85, 101, 218; tango's content versus form, 82–85

bandoneón, 46, 116, *117*, 227*n*1; players, 116, 133
barrio, *11*, 81–82
blacks: in Argentina, 20, 29–31; black gauchos, 27; chromatic blindness, 20; disappearance, 28–30; mulattos, 29; slaves, 26–28
blue-collar: Argentines 49, 149, 164; economy, 119
Bourdieu, Pierre, 15, 17–19, 47, 143, 147, 157, 198, 208, 226*n*8, 226*n*9
brain drain, 39, 76. *See also* Argentine emigrants
brothels, 34–35, 44; prostitution 34, 36
Buenos Aires: the "Disney World" of tango, 6; "the Paris of the South," 20; tango in, 3–5, *11, 12,* 14–15, 43, 46–47, 57, 67, 75, 77, 82, 84, 145; tango history in, 8–9, 34–5; tango kingdom, 53; "Tango Mecca," 14

cabecitas negras (little black heads), 37, 44; *descamisados* (shirtless) 37; *música de negros* (dark-skinned people's music), 39. *See also* creole; Perón
candombe, 32, 43, 226*n*2. *See also* African and black roots of tango; Afro-Argentines
capital: economic, 16, 19, 52, 157, 210; emotional, 5, 101, 114; human, 22, 75, 122, 125, 143–44, 147. *See also* social capital

commodities, 157, 216; commoditized forms of tango, 40
community: leaders, 59; 164; organizations and groups, 58–59, 64, 164–65,

223. *See also* old guard; outer borough; Queens
compadrazgo (godparenting), 16, 173–74
competition among Argentines, 15, 17–18, 21, 24, 75, 86, 99 , 103, 121, 165, 170–71, 177, 180, 183–84, 189, 191, 221–22
Conquista del Desierto, La (Conquest of the Desert), 33. *See also* Argentine nation
contracts, 10, 91, 127, 179, 223
cosmopolitanism (in tango), 3, 21, 67, 73, 154, 157, 159, 168–69, 213, 220; cosmopolitan regulars, 22, 47, 148–49, 167, 185, 223
creole (*criollo*), 9, 23, 31, 33, 36–37, 73, 149, 152–54, 160–62, 225*n*4; tango roots, 20, 32, 44. *See also* darker-skinned Argentines; Perón

dancing styles, 35, 43, 66, 82-85, 88, 168; ballroom tango dancing, 14, 43, 50, 52; improvisation, 66, 78, 83; stage, fantasy, or "for export" tango, 40, 43, 193, *194, 195; tango salón* (ballroom), 66, 87, 182
darker-skinned Argentines, 7, 23, 152–55, 159–61, 167, 169, 223; *negrear*, 135; *negro/negra*, 32, 45, 135, 153–54, 162, 227*n*7; *negros*, 37, 44
Dávila, Arlene, 6, 14, 45, 76, 157
December 2001 (Argentina's crisis), 1, 128
democracy: alternated democratic periods, 40–41, 128; transition to, 13, 20, 42
"disappeared" Argentines, 41; CONADEP (National Council for the Disappeared People), 13, 226*n*4. *See also* military

elite: agro-industrial, 35–36; Argentine, 20, 28, 29, 34, 39, 44; global and foreign, 14, 157; global leisure class, 218
embrace (in tango dancing), 32, 55, 56, 65–67, 73, 217. *See also* dancing styles

ethnic entrepreneurship, 17, 93, 97, 100, 178–79, 187; tango entrepreneurship and entrepreneurs, 7, 21, 50, 52, 55, 57, 73, 88, 94, 98, 100, 102, 108, 114, 131, 133, 159, 187–88, 216, 220–21. *See also* self-employment

ethnographic mapping, 58, 158

Europe: Argentines in, 6, 15, 93, 117, 124, 127, 129, 137–38; artists traveling to, 93, 115, 117, 124, 127, 129, 136–39; European heritage and looks. 7, 30, 32, 34, 73, 136–37, 141, 150–52, 155, 160, 169; European immigration, 28–29, 34, 36–37; "European whites," 23

European citizenship, 124, 129, 137–38, 145; "citizenship capital," 138; Euro-Argentines, 138; *jus sanguinis*, 138

exoticism (in tango), 8, 14, 23, 35, 47, 216; exotic tango practitioners, 154–55, 184, 191

expatriates, 6, 15, 47

exploitation: among co-ethnics, 17, 131; "networks of exploitation," 17; by visa sponsors, 146

folklore and folkloric traditions, 8–9; 13, 38–39, 88–90, 95, 132–33, 162, 164–65, 169; *peñas*, 162

France, 8, 65; French (origin), 149, 151, 228n1; French ballrooms, 35; French protests of May 1968, 41. *See also* Paris

Gardel, Carlos, 8–10, *10, 11,* 46, 50, *51,* 84, 227n

gaucho/s, 8–9, 25, 27, 31–32, 44, 185, 189, 226n5; black gauchos, 27, 31; *la gauchada,* 185; *gauchesca* literature, 9; *El Gaucho Martín Fierro,* 189

Gavito, Carlos, 8, 81

gender: conflict and inequalities, 69–70; and disadvantaged female immigrants in the United States, 112; relationships in Argentina, 36; roles in tango, 65–67; "wallflowering," 67

generations (in tango), 54, 61; generational alliances, 166–68; generation gap, 106

globalization: cultural, 47; economic, 219; global cities, 1, 21, 85, 106, metropolises, 119; of music and dance, 3, 13, 87; of tango, 13–14, 22, 63, 73, 77, 84, 87, 91, 93, 101, 218

Goffman, Erving, 22, 119, 125, 228n1

Golden Age (Época de Oro) of tango or New Guard, 20, 36, 84

Granovetter, Mark, 16, 213

habitus, 18, 47, 147, 157. *See also* Bourdieu, Pierre

healing systems, 196, 198, 215; alternative providers and models, 196–97, 199, 200, 210, 213, 215, 224; folk healing systems, 196, 200, 213; healing (in tango), 54; health-seeking, 23, 197, 200, 213, 215, 224; therapeutic eclecticism, 198, 213, 215

health brokers and health-broker model, 63, 198–203, 206–8, 210, 213–15, 224; Latino and Argentine doctors, 204, 207, 208; Spanish-speaking medical providers, 204

health system, US, 205–7, 210, 213, 224; health insurance, 72, 194, 224; lack of health insurance, coverage, and benefits, 112, 116, 134, 185, 193–94, 199, 202–3, 210

hierarchy/ies: social and racial, 18, 20–21, 29, 151–52, 154–55, 161, 222; in tango, 54, 65, 103, 179, 186, 209

Hispanic: Argentine population, 49; Latin American and Latino groups, 17, 49, 149, 152, 160, 162–9, 227n2; Latino/Hispanic category, 151–52, 169, 204

Hobsbawm, Eric, J., 9, 33, 216

humane treatment (*tratamiento humano*), 203, 207; patient-centered model, 204–6

hybridization, 5, 8

invisibility: Afro-Argentines, 31, 44; Argentines, 6, 49; older newcomers, 21; unauthorized immigrants, 141. *See also* anonymity

language barriers, 116, 204; double hurdle of language, 204
legal trajectories and careers, 22, 56, 123–25, 133–36, 138–40, 143–44, 146–47, 181; progressive, 147; retroactive, 139
Little Argentina, 58, 59, 71, 108, 149, 202; the Argentine corner (*la esquina argentina*), 49, 50, 51. *See also* community
lunfardo, 34, 40, 108, 218, 228n2

masters, 66, 73, 75, 84–85, 167; *de la calle* (of the street), 168; older generation, 168–69; "old masters," 82
melting pot (*crisol de razas*), 29, 34, 48
military: coup, 38–39, 41; dictatorships, 14, 20, 39–40, 113
milongas: in Buenos Aires, 88, 92; Manhattan milongas, 22, 55, 152, 154–55, 158–60, 163, 165–66, 168–69, 196, 199, 208, 220, 223; meaning 1, 43; nomadic, 47, 51, 93, 135; outer borough, 114, 159–60, 164, 169
milongueras/os, 66–67, 73, 99, 106; older, 40, 166
miscegenation (racial mixture), 28–29; *mestizos*, 33, mixed marriages, 28; mixed-race, 26, 29; *trigueños*, 29
multiplexity (rich social networks), 16; multiplexial, 109, 213, 220; Granovetter's "the strength of weak ties," 16

Oboler, Suzanne, 27–28, 33, 45, 150, 153–54, 228n1
old guard, 114, 131, 149, 154, 160–61, 166–69, 171, 211; the Tango Friends' Association 228n4. *See also* outer borough; Queens
oral tradition: in social capital, 179; in tango, 116, 168

outer borough: tango field and events, 22, 114, 149, 158–60, 163–66, 168–69, 222–23. *See also* Queens; old guard

paradoxical solidarities, 7, 192, 221; contradictory patterns, 219, paradoxical social ties and networks, 18, 23
Paris: in tango history, 8, 13, 35, 77; today, 102, 119. *See also* Buenos Aires
passion (in tango), 3, 14, 21, 47–48, 52, 73, 75, 78, 81–83, 93, 101, 184, 217
Perón: Juan Domingo, 37–41, 44, 162; Eva, 37–39
Piazzolla, Astor P., 10, 40
porteño, 8, 31, 47–48, 98, 149, 163
Portes, Alejandro, 16–19, 49, 106, 164, 175, 187, 198
práctica/s, 54–55, 79, 84

Queens: Argentine enclave, 202, 211; Argentines in, 49–50, 50, 51, 58–60, 71, 114, 136; tango in, 55, 159, 166–69, 223; *See also* Little Argentina; outer borough
queer, 67, 85; the tango's avant-garde, 87

race and ethnicity in Argentina, 22–23, 29; color blindness, 160; ethnicity, 22–23, 29, 149; legacy from Latin America, 28–29, 38, 228n1; racial fallacies, 26; racial neutrality, 37, 150; racial purity, 20
racism, 33, 45, 149–50, 153, 169; racial discrimination, 30, 163; racial prejudice and looks, 114, 153–55, 159, 162–63, 169, 228n1
reciprocity, 17–18, 23, 70–71, 91, 99, 167, 171, 188, 191, 197–98, 201, 207, 214, 221; lack and fracture of, 7, 23, 222; no corresponding, 175; recipients and donors of help, 171, 175–77, 181, 187, 191, 202; unfair, 177

self-employment, 93–94, 97, 176, 187–88, 219; "becoming your own boss," 94
self-reflexivity, 21, 65

September 11, 2001, 1, 54–55, 77, 121, 125–26, 132, 138
service economy and industry, 7, 21–22, 90, 102, 119–20, 131, 136, 146, 193, 219; informal jobs and labor, 97, 109, 120, 140
social capital, 7, 15–19, 22–24, 54, 57, 70–71, 74–75, 102, 106, 114, 116–17, 120–24, 146–47, 174–75, 177, 179, 189, 191, 197, 202, 214, 221–24, 226n8; 226n9; bonding: 16–17, bonding social networks, 16, 21, 171; 178, 186, 221; bridging, 16–17, 92, 106, 117, 120, 143, 146, 171, 216, 221–22, 224; ethnic capital, 74–75, 98, 102, 181, 187; health capital and health-related capital, 198, 212, 215. *See also* solidarity
social geography: of class and ethnic differences, 156, 158, 168; of race, 22, 150
social mobility, 23, 137, 187, 226n8; double downward mobility, 141; downward, 60, 76, 111, 122, 146, 171, 181; upward, 29, 34, 36–37, 49, 77, 137, 139, 141, 154, 160–61, 179, 182–83
social networks and webs, 2, 3, 6–7, 15, 18–19, 21–22, 48, 56–57, 59, 61, 75, 88, 91, 94, 103, 105–7, 111, 118, 122, 124, 127, 141, 146, 149, 154–55, 163, 165, 171, 174, 187, 196, 198, 200, 211–13, 215, 219–22, 224, 226n8; tango networks and tango webs, 7, 58, 61–63, 149, 153, 156, 196, 198, 200–201, 212, 222
social status: depreciation, 122; incongruencies, 172, 176, 190
solidarity: bounded, 19, 94, 109, 201, 222; community, 184–87; double-bounded solidarity, 221; and enforceable trust, 19, 191, 222; ethnic, 16–19, 21–23, 59, 75, 101–4 179, 180, 187–92; lack of, 170–73, 181, 183, 190, 192; paradoxical solidarities, 188; 222–24
South America, 32, 113; South American immigrants 49

stigma: "alien," 48; being from the provinces, 154; being viewed as Hispanics, 204; illegality, 141; skin color, 32, 37; street work, 110

tango: companies, 92–93, 96–97, 173; shows, 2, 13–14, 77, 177, 184–85; tours and touring, 77, 89, 91, 93, 96, 99, 113, 135, 182, 189; troupes, 26, 96, 117, 175–76, 184. *See also Tango Argentino*
tango as Argentines' national product, 14, 20, 48, 51, 69, 75, 78, 81–84, 90, 98, 101, 149, 187, 218, 222, 224
Tango Argentino (stage show), 13–14, 50, 110, 226n7
tango community, 21, 155, 168, 182, 221; Argentine, 114, 185; international and global, 6, 14, 57, 175
tango grandparents, 85, 166–69, 208; *abuelos del tango*, 167
tangomania (*tangomanía*), 8, 12–13, 34–35, 74, 216, 219, 225n5, 226n6. *See also* addiction (to tango)
tourism: to Argentina, 90; global and international, 13–14; sexual tourism, 226n6
transnationalism and transnational links, 3, 9, 17, 84, 99, 102–3, 168, 173, 187, 219; "from below," 91; globetrotters, 93, 167; levels, 17; migrants, pilgrims, and workers, 3, 5, 21, 91–92, 157; tango community and economy, 57, 81, 221; transnational artists, 3, 90, 95; transnational leisure class, 219
trust, 15, 17, 19, 101, 196–97; among Argentines, 23, 94, 103, 167, 179, 187–88, 191, 197–98, 221–22; distrust and mistrust, 205, 208–9, 228n7; in health professionals, 201–2, 206–7, 214, 221–22

Uruguay, 20, 33, 84, 226n2; Uruguayan performers, 82

Valentino, Rudolph, 8, 226n5
Vila, Pablo, 34–36, 38–39

Visa Waiver Program (VWP): with Europe (Spain and Italy) 129; with the United States, 107, 113, 125–129, *130*, 133, 136, 138–39, 142, 145

visibility (of tango immigrants), 12, 15, 23, 50, 56, 137; visible face of the Argentine minority, 21

vulnerable immigrants, 104, 126, 134, 165, 198, 206, 212, 223; disadvantaged artists and immigrants, 112, 182, 201, 225*n*2; elderly, 21, 111, 116, 118–19; immigrants' "dual life," 22, 103; newcomers, 178

welfare state (in Argentina), 37, 42. *See also* Perón

Western medicine, 204, 210; Argentine social medicine, 204, 207; biomedicine, 210, 212, 215

whiteness, 137, 150, 152, 160, 162; fair-skinned individuals, 141, 151; in tango, 31, 44, 149, 152, 154, , 157, 159–60, 167–69, 223, 226*n*3; white Argentines, 6, 7, 23, 26–31, 34, 36, 137, 150–52, 160–63; whitening project in Argentina, 20, 28

working class: Argentines, 7, 22–23, 35–37, 41, 76, 112, 114, 120, 159–60, 163, 169, 208, 223; origins of tango, 35–36; *trabajadores*, 159, 164; urban proletariat, 37

About the Author

Anahí Viladrich's early research career on gender and reproductive health in Argentina, her home country, led to her first book on adolescent motherhood in 1991. A graduate in sociology from the University of Buenos Aires, once in the United States, she received a master's degree in sociology with honors from The New School University in 1999; a master's degree in philosophy in 2000, and a PhD in sociomedical sciences (specializing in medical anthropology) from Columbia University in 2003. Her dissertation, which served as the basis for this book, was awarded with distinction and the Marisa de Castro Benton Dissertation Award in Sociomedical Sciences, the two highest honors conferred by Columbia University in her field.

Viladrich's teaching and research interests address the root causes of social and health disparities, with special focus on immigrants' health and human rights in the United States and abroad. She has published more than fifty articles and book chapters on gender, immigration, and health. Viladrich is currently an associate professor in the Departments of Sociology and Anthropology at Queens College, and in the Doctor of Public Health program at the Graduate Center of the City University of New York (CUNY). Before joining Queens College in 2010, she was an associate professor at Hunter College, CUNY.